THE BIG BOOK OF
PAINTING
NATURE
IN OIL

THE BIG BOOK OF PAINTING NATURE IN OIL

PAINTINGS BY S. ALLYN SCHAEFFER
PHOTOGRAPHS BY JOHN SHAW

WATSON-GUPTILL PUBLICATIONS/NEW YORK

S. ALLYN SCHAEFFER

Edited by Elizabeth Leonard
Designed by Bob Fillie
Graphic production by Hector Campbell
Text set in 11-point Century Old Style

First published 1991 in New York by Watson-Guptill Publications,
a division of VNU Business Media, Inc., 770 Broadway, New York, NY. 10003
www.watsonguptill.com

Library of Congress Cataloging-in-Publication Data

Schaeffer, S. Allyn, 1935–
 [Selections. 1991]
 The big book of painting nature in oil / paintings by S. Allyn
Schaeffer ; photographs by John Shaw.
 p. cm.
 Selections from The oil painter's guide to painting trees, The oil
painter's guide to painting skies, and The oil painter's guide to
painting water.
 Includes index.
 ISBN 0-8230-0503-8
 1. Painting–Technique. I. Shaw, John, 1944– . II. Title.
ND1500.S2425 1991
751.45'436–dc20 90-23572
 CIP

Manufactured in Malaysia

First printing, 1991

8 9 10 11 12 / 06 05 04 03 02

Contents

SKIES

WATER

Introduction

What can match the excitement of painting nature in oil? Whether you want to paint mountains or the seashore, intimate close-ups or sweeping vistas, elaborate cloud formations or a single flower, painting your subject in oil will prove to be endlessly challenging, continually fresh, and wonderfully satisfying. Since the fifteenth century, oil has been the foremost painting medium, a tradition that lives on today.

Unlike water-based paints, oils stay fresh and moist for days, giving you the freedom to work and rework your canvas. You can build compositions up slowly, adding layer after layer of thin color. Or you can work quickly and directly, using loose, expressive brushstrokes or even a painting knife to apply the color. And oil painting is forgiving. If you aren't happy with what results, you can easily scrape away what you have done and start fresh (a boon for beginners). Working with oils, it's easy to subtly adjust color by covering one area with a sheer glaze of another color. You can blend color directly on the canvas by adding other dabs of color, or you can mix it on your palette. Some artists relish working with color almost straight from the tube. Others prefer altering the paint with any one of a variety of painting mediums. Some like to finish a painting in one go, while others prefer a slower, more cerebral approach. Some like to render their subjects in exacting, near-photographic detail. Others enjoy creating a heavily textured, expressive surface. In short, oil is an incredibly flexible medium, one that works for many different types of painters and many different subjects. Using this book, we hope you will find an approach that is right for you.

HOW THIS BOOK IS ORGANIZED

This book brings you everything you need to begin to paint nature in oil. We begin with the basics, the essential materials and techniques. Next, we explore color, then go on to special effects that add excitement to your works. As soon as you have worked through this section, you can begin any of the 135 lessons in this book.

First, you will learn to depict trees, flowers, leaves, bark, and fruit, in all seasons of the year. Next, you will learn how to paint skies—all types of skies, quiet, dramatic, sun-filled, or stormy. Finally, you will explore painting water, everything from rivers, lakes, and the ocean to fog, mist, ice, and snow.

Each lesson focuses on a specific problem that you are likely to encounter when you paint nature. We begin by analyzing the problem you are facing, then present a working method. As you work your way through the book, you will find that many problems have more than one solution, and you will learn how to analyze all types of challenges. You will understand how to decide which approach is right for you.

Each lesson explains all the steps in the painting process, along with specific information about the colors and techniques used. Many of the lessons have step-by-step demonstrations that show you exactly how the painting was developed.

Supplementary assignments are

included throughout the book, either elaborating on a point covered in the lesson or branching out in a new direction. All the lessons are designed to increase your involvement with painting in oil and to take you beyond the limits of the illustrated demonstrations.

Feel free to turn to any lesson that interests you; they need not be done in any particular order. However, since some of the assignments are based on the lessons, it may be helpful to read the corresponding lesson before you work on an assignment.

THE PHOTOGRAPHS
The book includes the actual photographs the artist worked from as he executed the paintings, giving you an advantage that few painting instruction volumes provide. The photographs are an invaluable aid to understanding how to translate what you see into good paintings. Before you read each lesson, spend a little time looking at the photograph and at the finished painting. Soon you will start to grasp how the artist interpreted what he saw.

These masterful photographs can help you discover new ways of composing your paintings and new subject matter as well. When you look at a photograph, note how the scene is composed. What angle did the photographer use? How did he frame the subject? What kind of light fills the shot? Did he use any unusual effects? When you are outdoors, try to apply what you have learned as you look for new ways to see the world around you.

If you are inexperienced with composition and unsure of how to frame your subject, try using a viewfinder. They are easy to make. Measure the canvas or board you will be painting on, then divide its height and width by 4 (by 5 or 6 if you are working on a really large canvas). Draw a rectangle the resulting size on a piece of cardboard, then cut the rectangle out using a hobby knife or scissors. Outdoors, hold the cardboard up and look through it at the landscape, framing what you see. Try to imagine all the possible views. Look at your subject both horizontally and vertically. Step close to it, then step back and look at it from a distance.

Using a viewfinder also makes it easier to ignore distracting elements and to focus clearly on a subject. It simplifies preliminary work, just as studying the superbly composed photographs in this book will do.

DEVELOPING YOUR OWN STYLE
Don't feel you have to copy the lessons in this book slavishly. Instead, try to think up fresh solutions to the problems we pose. Look at each photograph before you read the lesson. Analyze it, and try to figure out how you would approach the scene if you encountered it outdoors. Now read the lesson. If the solution we offer seems better than the one you've thought of, follow it, but if you favor your own approach, give it a try. As you will quickly learn, there is no one way to paint a landscape—there are thousands of ways, and discovering them will be ceaselessly fascinating.

Materials

Always buy the best paint, canvas, and brushes you can afford. Inexpensive student-grade paints won't stand the test of time, and their colors aren't as vivid as more expensive paints. Cheap brushes break down rapidly, and they lack the spring of better models. Low-grade canvas is poorly woven, which will affect the appearance of your finished paintings, and it can be difficult to stretch.

Keep the rest of your supplies simple. The gadgets that line the shelves in art-supply stores can be enticing, but they often get in the way while you paint. Work with just a few tools and you will get to know them well. Mastering the tools you use is one key to painting satisfying pictures, for working with just a few you will learn to reach instinctively for the right brush or painting knife.

If the expense involved in buying even basic oil-painting supplies is daunting, don't be dismayed. Good equipment and supplies last for a long time, and they make the experience of painting in oil infinitely more satisfying.

BRUSHES

The array of brushes displayed in most catalogues and art-supply stores can be bewildering. Keep in mind that there are only a few basic ones that you will need.

Bristles are the backbone of oil painting. Happily, they aren't terribly expensive, and if treated well, they will last for years. There are three basic types. Brights are flat, somewhat short-haired brushes with a straight end. Flats are similar in shape but have longer bristles. Filberts resemble flats and brights, but they have rounded ends. Experiment with each type to see what kind of brushstrokes they produce. Buy big brushes, up to an inch wide, and you'll find it easier to loosen up and paint more expressively.

You will also need some soft-haired brushes for detailed work and for loosely sketching your compositions onto the canvas with thinned paint when you begin your paintings. A flat sable is also useful in applying glazes. Small sable flat and round brushes are the best, although they are expensive. If you can't afford them, a variety of synthetic brushes are available.

For some detail work, you may

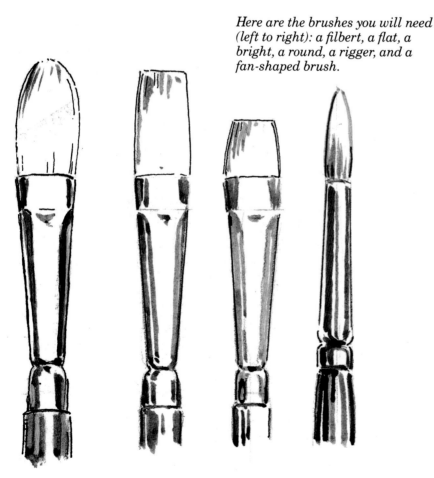

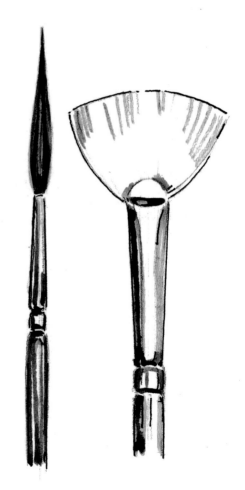

Here are the brushes you will need (left to right): a filbert, a flat, a bright, a round, a rigger, and a fan-shaped brush.

also want to buy a rigger. It has long, thin hairs, a springy touch, and is perfect for painting twigs, grasses, and the like. A fan-shaped brush is also a handy tool for gently blending colors together on the canvas. Finally, you will need an inexpensive housepainter's brush for applying sizing and varnish. Buy one that's two or three inches wide.

CARING FOR YOUR BRUSHES

Good brushes last for a long time, but only if they are cleaned correctly. Each time you finish a painting session, clean them thoroughly in turpentine or mineral spirits, then wipe them off on newspaper or on paper towels. Next, wash them clean using soap and water. Work up a soapy lather in the palm of your hand, then gently work the lather through the bristles until no trace of color is left. Rinse brushes with clean water, then squeeze them into shape. Never leave them standing in water. Store them upright until dry. When carrying brushes from place to place, roll them carefully in paper towels or a dish towel, or strap them onto heavy cardboard with rubber bands. Or try rolling them inside a slatted bamboo placemat and fastening the mat with a rubber band. The bamboo forms a rigid casing for the brushes.

PAINTING KNIVES AND PALETTE KNIVES

Painting knives and palette knives are often confused, but they actually have quite distinct functions. Painting knives are delicate, flexible implements and should be treated with care. They come in a variety of shapes. Use them as you would brushes to apply paint to the canvas.

Palette knives are sturdier. They resemble spatulas. Use a palette knife to scrape old paint off your palette, or even off the canvas. Many artists like to use the palette knife to mix colors, too, since the knives can be wiped clean in an instant, ensuring that the paints on the palette stay clean. In time, with repeated use, the edge of a palette knife can become dangerously sharp. Watch out for this. Either blunt overly sharp edges or replace the knife immediately.

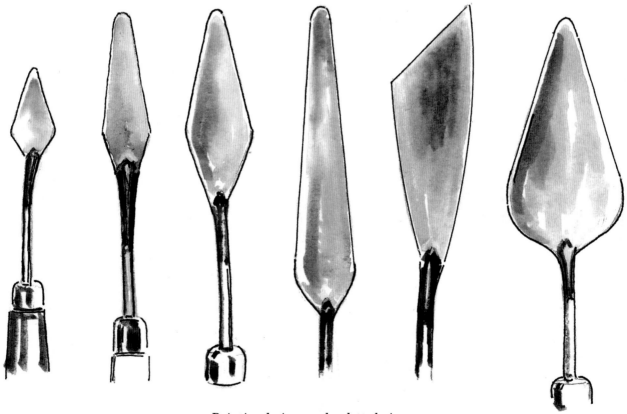

Painting knives and palette knives come in a wide range of shapes. Experiment until you find the shapes that you like the best.

CHOOSING YOUR SUPPORT

The least expensive support for oil painting is treated paper, and for rank beginners, this paper makes sense. Staple or tape it tightly to a board before you begin to paint.

Slightly more costly are the ubiquitous canvas boards, sheets of cardboard covered with inexpensive cloth that are painted white. These boards are very popular with beginners and students, for they are lightweight, easy to carry outdoors, and easy to store. Know, however, that they are not permanent.

By far the most satisfying support for painting in oil is canvas that has been stretched on a wooden frame. It has a wonderful spring and resilience, and history has shown us that it can last for hundreds and hundreds of years. If you are serious about painting, try working on it. Once you have, you will never want to go back to boards or treated paper again.

Canvas can be made of cotton or linen. The finest is made of linen, which stretches better and has better tooth. (Cotton can also be difficult to prime.) Look for cloth with an even weave. Textures can be tightly woven and smooth to fairly coarse with an open weave. Canvas also comes in a range of weights. Choosing the kind best suited to your subject matter and personal style is easier once you have experimented with a variety of types.

It's most economical to buy rolls of primed or unprimed (raw) canvas. If you are in a painting class, you may want to share the expense with other students.

For economy's sake, you may be tempted to begin working on small canvases. Don't! Unless you are very experienced, working on a small support can easily result in tight, overly controlled paintings. Choose a surface that measures at least 18 × 18″. Every now and then, try working on an even bigger canvas, one that measures 24 × 36″ or 30 × 40″.

STRETCHING CANVAS

It's easy to stretch canvas, once you know how. You will need stretcher bars from your art-supply store. These have tongue-and-groove corners, are usually about 1⅝″ wide, and can be ordered in lengths up to 50 or 60 inches. (You can also purchase heavier stretcher bars, which are 2½″ wide and come in lengths of up to 72 inches.) The four bars should fit together tightly, without nails. After you have assembled the stretcher, make sure the corners are square by using a T-square. Next, cut a piece of canvas 1½″ larger on all sides than the stretcher (figure 1). Center the stretcher over the canvas, then fold the canvas over two facing bars. With a number 4 brass carpet tack, fasten one side of the canvas to the center of a bar (figure 2). Pull the canvas taut, either by hand or using canvas pliers, then tack down the other side of the canvas. A straight crease will form, running from one tack to the other (figure 3). Once again, pull the canvas taut, then fasten the remaining sides in the same manner (figure 4). A diamond-shaped crease will form (figure 5). Moving outward from the center of each side, continue to tack the canvas to the bars about every 3 inches. To finish the corners, fold one side under the other, then tack them down (figures 6 and 7). Don't trim off excess canvas. Instead, fold it over the back of the stretcher and tack it down. This will make it much easier to restretch the canvas should it ever become necessary. If any wrinkles remain, remove one or two tacks from the back and pull the canvas taut. To get rid of small dents, try moistening the back of the wrinkled area and let the canvas dry.

Once the canvas has been stretched, you can drive small wooden wedges, called keys, into the slots at the inner corners of the stretchers to further tighten the canvas. You may want to wait, though, and use them only if, in time, the canvas becomes slack.

In recent years, many artists have begun to use staples and a staple gun instead of tacks to join the canvas to the stretchers. This method is somewhat quicker and easier, but it is not nearly as stable. If you use a staple gun, be sure to secure the canvas to the center of each bar with one carpet tack.

When you have finished a painting, protect the back of the canvas by loosely fixing a sheet of cardboard inside the back of the stretcher.

PRIMING THE CANVAS

Both linen and cotton will eventually rot if they are saturated with oil. To prevent this destruction, canvas must be primed—treated with a glue or gelatin solution to "size" the canvas, then coated with an oil-based primer. You can buy primed canvas, but make certain that the primer has an oil base, not an acrylic one.

After you have stretched the raw canvas, evenly brush the weak glue solution onto it, using a wide nylon or bristle brush. When the fabric dries, coat it with a mixture of white lead in oil and turpentine, again using a wide brush. The brilliant white surface that results makes it easier to gauge the colors you will be using while you paint. Let the canvas dry again, then sand it lightly. Finally, apply a second coat of the white lead in oil and turpentine solution, and sand the canvas again. All these materials (and more detailed instructions as to their use) can be found in art-supply stores.

Many painters enjoy working on wood panels, a support used for centuries. The old masters worked on oak, poplar, and mahogany, but today "wood panel" can mean anything from a piece of poplar to plywood to Masonite. The latter is increasingly popular because it is inexpensive, durable, and can be cut into virtually any

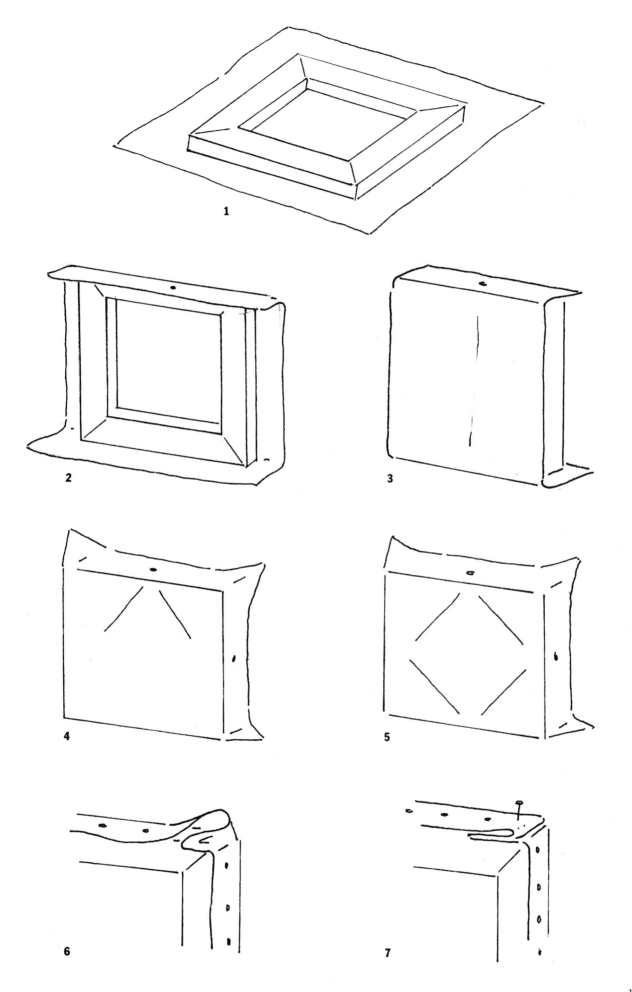

1

2

3

4

5

6

7

size. Wood panels are perfect for rendering intricate, detailed subjects where the weave of the canvas might interfere. You can buy prepared boards or you can make your own. (If you choose plywood, look for boards without pits or raised areas.) You must prime the panel with gesso before you begin painting. Dilute the gesso with water, apply it with a wide housepainter's brush, let it dry, then sand it smooth. Repeat the process two or more times. (If you want a slightly rougher surface, add less water to the gesso and don't sand the board.)

PAPER

For an interesting change of pace, try painting on watercolor paper or vellum. Size the paper with an acrylic medium first so the oil won't rot the paper. If permanence is a concern, choose a very heavy paper, one that is at least 200 pounds.

SELECTING PAINTS

It's good advice to buy good paints, but the relatively inexpensive student-grade paints have one blessing: Using them, many beginners feel free to paint loosely with big lush strokes without worrying about expense. As soon as the lesson is learned, move on to better paints. The finest are professional quality; if you can afford them, you can buy them knowing you are getting the best. In between student-grade and professional-grade paints are the brand-name paints you are likely to find in your art-supply store. Many brands are available, and colors may vary slightly from brand to brand.

Tube sizes vary. Once you have established your basic palette, buy big tubes of the colors you rely on. Right from the beginning, buy a big tube of white, since it is used in so many ways.

Always cap tubes as soon as you have squeezed out the paint. Roll them up tightly when you have finished painting. If a lid should stick

when you try to open a tube, don't force it. Instead, run it under hot water or hold a lit match to it for a few seconds. This usually does the trick.

SOLVENTS

To clean your brushes and to thin your paint in the early stages of a painting, you will need a solvent. Turpentine is the traditional, accepted solvent for oil colors. You can buy highly refined turpentine in art-supply stores, or you can purchase it in a hardware store. In some cases, the variety you buy in a hardware store may be fresher than the more highly refined type because of high-volume sales. Some artists prefer to work with mineral spirits. You can also buy this at hardware stores. Whatever you choose, buy a gallon, then re-bottle it at home in a smaller container for easier handling.

PAINTING MEDIUMS

A painting medium is a liquid solution that makes it easier to work with paint. Straight from the tube, oil paint is thick and rich, and it can be difficult to manipulate. Adding any one of a number of painting mediums changes the consistency of the paint and can even alter how rapidly it dries.

The most basic medium is plain turpentine, just enough to slightly thin the paint. Another standard is linseed oil, which makes the paint more fluid. (It tends to yellow paint, however.) The most common painting mediums are probably a combination of turpentine and linseed oil, sometimes with the addition of a resinous substance, such as damar varnish. All the paintings in this book were done using a medium of one to four or five parts turpentine to one part oil and one part damar varnish.

Begin by experimenting with a mixture of 50 percent turpentine and 50 percent linseed oil. Because linseed oil can retard drying, you may prefer to increase the proportion of turpentine. A good

mixture is one part oil to three parts turpentine. Once you find a medium you like, mix a good-size batch and store it in a tightly sealed jar. As you paint, dip your brush into the medium, then add a little paint, then mix them together on your palette.

When you are beginning a painting, you may want to rely on turpentine alone to thin your paint. With thin turp washes, you can "sketch" preliminary compositions onto the canvas and establish basic areas of color. The turps evaporates quickly, leaving behind overall color notes. Used alone, turps results in a fairly mat finish; linseed oil used alone results in a glossy finish. If you like energetic, rugged brushstrokes, you will probably want to use less medium.

Special painting mediums are also available to alter paint in different ways. The most common retard or hasten drying time. Check your art-supply store to see the range that is available.

VARNISH

Oil paintings must be varnished to protect them from dirt, dust, and toxins in the atmosphere. Varnish is a clear solution made from a resin and turpentine or some other solvent. In art-supply stores you will see two major types, retouching varnish and picture varnish. Depending on the thickness of the paint, it can take six months or longer for an oil painting to dry. In the meantime, the surface of the painting needs to be protected with a coat of retouching varnish, which is a solution that contains just a small amount of resin mixed with turpentine. After the varnish is applied to the canvas, the turpentine evaporates, leaving a thin protective covering. As soon as paint feels dry to the touch (usually in one to two weeks), apply this first coat of varnish.

Picture varnish contains more resin than retouching varnish does. It should be applied about six months after you complete a painting. If you paint with very

thick brushstrokes, you may want to wait as long as nine months to a year before applying the final coat.

Both types of varnish are applied in the same way. Use a broad, flat nylon brush—a housepainter's brush will do. Brush the varnish on evenly, using horizontal strokes.

You can also use retouching varnish while you paint. If one area of a painting has been dry for several days while you have worked on other sections, it can look flat and dull compared to the rest of the canvas. (Earth colors dry especially dull.) Dabbing retouching varnish onto the dry areas will restore the glossy look that the more recently painted areas have.

PALETTES

A palette is the mixing surface onto which you squeeze your paints. It's easy to make your own, or you can buy one. The standard, classic palette is made of polished hardwood and is either oblong or oval, typically with a hole carved out to accommodate the thumb. Oval palettes are favored by artists who like to hold their palette while they paint. (Some find holding a palette awkward and messy.)

If you want to keep both hands free, almost any flat surface will do. Plastic and turpentine don't mix, however, so make sure your palette isn't plastic. You can use a plate, cookie sheet, tile, or board. Some artists like to work on slabs of clear or opaque glass backed with a middle-value gray paper. Glass and porcelain palettes are the easiest to clean, but note that glass can break and be dangerous.

If you paint only once a week or even less frequently, a disposable palette might be your best choice. These palettes come in sheets of oil-proof paper. When you complete a painting session, simply tear off the used sheet and throw it away.

Many artists like their palette to be a neutral color, either wood with its natural color, or some other surface painted brown or gray. If you prefer, paint your palette white. If you are a beginner, you will find it easier to mix colors on a white ground, since the canvas is also white. On the other hand, neutral grounds can make it easier to gauge values.

When you are working on location, a palette that fits into your painting box is convenient. In the studio, choose the largest comfortable size to give you as much mixing area as possible.

PALETTE CUPS

To hold turpentine and your painting medium while you paint, you will need palette cups, which are called dippers. These are small cups that clip onto your palette. Many varieties are available. There are single-cup styles and double-cup styles, with and without covers. All are designed to fit tightly onto the edge of the palette.

Avoid very small dippers; large brushes won't even fit into them! And be sure that the size you choose will fit into your painting box. If you hold your palette, no doubt you will want covered dippers. Covers are also great if you want to keep your painting medium fresh from one painting session to the next.

Dippers quickly become sticky and dirty, and they are hard to clean. If you don't hold your palette, they need not clip onto it, so you can easily make your own. Try using small tin cans (the size that cat food comes in). Wash them thoroughly before using them, then throw them out when they become soiled.

BRUSH CLEANER

As you paint, you will frequently want to clean your brush with turpentine or mineral spirits. Special jars designed for cleaning brushes are available at art-supply stores, or you can easily make your own. Take a small tin can, clean it, then punch holes into its bottom with a hammer and a nail. Place the can inside a wide-mouth jar with the bottom facing upward. Now fill the bottle with cleaning solvent. When you dip a dirty brush into the solvent, the paint will fall through the holes in the can and remain at the bottom of the jar, keeping the solvent relatively clean.

EASEL

Your choice of an easel depends on where you plan to paint. Obviously, if all your painting is done indoors, you have no need for a large outdoor easel, and if you paint on the kitchen table, you have no use for a large studio easel!

If you work indoors and have room for it, invest in a solid, well-constructed studio easel, one that adjusts to different sizes of canvas. The key word here is solid. A poorly designed, shaky easel is worse than having no easel at all. If you don't have room for a studio easel, buy a small tabletop model or simply prop your canvas against your paintbox.

If you work mostly outdoors, you will want a lightweight portable easel. Today many come in aluminum. Be sure to test setting up the model you choose before you purchase it, and make sure that it is sturdy.

PAINTBOXES

If you want to paint outdoors, you will need a container that can tote all your equipment—paints, brushes, knives, palette, turps, oil, and painting medium. Some artists prefer a real paintbox, one designed to neatly store paint supplies. Paintboxes are designed to hold an easel loaded with paint, which is a big plus if you are moving from place to place. Use whatever suits you, be it an old tackle box or a canvas bag.

PENCILS AND CHARCOAL

Don't be in too much of a hurry to begin painting. A sketch pad and pencils are obvious necessities, used for preliminary sketches.

You will also need soft vine charcoal for sketching your sub-

*Working with white pastel on a
dark ground, you can easily cap-
ture the overall sweep of clouds,
the sea, or rolling fields. This kind
of sketch, as the examples at right
illustrate, can quickly give you
clues on how to develop your paint-
ing, and can help you fine-tune
values.*

ject on the canvas. Make sure you use natural charcoal; it can easily be wiped away with a tissue. Once you are happy with your sketch, gently blow onto the canvas to remove surplus charcoal.

In certain situations, you may need to execute more detailed drawings. Use a charcoal pencil, or spray your vine-charcoal drawing with a fixative.

Bold, highly effective landscape studies can also be done using white pastel on a dark ground, as the two pictures on the page opposite clearly illustrate. By varying the pressure and blending or erasing pastel, a wide range of values can be achieved.

RAGS

Use rags for general cleanup and for cleaning brushes as you work. Any lint-free absorbent material will work, including paper towels and tissues. Cloth diapers make great rags. Many artists prefer using cotton cloth not more than one square foot large. When a rag is small, it is easier to control.

While you are painting, try holding a rag in one hand, and use it to clean off the brush as you work. This helps ensure that the brush stays clean and that the colors you pick up stay clean as well.

CARE AND CLEANUP

Painting is much more fun if you are painting in a clean environment. Oil paints, linseed oil, and painting mediums leave sticky, tacky traces that can make a mess if they are not cleaned up on a regular basis.

After each painting session, clean your palette. Wipe the center clean and remove any dirty color around the mounds of untouched paint. If you are planning on painting again within the next few days, the mounds of paint will still be moist. If they feel hard when you next start painting, peel off the "skin" that forms on the top of the mounds. You will probably find that the paint underneath is still pliable.

Wipe tubes clean and carefully roll them up, and wipe paint off your palette and painting knives. Tighten the lids on your cans and bottles of turpentine, mineral spirits, linseed oil, and painting mediums.

Finally, throw away any dirty newspapers, rags, and paper towels that have accumulated. For safety's sake, put them in a tightly closed container before you throw them out.

SETTING UP YOUR WORK SPACE

You may be lucky enough to have a real studio, a room devoted solely to your painting. Most of us have to do with more modest quarters. Whether you work out of a studio or out of a drawer, however, you will find it much easier to paint if you organize all your equipment in a consistent way.

Keep brushes, dippers, and brush cleaners on one side of your easel (the right side for right-handed artists, the left side for left-handed ones). Your palette should be nearby on the same side, with tubes of paints within easy reach. Rags and towels are easiest to find if they are always in the same place. Even tools that you use only occasionally should never be far away.

Ventilation is very important when you are painting with oils. Keep a fan running or open a window while you paint.

STORING YOUR PAINTINGS

Be sure to store your paintings away from dust and dirt, especially before they are thoroughly dry. Never stack them. Store them on their sides separated by sheets of cardboard.

Color

Working with color is one of painting's great delights. Yet many beginning artists feel overwhelmed by the vast range of hues and by the color relationships that exist. They are also intimidated by the seemingly endless possibilities color offers for personal expression. At first, handling color may seem difficult, but once you understand the basic vocabulary, all you need to do is explore.

UNDERSTANDING COLOR
Red, yellow, and blue are primary colors, colors that cannot be mixed from any other colors. Mixing these primaries together results in the secondary colors: green (yellow plus blue), violet (blue plus red), and orange (red plus yellow). When secondary and primary colors are mixed to-gether, tertiary colors result, colors such as blue-violet and yellow-green. The easiest way to illustrate color relationships is to place the colors on a color wheel.

Colors that lie across from each other on the color wheel are said to be complementary.

True primary colors exist only in theory. The colors you buy in tubes aren't "true." Some blues tend toward violet, others toward green. And the secondary and tertiary colors have their own color personalities, too. The only way to understand the colors you use is to experiment with them.

COLOR CHARACTERISTICS
Every color has three main characteristics: hue, value, and intensity. *Hue* is the easiest to understand. Blue is a hue, and so is yellow, pink, green, violet, and any other color you can name.

Value measures how light or dark a hue is. White is high in value; black is low. All colors can be measured the same way. If you find it difficult to distinguish how light or dark certain colors are, try squinting, which emphasizes the lightest lights and the darkest darks. Another trick is to try to imagine how something would look if it were photographed in black and white.

Intensity refers to a hue's brilliance. Bright red is high in intensity. Since complementary colors tend to dull each other, adding a touch of bright green to the red makes it duller and less intense. Cadmium yellow is intense; a little mauve makes the yellow grayer and duller.

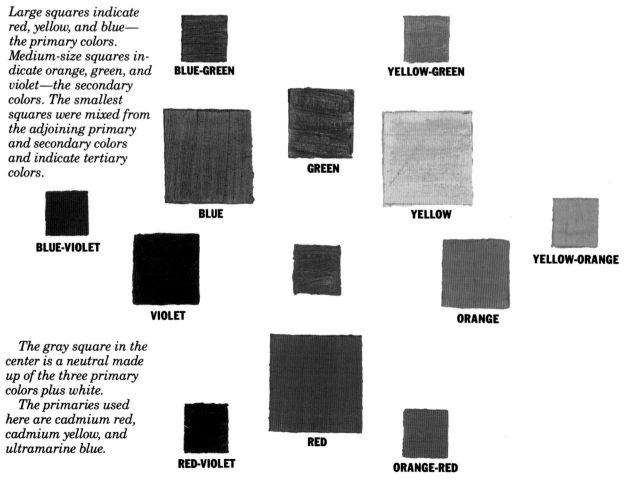

Large squares indicate red, yellow, and blue—the primary colors. Medium-size squares indicate orange, green, and violet—the secondary colors. The smallest squares were mixed from the adjoining primary and secondary colors and indicate tertiary colors.

BLUE-GREEN **YELLOW-GREEN**

GREEN

BLUE **YELLOW**

BLUE-VIOLET

YELLOW-ORANGE

VIOLET **ORANGE**

The gray square in the center is a neutral made up of the three primary colors plus white.

The primaries used here are cadmium red, cadmium yellow, and ultramarine blue.

RED

RED-VIOLET **ORANGE-RED**

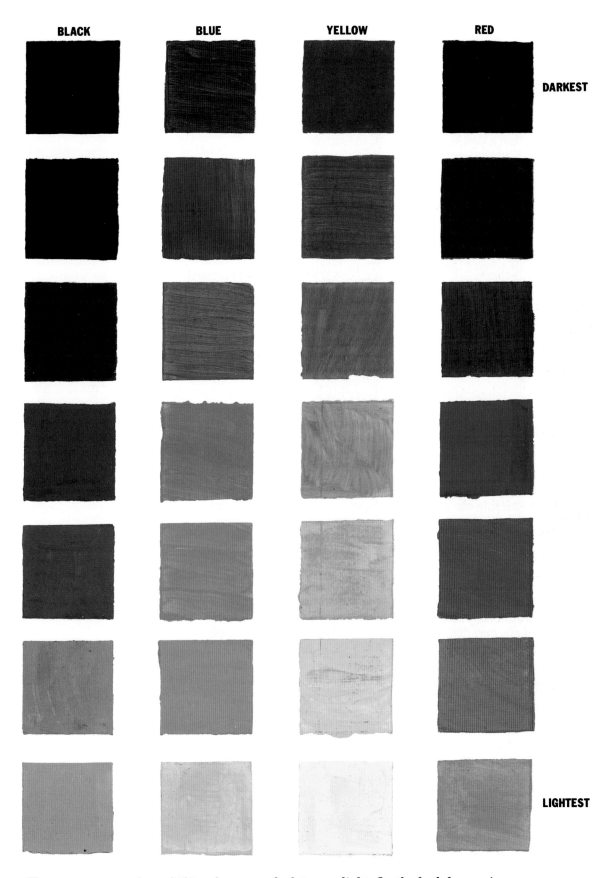

BLACK	BLUE	YELLOW	RED	
				DARKEST
				LIGHTEST

Here you can see values shifting from very dark to very light. On the far left, pure ivory black occupies the top square; increasing quantities of white are mixed into the pure black in each subsequent square. The three primary colors (here, ultramarine blue, cadmium yellow, and cadmium red) are similarly adjusted with additions of ivory black and white. It's interesting to note how black mixed with yellow creates a greenish hue.

21

TEMPERATURE

You will often see color described in terms of "temperature." Some colors are said to be warm, others are said to be cool. In general, red, yellow, and orange are warm colors, and blue, green, and violet are cool. Within a hue, temperature varies. Cadmium red is a warm red, alizarin crimson is a cool one. If you look at the two hues next to each other, the difference becomes obvious. Cadmium red tends toward the yellow side of the color wheel, while alizarin crimson tends toward the blue side. Cerulean is a warm blue, ultramarine is a cool one. Note that temperature can change in context. Against cool violet and blue, alizarin crimson looks warm. Beside cadmium red, cerulean blue looks cool.

You can use temperature as a tool in composing your paintings, since warm colors tend to advance and cool ones to recede. Adding a little purple to a distant mountain can push it backward visually. Using bright yellow in the foreground of a painting can push the area forward.

SELECTING YOUR PALETTE COLORS

Oil paints come in such a splendid array of colors that you will probably be tempted to buy many more than you need. (The relatively high cost of oils may dissuade you, however!) It's the preference of most professional artists to work with a limited palette, one made up of ten to fifteen colors. As you explore them, you will no doubt find ways to mix hundreds, even thousands of hues, and will discover which ones suit you best.

Most of the paintings in this book were completed using less than ten colors; for many of them, the artist worked with just five or six. In all 135 lessons, a total of 24 colors appear; they are listed here for reference.

White
Cadmium yellow light
Cadmium yellow deep
Yellow ocher
Raw sienna
Cadmium orange
Cadmium red light
Cadmium red medium
Cadmium red deep
Alizarin crimson
Light red
Burnt sienna
Mars violet
Burnt umber
Raw umber
Thalo (phthalo) blue
Ultramarine blue
Cobalt blue
Cerulean blue
Thalo (phthalo) green
Viridian
Permanent green light
Thalo (phthalo) yellow-green
Ivory black

ORGANIZING YOUR PALETTE

Always lay colors onto your palette the same way and in no time at all you will be able to reach for the hue you want instinctively. Figure out what scheme works best for you. You may want to start with blue, then move on to green, yellow, orange, red, and purple, finally adding grays and earth tones. Or you may prefer putting all your cool colors on one side and the warm ones on the other. If you like to work with a very broad range of colors, put those you use most often on one palette. Those you use less frequently can be kept near at hand on a second palette.

When you scrape up mixed color from your palette as it becomes dirty, don't throw it away. The accumulated paint makes an excellent neutral when you need gray.

In mixing colors, keep it simple. Whenever you mix more than three colors, you usually end up with mud!

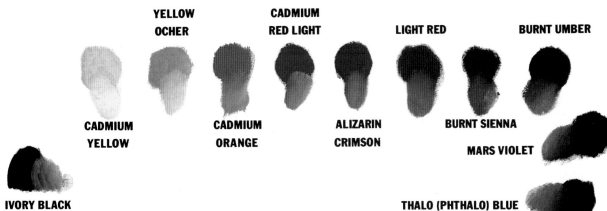

YELLOW OCHER

CADMIUM RED LIGHT

LIGHT RED

BURNT UMBER

CADMIUM YELLOW

CADMIUM ORANGE

ALIZARIN CRIMSON

BURNT SIENNA

MARS VIOLET

IVORY BLACK

THALO (PHTHALO) BLUE

COBALT BLUE

CERULEAN BLUE

THALO (PHTHALO) GREEN

PERMANENT GREEN LIGHT

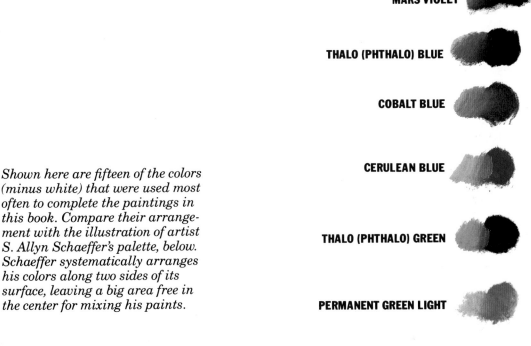

Shown here are fifteen of the colors (minus white) that were used most often to complete the paintings in this book. Compare their arrangement with the illustration of artist S. Allyn Schaeffer's palette, below. Schaeffer systematically arranges his colors along two sides of its surface, leaving a big area free in the center for mixing his paints.

EXPLORING YOUR PALETTE

Systematically practice mixing colors, and soon you will become acquainted with how color works. Record your experiments, then refer to your practice sheets when you are searching for a particular color. To get started, try the following color exercises.

1. To become acquainted with your palette, paint a swatch of each color, then label the swatches.

2. Paint long stripes with permanent green light, cerulean blue, ultramarine blue, light red, cadmium red, cadmium orange, and cadmium yellow. Let them dry. Now sweep a broad stripe of thinned yellow, red, and blue crosswise over the various colors to see how the primaries interact with them.

3. Mix two colors together five or six times, each time varying the amounts. How does a little ultramarine blue affect alizarin crimson? How does a lot affect it?

4. Mix complementary colors together in equal parts. Try purple with yellow, blue with orange, green with red. The result should be grayish or brownish.

5. Add just a touch of one color to its complementary color. See how just a hint of green dulls down red, and so on.

6. Experiment mixing warm colors together and cool colors together. Alizarin crimson is a cool red; cadmium red is a warm one. Ultramarine is a cool blue; cerulean blue is a warm one. Do two warm colors mixed together result in a warm color? How does a warm red mix with a cool blue? A cool green with a warm yellow?

7. Try painting a small landscape using only the primary colors—one red, one blue, and one yellow. What limitations do you discover? Or is it easier to mix the colors you want than you thought it would be? Do you find that it's the greens that cause you the most trouble?

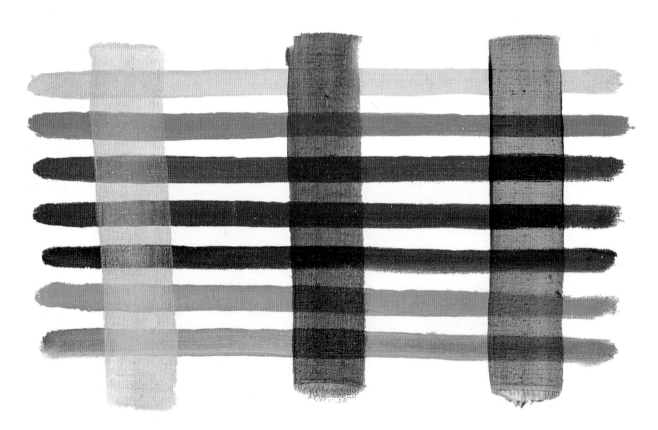

Here you can see how the three primary colors interact with several other hues on your palette, as described above. Try this exercise using different color combinations.

MIXING COMPLEMENTS

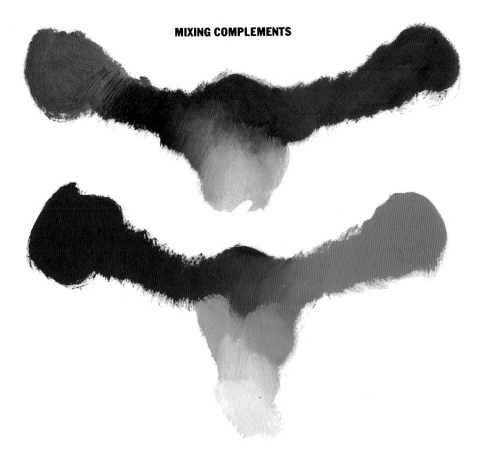

When you mix complementary colors, you get grayish or brownish hues. Here, cobalt blue and light red have been pulled together, as have Mars violet and cadmium orange. A touch of white has been added to each combination to make it easier to see the gray and brown tones that result.

MIXING GREENS

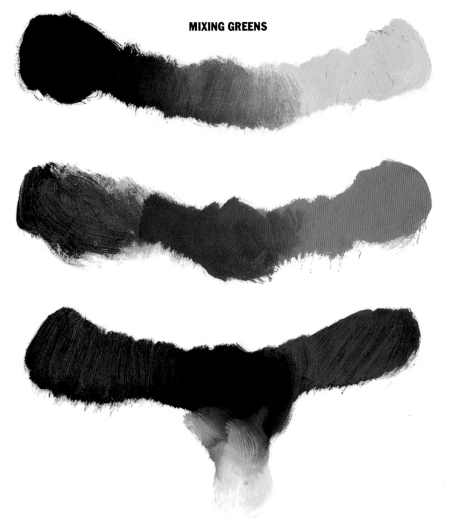

Explore the wide variety of greens you can create by mixing such unlikely colors as black and yellow. Also try dulling your tube greens with the addition of their complementary colors. Finding different ways of mixing colors will add considerable variety to your paintings.

Here, black and cadmium yellow produce an interesting olive green. Thalo green is mixed with a warm complement, cadmium orange, and with a cool one, alizarin crimson. In each, a little white has been added where the colors meet.

Working with Oils

Experimentation is the key to mastering oils. Begin by exploring your brushes. Let them act like brushes—respect their spring and the slightly uneven stroke a good bristle delivers. Brushmarks add sparkle, so don't get rid of them by scrubbing the paint onto the canvas! If you have trouble laying down assertive strokes, try using a bigger brush.

BRUSH TECHNIQUES

Each type of brush produces a distinctive brushstroke. Experiment with them. Mix some color on your palette, then load a filbert with it. Practice dabbing the tip of it onto the canvas, then pull the brush up over the canvas. Use varying degrees of pressure. Moisten the brush with paint once again, press the tip against the canvas, then pull the brush down and then up. Repeat the same motions using a flat.

Learn how to control a rigger. Mix some color and medium together, moisten the brush, then quickly run it over the canvas. It should create a thin, springy line.

Fan-shaped brushes are marvelous for smoothing color into an unbroken surface. Run over a wet canvas, they eliminate any sharp shifts in color. Watch out, though. They can also remove brushstrokes that you want to show. Try painting three bands of blue on a small canvas, with the darkest at the top and the lightest at the bottom. Use choppy strokes. Now pass the brush over the canvas, and see how the colors melt into one smooth surface. You can also add dabs of different colors onto the canvas, then blend them together using a fan-shaped brush. This can create a marvelous impressionistic feel.

Finally, try using a painting knife. Experiment by painting a mass of autumn leaves. First tone a canvas dark brown. With the knife, lift some cadmium orange from your palette, then lay the paint onto the canvas and spread it around. Now repeat the process using other oranges, reds, yellows, greens, blues, and browns. To enhance the effect, don't mix the colors together completely. Try not to deposit the paint too thickly—not only can it look gimmicky, but it may also crack apart. Finally, use the tip of the knife to scratch paint from the surface to reveal part of the canvas underneath and suggest branches.

HOLDING THE BRUSH

For the most flexibility and spontaneity, hold the brush a few inches away from the ferrule, the metal part of the brush between the handle and the hairs. For detailed work, hold the brush closer to the ferrule—it will give you more control over the brush.

If you find your arm tensing up as you paint, shake your hand in the air, then rotate your wrist for a minute or two. Repeat this exercise at regular intervals.

Strokes produced with a filbert.

Strokes produced with a flat.

Strokes produced with a rigger.

Color smoothed using a fan-shaped brush.

Autumn leaves executed with a small trowel-shaped painting knife.

THE CLASSIC OIL TECHNIQUE

Most of the paintings in this book were painted using the direct approach. They were completed in one continuous painting session, and from the beginning, the artist knew the look that he was after. All parts of the canvas were developed simultaneously, using expressive brushstrokes.

Begin by sketching the scene with vine charcoal. Softly blow off any surplus charcoal, then reinforce your drawing using paint that has been significantly thinned with turpentine (it should resemble a wash of watercolor). Next, begin working with thicker paint. Use big brushes to avoid becoming too tight, and apply big, sure strokes. Don't try to blend all your strokes together. Most important, move all over the surface of the canvas. Don't get caught fussing in one area.

Working wet paint into wet paint, go from general shapes to more definite ones. Toward the end, define edges and add details using a small round brush. Remember, a few details can suggest many—don't try to paint every leaf and twig.

Working in this direct way creates a richly textured canvas, one that has all of its parts beautifully woven together.

DRYBRUSH

If you have painted in watercolor, you will no doubt already be familiar with this technique. In it, the paint clings to raised surfaces, so it works best on canvas that has some tooth. The drybrush technique is great for suggesting masses of leaves or grasses. It can also very effectively indicate texture.

Pick up a little color with a bristle brush, wipe some of the paint off with a rag, then quickly drag the brush over the canvas. Use a light hand. Experimentation will tell you how much paint and how much pressure to use. Make sure the painting that you are working on has a fairly dry surface. If it is too wet, the brush will pick color up from the canvas rather than depositing pigment on it. For a very dry touch, squeeze some paint from the tube onto blotting paper or paper towels, then let the paper absorb surplus oil.

SCUMBLING

This technique resembles working in drybrush. A thin layer of paint is applied over paint of a different color, allowing the underlayer to show through. Like the drybrush technique, scumbling can create wonderful textured surfaces.

SCRATCHING OUT LIGHTS

When you want to pull lights out from beneath layers of paint, try scratching them out with a brush handle, a painting knife, or even a twig. This can result in brilliant and interesting lights.

WIPING OUT

To create soft, luminous lights and marvelous atmospheric effects or to meld two distinct areas together, try wiping out. Moisten a rag with some turps, then gently dab it onto the canvas. The paint on the canvas will come off onto the rag. Experimentation will teach you how much turps to use and how much pressure to apply.

The painting at the top of the facing page was completed in one "go," working all over the canvas in a classic wet-in-wet approach.

The drybrush technique, as illustrated in the painting at right, lets you create textural effects, masses of leaves, and the like with very little paint applied to a dry canvas. The pigment clings to raised surfaces.

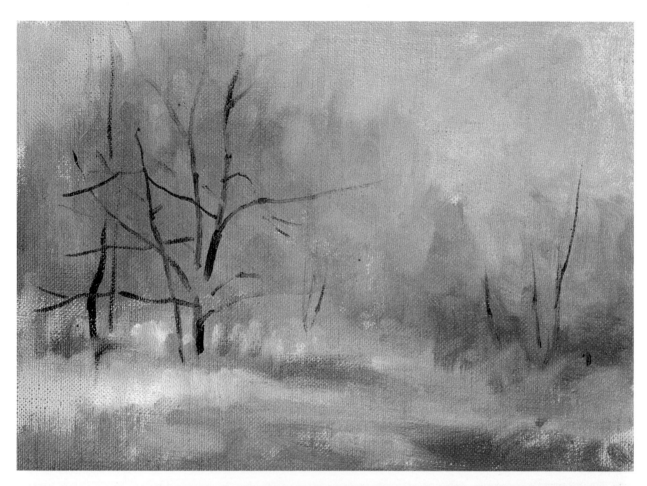

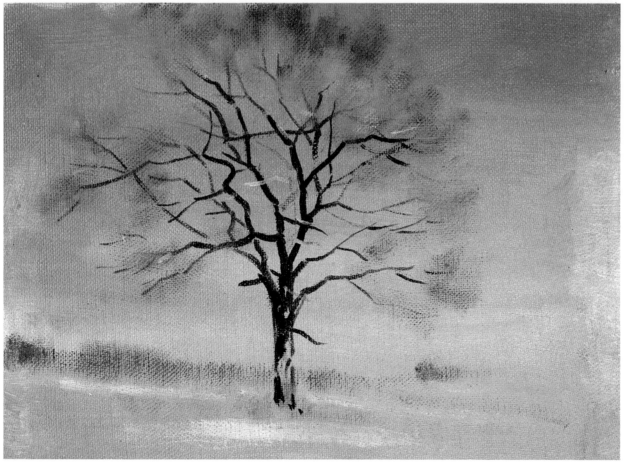

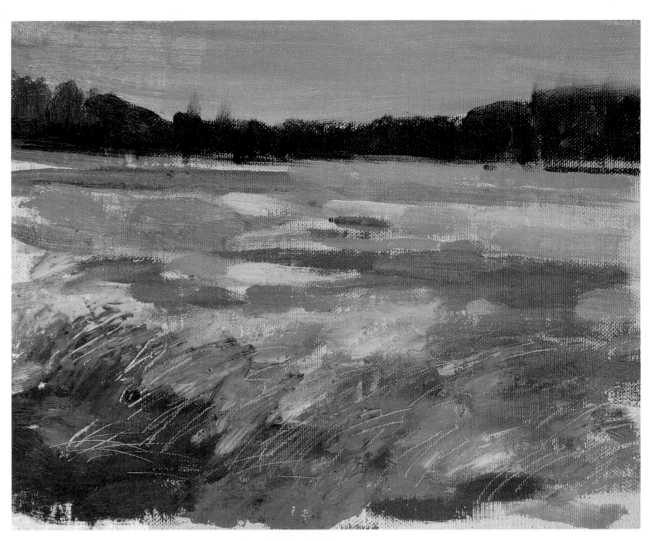

Here, a hobby knife pulled paint away from the canvas, creating the crisp white passages in the fore-ground. Many different tools come in handy for scratching out light areas and highlights this way, in-cluding twigs and the pointed ends of brush handles.

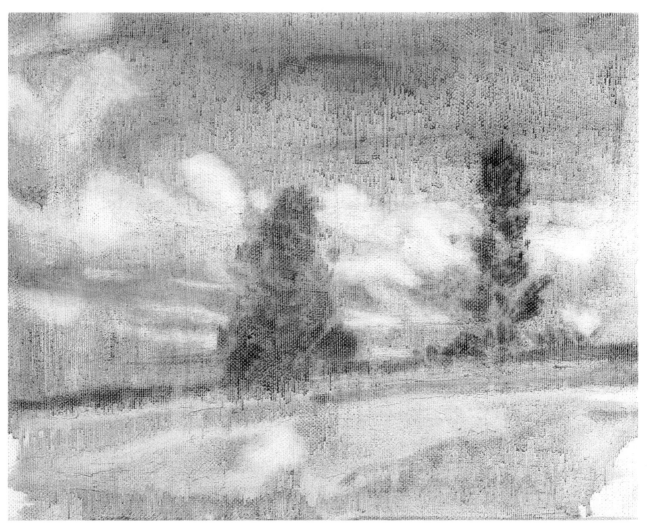

Soft, billowy clouds are suggested here by dabbing a rag dipped in turpentine onto the canvas and gently lifting off the blue of the sky. What results can be very subtle and interesting; you can easily achieve some lovely atmospheric effects with this wiping-out technique.

TREES

Accentuating a Lone Tree against a Dramatic Sky

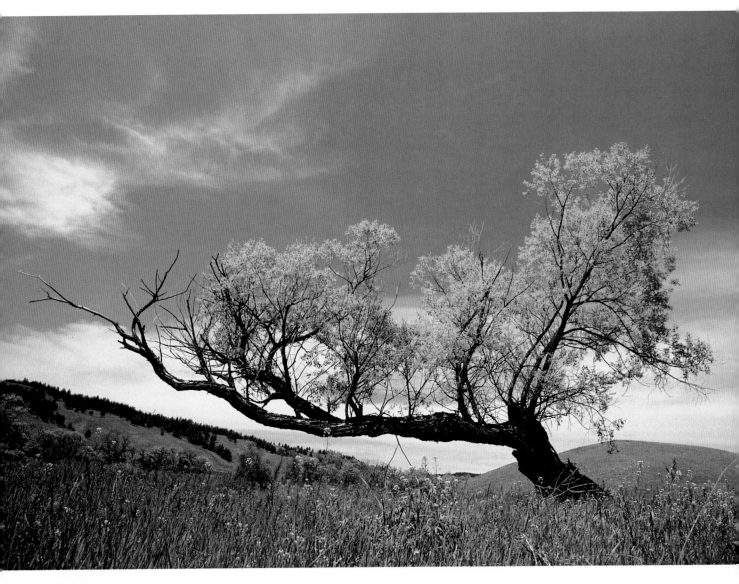

PROBLEM

The cloud-swept sky is so dramatic that it might easily become the center of the painting. If it does, the tree will seem insignificant.

SOLUTION

Emphasize the tree as much as possible by giving it a strong, definite silhouette. At the same time, play down the sweep of the sky.

On a prairie in the Midwest, an old willow tree bends gracefully toward the ground.

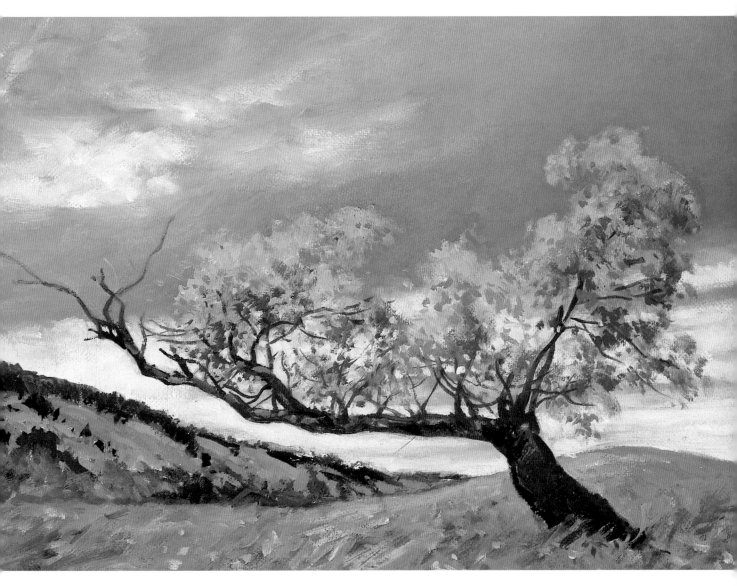

☐ In your preliminary charcoal sketch, pay careful attention to the shape of the tree. Analyze the way its main branch reaches across the ground. Next, using a wash of a dark, neutral color, go over the lines of your drawing with a brush. Don't worry about details. Concentrate on the tree's essential rhythm.

Begin laying in thin areas of color all over the surface. Start by establishing the darkest value —here the tree trunk and branches—and leave the area with the lightest value—the clouds—white. But think ahead.

How will you keep the intense white of the clouds from dominating the painting? By adding touches of yellow ocher to the clouds, you'll tone down their brilliance and, at the same time, achieve a more realistic depiction.

Once you've gotten down the basic color and value schemes, begin to work with stronger color, in thicker pigment. You may be tempted to use greens straight out of the tube. Don't. Your painting will be a lot more interesting if you temper the greens with other colors. Here the green foreground is broken up with

strokes of yellow ocher, blue, and even a mixture of black and yellow, which produces a lively silvery green.

Finally, step back and evaluate your painting critically. If some areas seem lackluster, bring them to life with touches of another color. Here flecks of dark green break up the masses of light and medium green in the tree's foliage. Dots of slightly greened yellow add highlights. Final touches like these help you achieve what you set out to do— they draw attention to the tree and make it stand out against the expanse of sky.

Creating a Convincing Sense of Space

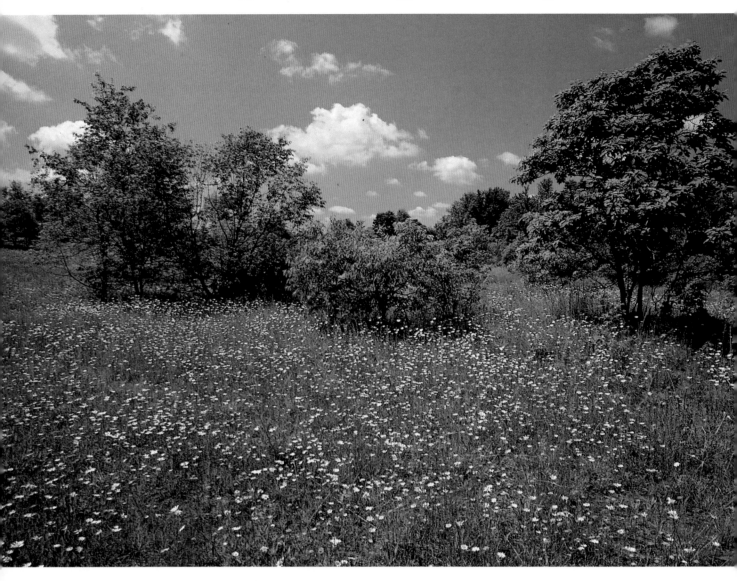

PROBLEM

All of the action in this scene occurs in the middle ground. There is nothing in the foreground to focus in on.

SOLUTION

After you have painted the entire scene, search for patterns in the foreground. Here you'll find them in the flowers that punctuate the grass.

Ox-eye daisies carpet a field, highlighting the vibrant greens of early summer.

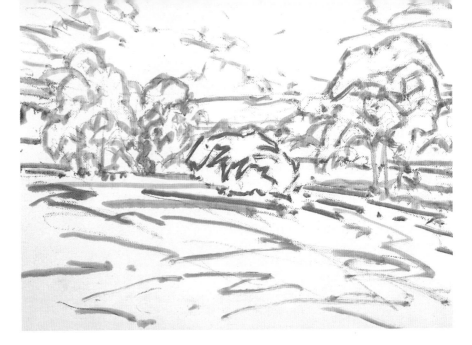

STEP ONE

With charcoal, sketch in the main forms that you see, even subtle ones, like the planes of the foreground. Then go over the lines of your drawing with thin washes. Use these washes to set the overall color mood of the painting by choosing two or three dominant tones—here blue for the shapes in the sky and greenish and brownish hues for the trees and grass.

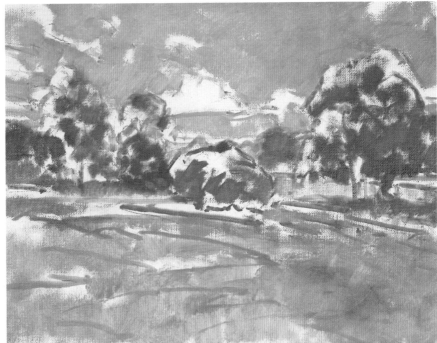

STEP TWO

Work from dark to light to bring out the tonal structure of the painting. The darkest areas are in the trees. Try mixing alizarin crimson with Thalo green for a deep, rich color. Keep your paint fluid at this stage by wetting your brush with turpentine. Next, lightly lay in the dark passages that run through the sky. A blend of cerulean and cobalt blue will give you the dynamic shade you see here. Loosely brush in the color patterns in the foreground with yellow ocher, raw sienna, permanent green light, and cadmium yellow.

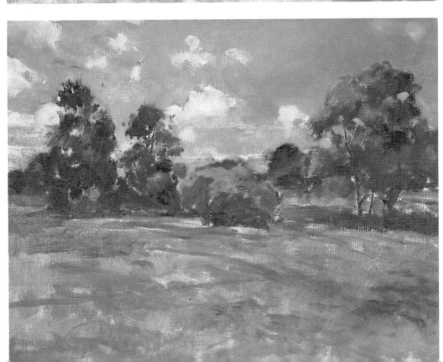

STEP THREE

Switch now to more opaque color as you begin to build up the trees. Once they are done, check the sky; you may have to adjust the blue to clarify its relationship with the trees' green. Be sure that the silhouettes of the trees stand out clearly against the sky. And don't forget the foreground; continue to define the contours of the field.

FINISHED PAINTING

Now refine what you've done. Start by sculpting out the shapes of the clouds by adding touches of yellow, gray, and purple. Then turn to the foreground. Using quick, light strokes, paint in the flowers that spill over the grass. What you are doing here is actually composing the foreground, creating stronger patterns than those that really exist. With dots of light color, you can lead the eye back to the darker trees—thus activating a strong sense of space.

ASSIGNMENT

In many landscapes, the focus lies in the middle distance, or even farther back in the picture plane. It's often tempting to concentrate on the scene's focal point, neglecting the rest of the subject. But if you do, you'll eventually run into trouble. Use your preliminary drawing as a tool to plan the design of the entire composition. In your sketch, lay in the contours that define the foreground and even the patterns that the clouds trace across the sky. Flip through the pages of this book and study the preliminary drawings. Note how directional lines are established right away, and how the major lines of the composition are clearly sketched in before painting actually begins.

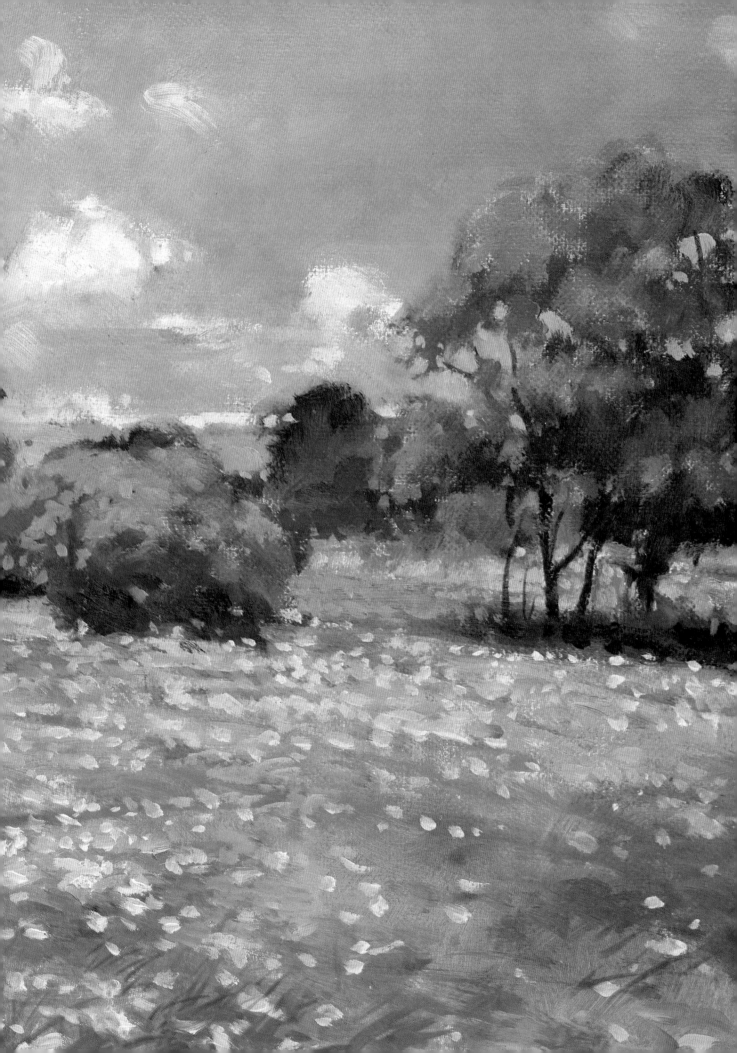

Capturing the Individuality of a Particular Tree

PROBLEM

A scene like this one—a handsome tree set against a clear blue sky—can be found almost anywhere. The challenge for the painter is how to make this tree unique.

SOLUTION

Pay attention to those things that give this particular tree its character. Make sure that your sketch captures the silhouette of the tree and the way its trunk and branches work together.

☐ Carefully sketch the tree's skeleton and the shape of its crown, then go over the drawing with a thin wash of color. Now start painting. Lightly brush in the sky and the trees along the horizon, then turn to the birch. Begin by painting in the darkest portions of the foliage. Save the trunk and branches for last.

Using heavier, darker color, continue to build up the tree and the sky. Work on both simultaneously, balancing the values of the blue and the greens. To break up the masses in the tree's crown and give a sense of the play of light, use a variety of colors to mix your greens.

Next, develop the foreground. Strong, vertical strokes will suggest the way the grass grows. To complete your work, paint the tree trunk. Capture the shadows that fall over its surface by experimenting with cool grays, blues, and purples. They will make the white areas much more exciting.

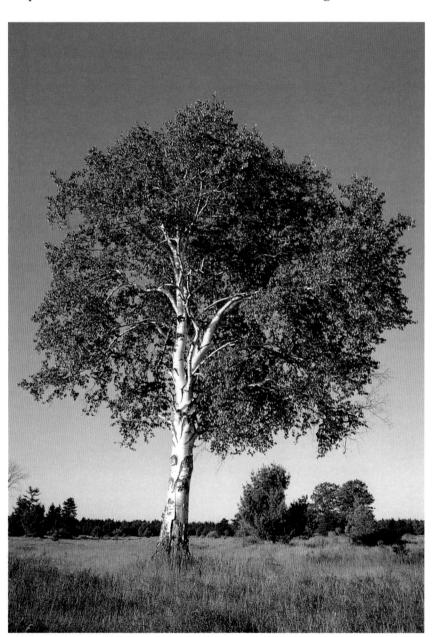

In late summer a majestic white birch stands against a deep blue sky.

ASSIGNMENT

Next time you go out scouting locations for your paintings, take along a sketchbook, pencils, and charcoal. Select a variety of trees to draw; search for stately conifers, delicate trees with lacy foliage, and handsome oaks and maples with dense, rounded crowns. As you sketch, pay careful attention to what makes each tree individual—how its trunk branches out, how the leaves are attached to the branches, and the pattern the foliage forms against the sky. Too many artists fall into the habit of drawing or painting an approximation of a tree. Instead of looking, they rely on an image they carry about with them, made up of all the trees they have seen in their lives—there's no greater obstacle to creating fresh, interesting paintings.

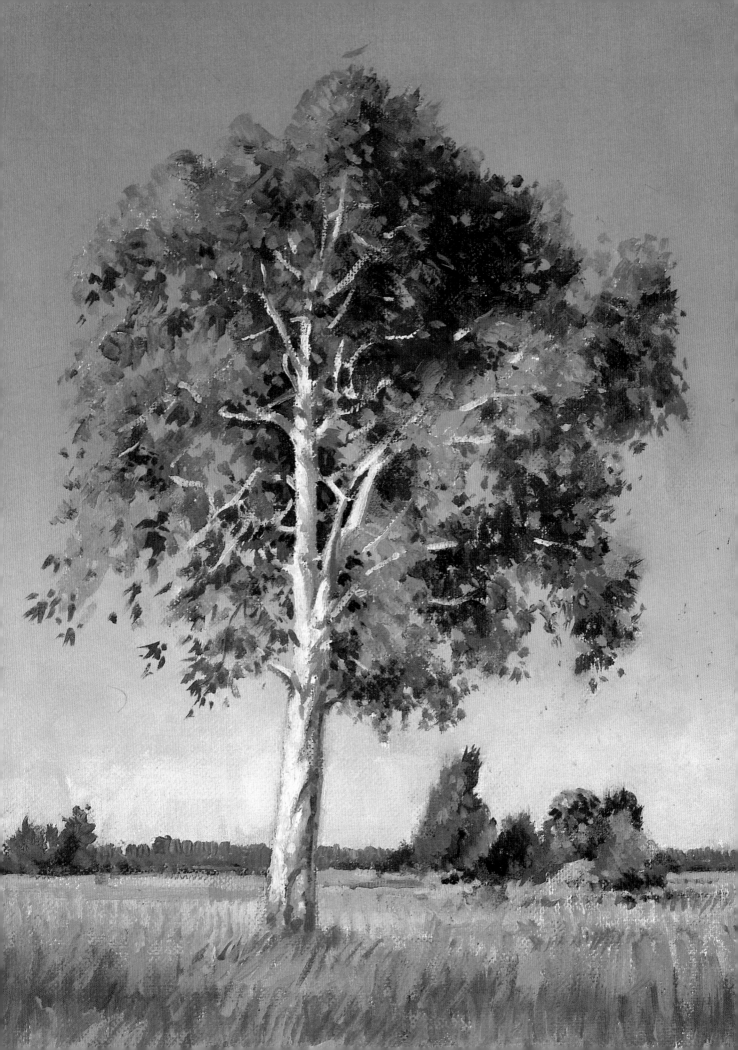

Stimulating Interest through Detail

PROBLEM

The myriad branches and twigs of this sycamore are almost lost against the brilliance of the blue sky. It's going to be hard to make them stand out clearly.

SOLUTION

A careful, detailed drawing is the secret to coping with such a complex pattern of lines. In it you can depict as many nuances as you like; then, when you start to paint, you can check specific reference points if you lose your way.

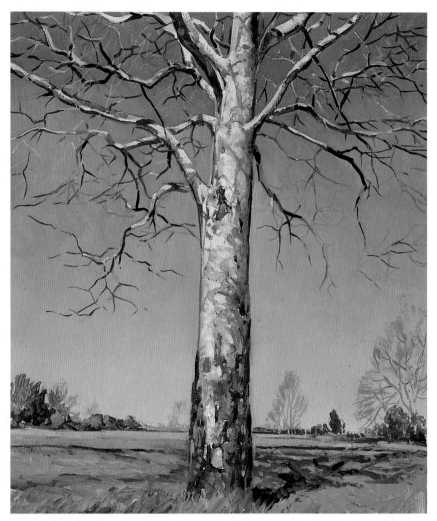

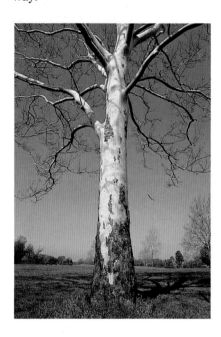

In May the twisting branches of an American sycamore create an intricate maze against the sky.

☐ Ask yourself: What kind of surface is best suited to this subject? The smooth white bark of the sycamore suggests a support like Masonite. Its smooth surface will help you convey the feel of the sycamore, whereas the texture of canvas might interfere with what you are trying to show.

Take your time with your charcoal drawing. Be sure to get the major branches down accurately; note where they bend and how they curve.

As you start to paint, use very thin washes—you want your drawing to remain visible. Lay in the sky all the way down to the horizon, then go back and pick out the whites of the branches

with a clean brush.

Now focus on the tree, working back and forth between lights and darks. By attending to the play of light on the trunk and branches, you can enhance the pattern of the tree against the sky. Search for colors that form the shadows on the trunk. They aren't just gray, but flecked with tints of blue and yellow.

Now enliven the grass with strong brushstrokes of varying greens and carefully render the dark shadows that run across the ground. Finally, paint the green trees along the horizon; then, using an almost dry brush, sketch in the delicate golden trees in front of them.

Unifying a Complex Maze of Branches

PROBLEM

There's order in this tangle of branches and twigs, but it's difficult to see at first. Unless you are careful, your painting will lack unity.

SOLUTION

Concentrate on the major branches and their extensions. In your drawing, work out the underlying pattern of lines. Then, with paint, focus on the play of light and dark.

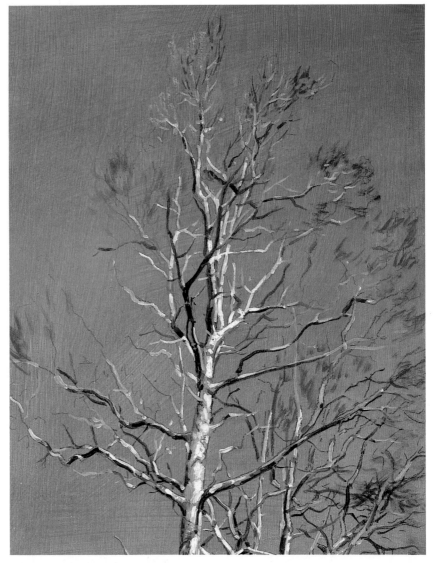

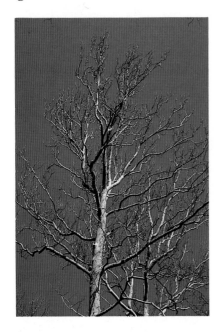

Brilliant spring sunshine picks out the tracery of a sycamore, highlighting its graceful lines.

☐ Once again, use Masonite for your support. Don't force this strongly vertical subject onto a standard-size board; instead, pick one that is tall and narrow. With soft vine charcoal, outline the twists and turns of the tree's skeleton. After fixing your drawing, you're ready to paint.

Cover the entire surface with transparent layers of blue paint, but don't lose your drawing. Now turn to the tree. For the darkest branches, try mixing cobalt blue and burnt sienna. The blue will soften the brown and relate the tree to the sky.

When the strong darks and lights have been established, concentrate on the transitions between them. Touches of yellow ocher and alizarin crimson relate the darker areas here to the creamy and pinkish whites. Add dabs of blue and yellow to convey the flicker of light shadows across the bark. It's these subtle color variations that take your painting beyond drawing.

You can't paint every little twig—if you do, your painting will be too busy. Instead, use a dry brush and feathery strokes for the twigs at the branches' tips. Here touches of raw sienna get across their spidery feel.

Working with Strong Contrasts

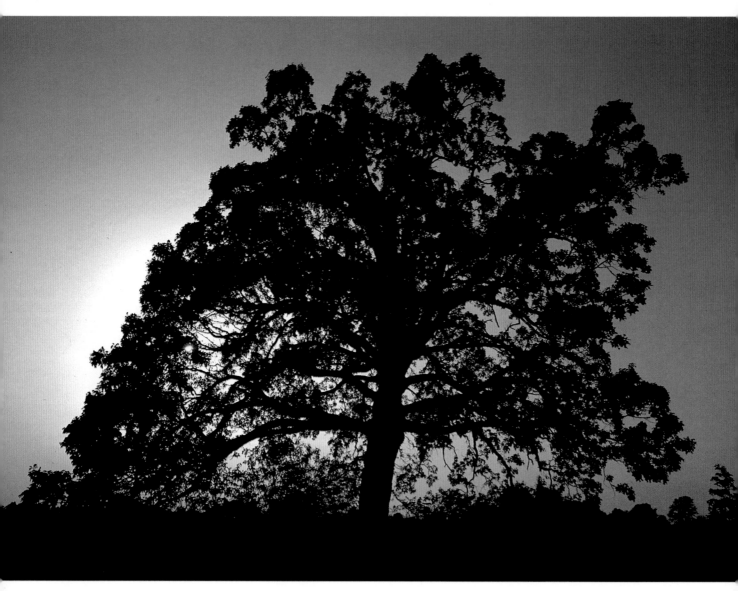

PROBLEM

When the contrast between a tree and the sky is this strong, it's easy to overlook the subtle points that make this dramatic scene arresting.

SOLUTION

Pretend at first that the tree isn't present. Start by trying to capture the beauty of the evening sky.

☐ In your preliminary charcoal sketch, aim at getting three things down: the tree trunk, the shape of the tree's crown, and the horizon line. Now reinforce your drawing with paint. Mix a bit of pigment with a good amount of turpentine and brush the mixture over the charcoal drawing. Once this thin wash is dry, turn to the sky. At first, use a bristle brush. Later, you can even out your strokes with a fan brush.

Work from the horizon line up toward the top of the canvas.

In the haze of summer, an old oak is silhouetted against a pale blue and gold sunset.

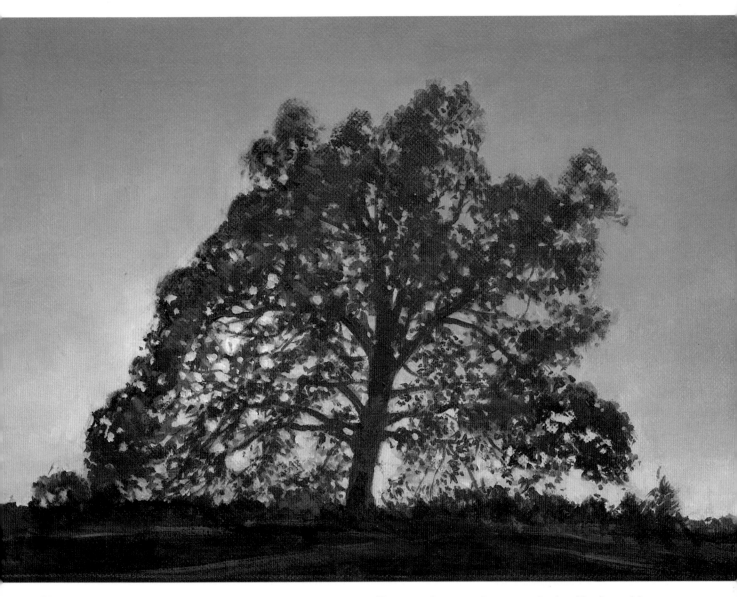

Near the horizon, use pale shades of yellow and cadmium orange. Gradually add a hint of crimson, then begin to blend in your blues. Make them strongest near the very top.

Let the sky dry for a bit, then turn to the tree. Its beauty stems, in large part, from the lacy delicacy of its foliage. Instead of using a broad bristle brush, try a small, pointed sable. With it, you'll be able to dab the paint on, gradually building up the masses

of leaves that are silhouetted against the evening sky.

Don't use straight black for the tree. Even though it's very dark, there's a lot of hidden color in it. Mixing blue with brown will give you an interesting dark color, with a slightly purple cast. Also look for the areas of deep green.

At some point, you'll probably find that you need to add touches of sky where the darker strokes have become too dense. Work back and forth, striving constantly

for a convincing illusion without worrying about detailed accuracy.

Finally, paint in the foreground with a bristle brush. Right along the horizon, take your sable brush again and dab paint onto the surface to break up what could become a monotonous stretch of flat land. In the finished painting, the tree's silhouette stands out clearly. Its branches and leaves have character, yet they retain the delicacy that makes this scene so appealing.

Grasping a Complicated Silhouette

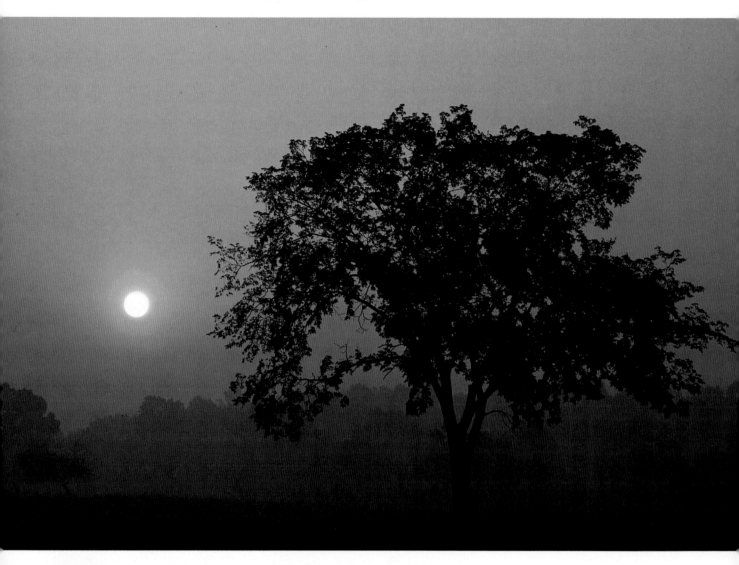

PROBLEM
This tree's silhouette is fairly complicated—it's made up of masses of tiny leaves. They have to be strong enough to convey the feel of this particular tree, but not so strong that the scene looks artificial.

SOLUTION
Paint the sky first. When you add the tree, follow what you see as carefully as possible, rendering the leaves with a small sable brush. Finally, soften the edges with dabs of lighter paint.

As the sun begins to rise, an American elm is set off by a rich, warm orange sky.

STEP ONE

On a separate piece of paper, draw in the tree, the horizon line, and the sun. Outline the major masses of leaves and the clumps of foliage along the horizon. You'll refer back to this drawing once you've laid in the sky.

STEP TWO

On your canvas, use soft charcoal to sketch in the horizon line, background shrubbery, and the sun. Now, with very thin washes of pale yellow, lay in the sky. By introducing a little orange, you can begin to hint at the warm glow surrounding the sun. Continuing to use thin washes, suggest the planes of the foreground and the shapes of the distant trees.

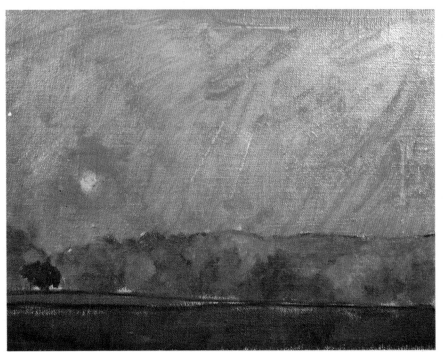

STEP THREE

Once the paint has dried, take your original drawing and copy the tree onto the canvas with charcoal. Softly blow any loose dust off the surface, then begin to paint. First, step up the brilliance of the orange surrounding the sun.

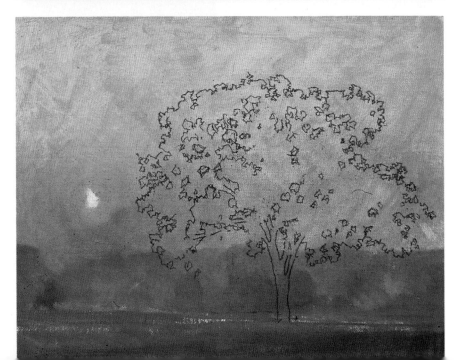

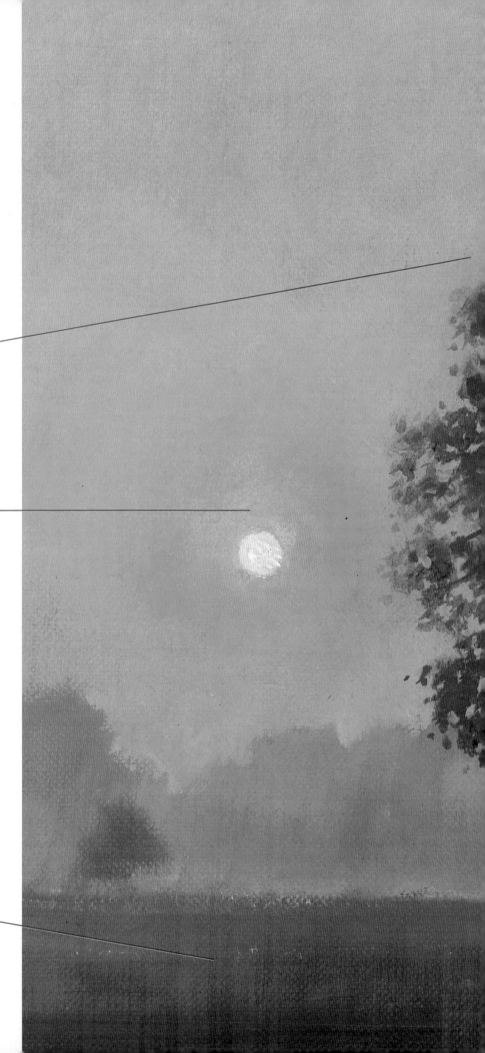

FINISHED PAINTING

To paint the tree, take a small, round, sable brush and dab the paint on gently, coaxing it onto the canvas. Don't use pure black; it will look heavy and dead. Instead, mix one of your browns with some alizarin crimson. At the very end, add a little white to your brown and crimson paints and scumble this mixture into the sky. Finally, with a dry brush, drag some of this mixture over the tree's crown to soften its edges.

The pale sky mixture dragged over the tips of the branches softens the harshness of the tree's silhouette and makes the entire scene seem more natural and convincing.

The sky can't be too light if it is to set off the yellowish-white color of the sun. The bright halo of orange accentuates this focal point, but the orange gradually diffuses as one moves away from the sun.

Painted simply and without much detail, the ground anchors the tree and establishes a strong middle value. Its rich reddish brown warms the sky and heightens its drama.

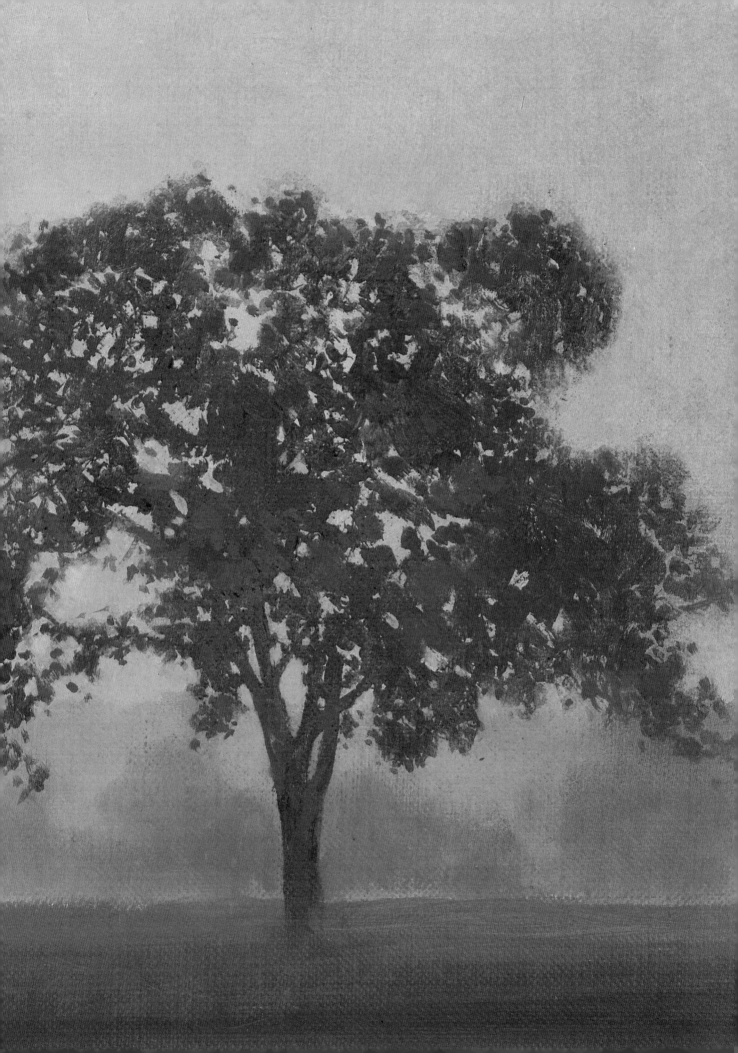

Translating a Tree's Skeleton at Sunset

PROBLEM

This handsome elm tree has countless branches and twigs, all thrown into sharp relief by the golden-orange sky. Don't be tempted to depict each and every one—you'll become lost in the maze, and your painting will look confusing and lack unity.

SOLUTION

Once the sky is established, focus on the main elements of the tree—its trunk and the largest branches. As you work, be faithful to what you see. When it comes time to add the small, wispy branches, make sure that they have the same feel as the rest of the tree.

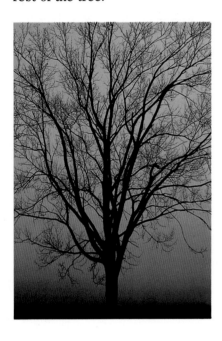

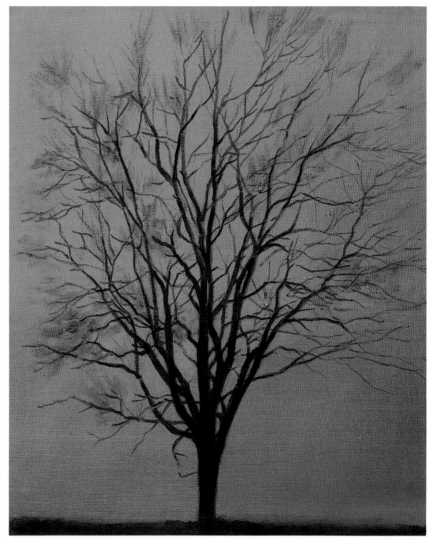

At sunset the branches of an American elm etch an elaborate network of lines in a pumpkin sky.

☐ Paint the deep orange sky first, with no thought of the tree, using full-strength paint right from the tube. Here the sky is colored by cadmium orange, cadmium yellow, cadmium red, and a touch of alizarin crimson. Painting the entire sky first is a handy approach whenever the sky serves as a fairly flat backdrop, without much detail, for a fairly complicated tree. It would be almost impossible to work back and forth between the tree and sky, picking out the bits of sky that appear between the branches.

Once the yellows, oranges, and reds are down on the canvas, smooth them together with a fan brush and let them dry. Then draw in the major lines of the tree with soft vine charcoal. To paint the tree, choose a small, long-haired, pointed brush and make your pigment wet enough to glide effortlessly onto the canvas.

Here the tree is painted primarily with a warm brown mixed from violet and blue. Occasional strokes of ocher complement and accent the interweaving of the darker lines. The fine, feathery twigs are indicated in the very last step.

DETAIL

To suggest the wispy twigs at the tips of the branches, use a dry-brush technique. Just barely moisten your brush with pigment, then drag it quickly across the surface. The result will be a soft blur of color, giving a convincing sense of how the myriad twigs blend together visually.

ASSIGNMENT

A drybrush technique is invaluable for depicting masses of distant foliage and for painting thin, terminal twigs. Here's how it's done.

Take a bristle brush and dab it onto your palette, then wipe the brush off on a rag. You want it to be barely moistened with pigment. Now, with a very light hand, quickly drag the brush over the canvas. Once you are comfortable with the technique, apply it to an actual painting.

Choose a subject with a mass of trees in the distance, along the horizon line. Sketch the scene, build up the surface with thin washes of color, then paint everything but the distant trees. As soon as the sky dries, lay in the trees with a very dry brush. Quickly drag the brush up over the sky. The thin, uneven strokes will get across the feeling of trees that are far away.

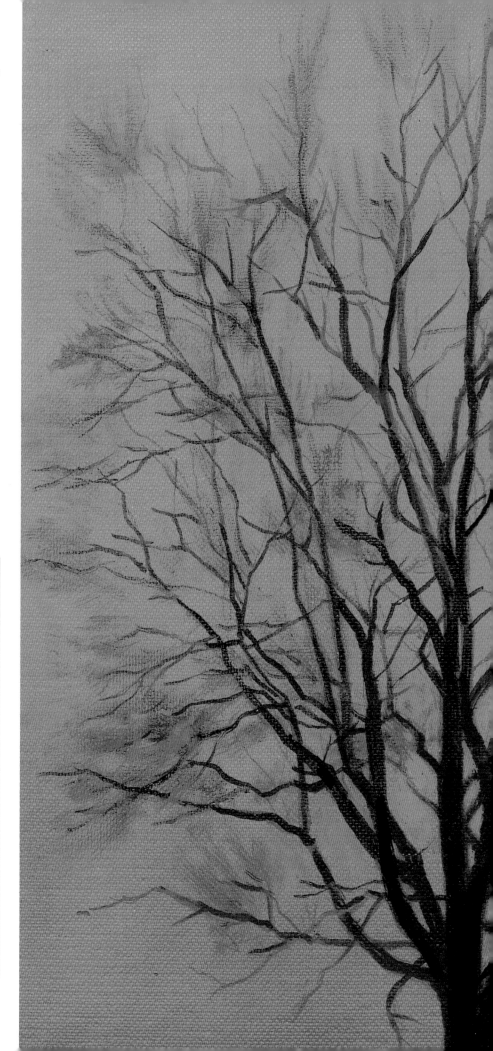

Balancing Strong and Delicate Elements

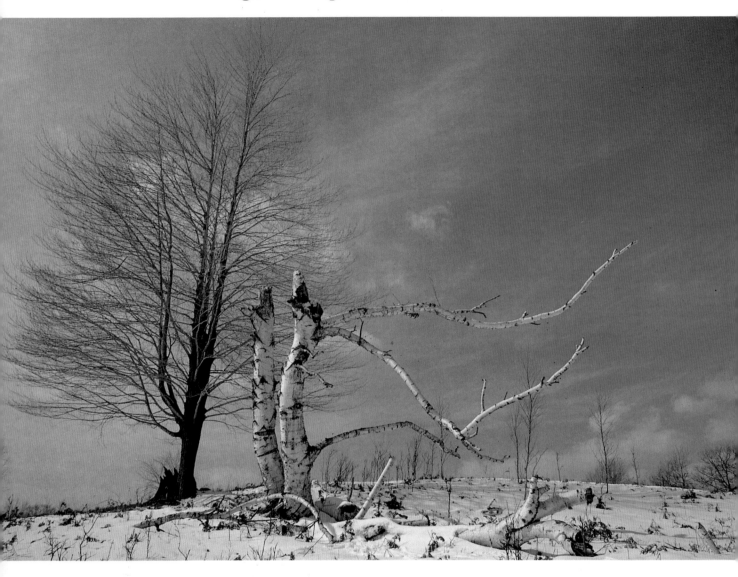

PROBLEM

The dramatic sweep of the clouds overshadows the stable trees below. To further complicate matters, the two trees are very different. The dark maple, with the upward surge of its trunk and delicate web of branches, seems far removed from the broken and bent white birch in the foreground.

SOLUTION

Capture the essence of the trees right away with a clear, loose drawing. Work up the sky gradually, starting with thin washes. As you begin to add opaque color, do so carefully, never letting it become so thick or intense that it steals attention from the trees.

On a chilly March afternoon, a cloud-swept sky forms the backdrop for a graceful maple and the remains of an old birch tree.

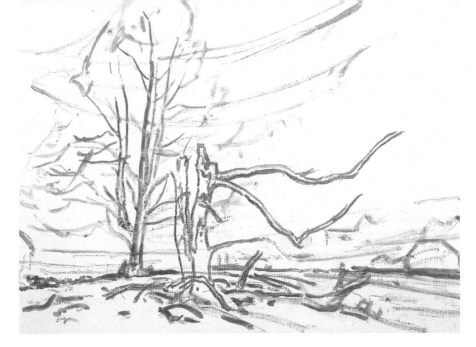

STEP ONE

In your preliminary charcoal sketch, free your hand to follow the major directional lines that rush through the scene. Try to convey the movement of the clouds as well as the flow of the trees. Now, with a pointed brush, go over the lines of your drawing with thin washes. Don't pick just any hue for these washes; select one or two that will set the color mood of the scene.

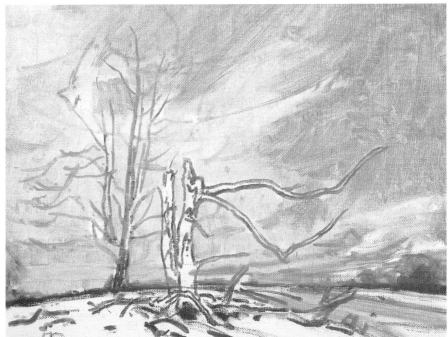

STEP TWO

Begin to develop the sky. Once again, you should use very thin washes—washes so thin, in fact, that they simply stain the canvas. Work expressively, sweeping your brush in rhythm with the race of clouds across the sky.

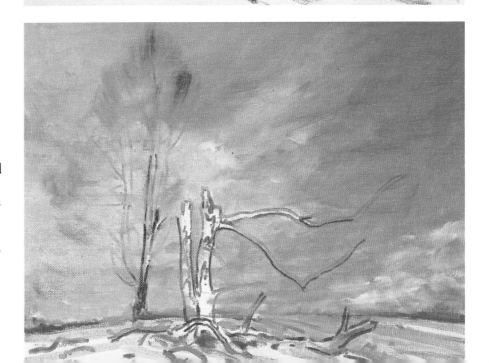

STEP THREE

Now it's time to start working with thicker pigment. Using the washes you laid down in step two as a guide, continue to build up the sky. Here most of it is colored in cobalt and cerulean blue, with touches of white and even alizarin crimson. Once the sky is down, set the character of the maple by using a drybrush technique for its feathered edges. Also start on the foreground.

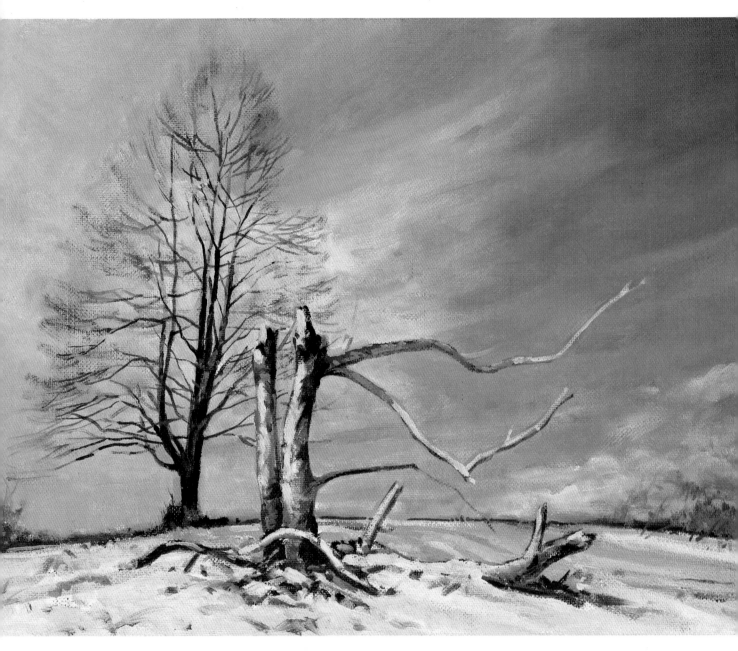

FINISHED PAINTING

With the sky completed, it's easy to gauge how dark you want the trees to be. You'll also see how to work in their contrasting elements. A rich, warm brown will distinguish the maple's elegance against the cool drama of the sky. To bring out the birch in front, play the shadows that define its volume against the areas of sparkling white. As a final step, mix together a very pale shade of whitish blue to lay in the rest of the foreground.

ASSIGNMENT

Working effectively with turp washes calls for a free touch. If they are laid in too rigidly, they will stiffen your paintings and become an obstacle rather than a help.

To become comfortable with them, select a subject, sketch it with charcoal, then begin to paint. Mix your pigment with a fair amount of turpentine or mineral spirits, then load a large bristle brush with the mixture. Don't be too fussy about exact hues or values; just aim at an approximation of the color you eventually want. Sweep the brush over the surface, using your drawing as a general guide. Don't be alarmed if the wash starts to run—when you start working with thicker pigment, you can paint over anything that doesn't work.

You may find that unexpected drips and splatters suggest new avenues of approach. If they do, try playing with them rather than avoiding them. Finally, don't let your drawing get in the way of the painting process. It's tempting to stay within the lines of your drawing, but if you do, the chances are that your finished work will look more like a colored drawing than a painting in oil.

DETAIL

The broken birch stems in the foreground are painted with thick, rich pigment, which brings them into focus and makes them stand out from all the other elements in the painting. Yet the maple in the background has its own power. With its trunk warmed by a rich, dark brown, the tree is clearly silhouetted against the cloud-swept sky.

DETAIL

Snow may at first seem pure white, but when you stop and analyze it, you'll find that it's full of nuances of color. Here, for example, touches of blue, brown, and even alizarin crimson temper the harshness of pure white. These hints of color not only soften the white; they also relate the snow to the painting's overall color scheme.

Exploring Color Veiled by Fog

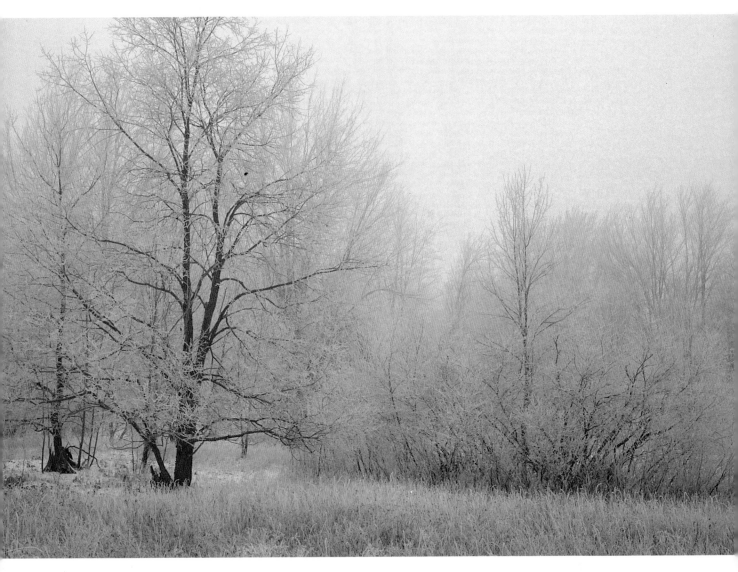

PROBLEM

Fog affects how we see objects. Their edges blur and their colors are muted; even a lively, variegated scene seems still and monochromatic. Working within this limited range of values can be difficult.

SOLUTION

Develop your painting very slowly, working from thin washes of color to slightly thicker, more opaque ones. Set the color mood from the very beginning; when you reinforce your charcoal drawing with diluted paint, choose a cool blue.

A frosty fog shrouds a stand of oaks in layers of ice.

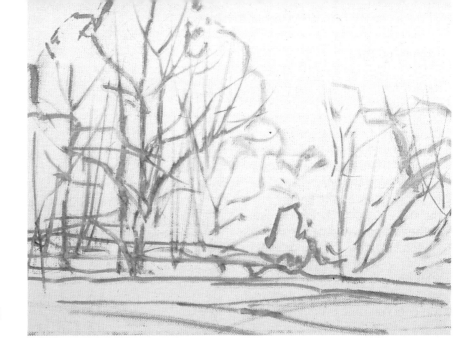

STEP ONE

In your drawing, aim for the overall silhouettes of the trees, not every twig and branch. Try, too, to indicate the ridges that separate the ground into distinct areas. Now go over your charcoal drawing with a thin blue wash.

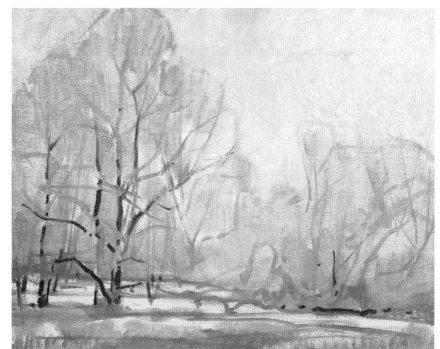

STEP TWO

Let the paint dry, then introduce somewhat thicker layers of paint. Tone the simple shapes formed by the masses of trees and let the white of the canvas indicate where snow lies on the ground. Add the darkest value, too—the deep brown of the tree trunks.

STEP THREE

To capture the shimmering, icy effect you are after, work wet into wet as you begin to use thicker pigment. Brush in a bit of the sky, then move to the branches of the trees. Work back and forth between these two major areas, avoiding sharp boundaries. Start to develop the foreground, too.

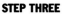

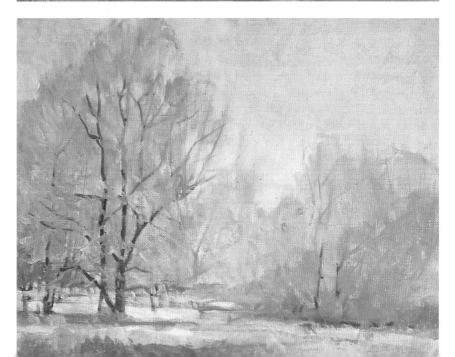

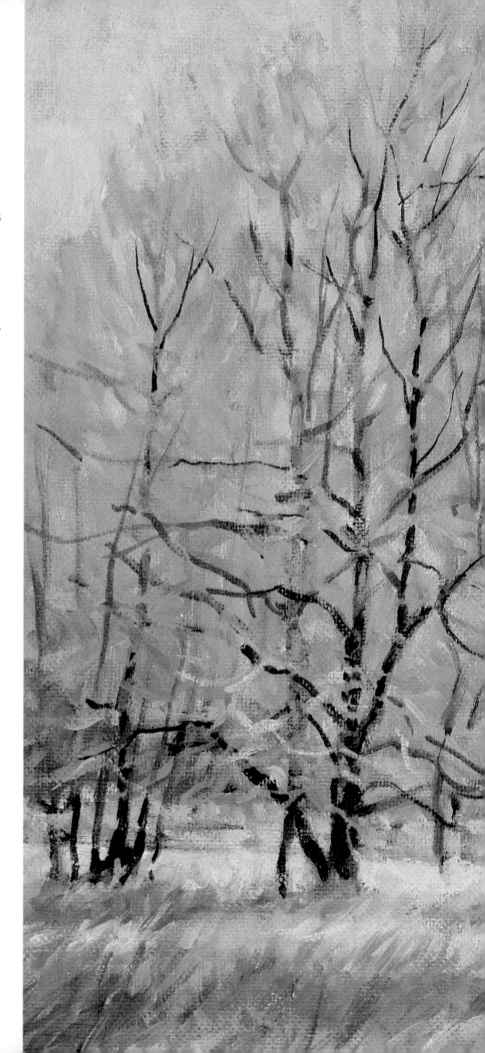

FINISHED PAINTING

Much of what gives this painting its strength occurs in the final steps. It's then that definite touches specify the misty atmosphere and clarify spatial relationships. The delicate lines of the tree trunks and branches are brought out by a fine, pointed brush that has barely been moistened. Quick, bolder strokes in the foreground give it a strong, rhythmic sense. Finally, pale yellow is scumbled into the sky and the spaces between the trees. The soft yellow warms up the cool colors that dominate the composition and makes the painting seem livelier and more realistic.

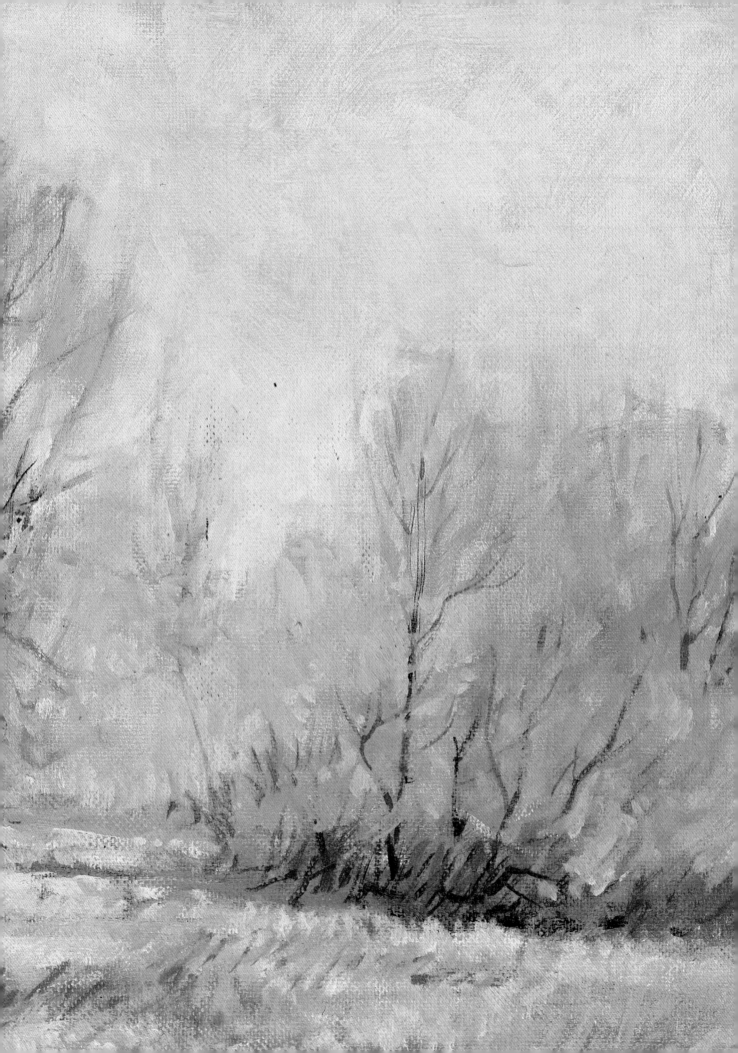

Suggesting the Feel of Ice

PROBLEM

What you are really looking at here is a complicated still life. The needles themselves are fairly intricate; covered with ice, they become even more difficult to decipher.

SOLUTION

Subjects like this call for a clear, strong drawing. Without one, you could easily lose your way in a tangle of details.

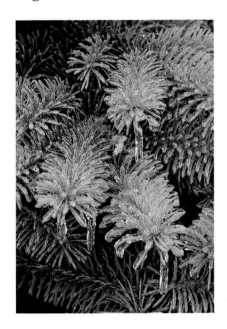

A thick layer of ice encases the living green needles of a spruce tree.

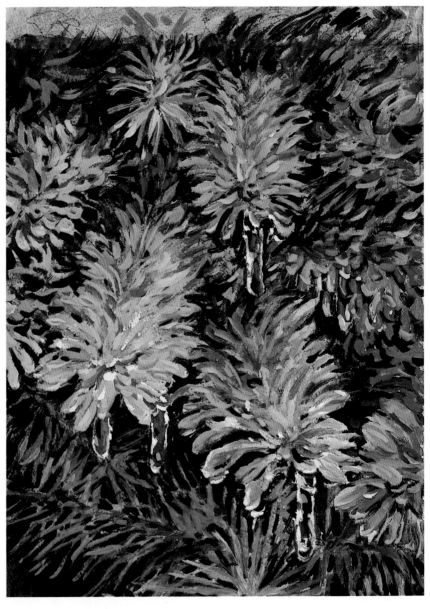

☐ Execute a very careful charcoal drawing—picking out each mass of spruce needles and giving the feel of the individual needles, too. With such a complex subject, work on Masonite so you don't have to contend with the texture of the canvas. When your drawing is complete, spray it with fixative before you start to paint.

First cover the entire surface with a middle-value green. This overall coat of green will give you something to react to; you'll be able to judge how dark your darks are and how light your lights are. With all the detail in this closeup, you'll want to keep your paint fairly fluid. If it's too thick, it won't glide easily over the surface.

On your palette, mix a deep, dark green to use for the background and several lighter greens for the individual needles. As you mix the light colors, keep an eye on the subject. When you look carefully, you can see that the

needles aren't just green; they have a lot of blue in them, too.

With a medium-size round sable, work back and forth between the lights and the darks. Use the strokes of your brush to give the sense of individual needles. When you feel that you are nearing the end, stop and evaluate your painting. Are there enough light passages to suggest the brilliance of the ice? If not, go back and add small touches of pure white to set off the surrounding greens.

DETAIL

The dripping icicles are crucial in conveying the feeling of ice. Observe how the irregular contour of the icicle is brought out here by the contrast of the white with the dark blues and greens around it. At times the white is straight from the tube. The white is also applied more thickly than the other colors so that it springs forcefully into focus.

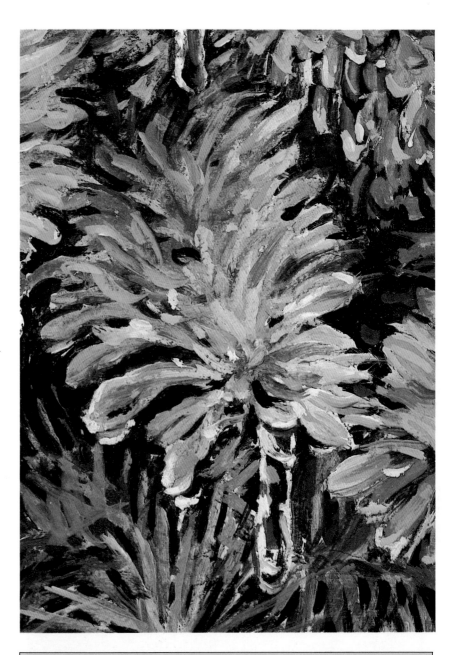

ASSIGNMENT

In addition to exploring your tube greens, learn how to mix greens from the other colors on your palette. Experiment with as broad a palette as possible to avoid relying on two or three tried-and-true formulas. Discovering a variety of greens will add freshness to your paintings.

Start with black and one of your yellows. Lay dabs of both colors a few inches apart on your palette. Drag one into the other gradually to see the range of hues they can produce. When black combines with yellow, you'll find that the result is generally a grayed olive-green tone. Follow the same procedure with cerulean blue, cobalt blue, and ultramarine blue. To each blue, add your yellows one at a time. Don't stop with straightforward yellows; continue your experiments with yellow ocher and cadmium orange.

When you begin to apply the results of your experiments to your paintings, don't mix a huge amount of any one green. Instead, repeatedly mix small amounts of the color you want. You'll find that from batch to batch small, subtle differences occur. These differences may not be obvious at first glance, but cumulatively they can make your paintings more vigorous and exciting.

Narrowing in on Texture

PROBLEM

The problem here is clearly the complicated structure of the peeling bark. Its cracks, tears, and bumps weave an incredibly intricate pattern, one that's difficult to depict.

SOLUTION

Work on primed watercolor paper, which mimics the texture of the trunk, and rely on watercolor techniques. Start with your lights, then gradually introduce stronger, darker colors.

☐ When you work with oils on watercolor paper, you have to size the paper first. If you don't, the paint will be absorbed by the paper and you'll end up with very little pigment to work with. Coat the paper with an acrylic medium —matt was used here—then let the medium dry.

Now sketch in the main patterns with a graphite pencil—it's easier to control than charcoal, and you'll find that it's ideal for subjects that are mostly dark. Your paint will cover most of the pencil drawing, and what the paint doesn't cover will add structure to the finished work.

Start painting with your lightest colors, here mostly yellow ocher and pale washes of brown. In this wet stage, the very lightest areas can be picked out with a dry brush or even blotted with a bit of paper toweling to show the white paper beneath. Gradually introduce darker colors, keeping them translucent, diluted with a lot of turpentine. Continue, too, to pick out the white of the paper with a dry brush or toweling.

As you build up the paint, try scumbling light and dark colors over each other, enhancing the texture of the watercolor paper. Here light colors were mostly dragged over deeper, darker ones. The broken color that results, combined with the roughness of the paper, will emphasize the textured quality of your subject.

As a final step, take a painting knife and scratch thin highlights into the paper. The knife reaches down beneath the pigment and isolates patches of clear white. These thin slashes of white animate the entire surface, breaking up large areas of dark color with slivers of light. They also highlight the rich layering of the tree's bark and convey the feel of cracks and tears.

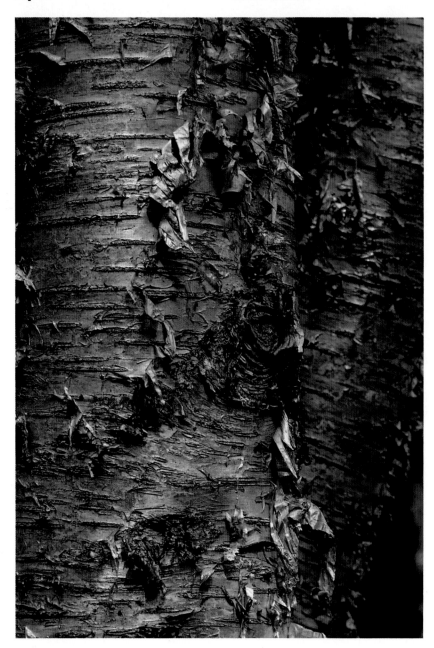

The papery bark of a yellow birch separates into strips, revealing different layers.

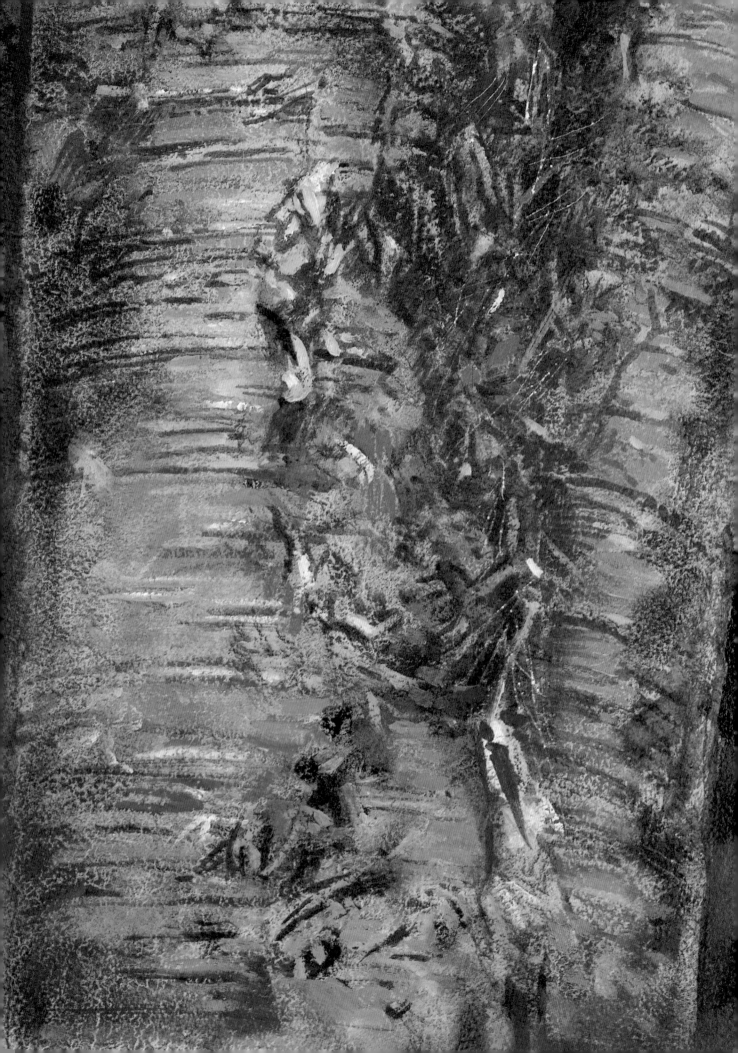

Emphasizing What's Important

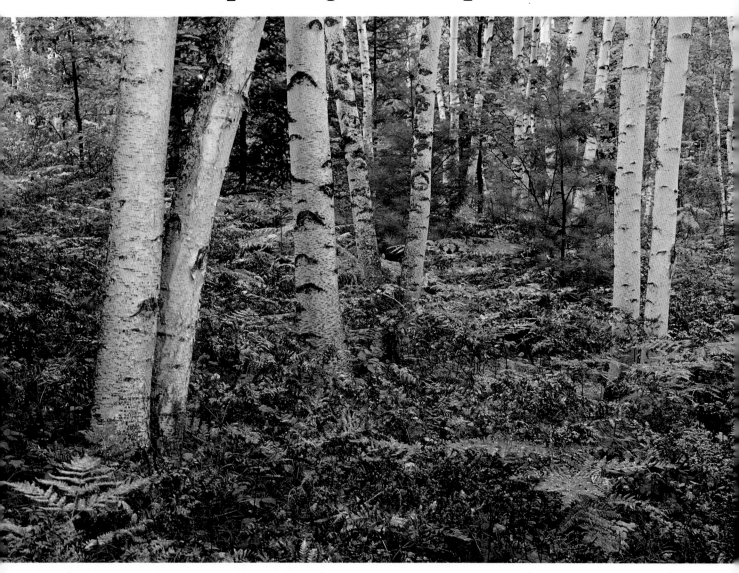

PROBLEM

There's lots going on here. The tree trunks set up a lively pattern and the richly colored ferns scatter an intricate tangle on the forest floor. But you can't emphasize everything; you have to select a focus for your painting.

SOLUTION

Look at the scene carefully and figure out what draws you to it. What makes it hang together? What gives it life and vitality? Once you've decided which element means the most to you, concentrate on it. Here the tree trunks become the focus of the painting.

In a grove of white birch trees, golden ferns nestle on the ground, proclaiming the approach of autumn.

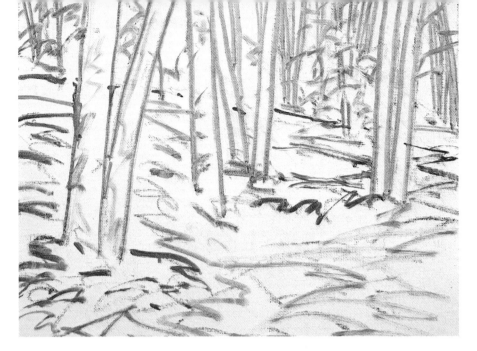

STEP ONE

Using vine charcoal, sketch in the scene, concentrating on the trunks of the trees. Lightly blow away any charcoal that might muddy your painting. Next, go over the lines of your drawing with a warm color diluted with turpentine. Here a rich brown sets the overall mood of the painting; it's dark enough to stand out against the white canvas, but it won't be difficult to work over later.

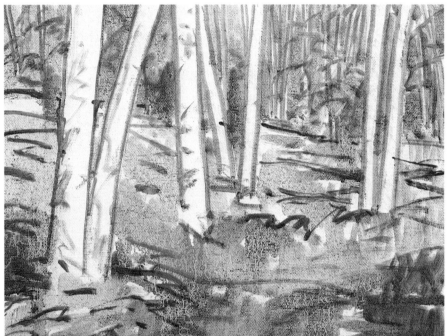

STEP TWO

As you develop the surface with thin washes, leave the tree trunks pure white. Concentrate on the varied greens and ochers that fill the background and spill over the forest floor. At this point your drawing is still quite visible and easy to work with.

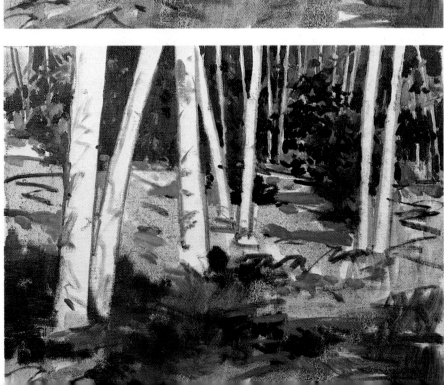

STEP THREE

Start to build the rich green foliage in the background and the golden ochers with hints of green that cover the forest floor. Pay attention to the play of light and dark. In the foreground try short, broken strokes to suggest the texture of the dry, brittle ferns.

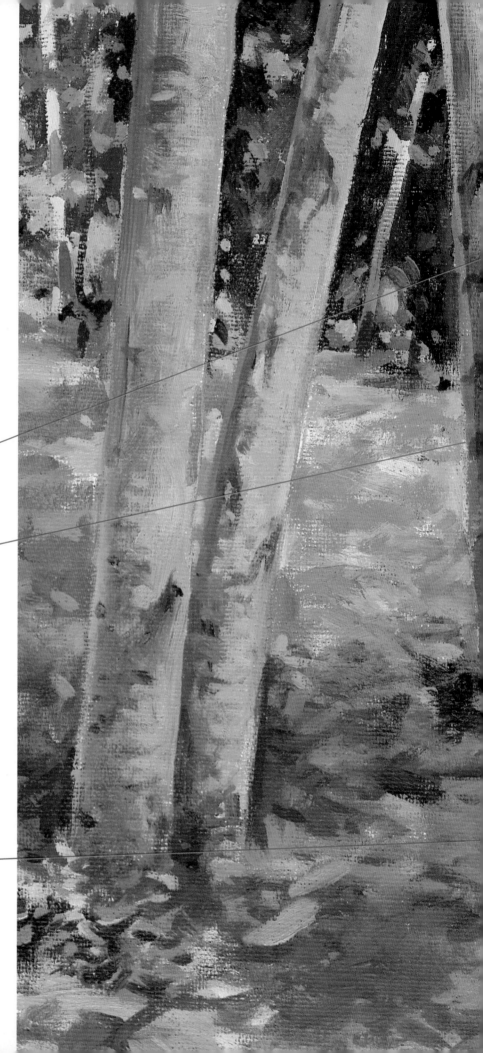

FINISHED PAINTING

A lot happens in the final polishing. First, bring out the highlights in the background trees with touches of bright yellowish-green paint. Now turn to the tree trunks. Make them the center of attention by using quick, bold strokes. Don't worry about a lot of detail; here even the shadows and bits of dark bark are laid in with rapid strokes. Finally, complete the forest floor. Continue to use short, broken strokes, bringing out the subtle variations in tone that establish the drift of sunlight. To create a sense of recession into space, keep the middle ground less developed than the foreground. Less detail almost always means less attention.

The deep, rich greens that make up the background are rendered with loose, free strokes. Highlights are picked out in the final stages with dabs of bright yellowish green.

In the finished painting, these birch trunks are clearly what matters the most. Painted with smooth, decisive brushstrokes, they sweep boldly upward. Their strong verticals form a rhythmic pattern across the surface of the canvas.

Stripped of most of their detail and depicted with brisk strokes, the golden ferns become an important accent. Without their flickering layers of color and the flurry of their brushstrokes, the tree trunks would be less dynamic. By simplifying one part of the composition, you can make the entire painting come alive.

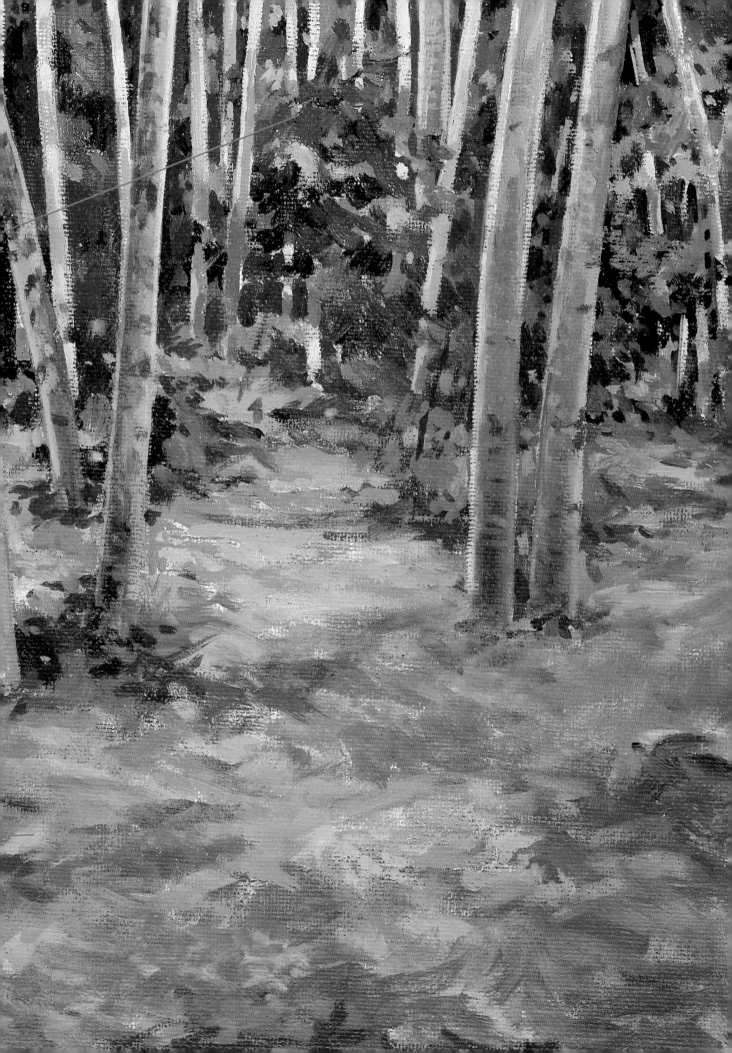

Experimenting with a Variety of Greens

PROBLEM

There's beauty in the minute details of a segment of a tree, but it takes a special kind of vision to capture the abstract patterns that make the part seem greater than the whole.

SOLUTION

A complicated subject like this one deserves a careful drawing as an anchor for the entire painting. When you start to paint, use a variety of greens to indicate the pattern of lights and darks that makes the foliage so interesting.

☐ In your charcoal drawing, don't try to delineate every twig. Concentrate, instead, on the tree's trunk and the major branches. When they are established, you can start to paint. Working with oils, you'll soon discover that it's often easiest to build from dark to light. Once the darks are down, you can bring them to life with touches of lighter, brighter color.

Using thin washes, lay in the large patches of dark green and then the lighter areas. Now introduce thicker paint. First, render the tree trunk and the main branches; then return to the foliage. Mix two basic greens—one very dark, one a medium value. With these, begin to firm up the play between dark and light indicated by your washes.

From this point on, you'll need to move back and forth between the darks and lights, with an eye to how each affects the other. Don't worry about painting over the branches at this point; you'll go back to them later. What you want to do is make the mass of green foliage lively. Try introducing subtle variations in color throughout the painting. Mix touches of orange, ocher, and deep blue with your basic shades of green.

As soon as the entire surface is fairly well developed, redefine the branches and their shadows. With quick, thin strokes, you can create a web of lines that gives the feel of numerous branchings without detailing every one.

Now refine the light and dark patterns you've created. Mix a bright yellow-green for the lightest bits of foliage. Again, you will need to work back and forth, adding touches of the darker greens to break up the lights. By looking for the variations in the green you see, you'll create a center of interest and convey the wonder of sunlight in this view.

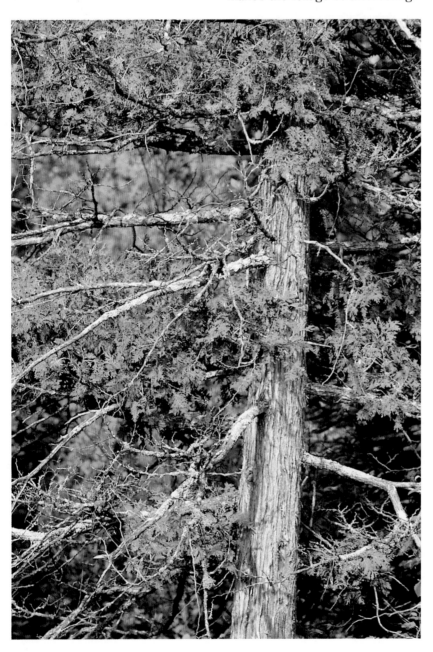

Sturdy branches reach out from the trunk of a northern white cedar.

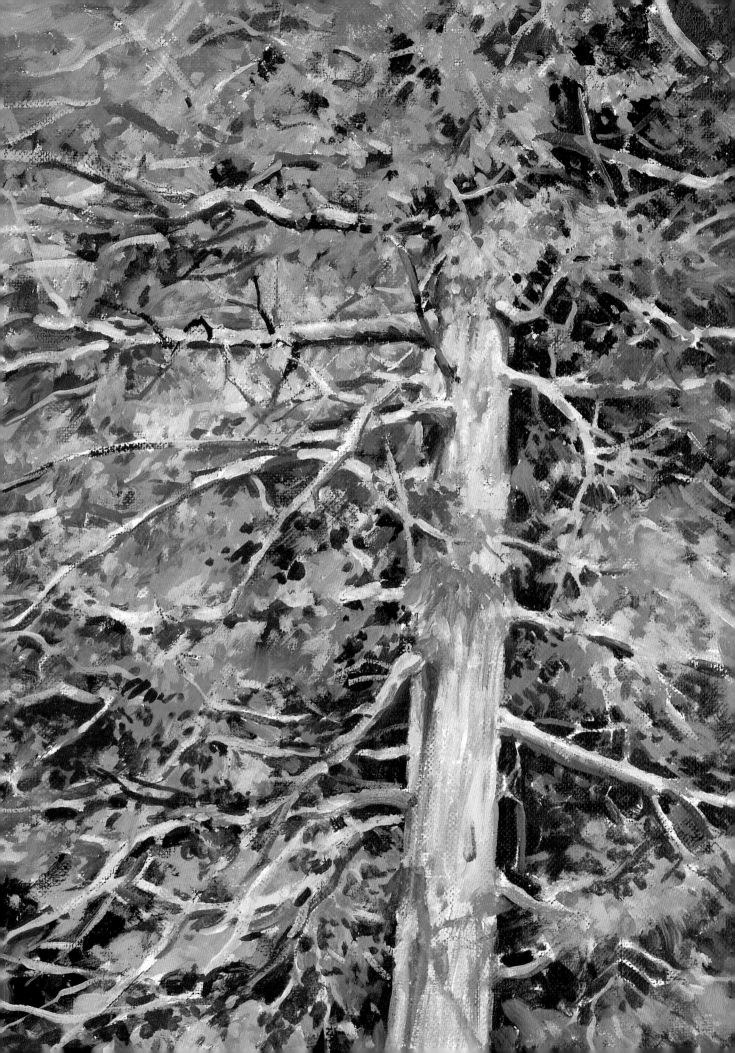

Using Brushstrokes to Break up Masses of Foliage

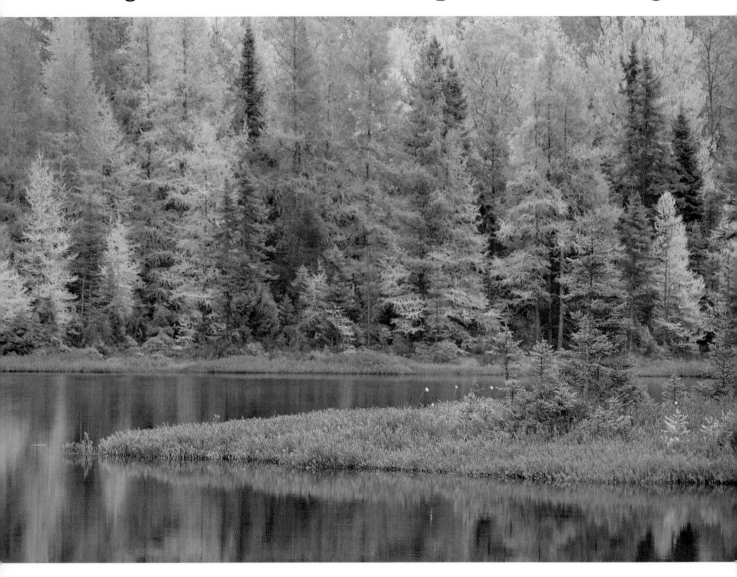

PROBLEM

It's just what makes this scene so arresting that makes it so difficult to paint. Clustered together, the trees lose their individuality in a veil of golden-green color.

SOLUTION

Don't just rely on color to pull apart individual trees; use your brushstrokes as well. With bold, powerful gestures, you can suggest the feel of the trees—how the branches spread out and the trees soar upward.

Stately larches crowd the peat-filled banks of a bog lake.

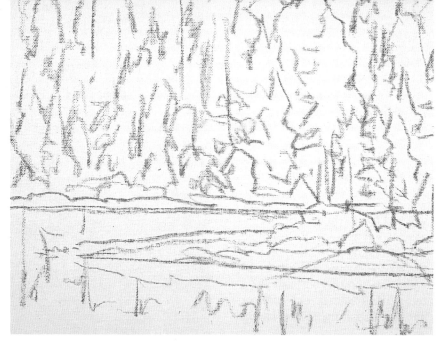

STEP ONE

Since your eventual goal is a strong, painterly effect, a bold drawing is important. Look for the overall shapes of the trees; then, using charcoal, sketch them in with quick, expressive lines. Don't dust your drawing down—you'll want all its strength to guide you as you begin to paint.

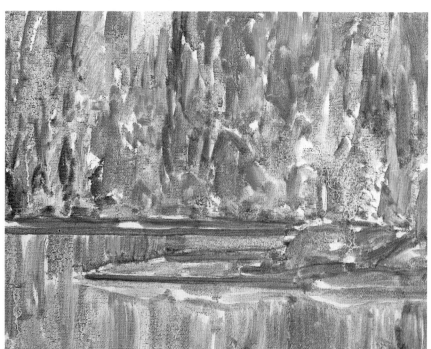

STEP TWO

Even in a crowded, problematic scene like this one, thin washes can help you structure the bones of your painting. Lay in areas of local color, but don't be too fussy. What you want at this point is a basic plan. Add some definite strokes to suggest the character of individual trees. Note how some strokes move toward the left while others sweep to the right. Nothing is static—everything is full of life.

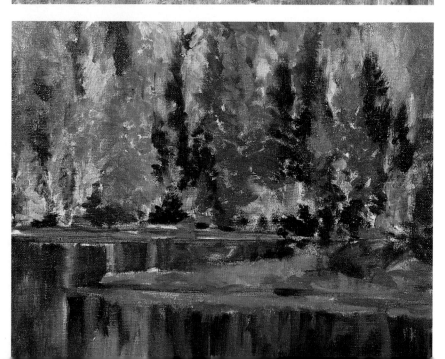

STEP THREE

Now it's time for thicker pigment. Before you take up your brush, though, study each tree's shape. Once you're conscious of how the trees fit together, transfer what you see onto your canvas, using short, rapid strokes of varied yellows, oranges, and greens. To capture the reflections in the water, use a different technique: work wet into wet with long, fluid strokes.

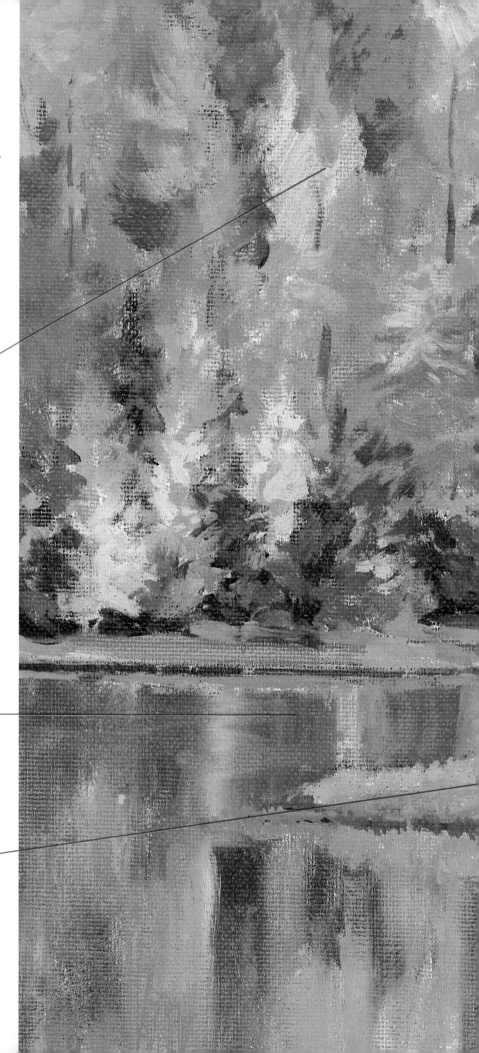

FINISHED PAINTING

Although by now your painting probably has a lot of life, it may lack definition. Do you have a sense of where one tree starts and where it stops? If not, pick out its shape by clarifying its color and distinguishing its brushwork. For accents, look for the places where a touch of a different hue will add life to the colors you already have. Here, for example, the bit of land that juts out into the lake becomes more definite and interesting as purplish pinks temper the blue-greens and siennas that had already been laid in.

The brighter, bolder golden-yellow trees stand out clearly against the trees in the background. It isn't just color that makes them so crisp. The yellow paint has been applied with quick, energetic brushstrokes.

Worked wet into wet, the fluid paint of the reflections in the water contrasts with the thicker pigment in other areas. The yellows, ochers, and greens blend together easily, setting the lake off from the bolder, staccato strokes of the trees.

The purplish-pink tones added at the very end also help to separate land from water. More than that, they sound a lively color note that complements the rest of the painting.

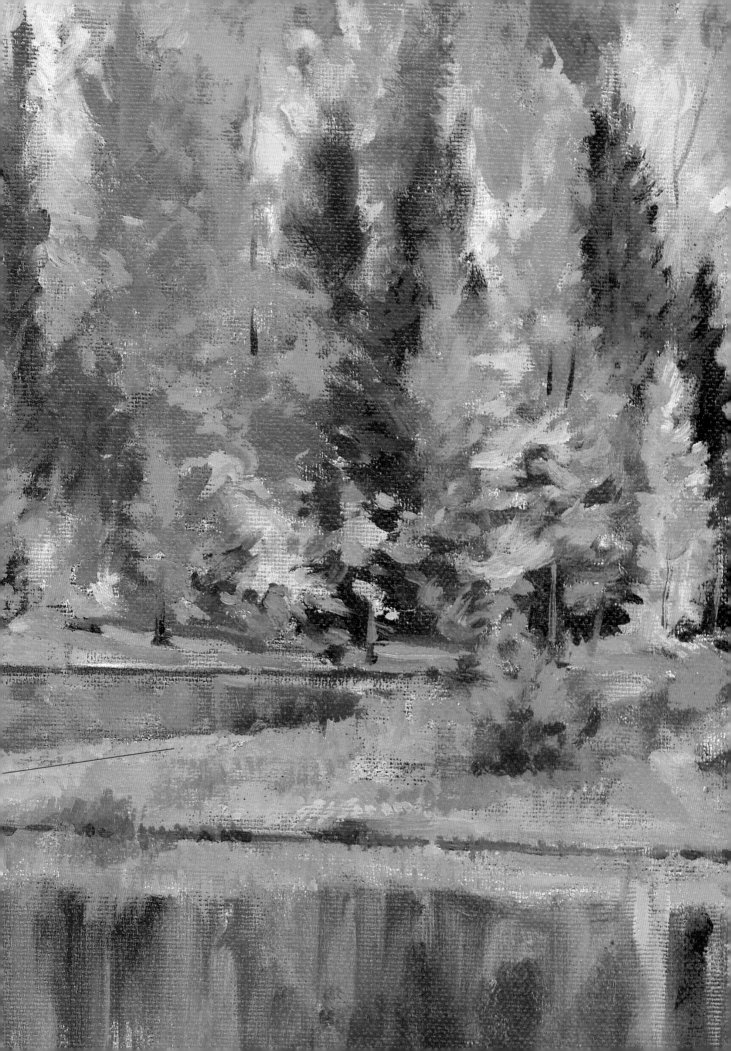

Deciphering a Multifaceted Subject

PROBLEM

Several things are happening all at once here. The background is closed in by a dense mass of woodland foliage, while in front the trees look lacy and delicate. The brilliant gold of the larch in the center adds to the confusion.

SOLUTION

Key your painting to the yellow of the center tree. After a careful preliminary drawing, cover the entire canvas with a light yellow tone. Establish the darks, then refine the light colors.

☐ In your charcoal sketch, pick out the definite lines of the golden larch and the spindly trees around it. Keep the drawing of the background trees loose.

Since touches of gold appear not only in the larch but also in the foreground and background, stain the entire surface with a deep yellow wash. If you've fixed your charcoal drawing, it will stay crisp and clearly visible beneath the thin yellow paint. Another approach is to stain the canvas first, but then allow the surface time to dry before you draw.

Now lay in the darkest tones, the deep greens that run through the background. Once they're down, you'll have established the darkest and lightest areas in your painting. Knowing the extremes ahead of time makes it easier to gauge the middle values.

When you're confronted by a lacy tree like this larch, it's a good idea to work back and forth between the darks and the lights. Here the effect of brilliant gold is created by combinations of cadmium yellow and yellow ocher applied densely, with short, rapid strokes. Then touches of green are introduced to break up the masses of gold. If your green strokes start to take over, go back and paint over them with your yellows. Keep moving back and forth, sculpting out the center tree, until you are happy with the effect you achieve. Now, blend a little green into your yellows and use the mixture to render the golden larches that stand behind the center one.

In the final stages of your painting, quickly indicate the thin, dark trunks and branches that spill into the foreground, then add a splash of bright red to the forest floor. Don't try to pick out every detail here—there's already enough action between the golds and greens.

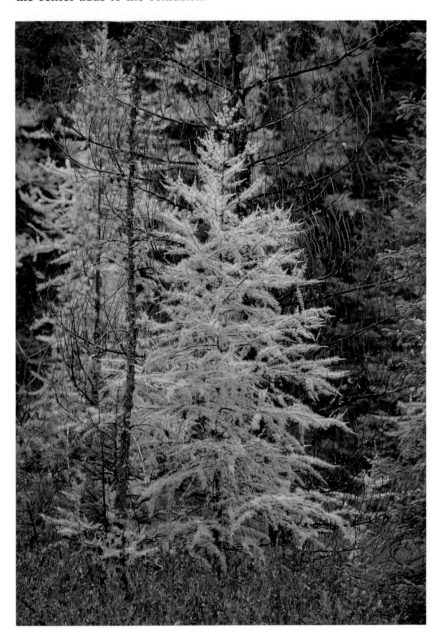

In early autumn, just before a larch begins to shed its needles, the needles turn a brilliant golden yellow.

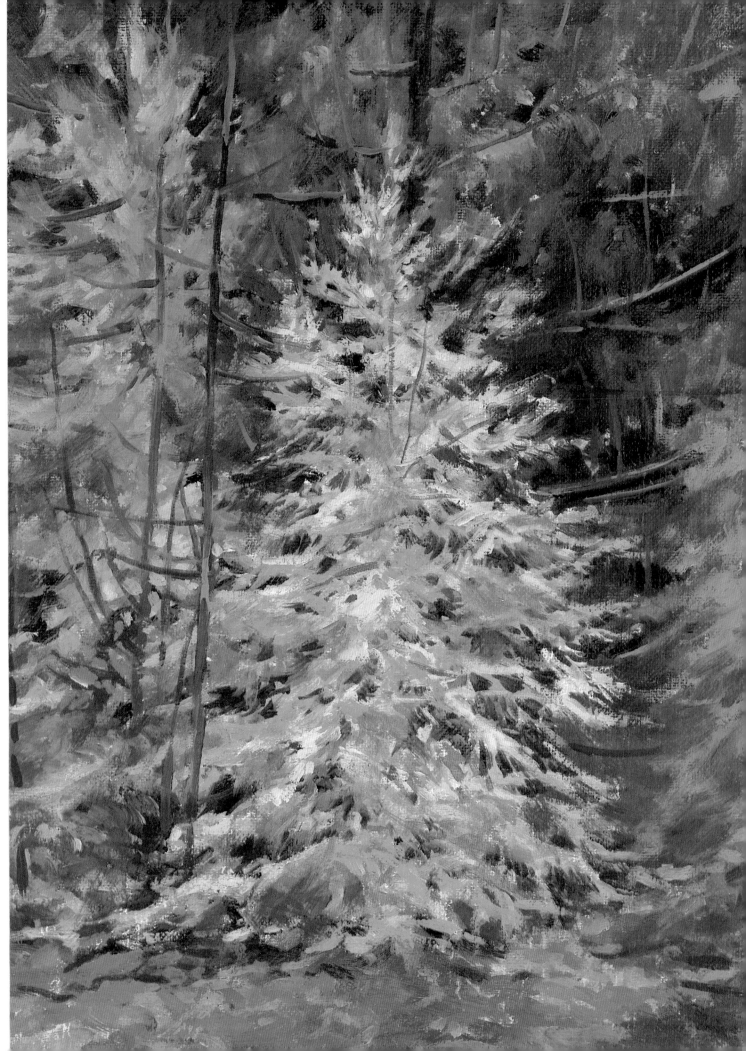

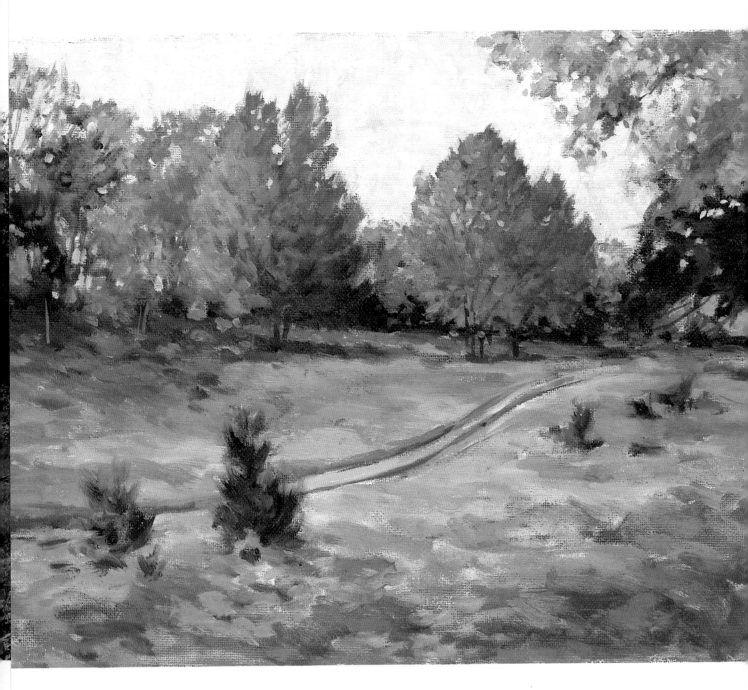

FINISHED PAINTING

All along you've been trying to make the background trees stand out as dramatic and powerful, so don't ruin what you've done now. It's hard to make the things that are closest to you seem soft and out of focus—that's not how the eye sees. But you need to downplay the foreground if you're going to highlight elements that are actually farther away.

Choose a broad brush to lay in the foreground and take a soft approach, using gentle, overlapping strokes. Don't let the colors get too brilliant; if they do, they will command more attention than the trees farther back.

Finally, return to the focus of the scene. With a small bristle brush, sharpen the definition of the background trees. Short, vigorous strokes of color will help to draw the eye to this area.

ASSIGNMENT

Try to imagine how the scene featured here would look at different times of the year. In winter, the bare branches of the trees would appear thin and spidery. In spring, the trees would perhaps be heavy with blossoms. In summer, they would form a mass of rich greens.

As a long-term project, select a scene near your home—one that you see frequently and have come to know—then draw and paint it at different times of the year. Because the scene is familiar, composition will mostly take care of itself, leaving you free to concentrate on how the changing seasons transform a familiar subject.

DETAIL

When the sky is this pale and even, save it till the very end. To paint it, squeeze some white onto your palette, then mix in a touch of the color that dominates your painting. Here a dab of yellow tempers the intensity of white and brings the sky into harmony with the rest of the painting.

DETAIL

Everything in the foreground is soft and muted, allowing attention to focus on the brightly colored background. Note how the diagonal brushstrokes lead the eye back and at the same time give a sense of drifting fallen leaves.

81

Mastering an All-over Pattern

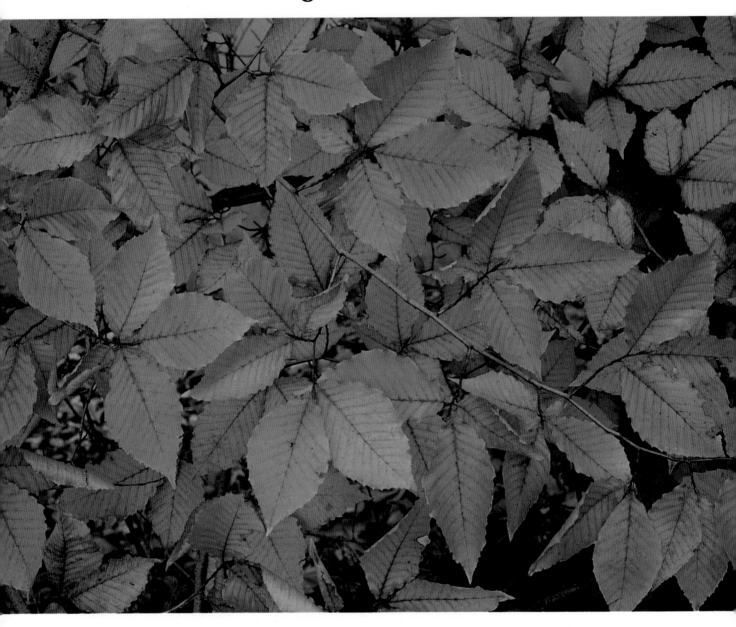

PROBLEM

Intricate closeups such as this one seem almost like abstract constructions at first. It's hard to figure out what holds the subject together.

SOLUTION

Start by working generally—lay in the overall patterns that you see. Once you've established them concentrate on the specifics. You can't hope to depict every detail, so aim at capturing the spirit of what you see.

☐ You'll need to start with a careful drawing. Instead of soft vine charcoal, try a charcoal pencil; you'll find that it's easier to manipulate than vine charcoal when you're depicting fine details. As soon as you have finished your drawing, spray it with fixative.

Using thin washes, now cover the entire surface with the approximate colors and values that you want in your finished painting. If you keep your washes thin, you won't lose your drawing, not even with the darkest hues you use.

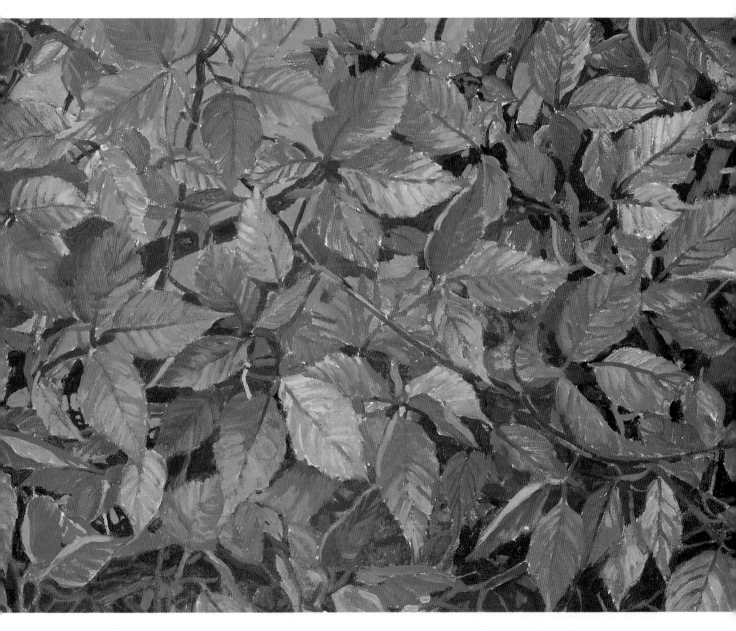

When you're ready for thicker pigment, begin by laying in the areas where the sky shines through. Here the sky is painted with a mixture of cerulean blue and white, warmed with just a touch of red. Next, select a few groups of leaves and concentrate on them. As you paint, remember that you'll never be able to follow every detail. Instead, keep your eye on the overall patterns you are creating on the canvas.

Two things are important at this point. First, all the leaves have to connect in a logical way. Second, you need to capture the subtle changes in color that occur from leaf to leaf, as well as the shadows that fall across the leaves. Start by mixing one basic brownish-gold tone; then, as you paint the leaves, add a little more yellow or brown, or even a touch of red to your basic color.

When you feel that you are almost finished, step back and look at what you've done. Is one section of the painting more prominent than the others? If so, you may want to temper its strength a bit. Do all the leaves look exactly the same? If so, try to vary them by introducing touches of other colors—darker browns, brighter ochers, an occasional blush of red. Finally, do the leaves connect in a natural way? If they don't, turn to the trouble spots and analyze what's wrong. With oils, it's easy to rework any portion of the painting.

Simplifying the Pattern of Fallen Leaves

PROBLEM

Two things catch the eye here: the strong lines formed by the massive roots and the lively pattern of autumn leaves on the ground. The danger is that one will compete with the other.

SOLUTION

Emphasize just one aspect of the subject. Here the trunk and roots are clearly the focus of the painting. The leaves are treated much more generally.

☐ Sketch the tree's roots with soft vine charcoal, then reinforce your drawing with a wash of burnt umber. Continue using thin washes to build up your painting. Try developing the incidental elements first. Here the fallen leaves that carpet the ground are given a wash of raw sienna and raw umber. Next, with raw umber and ivory black, begin to indicate the shadows that fall across the leaves. Now turn to the brighter greens. Sweep a wash of permanent green light and ocher across the canvas with a small bristle brush. Then pick out the shadows with Thalo green and a bit of alizarin crimson. Finally, for the tree's trunk, choose a basic mixture of ocher and white, with just a touch of black.

At this point the canvas should be completely covered with washes of paint. The task now is to indicate the detail of the forest floor and to build up the trunks and roots. Texture is what matters here. Don't get overly involved with minute detail; the important thing is to capture the overall feel of the scene.

Begin by sculpting out the shadowed hollows between the roots. For this, select a fine brush; if your strokes are too broad, you'll lose the realistic touch you're aiming for. To convey the texture of the leaves on the ground, use a small bristle brush and short, light strokes, one drifting into the other.

Once you've built up the entire surface of your painting, spend some time looking at what you've done. Does your painting still need a little punch? Here the dark bluish-green areas at the base of the tree were the final touch. They clarify the roots' structure and give the entire painting a crisp, focused look.

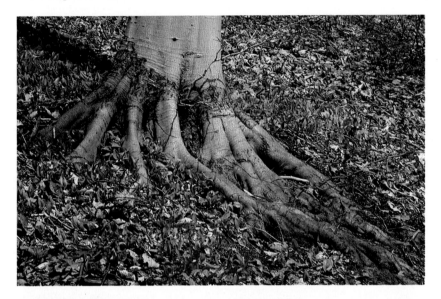

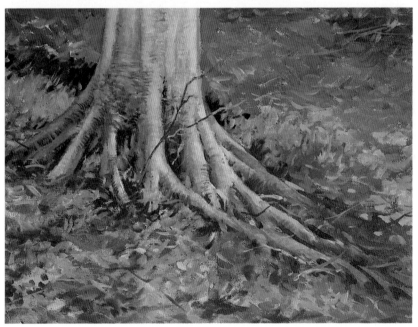

In early autumn, thick roots stretch out from the base of an old beech tree.

Working with Oil on Paper

PROBLEM

With a tree surface like this one, what stands out is the abstract configuration of shapes and lines. To make this closeup work as a painting requires something more than simply copying what you see.

SOLUTION

Subtle variations in texture are crucial when you are rendering bark, so don't let the weave of canvas or the smoothness of Masonite interfere with the quality you want to convey. Work instead on watercolor paper; its rough surface will mimic that of the tree trunk.

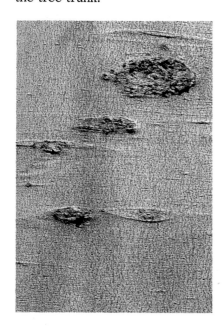

Stark, abstract patterns lie hidden in the smooth bark of a beech tree.

☐ Size the paper with a solution of acrylic medium. While you let the medium dry, figure out your approach. Oil paint need not always be applied thickly. Mixed with turpentine it handles almost like watercolor, and that can be an advantage when you want to paint a delicate subject like this one.

To start out, sketch the subject in pencil, then pour a little turpentine on your palette and add just a touch of brown pigment. Quickly apply this fluid wash to the paper. Next, use a slightly darker, brownish-gray wash to pick out surface details—the cracks and fissures in the bark. While the paper is still wet, hold it up and let the dark pigment run up and down, backward and forward. You'll be amazed at how much control you actually have over the flow. Once a satisfactory pattern is achieved, use a dry brush to lift the wash off the paper in places, thus establishing your lights.

Wait for the paper to dry, then repeat these steps as often as needed until the image looks realistic. Toward the end, you may want to use a fine sable brush dipped into a brown wash to refine bits of the trunk. As a final step, take a sharp blade and scratch off some of the dark paint. Used sparingly, this technique can enhance the textural effect.

DETAIL

The varied techniques used in this painting can all be seen in this detail. First, note the bumpy texture of the watercolor paper and how the pale brown washes have settled into the paper's depressions, leaving interesting patterns as they dry. The darker washes are soft and indistinct, the result of allowing the washes to flow naturally into each other. A few small details stand out crisp and clear because they were painted with a small brush after the surface was dry. Finally, the pale, horizontal lines were made by scraping the paper with a sharp blade.

ASSIGNMENT

As you've discovered in this lesson, there are times when watercolor paper provides an ideal support for the oil painter. Use it when its bumpy, irregular surface imitates the surface of the subject you are painting. It's perfect, for example, when you are rendering the rough, irregular bark of a tree.

Priming the paper is essential if your painting is going to work. If you skip this step, you'll discover that the oil seeps through the fiber of the paper. This isn't just unsightly—it will make your painting less permanent as well. Try priming several sheets of watercolor paper, then start to experiment. You'll discover that thin washes of color float easily over the paper; laid on in successive layers, they slowly build to create a powerful effect.

Making Bright Colors Bold

PROBLEM

The strong, crisp colors of this hickory tree are going to be hard to depict. It's easy to add too much white and to lose the brilliance of the tree's foliage.

SOLUTION

You'll be better able to gauge your bright tones accurately if you keep your darks really dark. Set against dark passages of paint, strong, bright colors seem even brighter.

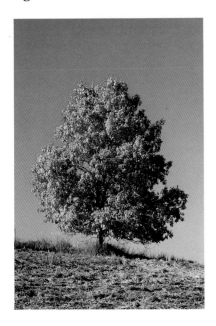

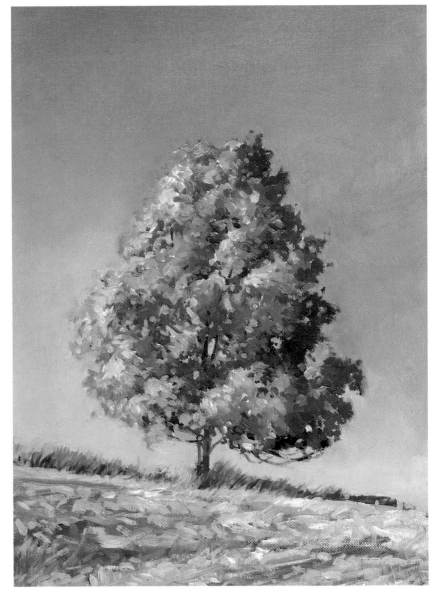

In autumn a handsome hickory asserts its golden shape against an azure sky.

☐ After reinforcing your sketch with a brush, lay in the tree's shadowy masses. Make them really dark to set off the brilliant leaves. Wash the rest of the tree in cadmium yellow and the ground in ocher, then turn to the sky.

Using a large bristle brush, start at the top with cobalt blue and alizarin crimson, but quickly eliminate the crimson. About halfway down, shift to cerulean blue, Thalo green, and a touch of white. Finally, smooth everything with a fan brush.

Now return to the foliage. With a small bristle brush and broken strokes, apply a mixture of cadmium yellow, cadmium orange, and a mere touch of white to the crown. Don't use too much white, or your colors will look washed out. Continue with just the yellow and orange. Also add dark accents of Mars violet and cobalt blue to sculpt the tree's volume.

If you paint the foreground the same color as the tree, the tree will lose its drama. Choose a mix of yellow ocher and raw sienna. At the end, enliven the ground with quick, rough strokes.

Downplaying a Potentially Dramatic Element

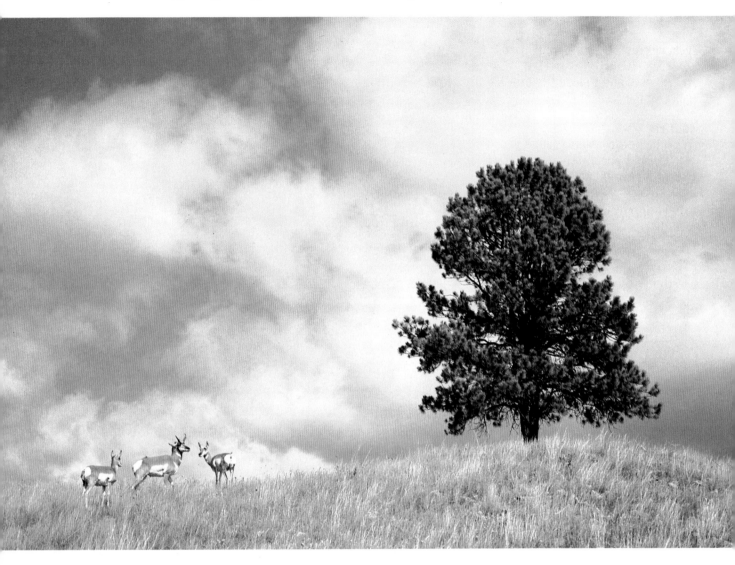

PROBLEM

Whenever an animal appears in a painting, you can bet it's going to become the center of attention. But sometimes that's not what you want. Here, for example, the pronghorns seem almost incidental; it's the dramatic sky and the tree's handsome profile that define the view.

SOLUTION

Paint the entire scene before you develop the pronghorns. Make the tree even bolder than it really is and play up the excitement of the sky. When it comes time to paint in the animals, just suggest their shapes; don't pick out every detail.

Three pronghorns pause briefly near a ponderosa pine.

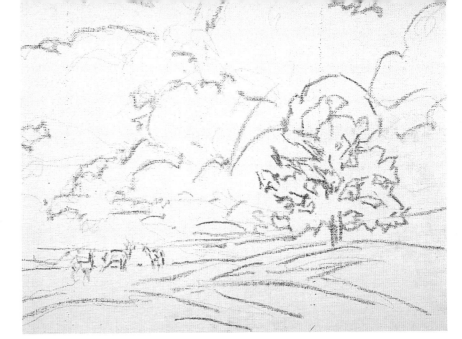

STEP ONE

Simple subjects like this one don't require complicated sketches. Just lay in the main lines of the composition with vine charcoal. As you sketch, remember to pay attention to the shapes of the clouds as well as the tree, animals, and ground.

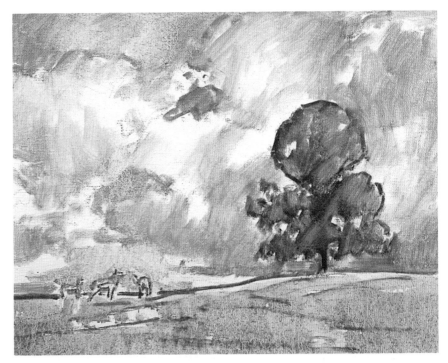

STEP TWO

Loosely brush in the dark greens of the tree, then, with a fine brush, indicate the animals and the horizon line. Next, turn to the sky. Working with thin washes, establish the blue of the sky, then use a grayish wash to show the shadowed areas of the clouds. For the time being, let the white of the canvas represent the brightest, lightest portions of the composition. Finally, lay in the grass that sweeps across the foreground with a yellow ocher wash.

STEP THREE

Using opaque pigment, start with the sky since it is so much lighter than the tree. Work wet into wet to capture its soft, fluid quality. The grayish shadows that you indicated earlier will serve as guides now. Try working around them with a mixture of white and yellow ocher—even the brightest areas in a cloud are rarely pure white. Then develop the tree, applying your paint with a small bristle brush. Choose just one basic green here; for the shadows, add a little brown to the green; for the highlights, mix in a dab of white.

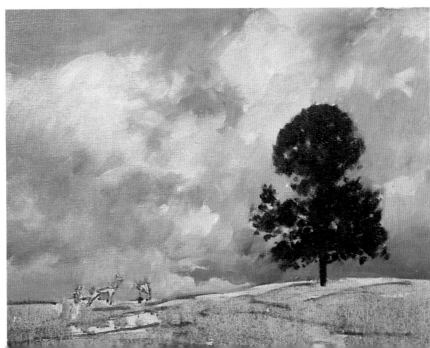

Most of the sky is painted with cerulean blue, but here a touch of ultramarine has been mixed in. This dark wedge of color at the edge directs the eye in, toward the center of the painting.

The ponderosa pine's silhouette stands out forcefully against the cloudy sky. When you are working with such a dramatic backdrop, be sure to keep the other elements in your painting simple yet strong. If this tree were overly fussy, its impact against the sky would disappear in the trivia of detail and the whole painting would lose its focus.

Painted simply at the very end, the pronghorns blend easily into the rest of the picture. Note the fine brushstrokes that were used to delineate their basic form; it seems almost as though the animals were drawn, not painted.

FINISHED PAINTING

Paint the grassy foreground with yellow ocher. Use short, calligraphic strokes to break up the surface and to pull the foreground out to the front of the picture plane. Now, with a fine sable brush, complete the animals; remember: don't go into too much detail here. Finally, examine your whole painting critically, gauging how well the different parts work together. Here the clouds seemed just a little on the dark side. Adding some bright white passages to them made the whole painting spring to life.

Experimenting with Fog

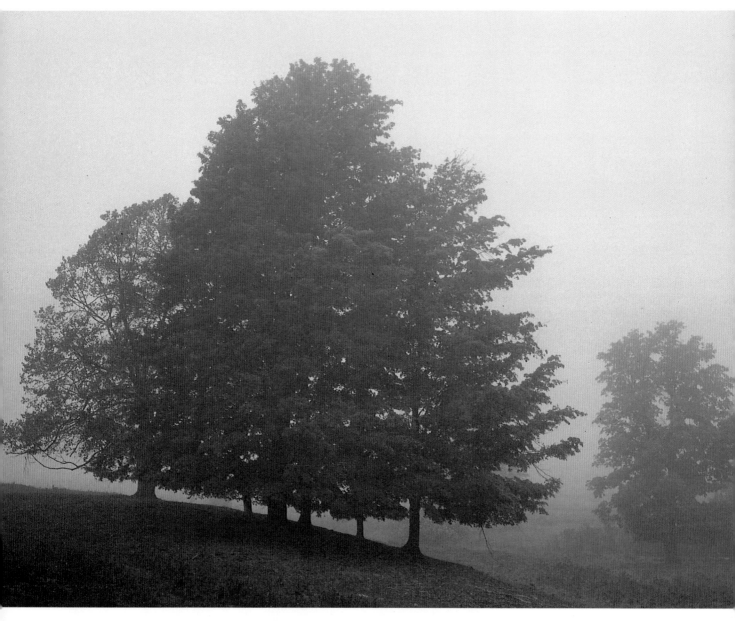

PROBLEM

A foggy scene can be hard to paint. Fog softens the edges of everything it envelops and tends to narrow the range of values.

SOLUTION

Don't be too literal in your interpretation. If you stick too closely to what you see, you may lose the sense of space. Make the tree in the foreground slightly darker than it really is to clarify its position in the landscape.

Fog rolls in over a gentle hillside, shrouding a grove of maples.

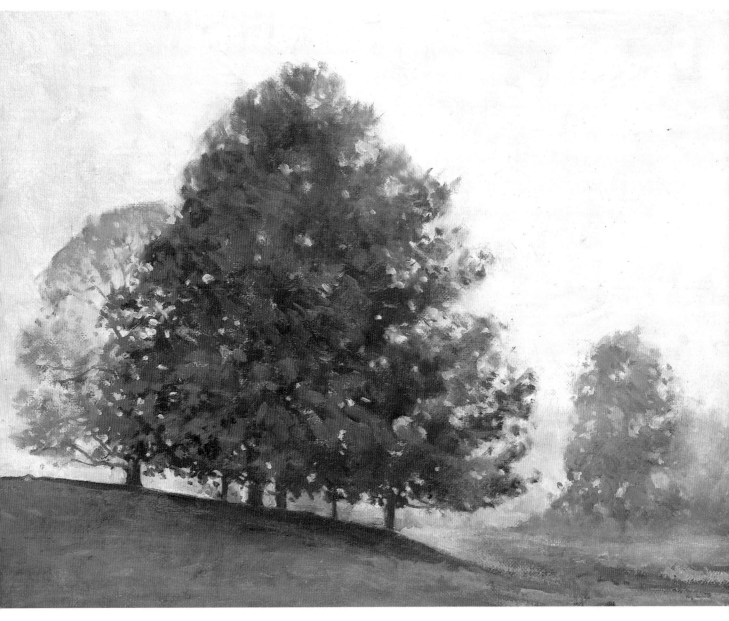

☐ With charcoal, define the major shapes in the composition and then dust your drawing down. Now redraw the scene with a small brush dipped into a pale wash. In preparing these preliminary washes, look for the colors that dominate in this scene. Here bluish and reddish purples came into play.

Still working with thin washes, establish the dark trees in front. Introduce opaque pigment as you turn to the sky. Rendered with a mixture of yellow ocher, perma-

nent green light, and white, the sky has a luminous quality that suggests how the sun diffuses through the fog.

Now go back and build up the trees. To capture the soft atmosphere that bathes the entire scene, work wet into wet as you paint the trees. Gently blend their edges into the sky to avoid sharp, definite transitions. For the trees closest to you, use a blend of cadmium red, cobalt blue, Mars violet, and white. As you move to the trees in the distance, de-

crease the amount of red in your mixture and add a touch more white. The blue will help make the trees in the distance recede, while the red will make those in the foreground jump forward.

Now lay in the hillside with a large bristle brush. By using the same colors found in the trees, you'll create a pleasing sense of color harmony. As a final note, emphasize the nearest tree by building up its texture with short, vigorous strokes of thick paint.

Bringing out Early Autumn Color

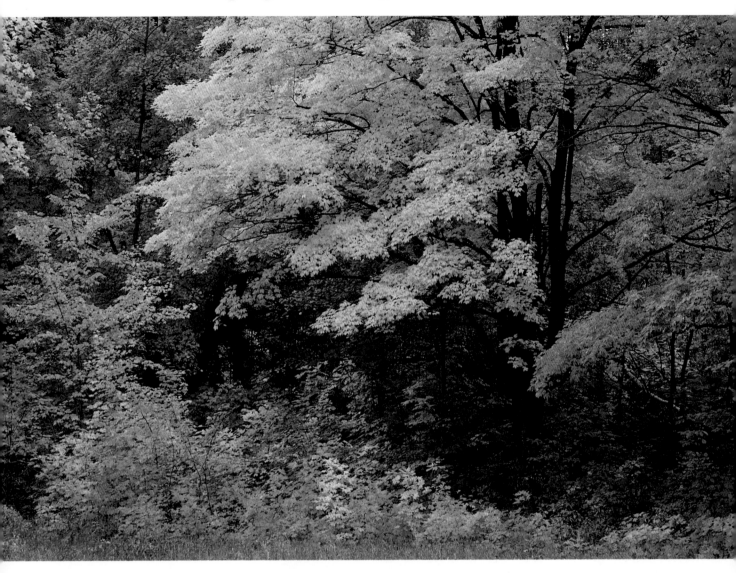

PROBLEM

Packed together, thick, colorful foliage is exciting to look at but awfully hard to paint. Somehow you have to capture how the color relates to the individual trees or your painting won't make sense.

SOLUTION

Use your brushstrokes to convey the rhythmic buildup of color. Short, deft strokes with a bristle brush give the sense of many separate leaves joining together. This painterly approach will enliven the surface of your painting and help make the individual colors sing.

Autumn maples cluster together in a flourish of rich greenish golds and oranges.

STEP ONE

Before you sketch the scene, spend a little time studying it. There's nothing tangible to hang onto here; instead, you are dealing with amorphous masses of color. Figure out where the main hues start and stop, then indicate those places with charcoal. Next, sketch in the major directional lines with thin washes of ocher and green.

STEP TWO

Mix washes of your major colors—golden oranges, ochers, and greens—then rapidly cover the entire surface, working from dark to light. Don't try to portray exact hues; instead, concentrate on values and the patterns of light and dark you are creating.

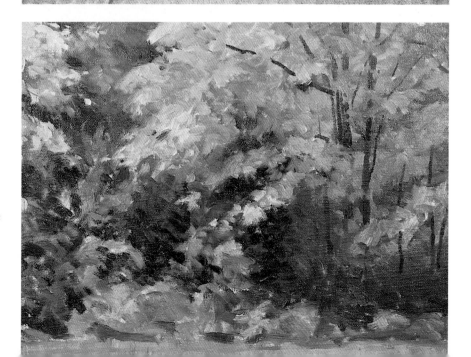

STEP THREE

To capture the feel of dense, overlapping leaves, use short, broken strokes as you begin to work with opaque pigment. Let the colors you laid down with your washes act as a guide. At this stage work wet into wet and, again, move from dark to light. Your focus is still on defining large blocks of color, though you can begin to break these areas up with touches of lighter or darker color.

FINISHED PAINTING

Once the major color areas are clearly defined, shift your attention to the range within the areas. You want to show the rich mix of color that makes this scene exciting. In particular, observe how the light strikes the leaves; capturing the direction of the light can help to unify your painting.

At this stage, the needs of the painting take over. Look at it and figure out what has to be done if it's going to be convincing. Here the masses of color were still too broad and general. They needed more variety and distinction to suggest the wealth of foliage. If that's the effect you want, accent the dashes of color with short, broken strokes. Keep your eye on the subject so the direction of your strokes will suggest the way the leaves hang on the trees.

Creating the Feel of Backlighting

PROBLEM

Backlit scenes are among the most difficult to paint. They can easily become unconvincing if the contrasts between light and shadow are too emphatic, or if you ignore subtle changes in color.

SOLUTION

After you've finished your preliminary sketch, establish the brightest tone by laying a light yellow wash over the entire surface. For the darkest value, don't choose pure black. Instead, mix a deep, rich tone from your browns and reds or blues.

☐ Your charcoal sketch should be simple. Draw the trunk and the powerful branches that soar up from it; also lightly indicate the darkest masses of foliage. Now cover your drawing with a burnt umber wash. Then, to infuse your subject with a golden glow, bathe the canvas in a wash of cadmium yellow light. But first protect what you've done by sealing the surface with a coat of varnish.

As you turn to thicker paint, study how clusters of leaves look when they are lit from behind. Instead of forming bold areas of color, they break up into small patches of light and shade. To capture this sensation, work with a small bristle brush and short, broken strokes. First develop the dark patches; next turn to the lighter areas; then move back and forth. Note how just one dark stroke can change the entire feel of the painting. Don't worry: you can always go back and readjust the other lights and darks.

Now return to the trunks and branches. What color should you use? You may be tempted to try pure black; after all, the trunk is very dark compared with the leaves. But pure black will make the transition between the leaves and bark too harsh. Instead, take a burnt umber and temper it with a touch of red.

Once you've established the trunk and branches, let the painting tell you what to do. Assess the patterns of dark and light that run through the foliage. If some passages seem too dark or too light, readjust your value scheme. You may also want to introduce touches of pure color—here dabs of brilliant cadmium yellow reinforce the wash that was laid down earlier.

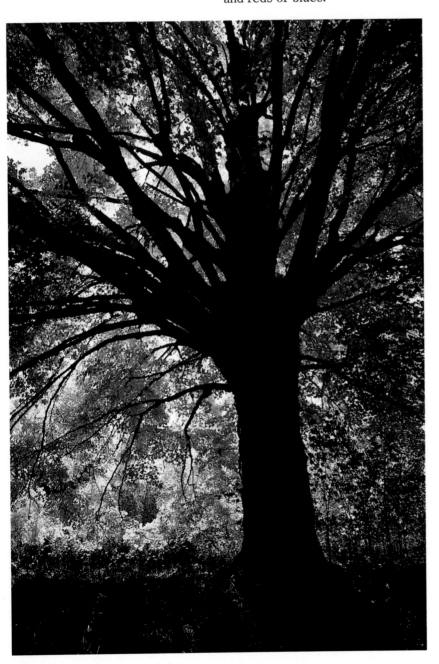

The strong trunk of a maple stands boldly silhouetted against a riot of autumn foliage.

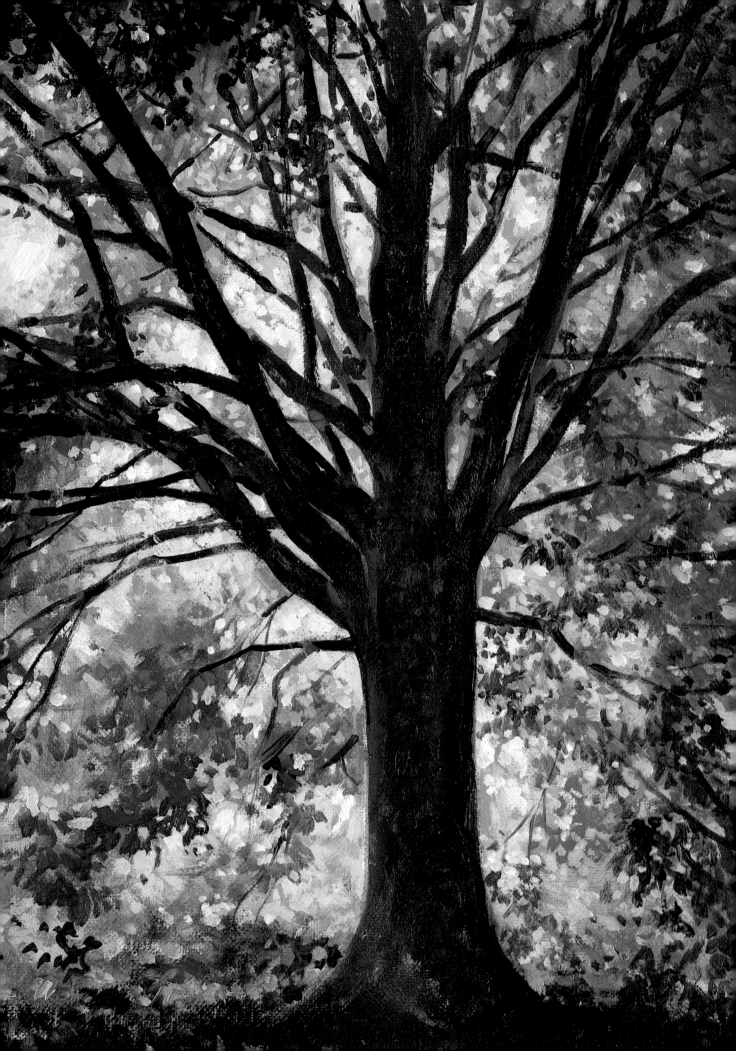

Handling a Painting Knife

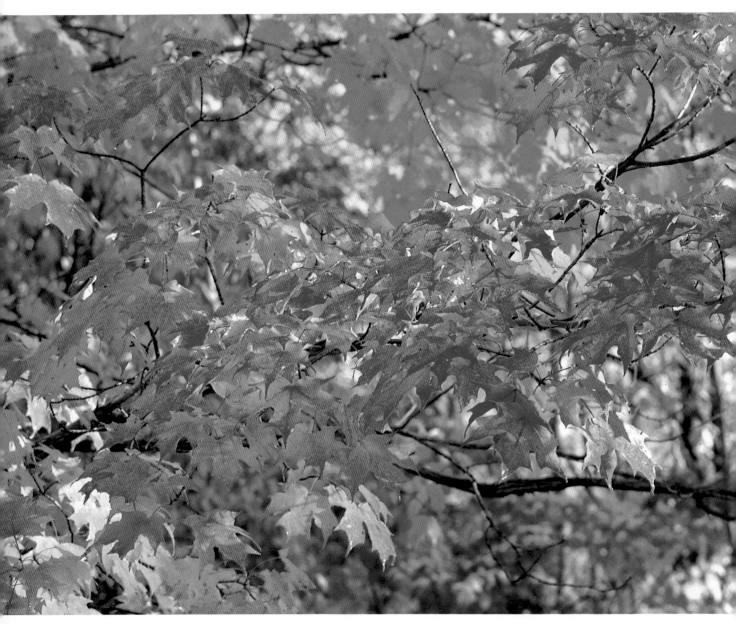

PROBLEM

Bright reds, yellows, and oranges tend to bleed together visually, making it difficult to get a sense of individual leaves.

SOLUTION

Don't rely on color alone to punctuate the surface of the painting. Once you've set up the overall composition with thin washes, use a painting knife to apply the paint.

☐ In your drawing, concentrate on just one thing: the patterns formed by the dominant red leaves. Then redraw them with a small brush and a thin wash of red to further separate them from the background. When you've indicated the hottest, boldest areas, turn to the dark greens that lie in the background. This step helps you establish the overall design of the painting—as you lay in the darks, you have to figure out which areas should spring forward and which are less important.

It's at this point that many beginners want to add the branches, which they hope will structure their work. But if you put the branches down now, it's all too tempting to hang clumps of leaves on them—and nothing could make a scene look more unnatural. In views like this one, the branches are relatively unimportant. What you want to capture is the impact of the brilliant leaves. Forget the branches until the very end and concentrate on color.

*The glorious colors of maple leaves in
autumn rush together in a dazzling pattern.*

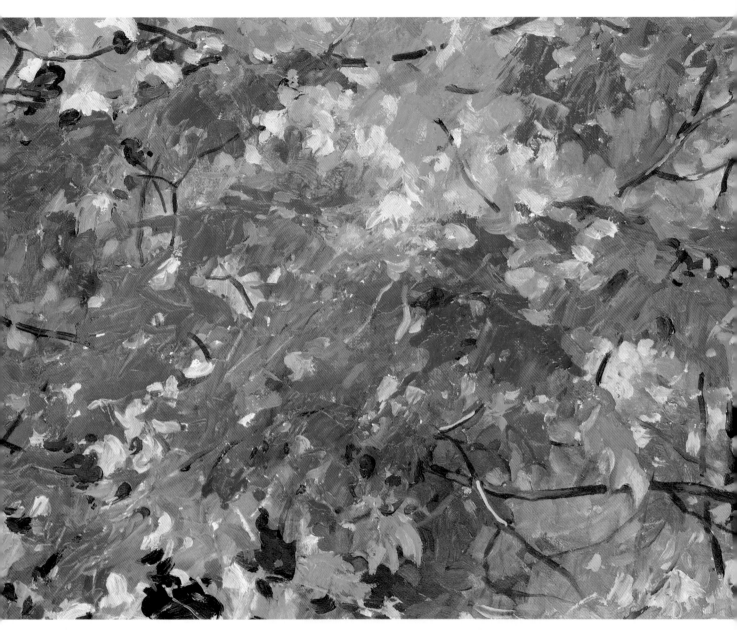

Start using thick paint now, applying your pigment with a painting knife. Working with a painting knife is faster than laying in color with a brush, and that can be an advantage in cases like this one where texture is critical. You can quickly build up a rich impasto that suggests the actual texture of the leaves. If you're wondering about drying time with such thick paint, it's true that the drying process can take longer. But if you add a gel medium to your pigment—one that speeds up dry-ing time—you'll find that thick paint dries almost as quickly as thin layers of paint.

Now that you've established the major areas of color, refine them with a brush. Use a bristle brush to coax the paint about, sharpening the edges of each mass of color. At the same time, pay attention to the background, building up the greens that you first laid in with thin washes. You'll need to work back and forth between the leaves and the back-ground, adjusting values and clar-ifying shapes.

It's at this point that the branches should be added. As you draw them in with a small sable brush, don't try to be exact. If you get caught up in detail now, you'll lose the rich, painterly feel you've already achieved. Finally, mix a little cerulean blue and white; then, with a bristle brush, roughly indicate the patches of sky that peek through the leaves. In the end, you'll have a blaze of color, flaming so vigorously that it almost seems to pulsate.

Playing Sharp against Soft Focus

PROBLEM

This knot of flowers is packed with detail—so much detail, in fact, that it will be hard to capture and present clearly.

SOLUTION

First, choose a small support, one only a little larger than the actual cluster of flowers. It's also a good idea to use Masonite. Concentrate on the flowers closest to you; just suggest those in back.

☐ When detail matters as much as it does here, a careful drawing is a must. Instead of charcoal, try a carbon pencil; you'll find it has a crisper, more definite edge. After fixing your drawing, you're ready to lay in color. But where do you begin with so much intricate detail?

What you want to do is to take advantage of the soft blur of the background flowers to bring out the sharp focus in front. A good way to start is by laying in the general patterns of dark and light. Apply washes of pink and red to indicate the main highlights and shadows of the blossoms, then gradually add a few definite shapes. Don't forget about the background; develop it, too, with thin washes of green. Since your drawing will still be visible through the transparent washes of color, use it as a guide to help you separate one area from another.

Now turn to opaque pigment. If you paint portions of the flower clearly, with sharp detail, the rest will be carried along; the eye will fill in the details that are glossed over in the painting process. Start with the pale pinks—they'll set the stage for the darker pinks and reds. Use your medium-value pinks to depict the parts of the flower closest to the viewer; then sharpen up the details you've chosen to accentuate with deep, rich red.

The white tips of the blossoms, as well as the green leaves and stems, are set down at the very end. By scattering dabs of white over the surface of the painting, you'll create a lively rhythm. The greens will temper the brilliance of the pinks and reds and, at the same time, help convey the feel of living flowers.

In early spring, just as the chill of winter dies away, a cluster of flowers bursts out on a red maple.

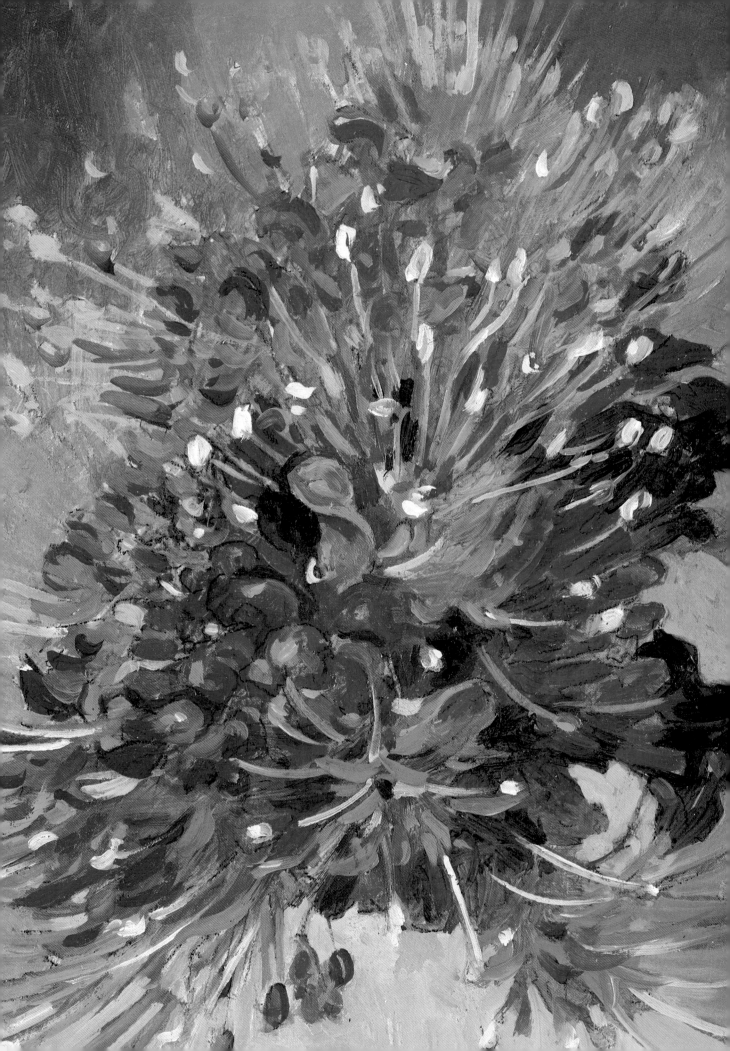

Balancing Two Competing Colors

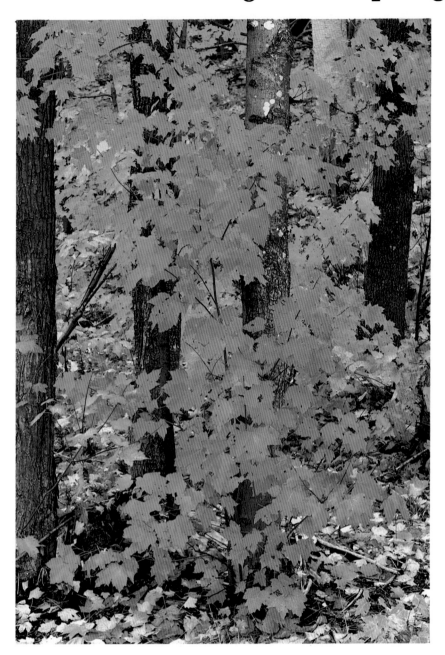

PROBLEM

The colors in both the foreground and the middle ground are strong and bright. If you make them equally vivid, you may lose a clear sense of space.

SOLUTION

Exaggerate the contrast between the reds and the oranges so that one color—red—stands out clearly.

STEP ONE

In your preliminary drawing, concentrate on the vertical tree trunks and the overall pattern of the leaves. Detail isn't important here. Search instead for the rhythm that the clusters of leaves set up. Then, redraw the scene with a thin red wash, outlining the masses of bright red leaves. For the time being, ignore the orange leaves; it's important to emphasize just one color.

Partially hidden by a maze of brilliant red and orange autumn leaves, tall maple trunks sweep upward.

STEP TWO

To further distinguish the red leaves from the rest of the composition, cover the background with a thin, dull wash of ocher and raw sienna. At the same time, bathe the tree trunks with a brownish wash to clearly establish their shapes. Continue to let the white of the canvas represent the red leaves.

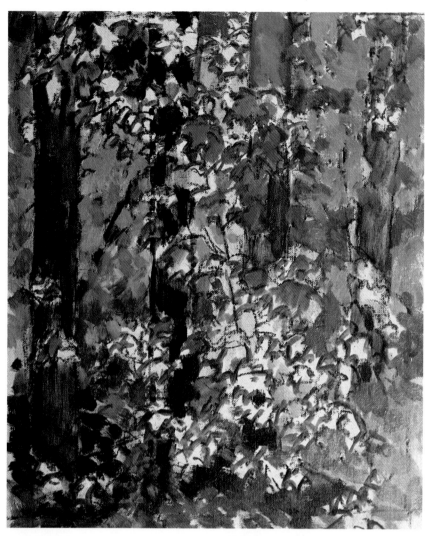

STEP THREE

Now begin to work with thicker pigment. To make the reds really stand out, use a painting knife. In this way you can lay in bold, dramatic masses of paint and build a tangible surface texture. After you've piled on the red pigment with your painting knife, refine the contours of the red leaves with a small bristle brush.

FINISHED PAINTING *(overleaf)*

Almost everything that makes this painting special happens in the final stages—the colors are intensified, the texture becomes more dramatic, and the forms are defined. First, go back to the dark tree trunks, working around the red leaves you've already established. Now turn to the red and orange leaves. On your palette prepare good-sized dabs of red and a bright yellow-orange, then mix portions of the two colors together to get a strong reddish orange. To all three colors, add gel medium to hasten drying time.

Moving all over the canvas, apply dabs of color with a painting knife. Get the yellow-oranges down first and keep them thin. For the reds and red-oranges, use

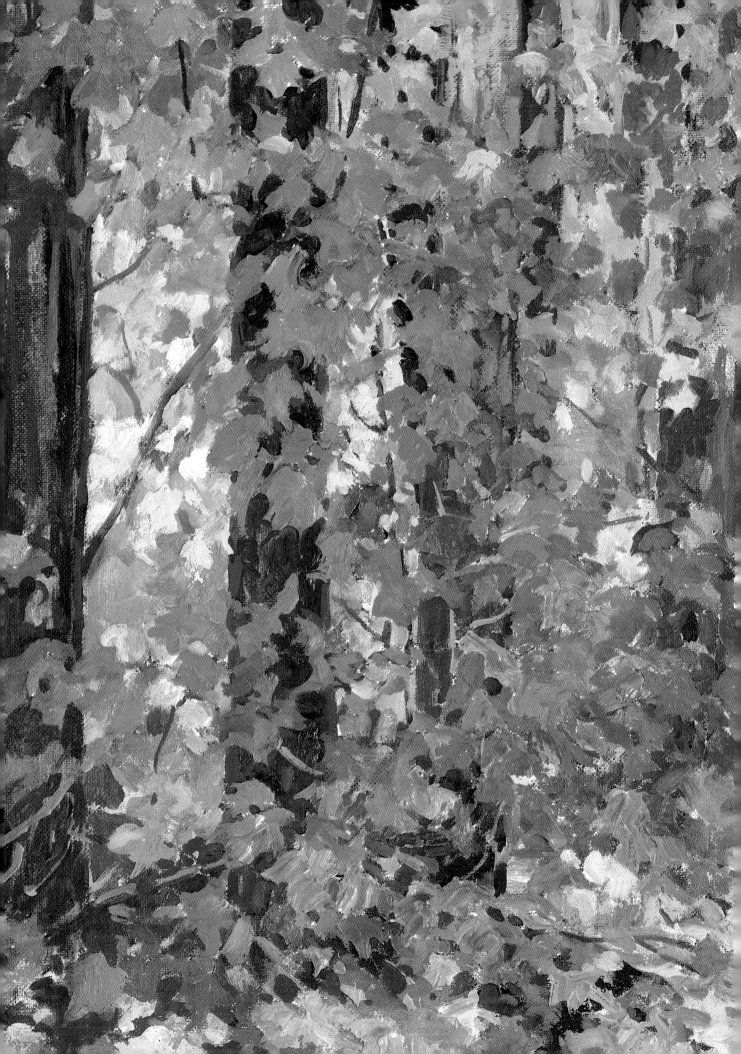

more paint so their texture will literally make them stand out.

Once you're satisfied with the overall pattern, introduce a few bright color accents with cadmium yellow. Finally, while the paint is still wet, take a small bristle brush and refine the strokes laid in with the painting knife. In some places you'll want to soften the edges; in others you may want to add still more pigment to enhance the three-dimensional effect.

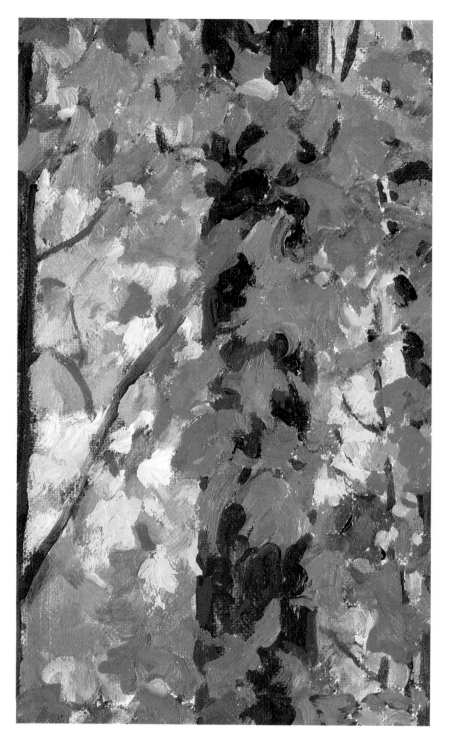

DETAIL
When you lay touches of bright yellow on top of your reds and oranges, what you are doing is setting up a lively sense of space. Like the reds, the intense yellows spring forward, giving your painting a sense of immediacy. More than that, they break up and thus activate the pattern of the reds— which is important when the reds are as strong as they are in this scene.

Finding the Details That Count

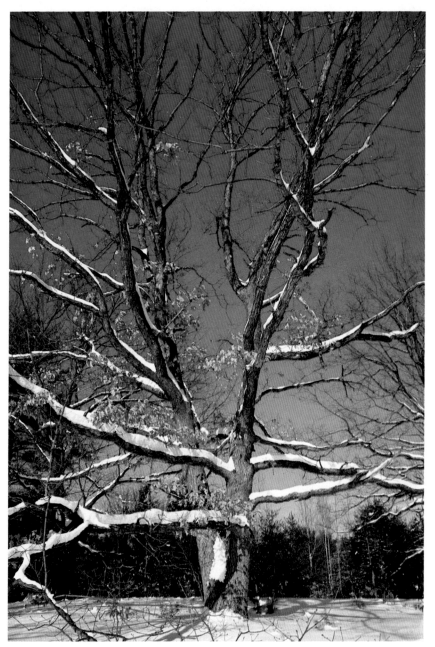

PROBLEM

Although this scene looks straightforward at first, once you start to analyze it, you'll find it's quite complex. The intertwining branches of the oak, with their snowy covering and dried-out leaves, make for detail—detail that has to be captured if your painting is to convey the tree's essence.

SOLUTION

Make sure you establish the basic lines of the oak in a good, clear drawing. Paint the strong blue sky first, however. Once it's down, you'll be able to focus on the details of the tree that give it character.

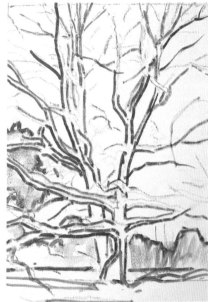

STEP ONE

Capture the structure of the tree with a strong charcoal drawing, then reinforce it with diluted color. Also use thin washes to lay in the incidental elements of the scene—here the trees that hover on the horizon.

In early February snow lays heavily on the sturdy branches of an old oak tree.

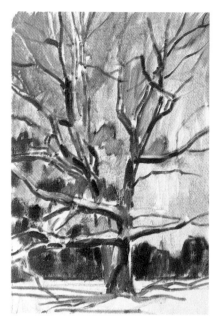

STEP TWO

Now's the time to establish your overall color scheme. Still working with thin washes, get down the blue of the sky. As you turn to the tree and its leaves, let the white of the canvas represent the snow weighing down its branches. Then build up the dark hues that define the background.

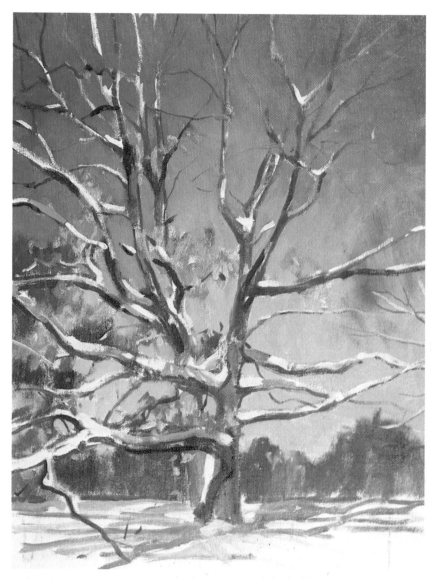

STEP THREE

In winter scenes, the warmth or coolness of the sky does a lot to establish the mood of a painting. Here the sky is a warm, radiant blue. As soon as you start to work with opaque pigment, get the value and warmth of the sky down. Once it's done, you can concentrate on the tree. After reasserting the lines of the tree, begin to build its lights and darks with different browns. It's time, too, to render the snow—use a small sable brush and pure white paint, plus white mixed with a touch of blue. Next turn to the snow in the foreground. Get the bluish shadows down first.

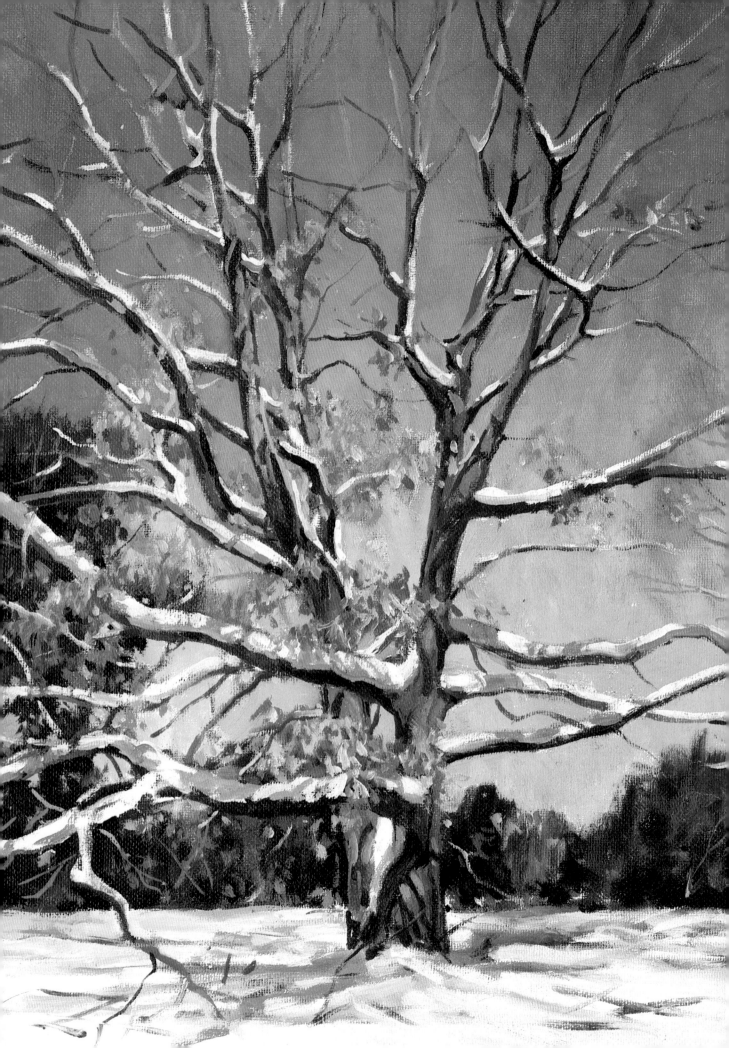

FINISHED PAINTING

In the final stages, bring out the leaves that cling to the tree. Working with your browns and yellow ocher, gently dab the leaves in with a small sable brush. The point is to make the leaves look dry and fragile; with heavy, unbroken pigment, you'd lose the feel of winter. At times you may need to work back and forth between the leaves and the sky, adding touches of blue to break up the golden-brown tones, or vice versa.

Next, complete the foreground. To tie the ground to the tree, add touches of yellow ocher and brown to the snow beneath the tree. Finally, turn a critical eye toward the tree. Is its structure clear? Here it was necessary to redraw portions with a small sable brush moistened with dark pigment. At the very end, paint in the shadows that weave over the trunk.

DETAIL (above)

Seen up close, the variety of colors used to render the snow-covered tree and its dried leaves becomes apparent. Bits of blue key some snowy passages to the color of the sky. Also notice how the broken strokes let the brown of the branches show through. The gentle dabs of yellow-browns in the leaves strike a different, more delicate note.

DETAIL (right)

There's a lot going on in the background; thick trees hug the horizon and the snow-covered ground is covered with deep shadows. In the finished painting, the background remains important, yet it is rendered with much less detail than the oak. If it were developed more fully, it would steal attention from the oak—the focus of the painting.

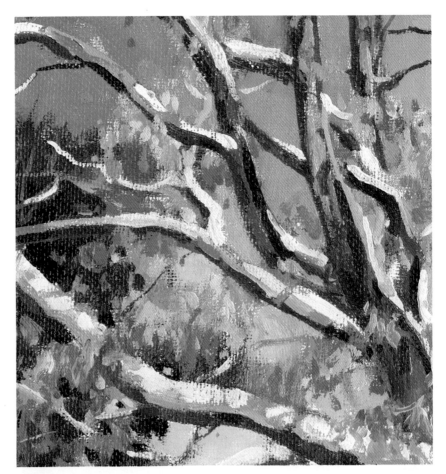

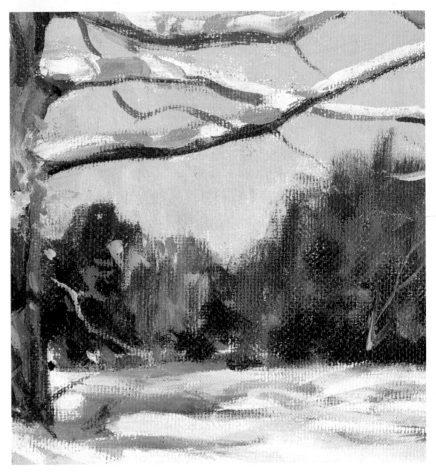

Using Value to Clarify an Intricate Pattern

PROBLEM

When you move in close on a scene, it can become extraordinarily complex. Here the branches form a spidery web interrupted only by the dead leaves. Making sense out of this jumble will be difficult.

SOLUTION

Establish your middle value right away. Once it's down, you won't have to struggle with the value scheme. You can easily gauge the strength of your darks and lights as you concentrate on what matters here—pattern.

☐ Use your preliminary sketch to delineate the major branches of the tree and the overall pattern of its foliage. You'll be staining the canvas with a middle-value wash, so fix your drawing before you proceed. When the fixative has dried, go over the lines of your drawing with thinned yellow ocher—the color you'll rely on when you paint the leaves.

Now tone the entire canvas with a cool bluish gray—the color that dominates the background. Mix a small amount of pigment on your palette, then add a good amount of turpentine. Sweep the mixture over the entire canvas with a large brush, or even a rag. Then take a small, dry brush and "erase" the areas of snow.

When you are confronted with a scene as complex as this one, work all over the canvas as soon as you begin to paint. Lay all the colors you'll need on your palette. As you work back and forth between the leaves, the branches, and the background, you'll see that each stroke you lay down influences those around it. First, get down major shapes— the tangle of branches, the tree trunks in the rear, and the overall configuration of the leaves. Next, tighten up the painting's structure by refining details. To make the leaves stand out, darken the areas that surround them and break up their masses.

Finally, with a light shade of bluish gray, paint the thin, delicate branches. Add the snow using a drybrush technique; slowly pull a barely moistened brush along the canvas, letting touches of the gray-brown break through the white. When you think your painting is finished, leave it alone for a while. When you come back to it, look to see if the overall pattern is clear, and if the lights and darks stand out from the grayish middle tone.

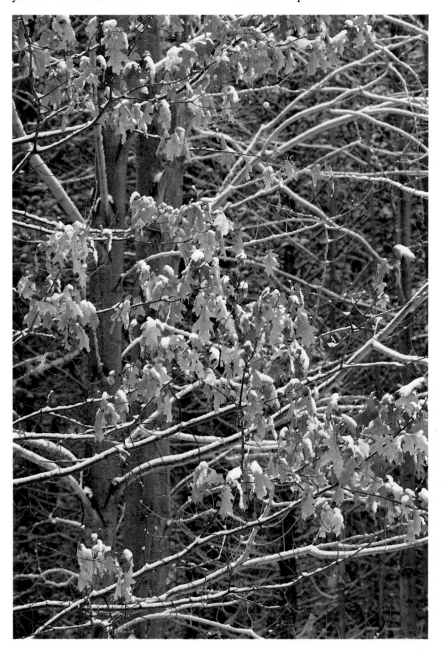

Clusters of dead leaves cling to the branches of an oak tree already coated with thick, wet snow.

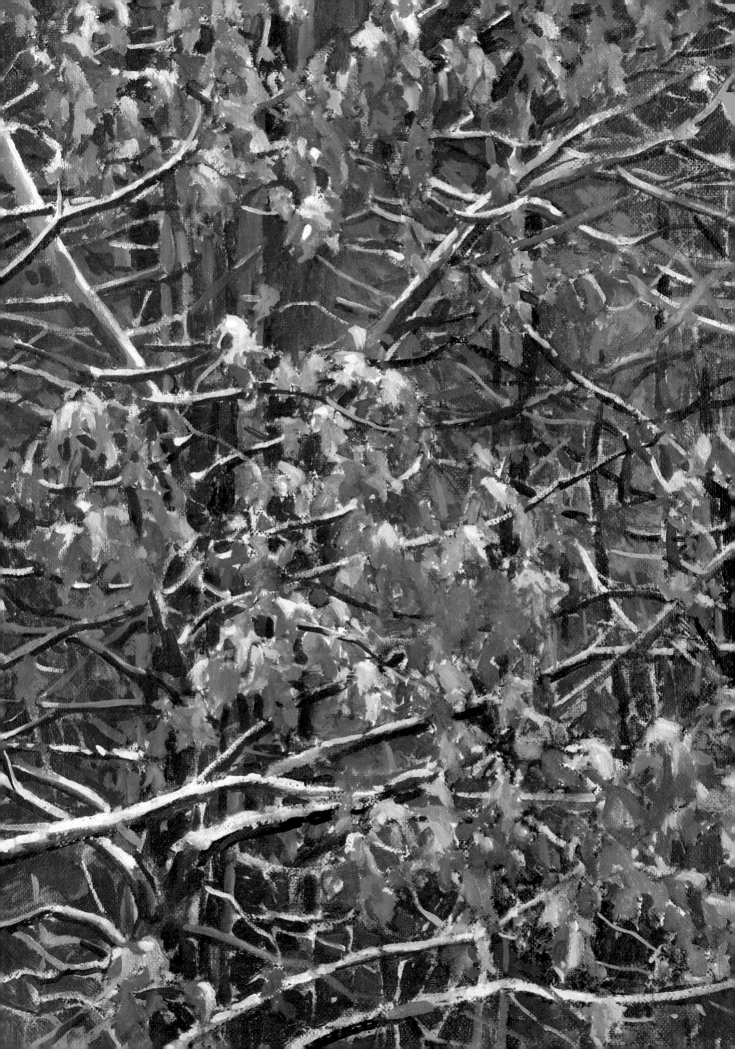

DETAIL
The delicate, snow-covered branches are subtly rendered with a drybrush technique. In places the white pigment covers only portions of the grayish-brown branches, re-creating the irregular patterning of snow. Observe how the blue-grays of the background enhance the cold, wintry feel of this scene.

DETAIL
Painted with overlapping strokes of blues, grays, yellow ocher, browns, and white, the leaves of the oak tree develop a three-dimensional feel. The strokes that were laid down last seem to lie in front of those that were painted first. Note, for example, how the dabs of white stand out against the darker hues, and how they link the leaves to the snowy branches.

Distinguishing Spidery Branches against a Pale Sky

PROBLEM

The branches of this oak tree are thin and spidery. Set against a pale sky, they are very hard to see. Unless you take care, they will lose their delicacy and look harsh and unrealistic.

SOLUTION

Paint the sky before you tackle the tree. Then reestablish your preliminary drawing. With something as delicate as these branches, you may have to pause several times while painting to redo your drawing. If you let the drawing fade away, you'll never capture the branches' spidery quality.

☐ With charcoal, sketch the tree and go over your drawing with thinned burnt umber. As soon as your color drawing has dried, turn to the sky. Load a large bristle brush with cobalt and cerulean blue lightened with a touch of white. To indicate the clouds that soften the sky, gently coax white pigment onto the blue ground. For a more realistic look, add touches of yellow ocher and even gray to the white.

If your drawing has become lost as you laid in the sky, reestablish it with thin color. Then, with thicker paint, build up the trunk and the major branches. To make your brownish hue more interesting, try adding a touch of cobalt blue to your burnt umber. Next, brush in the line of distant trees and the basic planes of the foreground. For the time being, let the white of the canvas represent the snow.

Once the darks of the tree are down, you may want to adjust the strength of the sky. While the sky is still wet, lightly brush in the tree's delicate, spidery branches with a thin sable brush; the brown will become soft and fuzzy as it blends with the colors of the sky.

To complete your painting, add thin strokes of white to suggest the snow on the branches; then build up the grass in the foreground. You'll want to render the grass boldly, with rapid, calligraphic strokes, to give the tree a solid base.

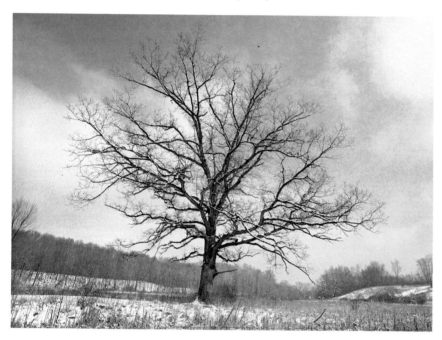

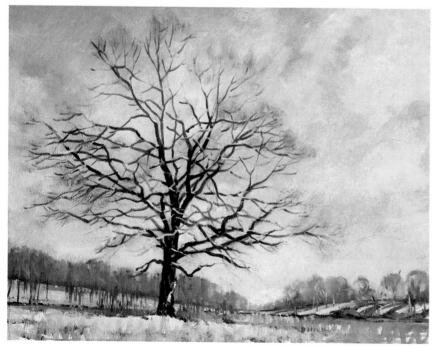

The barren branches of a white oak reach out across a cool winter sky.

Capturing the Sparkle of Frost

PROBLEM

What's unusual about this subject is the sparkle of frost that adorns the leaves. But if you concentrate on just that, you'll lose the overall sense of the composition.

SOLUTION

Before you turn to the frost, carefully analyze the pattern of lights and darks running through the leaves. Only when you've finished everything else, add the slivers of white that cling to the edges of the leaves.

☐ Carefully draw the leaves, then cover your drawing with thinned color. Here the view has been extended beyond the photograph on the right side. Feel free to alter what you see if it will improve your composition.

When you start to paint, establish the darks right away. Moisten your brush slightly with pigment, then stroke the paint over the surface to indicate the shadowy portions of the leaves. As soon as they are down, capture the hazy, indistinct background by scrubbing color onto the canvas with a barely moistened brush. Use the same colors that you intend to use for the leaves.

In painting the shadowy areas, you had to gauge their values against the white of the canvas. Now that the background is painted, you'll probably find that the shadows are too light. Deepen their color, then let the surface dry.

To build up the leaves, work with glazes—mixing your pigment with a medium to create a transparent veil of color. Because the color is transparent, the shadows you've established are never lost. Instead, they shine through the lighter, brighter colors laid down on top of them. Don't try this technique with turp washes because the turpentine will stir up the paint already on the canvas.

As you apply successive glazes, work from dark to light. Only when you are completely satisfied with the pattern of darks and lights should you think about the frost. Take a small sable brush; dip it into white pigment; then gently dab the white around each leaf. As a final step, mix a dull grayish tone to temper some of the dots of white. Not only will this suggest the shadows that fall across the frost, but it will also bring out the sparkle of the pure white.

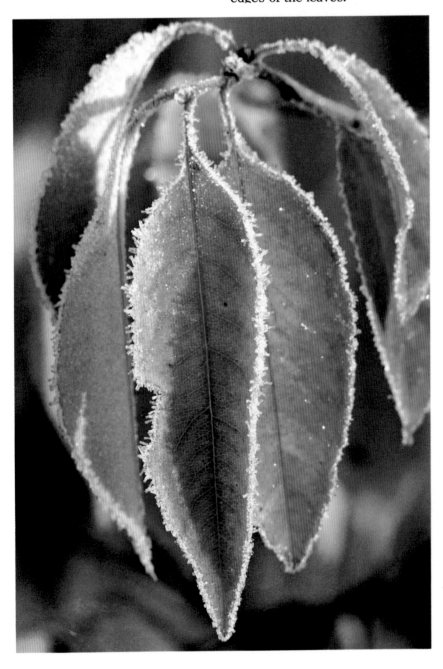

An early frost decorates the long, thin leaves of a cherry tree.

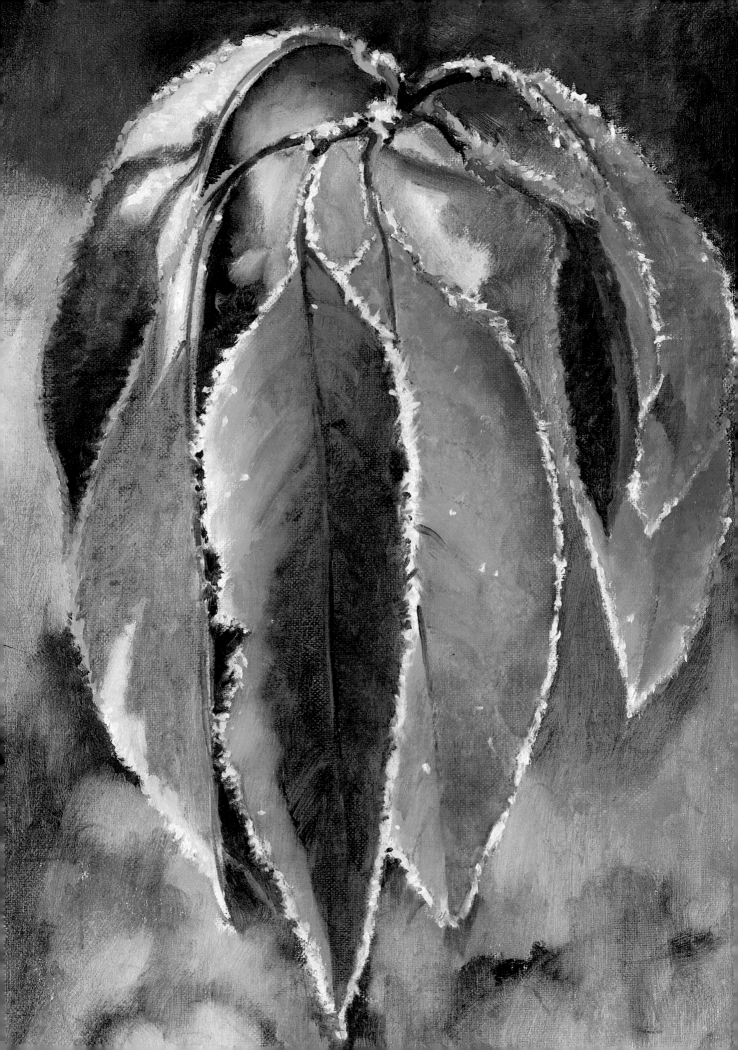

DETAIL *(left)*
The touches of white that indicate the frost look soft and unfocused. When you are working with something ephemeral like frost, don't let your strokes become too strong and definite. Here, for example, the white gently edges the golden oranges and yellows of the leaves. The white strokes become even subtler as touches of bluish gray are introduced to suggest shadows playing over the frost.

DETAIL *(below)*
This soft, diffused background is in harmony with the rest of the painting, in large part because it is painted with the same colors as the leaves. When you are working with an unfocused area in a painting—usually a background—don't make it too dark and be sure to use colors found elsewhere in your painting. It's best not to work with thick paint, however; thin washes of color will downplay the area's importance and let attention focus on the main subject.

ASSIGNMENT
Glazes can unify a painting, add nuance to a plain area, or suggest a particular mood. Experiment with them to learn their power. Choose a landscape with a diffuse background—one that has lots of different things going on in it all at once. Work up the whole surface of the painting, then let it dry. As soon as it is dry to the touch, select an appropriate color—yellow ocher, for example, if you are working with a sun-filled scene—and mix it together with painting medium. Lay in this glaze over the entire background and see how it pulls together all of the different elements in your painting.

Giving Power to a Decorative Closeup

PROBLEM
This complex tangle of leaves has no center of interest. The whole surface is evenly packed with intricate detail. Unless you find something to engage the viewer's eye, the decorative elements may seem boring.

SOLUTION
Search for the patterns formed by darks and lights and by the red, green, and purple tones. Work all over your canvas, accenting individual leaves as you develop the entire scene.

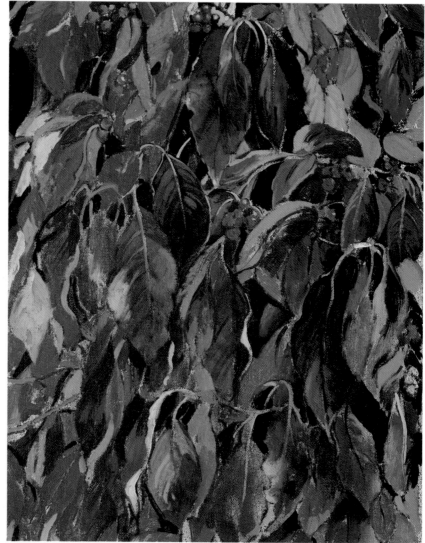

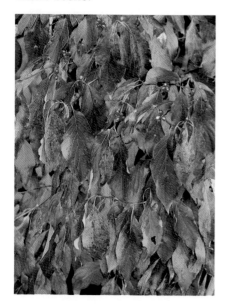

The shiny berries of a flowering dogwood accent the rich pattern of its green and red-tinged leaves.

☐ With charcoal, sketch in the foreground leaves; then spray the drawing with fixative. Now study your subject. Despite the variety of tones, one color—a silvery green—dominates the scene. To establish this color note right away, flood the surface with a wash of alizarin crimson and Thalo green. You'll find that alizarin crimson—a complementary color—grays the green, creating a cool, mysterious hue.

Now build up the surface with thinned color, concentrating on the play of light and dark. Don't get locked into any one corner of the painting—instead, work all over, moving rapidly from one area to the next. Continue to use your mixture of Thalo green and alizarin crimson, adding white to suggest your lights and more green to define your darks.

Next introduce thicker paint. Working back and forth between the near and far leaves, search out the strong patterns created by variations in color and value. Once you are pleased with the result, turn to the details. Take a small sable brush and add the veins of the leaves and the thin branches. Finally, paint the clusters of berries that punctuate the tapestry of leaves.

119

Highlighting One Element in a Complicated Scene

PROBLEM

Sometimes there can be just too much that attracts the eye in a particular scene. Here the varied textures of the bark, the powerful lines of the tree trunks, and the subtle shifts in color are all intriguing. But no one element stands out clearly.

SOLUTION

To create a center of interest, decide to emphasize one element. Here the purple iris is a logical choice—it's the only color accent in a predominantly greenish scene. To strengthen this color note, play up the red in the purple, in contrast to the cool surroundings.

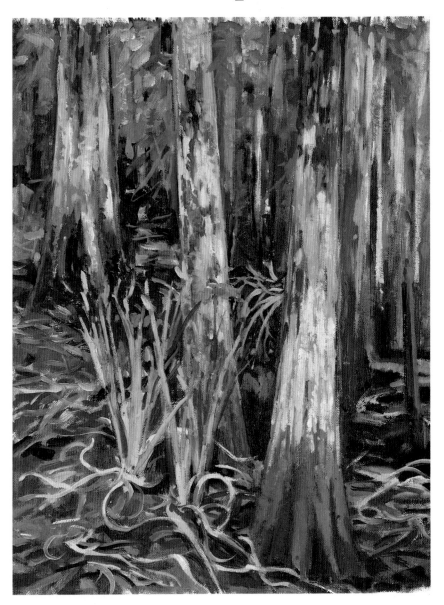

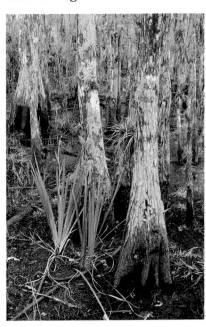

A lone iris springs into bloom alongside the massive trunks of cypress trees.

☐ Draw the cypress trunks, indicating both their contours and their surface texture. Next, sketch the plants that grow alongside. Choose the base colors for your painting—a cool purple, a rich brown, and a green—then go over the lines of your drawing with thinned color. Continue working with thin washes as you lay in strong, vertical strokes to convey the power of the trees. Don't forget to add the browns that create the spaces between the trees. Since the iris is going to be crucial to the finished painting, be sure to note it right away. Then, as you continue to paint, you'll remember its importance.

When you start to lay in opaque color, break up your verticals with short, broken strokes. With a medium-size bristle brush, introduce touches of green and greenish blue to indicate the foliage in the background. Then, with grayish white, gray, and brown, work over the trunks' surfaces to suggest their texture. Try to get across the feeling of roughness, without going into every little

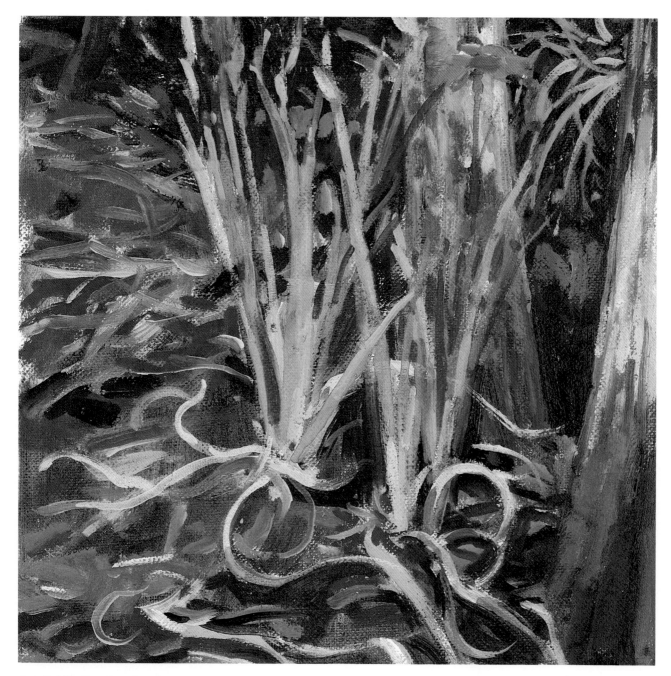

detail. Finally, develop the spaces in between and accentuate the fresh, bright greens of the iris.

Everything comes together in the final stages of the painting. Mix your pigment with a lot of medium to keep it fluid, then start to paint the sinewy roots that spread over the ground. Next, turn to the iris. Accent the bright yellow-greens of its stem, then build up the rosy color of the flower. Finish up your painting by adding touches of bright bluish white to the three major trees.

DETAIL
The swirling lines of these roots, drawn with a brush, give a sense of the swampy location of this scene. Their light color draws attention to the foreground, while their wavy contours direct the viewer's eye to the iris. They also add a lively note to the painting.

Working with Subdued Light

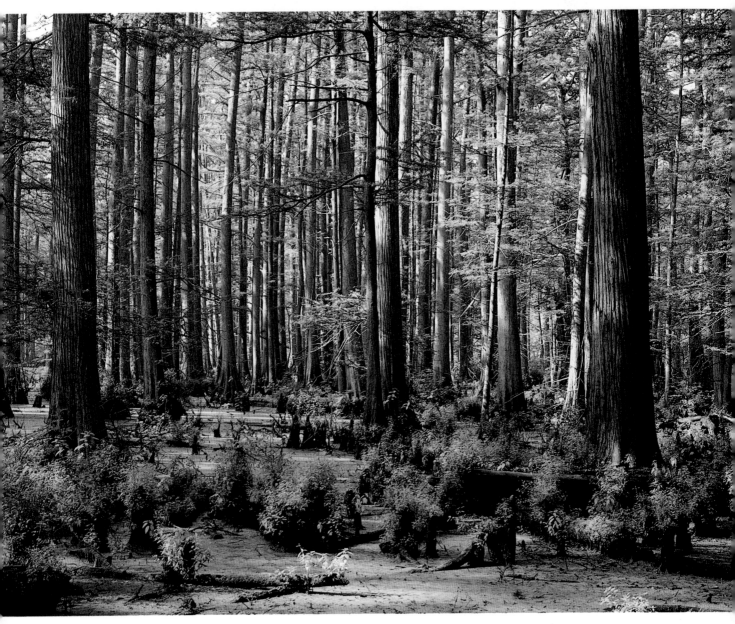

PROBLEM

Massed together as they are, these cypress trees present a difficult challenge: there's little that differentiates one tree from the next. To heighten the challenge, the light filtering in from above creates a rich array of lights and darks.

SOLUTION

To break up the mass of trees, it's very important that you space them correctly. Take special care with your preliminary sketch. When you start to paint, concentrate on value, not color, to capture the pattern of flickering light.

☐ With soft vine charcoal, draw the most prominent trees. Edit what you see—you can't pay equal attention to every trunk. Now reinforce your sketch with a wash of raw umber, using a small, round brush.

Continue working with washes as you set up your lights and darks. Since the scene is infused with greens, put all the ones you'll need on your palette. But don't stop with your tube greens—touches of alizarin crim-

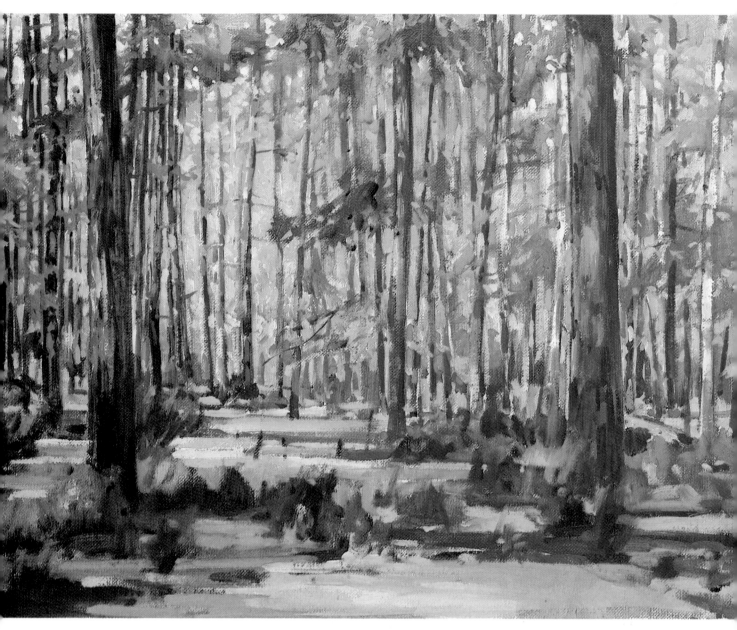

son will gray your greens; touches of brown or yellow, warm them; and touches of blue, cool them. As you lay in your green washes, concentrate on value. Establish the dark brown trunks that shoot up from the swamp and the dark greens that shadow the foreground. Let the white of the canvas represent the brightest areas.

To capture the rhythm of the trees massed together in the background, move back and forth between the trees themselves and the greenish tone around them, adding dabs of blue to suggest the sky breaking through the foliage. Finally, lay in the sunlit patches of brilliant yellow-green that flow across the foreground, with echoes in the middle ground. Use strong horizontal strokes to counter all the vertical lines that run through your composition. To really pull the foreground forward—something that's important when you're working with so much generalized pattern—accentuate the variety of greens.

The finished painting succeeds in giving a sense of depth, with the trees clearly receding into the distance. Note how the background trees are rendered almost entirely with short, broken strokes, while the foreground is treated with much bolder brushwork. Touches like this can make a world of difference in painting.

Conveying the Poetry of a Misty Landscape

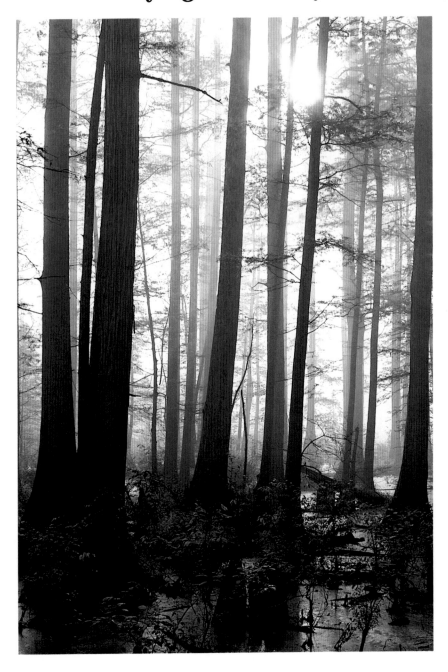

The glow of morning sunlight gently breaks through the veil of mist enveloping a cypress swamp.

PROBLEM

To capture the feel of this scene, you'll have to pay attention to three things: the delicate tracery of the trees, the quality of the morning light, and the atmospheric effect of the mist.

SOLUTION

A careful drawing will establish the profiles of the trees, leaving you free to concentrate on the sunlight and mist. To suggest the warm, enclosed intimacy of the scene—the feeling of a quiet, private moment—first cover the entire surface with a wash of pale yellow ocher.

STEP ONE

The milky iridescence of the light matters the most in this scene; nothing, not even the weave of canvas, should interfere with it, so choose a smooth Masonite support. Start by executing a very careful drawing, one that captures the delicate tracery of the tree trunks and the graceful shapes of the foliage. After spraying your drawing with fixative, go over its lines with a small round brush. Finally, tone the entire surface with an uneven wash of yellow ocher.

STEP TWO

The yellow ocher wash establishes the mood of the painting. As you lay in the trunks with washes of brown, use uneven strokes, allowing glimpses of yellow to break through. At this stage begin to depict the ground, lay in pale bluish-gray washes over the sky, and indicate the pale yellow sun hovering behind the trees.

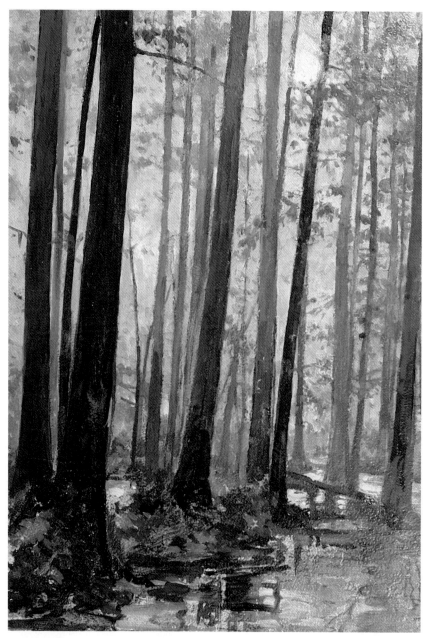

STEP THREE

As you move to thicker paint, don't forget that your goal is to create a mellow, misty feeling. Choose soft, round sable or synthetic brushes rather than stiffer bristle ones, and gently coax the paint over the surface. To indicate the very distant trees, try a pale, cool shade of blue; blue tends to recede, pushing these trees to the back of the picture plane. Conversely, to pull the nearer trees forward, use warmer, purplish-brown and gray hues. Darker, stronger blues come into play in the water in the foreground.

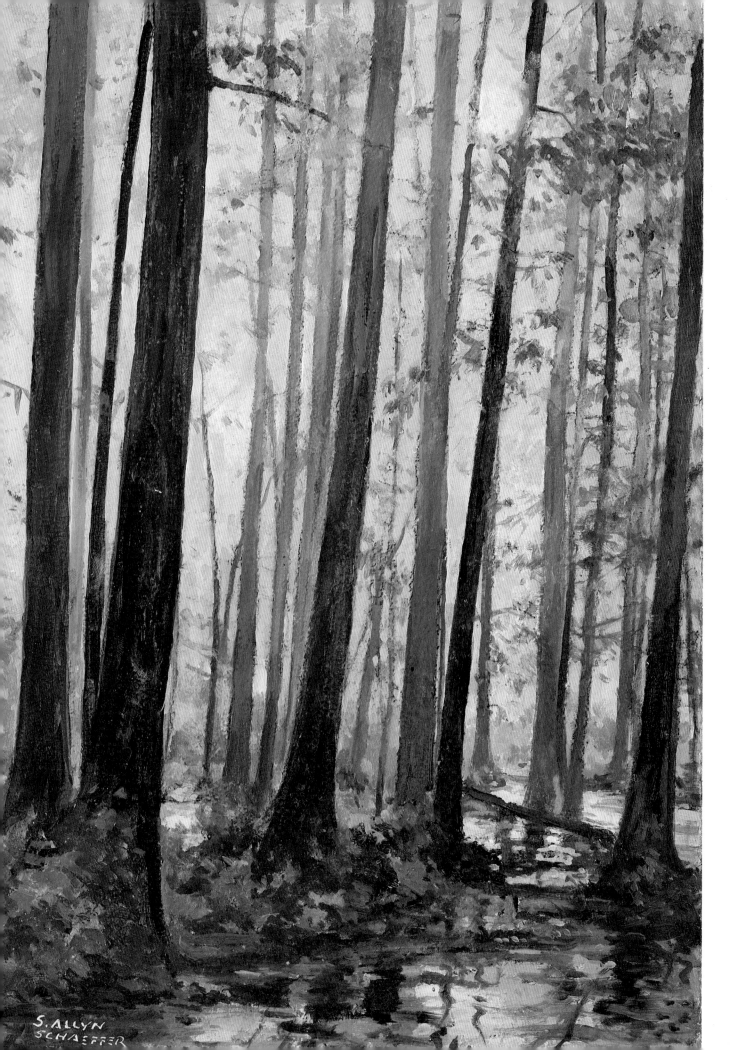

S. ALLYN
SCHAEFFER

FINISHED PAINTING

Refine the colors and values you've set up, adjusting them in relation to each other. Are the trees dark enough against the sky? Do they recede logically into space? Is the range of value broad enough? Critically examine what you've done and tighten up any loose areas. Here the ground was weak; its patterns were clarified and the reflections in the water added to strengthen the whole area. Finally, complete your painting by adding small accents such as the tiniest branches and sprinkles of foliage.

ASSIGNMENT

Light can dramatically change a landscape; what looks clear and fresh early in the morning can seem mysterious and full of gloom by late afternoon.

Choose a familiar scene—one that you often pass—and figure out at what time of day it is most appealing. Plan to do a painting on the site at that particular time. Arrive at the site, however, a few hours earlier. Use those hours to build up much of your painting. Sketch the landscape with charcoal, lay in your preliminary washes, and start to work with opaque pigment. When the hour you've been waiting for comes along, you'll be ready to focus in on the lighting conditions that interest you.

If the light changes while you work, don't try to alter your entire painting. Instead, stop and make color notes or quick sketches. Two options are open: either finish the picture in your studio, working from your color notes and sketches, or return to the site on another day.

DETAIL

The wash of yellow ocher that was applied in step one shines through all the layers of paint that were added later, warming up the entire composition. Brushwork also helps establish the painting's lyrical mood. Note, for example, the way the foliage is rendered. Short, gentle strokes of greens and grays suggest the delicacy of the leaves.

127

Handling a Monochromatic Scene

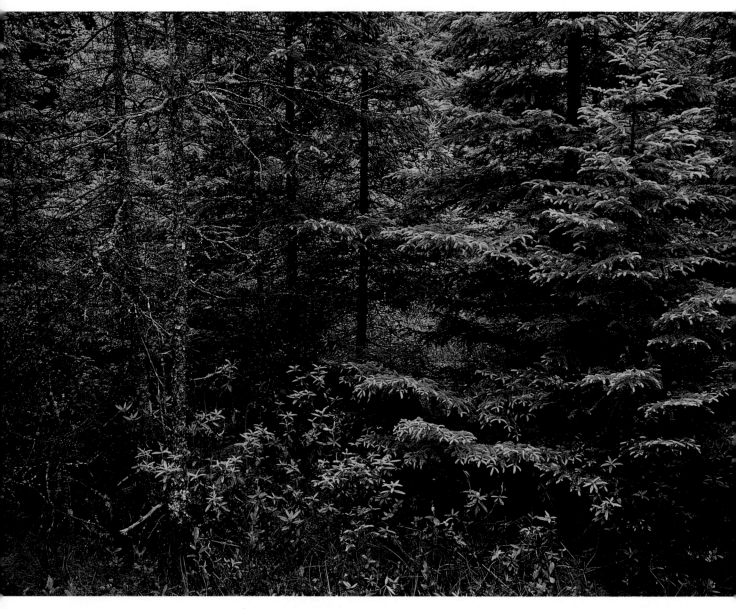

PROBLEM

You don't often see paintings that depict rich summer foliage, and for a good reason. Working with masses of green presents one of painting's most difficult challenges: How do you create a convincing image when all the colors and values seem basically the same?

SOLUTION

To give your painting a focus, concentrate on just a few of the trees. If you emphasize them and make them appear realistic, the surrounding greens will look convincing as well.

☐ Before doing a drawing, stain the entire canvas with a wash of medium-value green. Setting up a middle tone in this way simplifies your work later. When you add your darks and lights, you'll have something to react against.

As soon as the wash has dried, sketch the scene, concentrating on the trees you've decided to emphasize. Draw them fairly carefully, then loosely sketch in the overall shapes of the rest of the foliage.

Now decide which greens you'll use. It's important to have as

Deep within an eastern bog, black spruce trees, herbs, and shrubs form an unrelieved curtain of green.

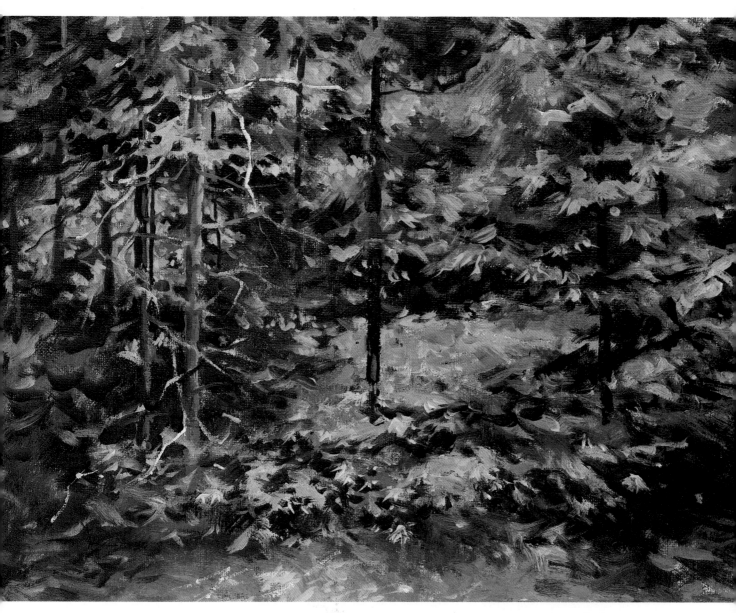

much variety as possible if your painting is going to have any life. For your dark greens, try mixing Thalo green with burnt sienna or alizarin crimson. For the brights, rely on permanent green light mixed with yellow ocher. To create an interesting, silvery blue-green, add a touch of white to Thalo green.

First, work over the entire surface with washes of green, quickly establishing the lights and darks, as well as the bright and dull hues. Introduce opaque pigment as you start to define the

trees you are going to emphasize. Lay in their trunks with strong, vertical strokes, then add their foliage with a loose, painterly touch.

Once you've gotten the feel of the most important trees, turn to the rest of the greenery. There's very little concrete visual data to hang onto here; you have to rely on shifts in value as you proceed. Try squinting at the scene—it may help you get a sense of the overall shapes and value differences. Continue to boldly sweep in strokes of green with a

large, soft, round brush. To differentiate the foreground from the solid wall of trees, introduce new colors—burnt sienna and yellow ocher, used alone and mixed together. Here a touch of ocher is also added to the center of the painting, drawing the eye into the forest of greens.

Finally, tighten up details. Make sure the trees you've chosen to emphasize stand out clearly against the greens. Add brownish-white highlights in small, delicate strokes to bring out their scraggly branches.

Matching Brushstrokes to a Conifer's Needles

PROBLEM

Once again, you're confronted with a subject that's almost entirely one color. To complicate matters, these spruce needles are packed with intricate detail. How can you convey their individuality, without fussiness?

SOLUTION

Stain the canvas with dark green and make a detailed charcoal drawing. In painting the needles, work from dark to light, searching for the shifts in value. Use your brushstrokes as needlelike lines of color.

☐ These needles are complex enough to demand a large support. Select a canvas that will allow you to paint the needles almost life size. Stain the canvas with a wash of dark green and, once it's dry, carefully sketch your subject with charcoal. Decide at the start to concentrate on the needles' overall appearance; don't get bogged down in detail.

You'll want to paint with long, thin strokes, so add plenty of medium to your pigment. Try, too, using a long-haired, pointed brush. Work from dark to light, carefully stroking the paint onto the canvas. If your drawing gets lost, redraw the needles with a light shade of green, one that will stand out clearly against the darker hues you've already put down.

As you move to the medium-value greens, try to establish as much variety as possible. Also add the brownish branches, again using a long-haired brush. Then introduce the lightest, brightest greens, concentrating them in the center of the painting.

Now, to pull the painting together and to capture the play of light on the needles, work back and forth between your lights, darks, and medium values. Draw the needles with your brushstrokes, letting the lines build in layers, much as the needles do in their clusters. Stop from time to time and evaluate what you've done. As soon as the needles seem focused and logical, slow down; it's easy to push a subject like this one too far and lose the effect you've set out to achieve.

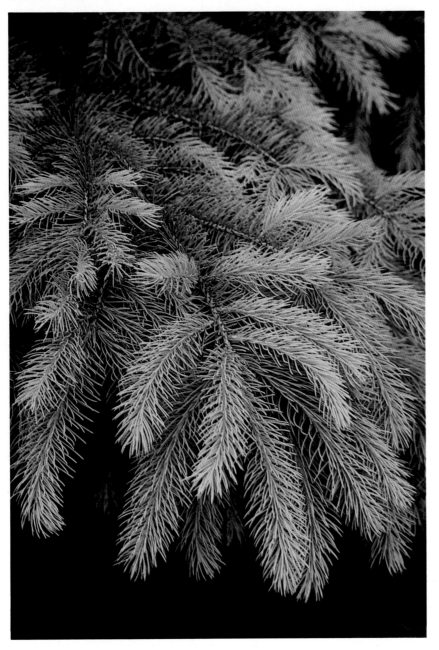

The stiff, sharp needles of a spruce tree pull its branches downward.

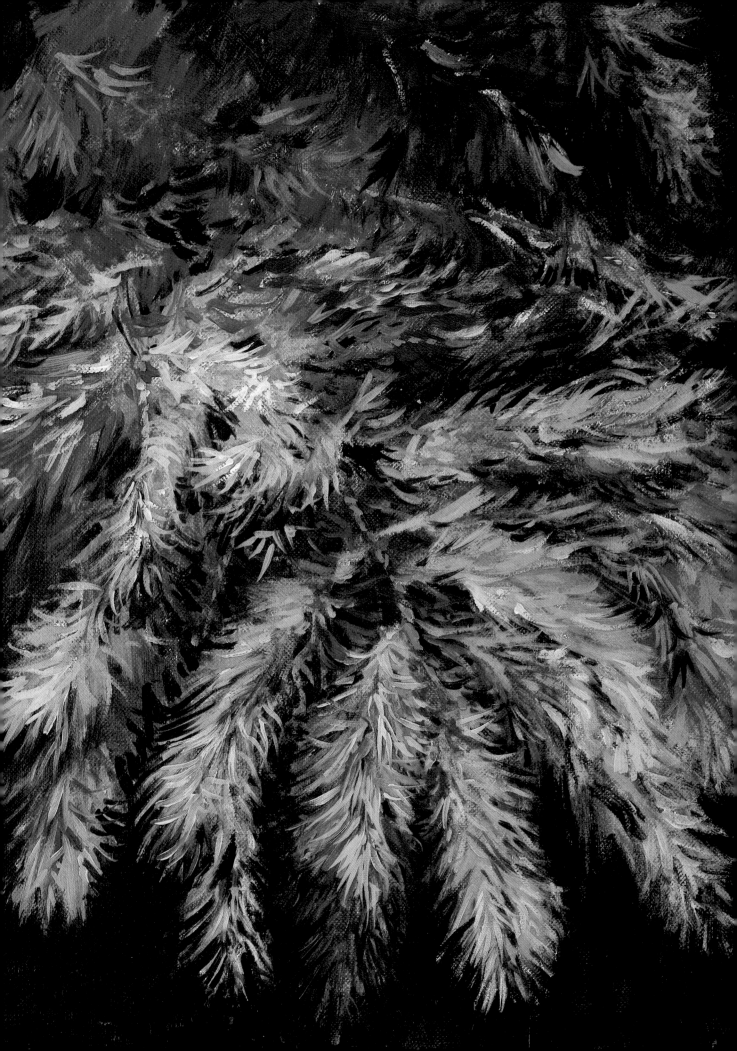

Isolating a Still Life in Nature

PROBLEM

These unusual cones stand out sharply against a dark, unfocused background. The detail that makes them so interesting has to be rendered crisply if you are to capture how they really look.

SOLUTION

Treat the cones just as you might treat a still life. Make the background even darker than it really is and work with opaque pigment right from the start.

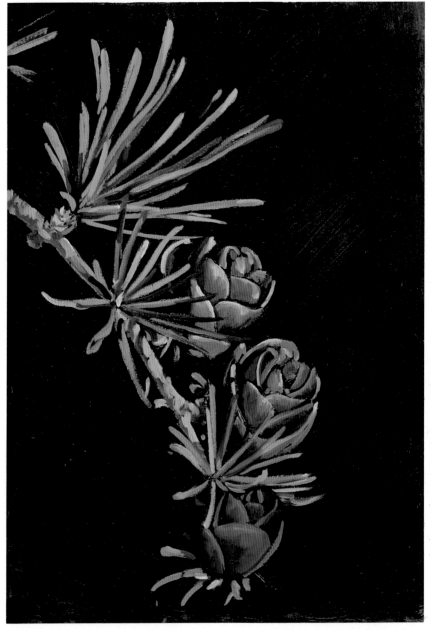

At the end of a larch tree's branch, the cones begin to turn from rose red to golden brown.

☐ Because clear, crisp detail is so important here, work on a small, smooth Masonite panel instead of canvas. Begin by covering the panel with a dark, rich green, using a large bristle brush; then go over the wet paint with a fan brush to remove any obvious brushstrokes. After the panel has dried thoroughly, carefully draw your subject with white charcoal.

Instead of starting with thin washes of color, when you encounter a detailed subject against a dark background, work with opaque color right away. Add a little medium to your pigment to keep it fluid, but not so much that the color is thinned. It's as if you were working with tempera—the color is fluid, but as it's put down, it covers what lies underneath.

Load a small, round brush with plenty of pigment and begin to paint the branch. Moving to the cones, start with the lightest shades, gradually introducing darker hues to sculpt out the

shadows. Then, moisten your brush with really dark pigment and paint each cone's contours.

Before you paint the needles, analyze the slight value differences that separate one needle from another. You'll want to exaggerate these differences to show how the needles move forward and backward in space.

DETAIL
The modeling of the pine cones makes them strongly three-dimensional against the dark green backdrop. Careful brushwork and delicate transitions between light and dark convey their rounded shape. Notice how the dark green of the background shows through in places, becoming the line that clarifies the edges of the cone's petals.

ASSIGNMENT
When winter comes, many a landscape artist retreats to the studio, waiting anxiously for warmer, finer weather to come again. You don't have to wait till spring to work with trees.

In late fall, go out into the woods, or even a public park, and collect branches, acorns, leaves, and pine cones that have fallen from trees. At home, set what you've found up in your studio. Try to create a believable backdrop; weathered boards would be great, or a piece of hopsacking tacked to the wall. Arrange the leaves, then take a strong light and shine it on your still life until you get a pleasing pattern of shadows.

As winter drags on, start to introduce other elements into your still lifes—old lanterns, horseshoes, or even a shovel— anything that suggests the out of doors.

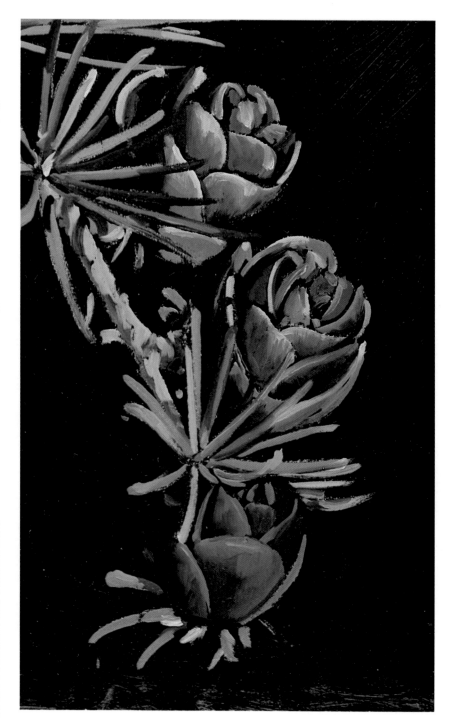

Exaggerating Shifts in Hue and Temperature

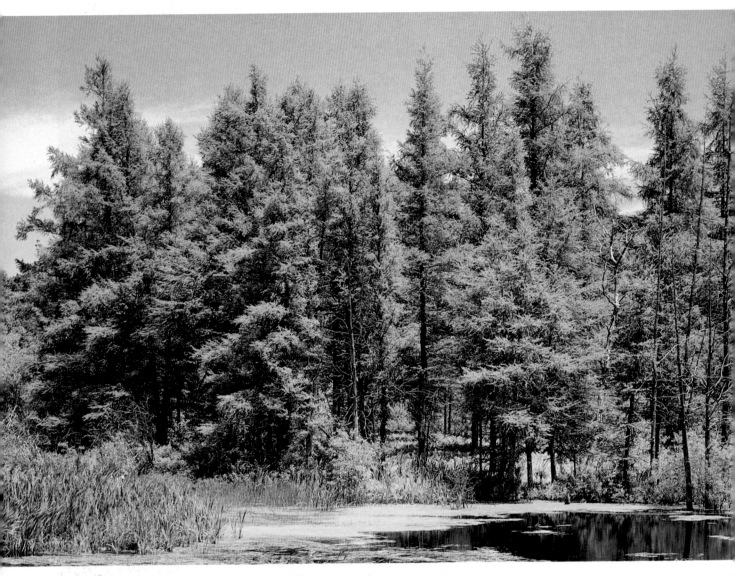

PROBLEM
This scene lacks drama. The trees are almost uniformly green; the sky is an everyday shade of blue; and the algae-covered pond isn't particularly interesting.

SOLUTION
To give your painting punch, play up the small shifts in hue and temperature. Use a variety of greens for the trees; make certain areas of the scene warmer than they really are; and enliven the sky by your choice of blue.

Tall larch trees huddle together beside an algae-covered pond.

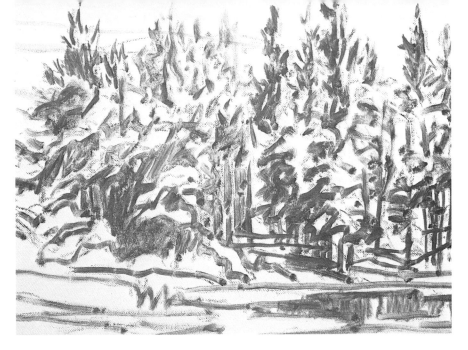

STEP ONE

In your charcoal drawing, concentrate on the shapes of the individual trees; then boldly sketch the horizontals that sweep across the sky and the ground. Now go over your drawing with diluted color. Choose a deep, rich green—the color that dominates the scene—here mixed from viridian and burnt umber.

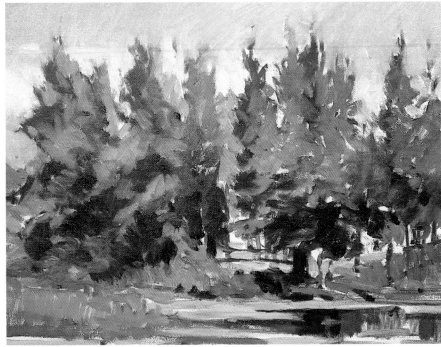

STEP TWO

Working with thin washes, build up the entire surface of your canvas. Use strong, lively strokes to lay in the paint—strokes that suggest the direction each mass of color takes. For the sky, use a warmer blue than the color you see. As you turn to the foreground, separate it from the trees behind by bringing out its bolder color.

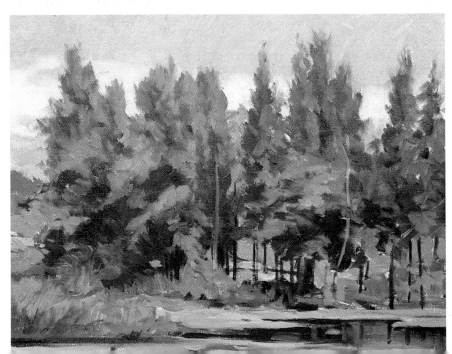

STEP THREE

Continue to exaggerate what you see as you start to use opaque color. Here the bluish-green tone used for the grass in the lower left corner becomes stronger and more arresting as it is overlaid with strokes of an olive green. The algae-covered pond gains in liveliness and interest as more yellowish-green pigment is applied. Finally, turn to the ground right under the trees. If you go for the color you see—which is just about the same color as the trees—it'll be lost in your painting. To distinguish it from the trees, mix a warm yellowish-green hue.

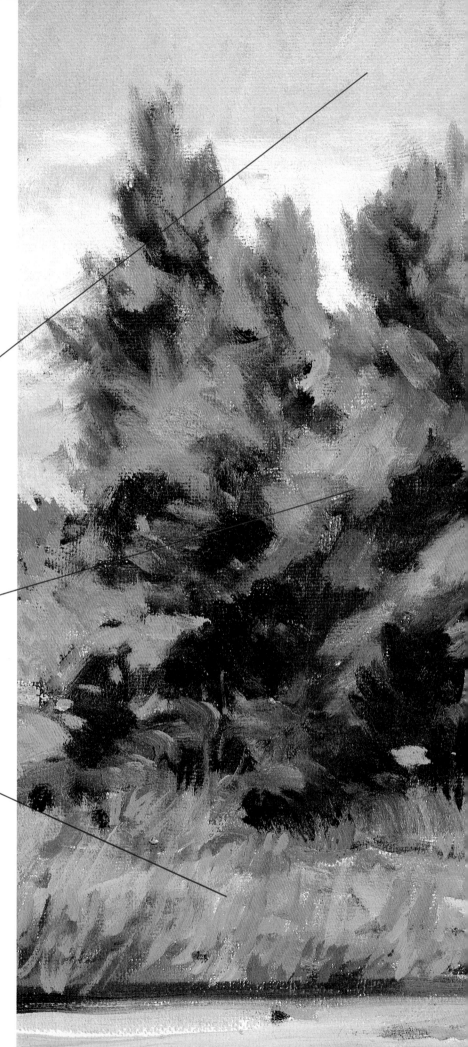

FINISHED PAINTING

Very little remains to be done. Look at your painting and ask yourself: Is there enough contrast between the darks and lights? Do the trees stand clearly apart from the ground and the pond? Is the color of the sky warm enough? Would more detail help or hurt your painting?

Here the tree trunks and branches lacked definition. Working with a very pale shade of brown—a shade much paler than the one that was seen—the branches and trunks were painted with thin, delicate strokes.

A dash of yellow makes the blue here warmer than the actual sky and relates it to the colors in the foreground. This shift in temperature helps establish the overall mood of the painting. Were the blue cooler, the entire scene would seem less vital and dynamic.

Vigorous brushwork helps suggest how the branches of each tree spread out from the trunk. Some strokes move upward, some downward— and they overlap, getting across the feel of the dense foliage.

In the actual subject, the grass is a cool silvery-green shade. By exaggerating its bluish cast, you can make the grass stand out and set up a strong foreground—one that will lead the viewer effortlessly into your painting.

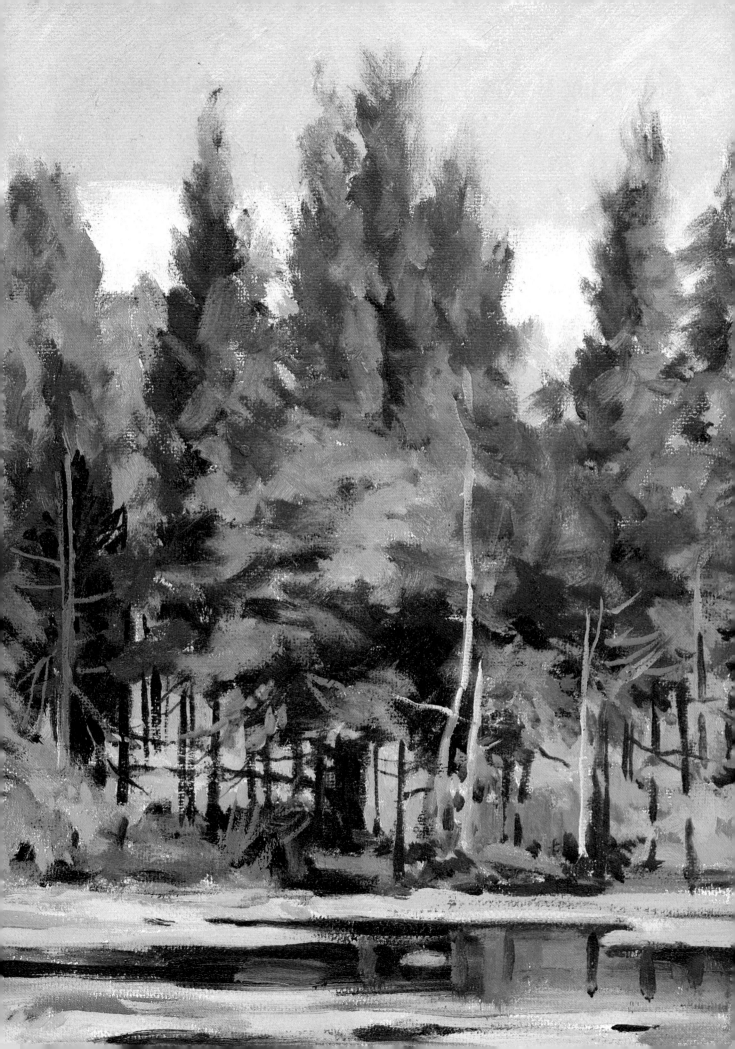

Indicating Broad Vistas and Specifics Simultaneously

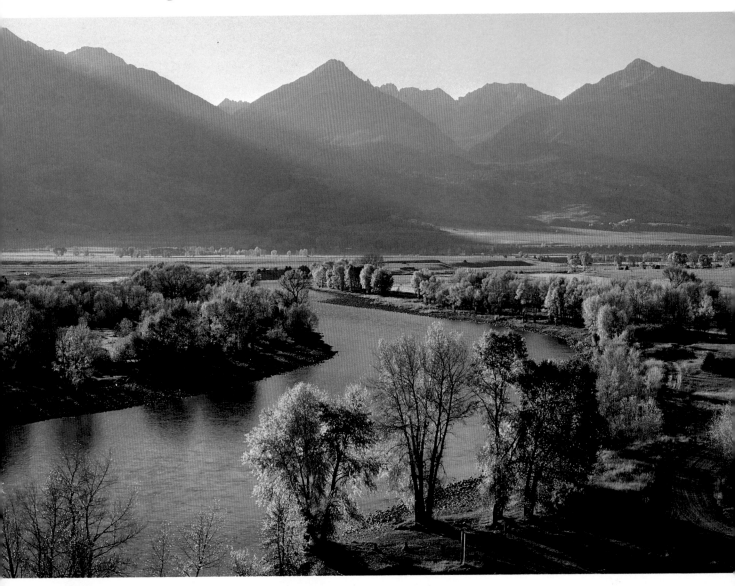

PROBLEM

Broad, sweeping vistas like this one are wonderful subjects. But panoramic views have their own special problems. It can be difficult to convey a clear sense of distance, and it's even harder to balance that distance with the specific references that make the subject unique.

SOLUTION

Use cool colors to push the distant mountains to the back of the picture plane. Warmer hues in the foreground will make the trees spring forward. And try to capture the shapes of the trees accurately; don't get caught up in a predictable pattern.

Golden autumn foliage lines the Yellowstone River in Paradise Valley, Montana.

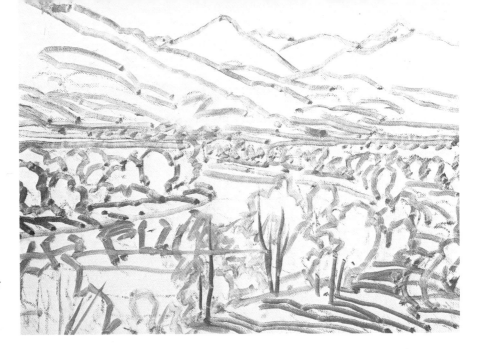

STEP ONE

Indicate the composition on your canvas with vine charcoal, then cover the lines of your drawing with diluted paint. Choose your colors carefully; you want to establish the color theme for each area of the painting at the very start. Blue will set the right note for the hills in the background. Moving forward, in the middle ground, greens gradually give way to browns. The trees in the immediate foreground are rendered in a golden yellow-orange.

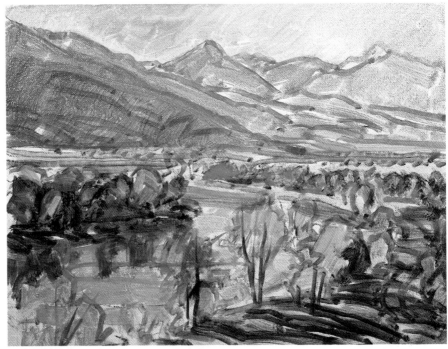

STEP TWO

Now establish the overall effect of light and color as you begin to work with slightly thicker washes. Don't try to define any one area fully; instead, cover the entire canvas with color. As you lay each area in, gauge the effect it has on adjacent areas. The pale blue sky, for example, seems even paler once the darker mountains are laid in. Make any necessary adjustments in color and value before you begin to work with opaque pigment.

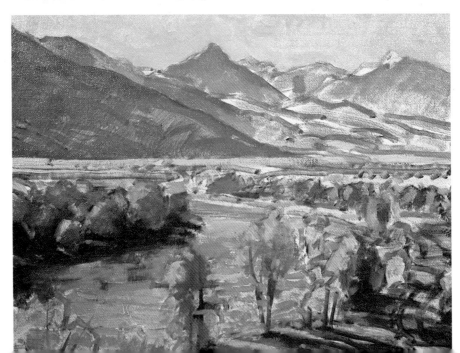

STEP THREE

Working now with opaque pigment, continue to build up the surface of your painting. Start with the distant hills, sharply defining them against the pale blue sky. Don't let the color of the mountains become too dark; remember, the paler the background is, the farther away it will seem. Now turn to the foreground. Refine the shapes of the trees and intensify the blue of the water. Work back and forth between the trees and the water, taking care to indicate the glimpses of water that are visible through the foliage.

FINISHED PAINTING

It's at the very end that all the small details are added. Brush in a sliver of blue in the middle ground to indicate where the river snakes backward. Then paint the dark shadows that play over the tips of the hills. Finally, turn to the trees. With a small sable brush, gently dab paint onto the canvas to suggest clumps of leaves. Strengthen the shadows cast by the trees, then add touches of cerulean blue to the water to intensify its color.

Painted with cool blues, purples, and greens, these mountains convey the sense of a vast, distant space. Note how the ones farthest back are paler and less distinct than those closer to the river.

Keep the middle ground fairly simple. Too much detail or strong, obvious brushstrokes would interfere with the sense of distance you're trying to convey. Detail tends to bring an area forward—and that's not what you want to happen here.

You need to work back and forth between the trees and the water to capture the feel of the foliage. Note the touches of blue that indicate where the water is visible through the branches. Without them, the trees would look heavy and lifeless.

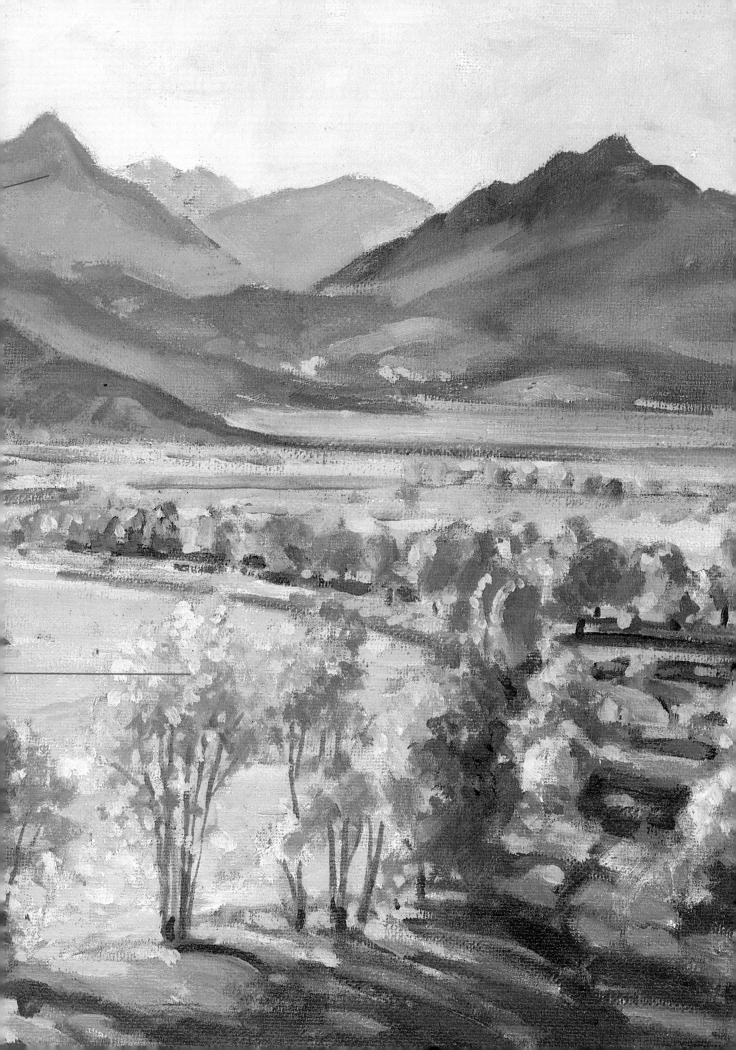

Offsetting Stark, Vertical Tree Trunks

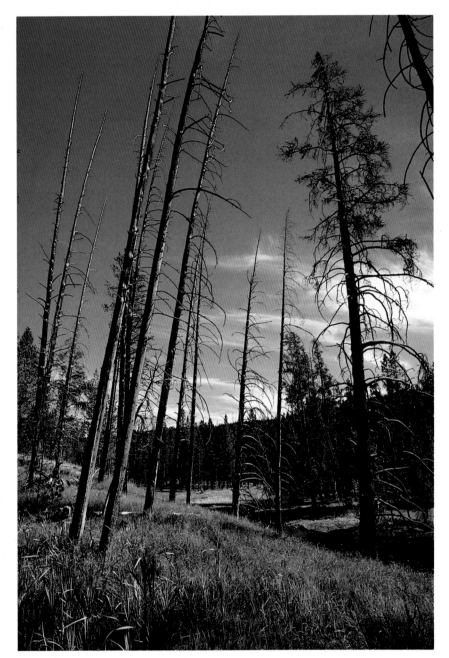

PROBLEM
This composition is dominated by the stark verticals of the tree trunks. In capturing their strong linear quality, you have to be careful that the verticals don't overpower the painting and make it look unbalanced.

SOLUTION
Emphasize all the horizontals in the scene to help balance the composition. Exaggerate the wedge of trees along the horizon and even the clouds that reach across the sky.

STEP ONE
For your preliminary drawing, try a charcoal pencil instead of the softer vine charcoal. Because it's less fragile, it will be easier to make a fairly detailed drawing, including all the thin, vertical lines of the tree trunks. Be sure to note all the horizontal elements of the composition.

On the West Coast, tall, slender lodgepole pines cut into a cloud-streaked sky.

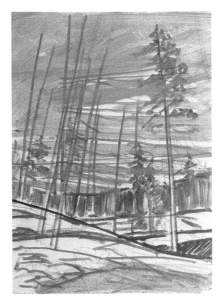

STEP TWO
Working with thinned color, strengthen the overall design of your painting. Concentrate on value, not specific colors, and on the horizontals that stabilize the strongly vertical trees. Use long horizontal strokes to lay in the sky. Next, reinforce the contours of the lodgepole pines. For the trees that run along the horizon, use short, vertical strokes; then flatten the strokes by sharply delineating the horizontal they form against the sky. Finally, establish the planes of the foreground.

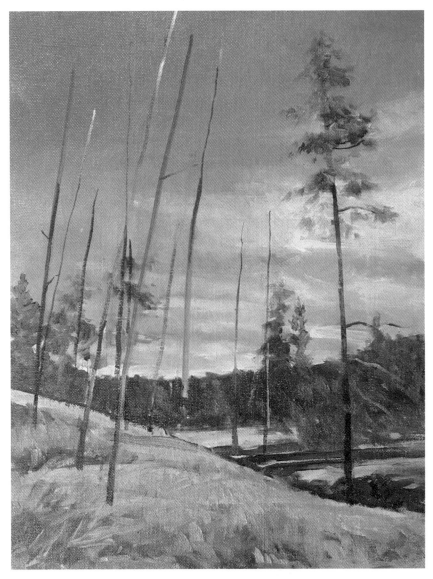

STEP THREE
Now, using heavier color, work from dark to light. Start with the dark line of trees in the background, then turn to the sky. If the dense blues and purple-blues you use to paint the sky cover some of the lodgepole pines, don't worry. Enough of your drawing will show through to guide you as you refine the trunks. Before you turn to the trunks, however, lay in the golden-ocher ground and the shadows that lie across it.

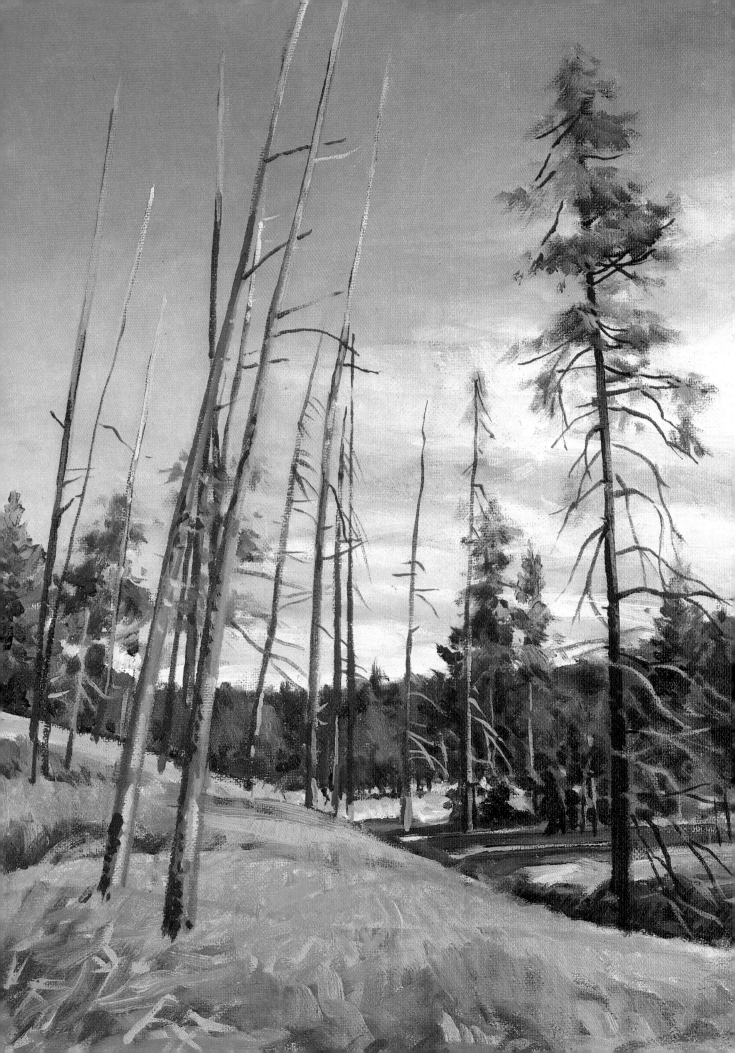

FINISHED PAINTING

In the finished painting, the tall, slender pines stand boldly against the deep purplish-blue sky. Painted at the very end, with fluid, liquid pigment, they glide upward easily. Because of the emphasis placed on the horizontal elements earlier, the strongly vertical tree trunks seem comfortably placed in the rest of the scene.

DETAIL

The rich purplish blue of the sky forms a handsome backdrop for the lodgepole pines. Its color provides a contrast with the bleached tips of the pines, helping them stand out clearly. If you look closely, you can see the smooth blending of the warm sky tones near the top into the cooler hues below, which then lead the eye back into the deep picture space.

DETAIL

In the middle ground, bands of orangish yellow alternate with bands of dark, deep green. These shifts in color not only break up the rolling planes that lie near the front of the picture space; they also lead the eye gradually backward toward the horizon.

Preserving Delicate Trees in Dramatic Surroundings

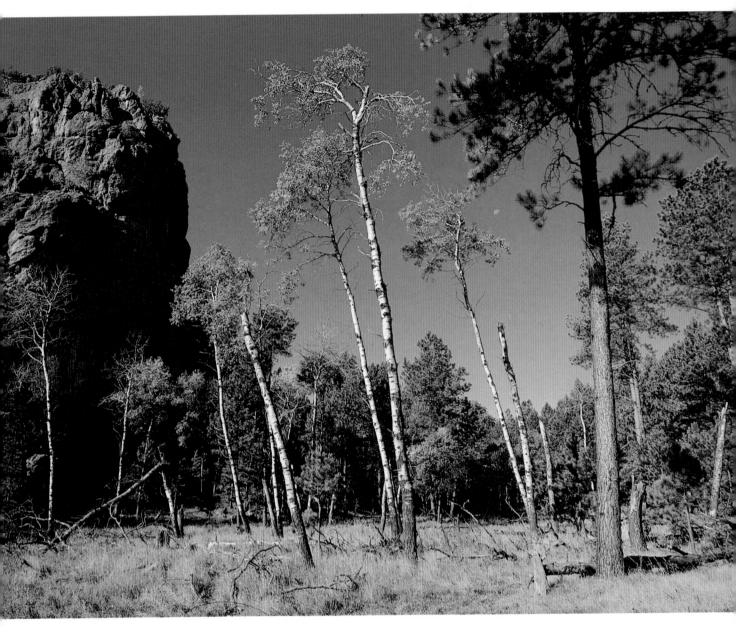

PROBLEM

The threadlike aspens could easily become lost in this dramatic scene. Many elements are competing for attention: the masses of dark foliage in the background, the green-tinged outcropping of rock, even the bright blue sky.

SOLUTION

Minimize the detail in the background and save the aspens for the very end. As you develop the rest of the scene, let the white of the canvas represent the spots where the trees will eventually appear.

☐ Sketch the scene using vine charcoal, with an eye to the major elements—the aspens, the backdrop of foliage, and the tower of rock. Next, reinforce your drawing with diluted permanent green light. Using the same wash of color, begin to lay in the darkest values.

Before you introduce thicker pigment, analyze the overall color scheme. Note the important role that green plays—even the rock is tinged with it. When one color dominates a composition, as it

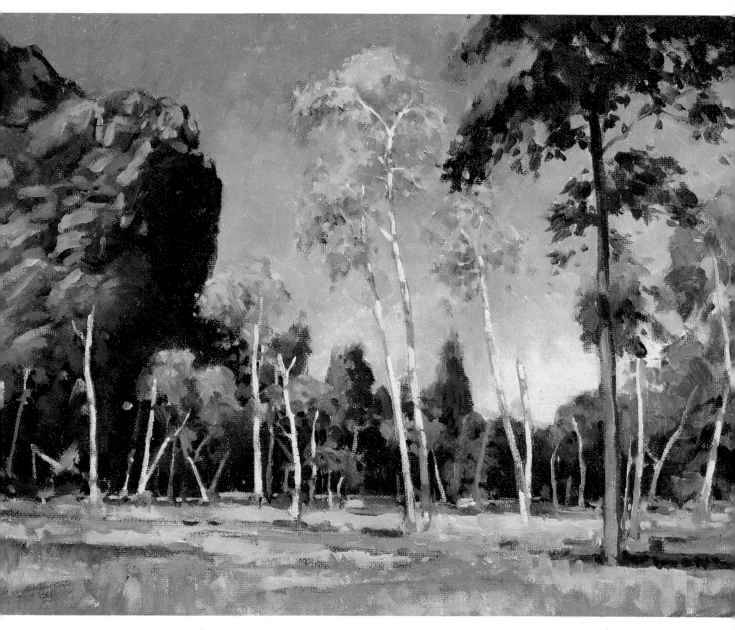

does here, it's vital that you think through your use of color before you start to paint. For your very darkest greens, try mixing Thalo green with alizarin crimson. A combination of permanent green light and cadmium yellow will give you your lighter greens. By adding yellow to this mixture, you can create a rich brownish-green hue for the foreground.

With your colors planned out, start to paint, moving from the sky, to the background trees, and then to the canyon wall. Re-member as you work to leave areas of white to indicate the placement of the aspen trees. Keep the background trees and the canyon wall as simple as possible—if you add too much detail to them, they'll steal attention from the aspens.

Once the dark and medium tones are down, establish the lights that spill across the foreground. Use short, choppy vertical strokes to break up the bands of light green with slightly deeper color. Now paint the as-pens. After you've laid in the white of the trunks, add patches of grayish blue to suggest their shadows. To depict the leaves, take a small sable brush and gently dab bits of light and me-dium-value green onto the can-vas. Finally, paint in the pools of shadow beneath each tree.

Take a few minutes to evaluate what you have done. Make sure you've suggested the scene's depth. Here the diagonal bands of color in the foreground lead the eye back into the painting.

Zooming in on Detail

PROBLEM

It's very difficult to move in this close to a subject, especially when it involves so many slender lines. Although you'll need to keep the overall pattern in focus, you'll also have to concentrate on the three-dimensional aspects to give a sense of space.

SOLUTION

After painting the background with a rich, dark green, sketch the needles with white charcoal. Rely heavily on your drawing as you paint; if you lose bits of it, redraw them immediately with a small brush, using light green paint. To position the needles in space, layer them in three different values of green.

Seen up close, the needles of a white pine form a bold, almost geometric pattern.

☐ Choose a smooth Masonite support, cover it with dark green paint, and then remove any signs of brushwork with a fan brush. After sketching the needles with white charcoal, begin to paint. To capture the crisp needles, select a long-haired brush and add plenty of medium to your pigment.

Decide on three basic values of green. Use the darkest first—for the needles farthest away from you. Introduce a slightly lighter green for the needles in the middle ground and, finally, the lightest green for the closest ones. As you move forward, each successive group of needles will overlay those behind, conveying depth.

After enlivening the needles with touches of color, add the cones. Painted accurately, they will clarify the structure—how the needles cling to the branches and how each branch ends in a cone.

Painting the Portrait of a Tree

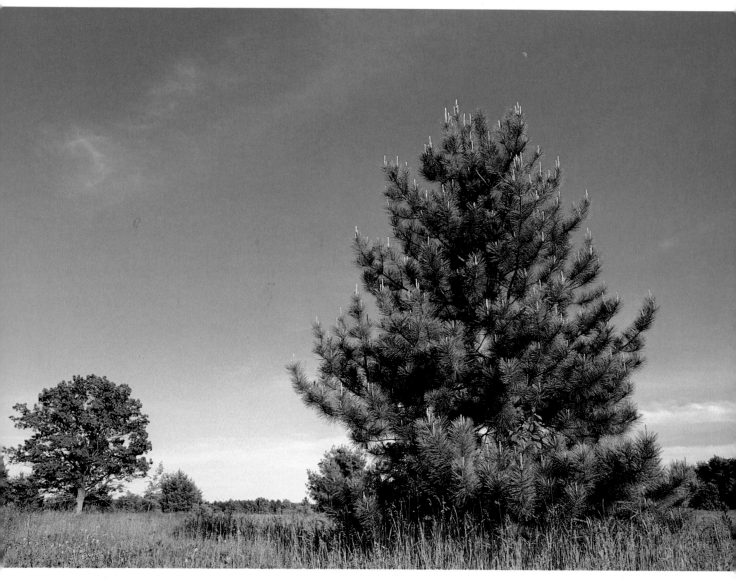

PROBLEM

On the face of it, this scene is like many others. The composition is simple, with vibrant colors and unambiguous lighting. When you start to paint, however, you'll find that it's not easy to capture the individuality of the red pine that dominates the foreground.

SOLUTION

What distinguishes the pine is its fullness and its buoyant, upward lift, accentuated by the white cones. With only two values, you can bring out the tree's shape. Then let your brushwork highlight the direction of the branches.

Candlelike cones on an aromatic red pine seem to glow against a vivid blue sky.

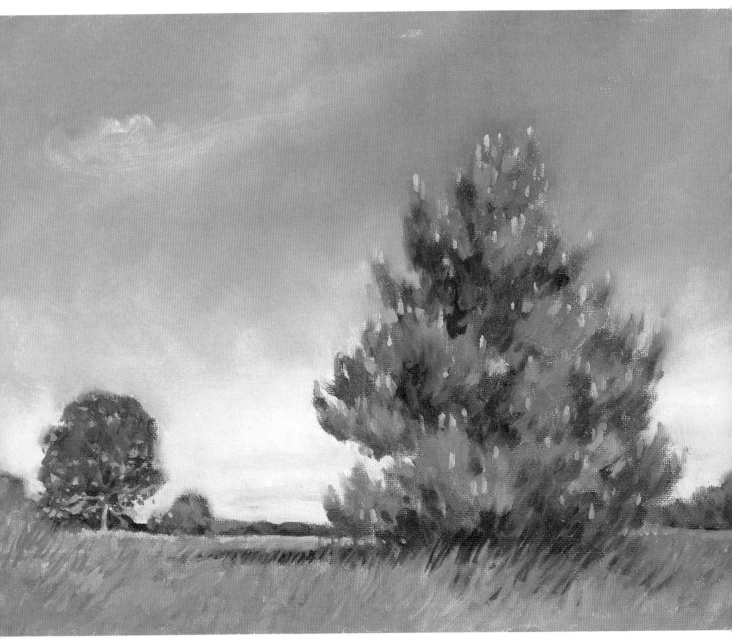

☐ Because the composition is so straightforward, there's no need to reinforce your drawing with thinned color. Instead, use opaque pigment right from the start. First, with a large bristle brush, paint the sky. As you sweep the blue over the canvas, leave bands of white near the horizon to suggest the clouds that gather there. Also blend in a touch of deep blue near the top.

Now turn to the pine in the foreground. First, paint the shadowy green areas; then turn to the middle-value greens. Try mixing the middle tones from viridian and cadmium orange for an interesting olive hue. Let your brushstrokes suggest the way the tree's branches sweep upward.

After you've built up the greens of the pine, lay in the rest of the painting. You'll want to establish a clear sense of depth, so exaggerate the color of the middle ground. Instead of painting it realistically in a middle-value green, use yellow ocher darkened with a touch of green.

At this point, add the trees along the horizon as well as the dark shadow beneath the pine. Then move to the grass in the foreground. As you paint the grass, use thin, upward-sweeping strokes that mimic the way it grows. To break up the plane of greens, introduce touches of yellow ocher and blue.

At the very end, paint the pine cones. Take a small, round brush moistened with yellow ocher and quickly dab the paint onto the tree. Be faithful to what you see: follow the pattern that the cones etch out against the green of the tree and the blue of the sky. Take advantage of their vertical note to accentuate the pine's upward reach.

Intimating the Delicacy of a Blooming Tree

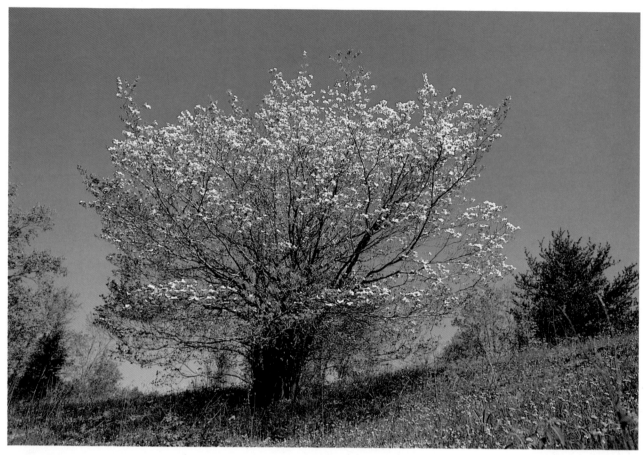

PROBLEM

To capture the spirit of this tree, you have to convey the fragility of the flowers. Since they are massed together, they could easily look heavy.

SOLUTION

Aim for the general effect created by the tree and flowers, rather than concentrating on specific details. Work impressionistically, with gentle, fluid strokes. Throughout, keep all your edges soft and unfocused.

☐ Use your charcoal drawing to place the tree and the horizon line, then go over the lines of your drawing with thinned blue paint. Now brush in the sky with opaque color, working around the tree. Let the white of the canvas represent the tree as you work out the rest of the composition. Keep your brushwork sketchy. Remember that everything—the sky, ground, and trees in the background—must remain soft and unfocused or the flowering dogwood won't dominate in the finished painting.

With a small, round brush, lay in the major branches of the dogwood and its trunk. Use long, fluid strokes for both the trunk

and branches; if they become too heavy, you'll lose the tree's delicate feel. Once you've established this framework, turn to the blossoms. Take a small bristle brush, load it with white paint, then scrub the paint onto the canvas, carefully following the major shapes that the white flowers form. Look for masses of white, not individual blossoms, and don't be afraid to really scrub the paint onto the surface.

Now add detail to the basic white shapes. With a small brush, gently dab white pigment over the areas you have scrubbed with color, then add touches of white tempered with yellow. Introduce strokes of pale olive green to

The spreading branches of a flowering dogwood are fluffed with elegant white blossoms.

151

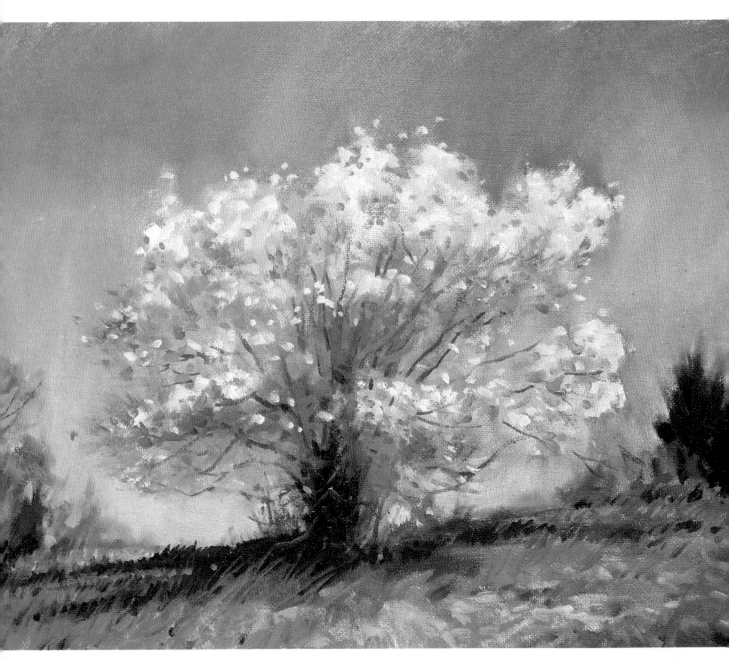

suggest the leaves, and bits of blue to break up the white masses, revealing the sky through the branches. Don't overwork the tree; stop painting it as soon as you are pleased with what you've accomplished.

As you evaluate your composition, look for what will make the painting work. Here bold brushwork was added to make the foreground spring to life. More than that, the strokes direct the eye toward the center of attention—the dogwood. Note also how the shadows under the tree give the work a definite focus.

ASSIGNMENT

Whites often enter into paintings of trees, whether in the blossoms of springtime, the clouds decorating the sky, or the cold snow of winter. If, however, you rely on the pure white from your tube, it may be too brilliant for the other colors in your painting. Tempering the tube white with another color can help you balance the lightest areas.

To discover just a few of the many possibilities, take a tube of white and lay dabs of paint down on one side of your palette. A few inches across from each dab of white, set down a variety of yellowish hues—everything from your yellow ocher to your cadmium orange. Slowly drag the white paint toward the yellow, then pull the yellow across the white. Done carefully, this exercise will show you a gamut of subtle colors. Now repeat it, using your blues.

DETAIL

The blossoms that adorn this tree might easily be too thickly painted. When you are working with soft, ephemeral elements like these flowers, try scrubbing your paint onto the surface. Once your basic patterns are down, you can go back and add as much detail as seems necessary.

DETAIL

Painted with quick, staccato strokes, the foreground adds a powerful note to what could become too soft and lyrical a painting. Notice how the lines of the brushstrokes converge toward the center, leading the viewer's eye directly to the dogwood tree.

Expressing the Luminosity of Fog

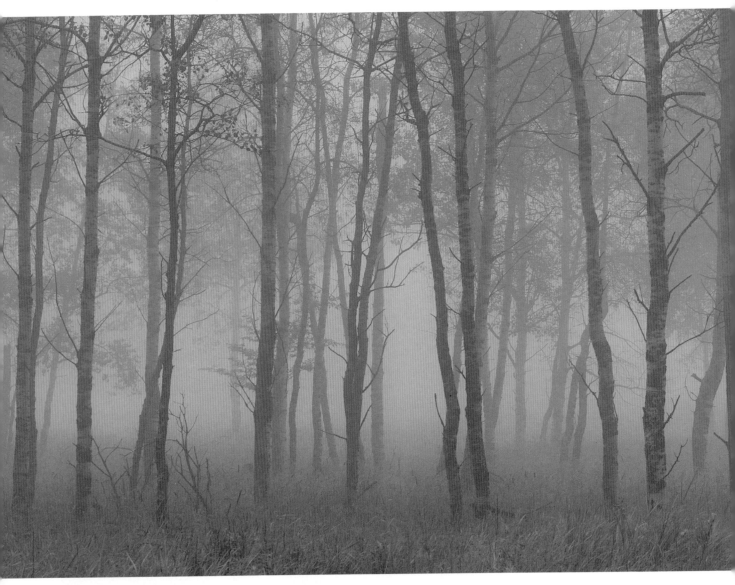

PROBLEM

As we've seen, when fog or mist moves in across a scene, the range of value and color is narrowed. Working within these limitations, you have to discover how the light wends its way through the fog.

SOLUTION

Set the mood of your painting by staining the canvas with an overall wash of warm ocher. To build up the surface, work with thin washes, or scumble layers of thinned paint over one another. The point is to keep the color nearly transparent; you don't want to spoil the mood by introducing heavy passages of pigment.

The stark, thin trunks of aspens create a soft, haunting pattern in the thick blue mist.

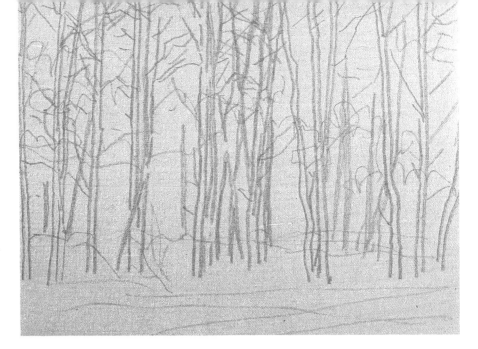

STEP ONE

The first step is to stain the canvas with a warm ocher color. Mix your pigment with a fair amount of turpentine, then apply the wash to the canvas with a rag. If you really soak the rag in diluted paint and then scrub the canvas with it, you'll create an even, undifferentiated flood of color. The effect is a lot different from the look you get by covering the surface with a moistened brush. More than that, the color will dry quickly. When it does, sketch the trees with a charcoal pencil.

STEP TWO

The charcoal pencil that you used in step one gives you freedom as you begin to develop your painting. Charcoal pencil isn't as fragile as vine charcoal; it clings to the surface longer, allowing you to lay in color without worrying about your drawing. Using thin washes of color, establish the patterns that the trees form and the blurred, misty effect that the fog creates in the sky and on the ground. To keep the shapes soft, work wet into wet with loose, fluid strokes.

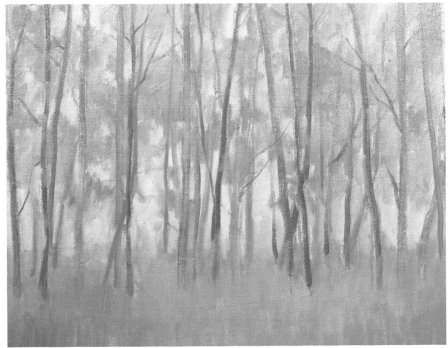

STEP THREE

To develop your forms, you'll want to use opaque color. But don't be tempted to lay it on thickly, or you'll lose the delicacy you're striving for. Thin your paint with just a little turpentine, then scumble the color onto the canvas. Take a bristle brush and dip it into the diluted color, then squeeze the brush until it is almost dry. Now begin to refine the shapes of the trees and branches. The drybrush technique will protect you from laying on your color too thickly and from losing the soft, unfocused effect you've set up.

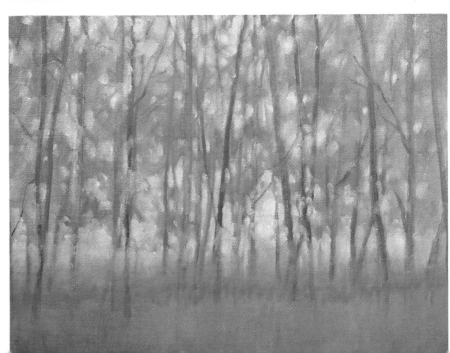

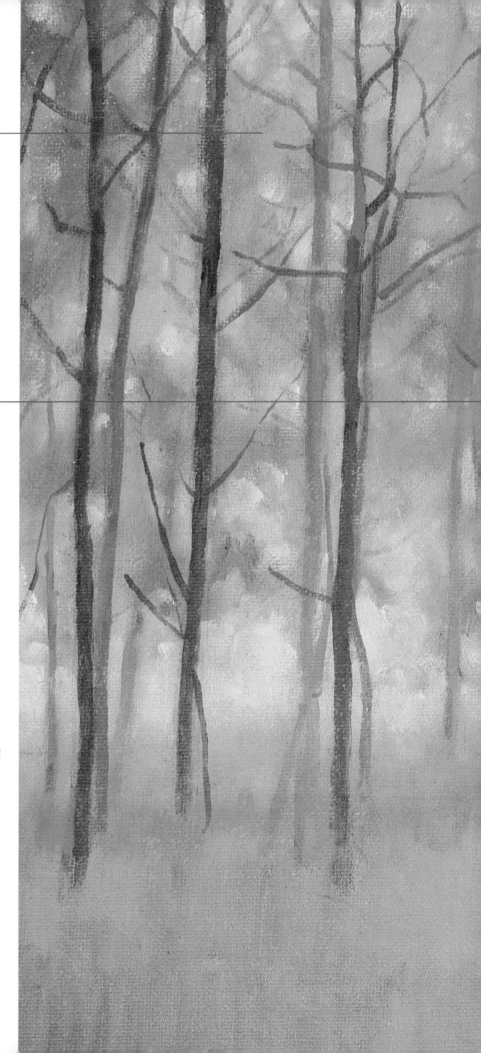

The warm ocher wash that was applied at the very beginning sets up a luminous quality that pervades the entire scene. The ocher shines through subsequent applications of transparent color and is never masked by thick pigment.

To define the shapes of the trees, thinned color is scumbled over the surface of the canvas. The paint is applied with a nearly dry brush, one that has been squeezed until very little paint remains on it. The broken strokes that result let patches of the warm ocher underpainting shine through.

FINISHED PAINTING

When you move in to complete your painting, pay attention to value. So far you've concentrated on laying in soft, unstudied layers of color; now it's time to sharpen up what you've done. Establishing a definite sense of progression into space isn't easy when you are working with hazy color. You'll probably find that you need to sharpen the trees closest to you to make them spring into focus. Don't abandon your original plan of attack, however; stay with thinned color as you rework what you've done. You want to deepen the value of the trees in the foreground without letting intense color disrupt the mysterious, quiet mood of your painting.

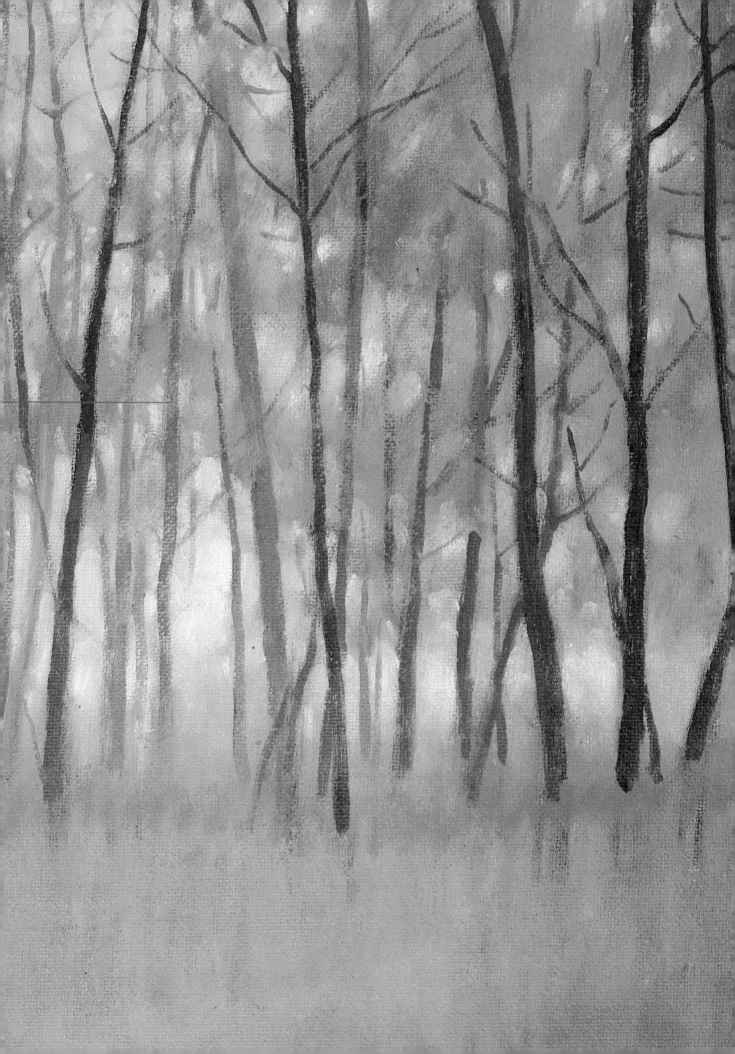

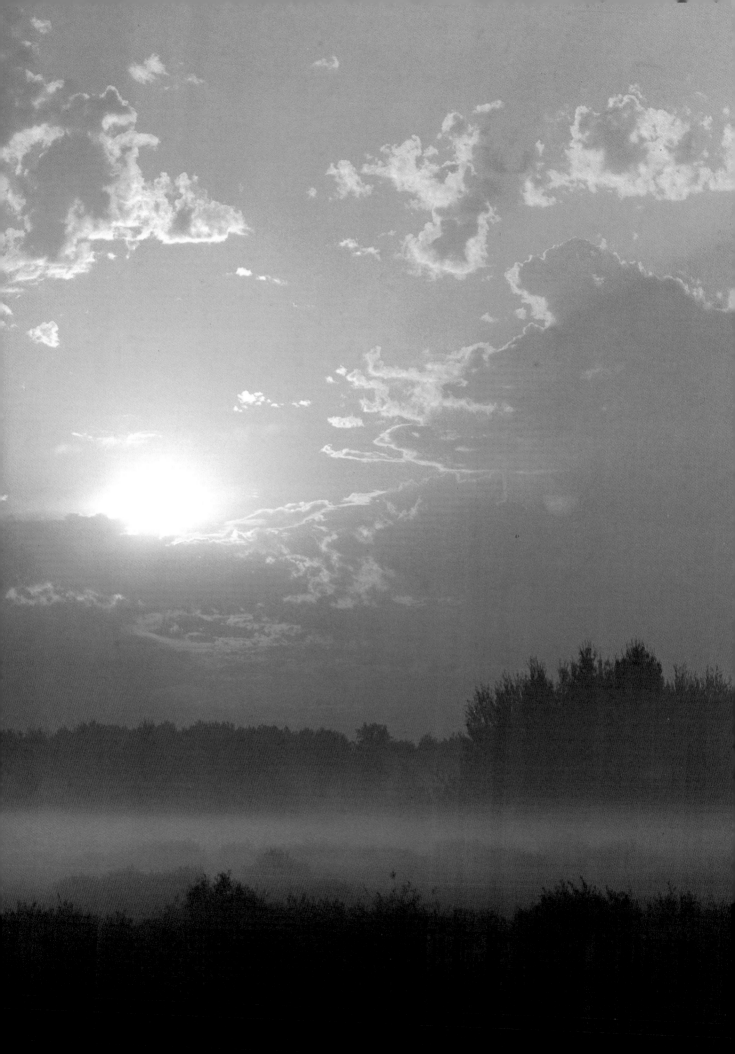

SKIES

Choosing a Center of Interest

PROBLEM

This composition is almost perfect; the foreground is visually interesting and forcefully directs the eye backward. But you can't let the foreground overpower the distant tree and clouds.

SOLUTION

Decide what to concentrate on right away; emphasize either the foreground or the tree and sky. If you make all three elements equally strong, your painting will lack power.

☐ Sketch the scene with charcoal, then reinforce the lines of your drawing with thinned color. Next, brush in the dark undersides of the clouds and the patterns that make up the foreground. Treat the tree as a simple silhouette, and let the white of the canvas represent the lights.

Now paint in the blues of the sky with thin washes of color. Start at the top of the canvas with cobalt blue and a touch of alizarin crimson; then, as you approach the horizon, gradually shift to cerulean blue mixed with thalo green. Next add the middle values to the clouds. Now build up the patterns formed by the grass in the foreground.

Working with opaque pigment, repaint the sky. Use a wet-in-wet approach to capture the soft edges of the wind-swept clouds. When you are satisfied with the sky, turn to the tree. Repaint it with thicker paint, then add small touches of blue to depict the breaks in the foliage that allow the sky to show through.

Now comes the step that matters most—painting the foreground. You've already established a powerful sky; to keep it powerful, you'll have to control how you deal with the grass. Lay in thinned yellow ocher overall, then begin to add detail to the immediate foreground. First lay in the grayish rocks, then the grasses that obscure them. Use a small, round brush and let your strokes suggest individual blades of grass. Temper the strength of the yellow ocher with touches of your browns and even greens, and keep your strokes fairly fluid.

In the finished painting, what matters most is the sky. The lines of the composition all sweep toward it, and it is painted with enough vigor to capture the immediate attention of the viewer.

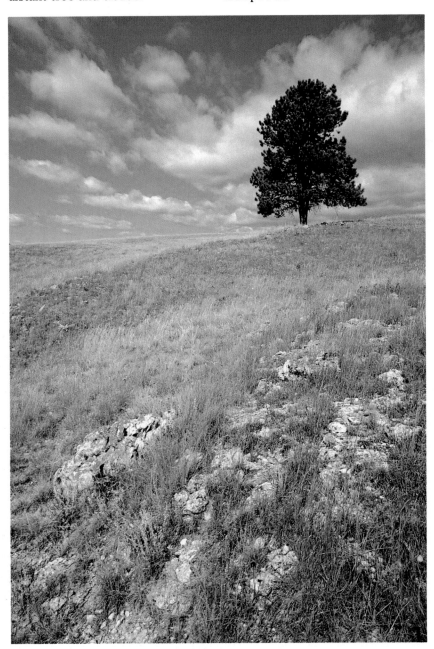

In early autumn, a lone ponderosa pine stands against a cloud-streaked sky.

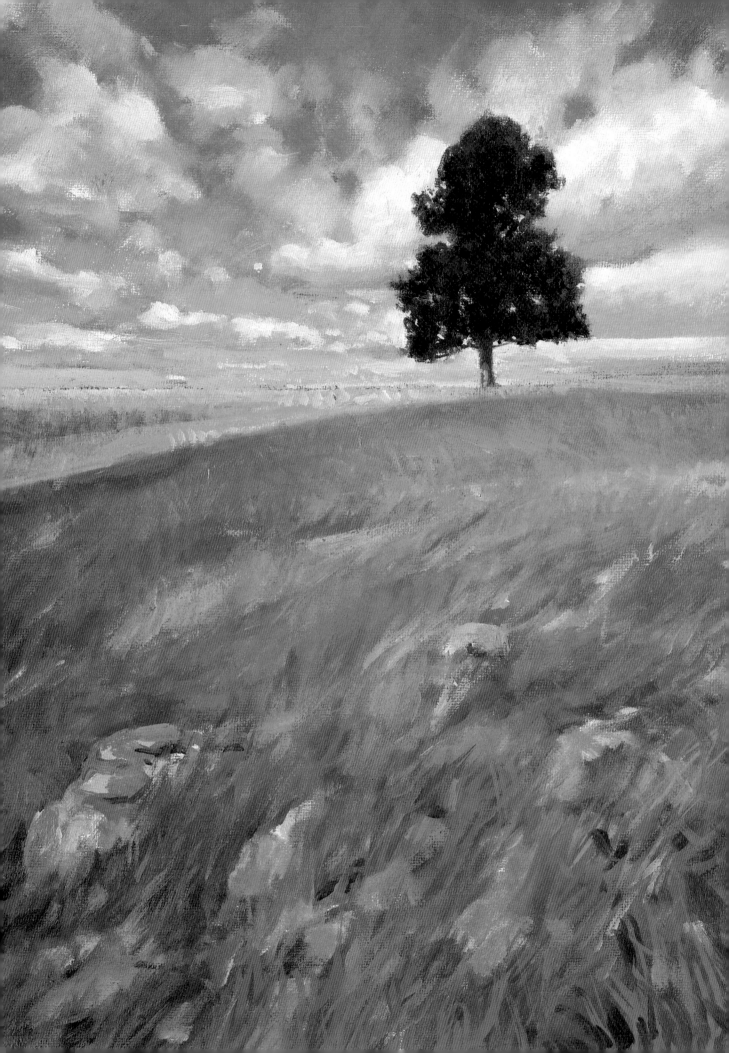

Depicting the Brooding Quality of a Coming Storm

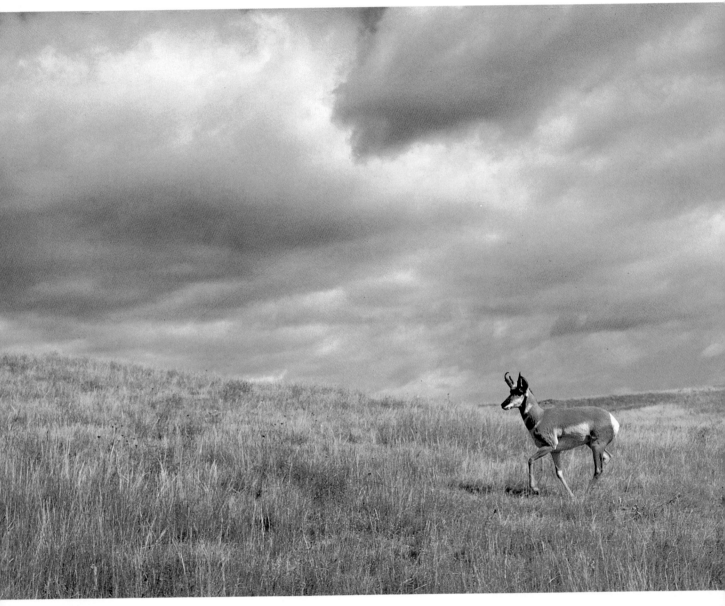

PROBLEM

Even though the animal in the foreground does a lot to establish the scale and mood of this scene, it isn't really the main subject. If you concentrate too heavily on it, you'll lose the power of the dark, threatening sky.

SOLUTION

Until the final stages of the painting, forget about the pronghorn and concentrate instead on the tension between the cloudy sky and the golden prairie. Once the sky and prairie have been established, turn to the animal.

☐ In your drawing loosely establish the motion of the clouds and sketch the pronghorn carefully.

Now brush in the entire canvas with thinned color. Lay in the clouds with washes of gray, raw umber, and cobalt blue. Render the patch of blue sky near the horizon with cerulean blue and use a simple wash of yellow ocher and permanent green light for the prairie.

Now switch to opaque pigment and begin to paint the sky. To capture the soft feel of the

In late October, a pronghorn antelope pauses briefly on a prairie, just before the wind becomes mixed with rain and snow.

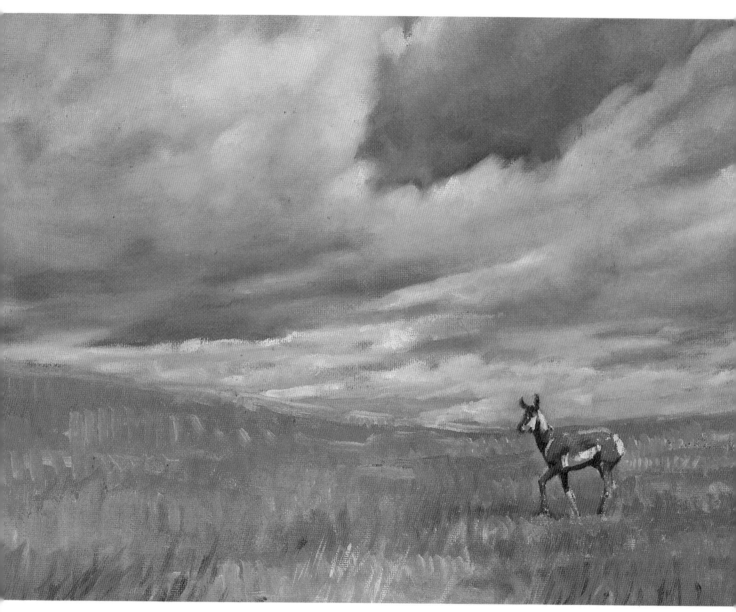

clouds, work wet-in-wet. Here dabs of cadmium red and yellow ocher both warm the clouds and make them more interesting.

Lay in the sliver of bright blue sky near the horizon with cerulean blue mixed with thalo green, then turn to the foreground. To render the grasses, take a small bristle brush and lay down many short, vertical strokes of yellow ocher and cadmium orange. Don't let them become too brilliant; tone them down with touches of burnt umber and per-

manent green light.

Now the scene is set for the antelope. Working with a small sable brush, begin to paint it, searching for the large, simple shapes that make up the anatomy of the animal.

Adding the pronghorn affects the texture of the grass. Some of the short, choppy strokes you used to depict the grass will probably have to be smoothed out in order to make the pronghorn stand out clearly against the field of gold.

ASSIGNMENT
A scene like this one, with an animal paused for a brief second, could only be painted from a photograph. Photographs can not only freeze animals for you, they can also capture the changing conditions of the sky.

Get into the habit of carrying a camera with you when you go outdoors to paint. Back home, keep a file of your photographs and refer to them when you want a particular kind of sky to establish the mood of a painting.

Handling Two Different Atmospheric Effects

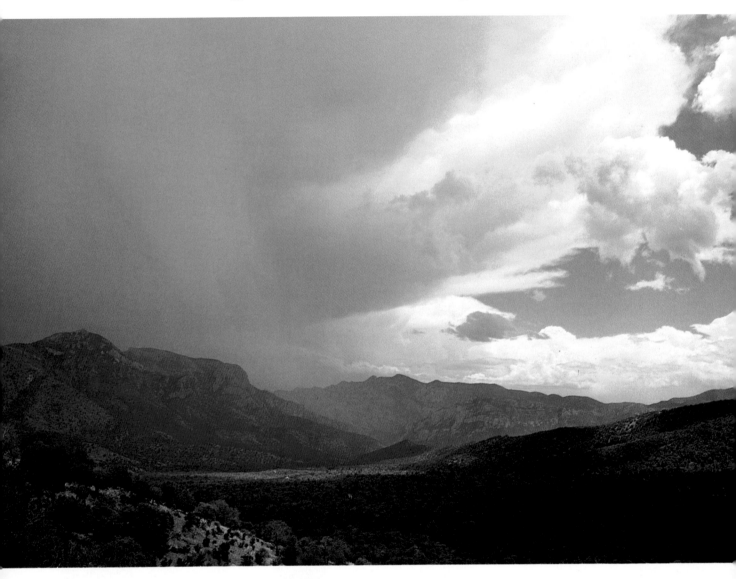

PROBLEM
Two distinct weather conditions appear in this scene—sunshine in the distance and a rainstorm in the foreground. Both must be captured simultaneously.

SOLUTION
Use different techniques to paint each of the two areas. In the foreground, work wet-in-wet to show how the rain softens edges. Paint the sun-filled mountains in the distance using shorter strokes.

In Arizona, sunshine brightens part of the sky while rain sweeps across the mountains.

STEP ONE

With soft vine charcoal, sketch the composition, then blow gently on the canvas to remove any loose charcoal dust. Now redraw the main shapes with thinned pigment. Work with the colors that dominate each area of the painting. Here the hills in the foreground are brushed in with green, while the distant mountains and the sky are painted with purples and blues.

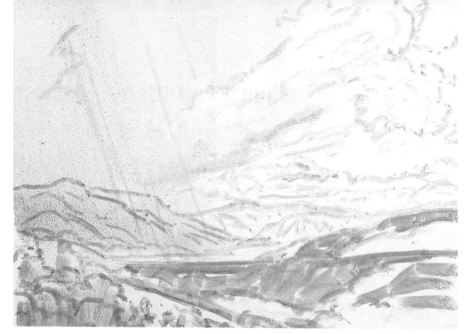

STEP TWO

With thinned pigment, establish the darkest areas of the painting. Once they're done, begin to work with thicker opaque pigment. First lay in the darkest areas— the dark green hills and purplish-brown mountains; then turn to the blue-gray mountains and the sky. While the paint is wet, pull the blue of the sky down over the purplish mountains to suggest how the rain comes sweeping over them.

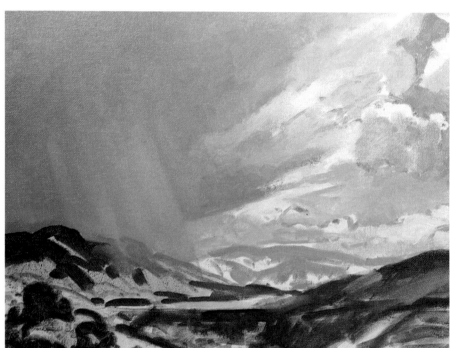

STEP THREE

In step two, you concentrated on the distant landscape. Now develop the foreground to keep the painting progressing evenly. Fill in the green hills that roll across the foreground and paint the sand-colored hills on the left. Then continue to build up the structure of the mountains. As you paint the purple mountains, be careful not to obscure the rainy effect you created earlier.

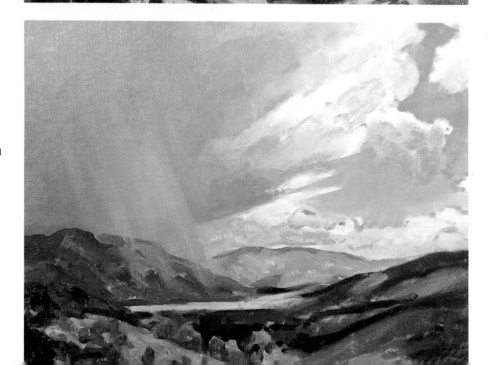

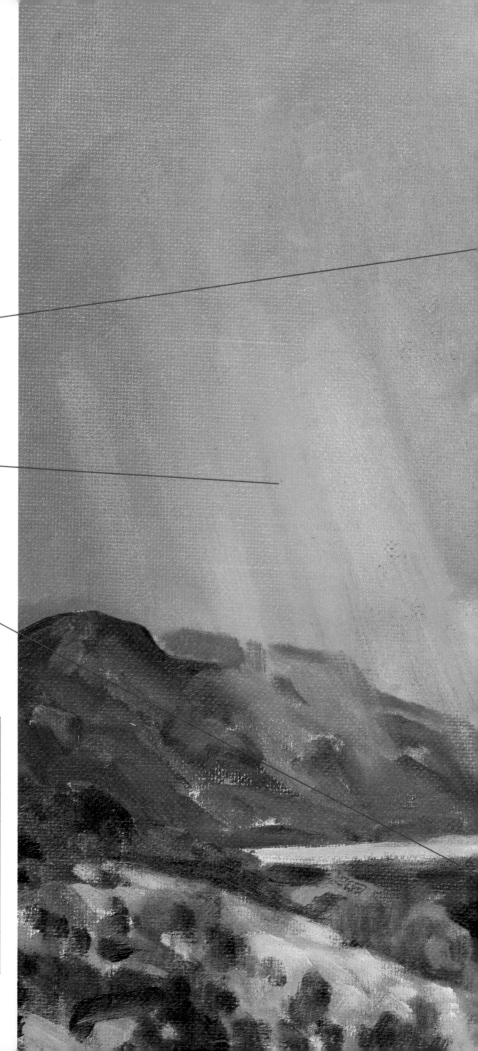

FINISHED PAINTING

To build up the clouds in the distance, take a small bristle brush and load it with white, then dab it against the canvas. The clouds that hover over the horizon are almost pure white; those close to the stormy grayish-blue sky are tinged with gray and yellow ocher. As a final step, look for any areas that still seem undeveloped. Here the immediate foreground was further built up with touches of bright green.

The bright white clouds that lie behind the dark storm front fit into the picture easily because they contain touches of the grayish tone that dominates the sky. A small amount of yellow ocher further tempers their brilliance.

Strong vertical strokes suggest the power of the rain that beats against the mountainside. When you want to create this effect, don't be afraid to use powerful brushstrokes; they are the key to mastering this technique.

To keep it from drawing attention away from the rest of the painting, the immediate foreground is rendered with loose, almost abstract strokes.

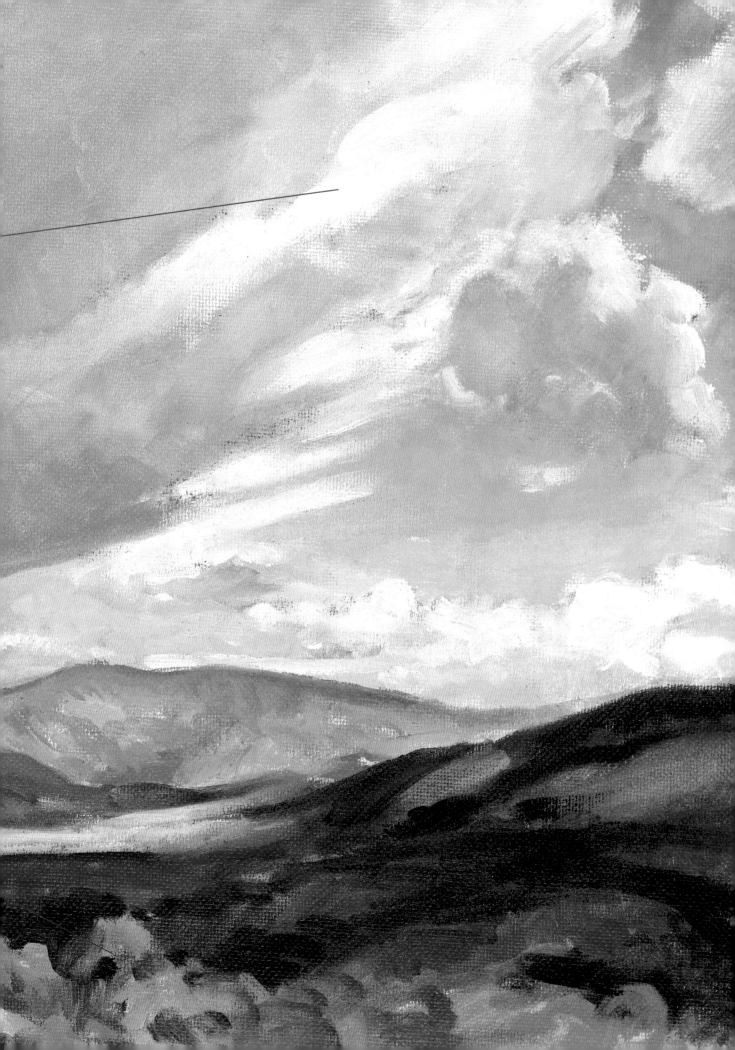

Working with Strong Lights and Darks

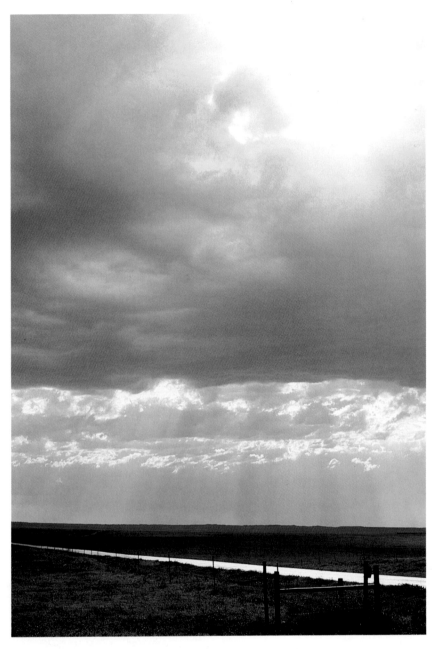

PROBLEM

The strength of this scene lies in the contrast between the dark, shadowy rain clouds and the rays of sunlight that break through them. Capturing these two very different atmospheric effects in one painting is very difficult.

SOLUTION

Play up the contrast between the darks and lights. If the darks are strong enough, they will increase the brilliance of the lights. In the final stages of the painting, infuse the scene with a warm, rosy tone to suggest the feel of sunlight after a storm.

STEP ONE

In your drawing, concentrate on the complicated patterns that the clouds form. Use loose gestures to capture how the clouds move about in the sky. Next, reinforce your drawing with thinned color, let the canvas dry, then lay in the dark areas of the sky and the foreground with a dull bluish-gray wash.

As storm clouds roll away, shafts of light break through and bathe the ground with soft color.

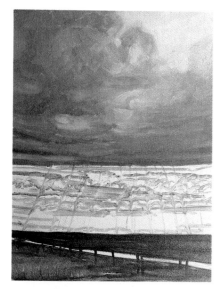

STEP TWO

For the time being, ignore the sun-filled portions of the sky. Instead, concentrate on the dark clouds and the foreground as you begin to work with thicker pigment. Use a big brush and a loose touch as you search for the shapes that the clouds form. Don't get too tight and controlled now; you can add as much detail as you want later on.

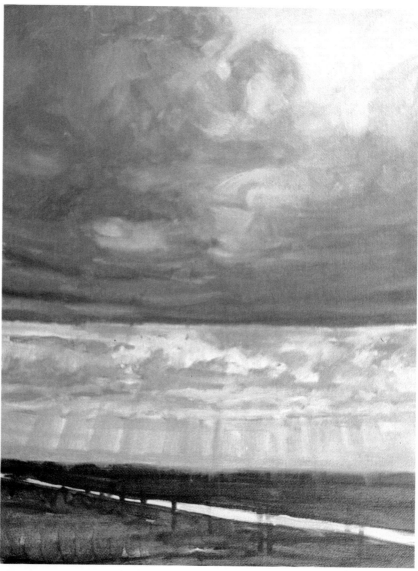

STEP THREE

Barely moisten your largest brush with dark bluish-gray paint, then scrub the color into the darkest areas of the cloud formation. Once the dark areas are clearly defined, add a little warmth to the blue-gray areas by gently scrubbing rose-purple pigment into them; be sure to scrub the dark and light edges together. Now turn to the sunny portion of the sky. With a small brush, lay in strokes of blue, leaving white areas for the clouds; near the horizon, add a strip of pale rose. While the paint is still wet, brush through the pigment to suggest the rays of light.

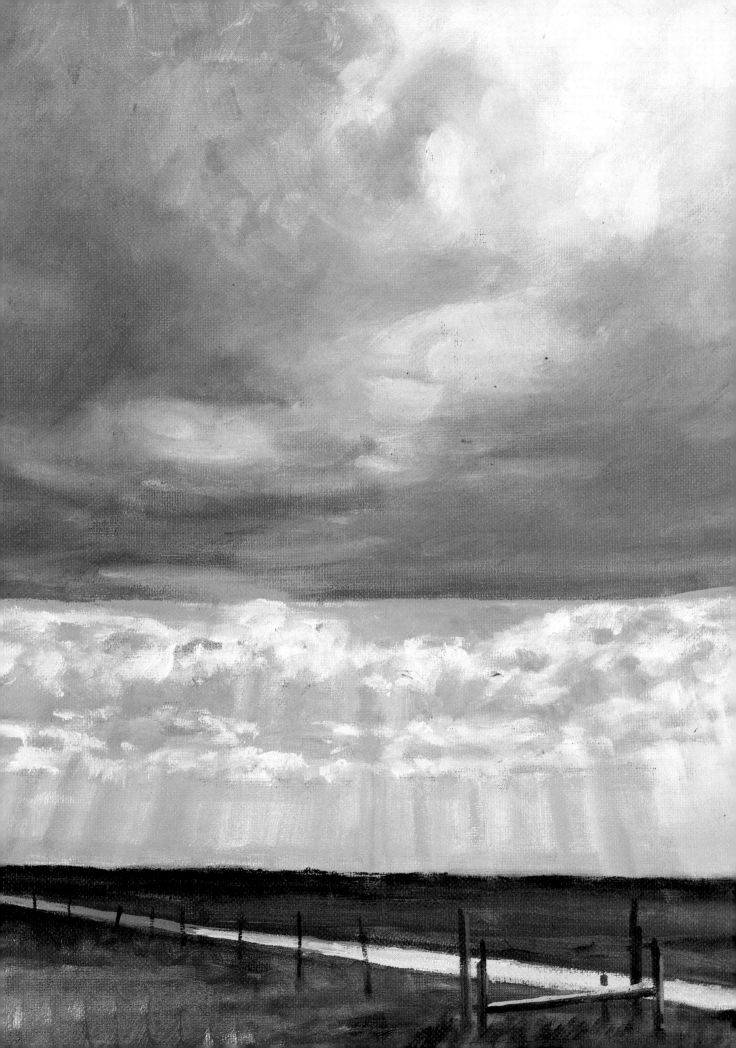

FINISHED PAINTING

Until the very end, the white of the canvas has represented the lightest, brightest areas of the painting. Now develop them. To paint the upper-right corner of the sky, mix together white and yellow ocher, then gently work it onto the canvas. Use the same mixture to lay in the small clouds near the horizon and the small stream that runs behind the fence. Finally, pull dark paint along the horizon line and add the fence posts and details in the foreground.

DETAIL

To capture the effect of light rays breaking through clouds, pull a dry brush through your wet paint. The light, white clouds are added later.

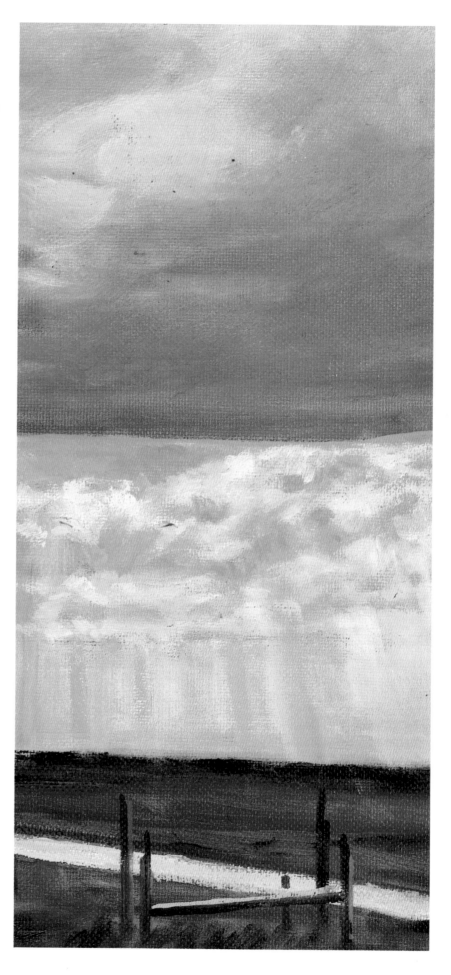

Mastering Unusual Light Effects

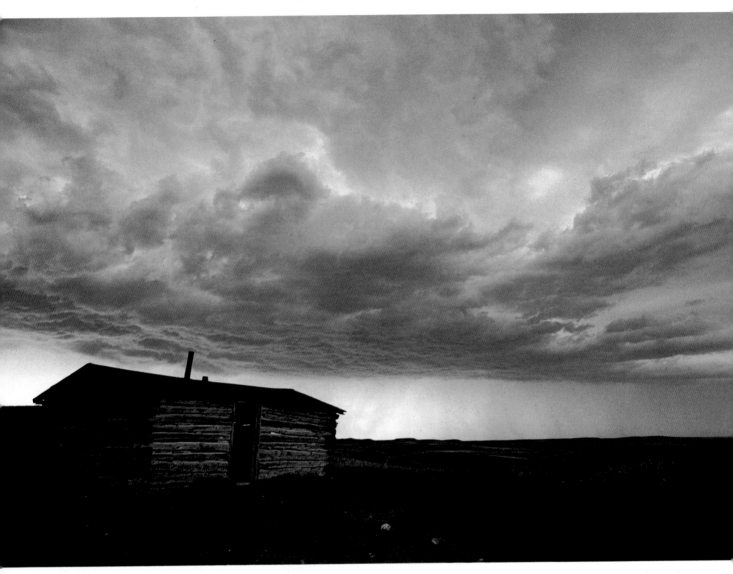

PROBLEM
The eerie light that washes over the ground is highly unusual; it stands in sharp contrast to the heavy storm clouds overhead. If something looks unlikely in nature, it will be doubly difficult to capture in paint.

SOLUTION
Pull the foreground and storm clouds together through the use of related colors. The yellow band of sky that runs between them will seem more likely if the rest of the picture is unified.

A lone cabin crouches against a prairie as dark, brooding storm clouds press toward the ground.

STEP ONE

Sketch the scene with vine charcoal, blow away any surplus charcoal dust, then fix your drawing with a spray preservative. Next, tone the ground and the cloud with a wash of light bluish gray to set the color mood of your painting. While the wash is still wet, pick out the light areas with a dry brush.

STEP TWO

Redraw the cabin and the patterns that lie in the foreground with a thin wash of burnt umber. Next, lay in the darks of the foreground and cabin with a slightly darker wash of burnt umber. Now turn to the sky. Using washes of cobalt blue and burnt umber, develop the dark undersides of the clouds.

STEP THREE

Since the soft, heavy feel of the clouds is so important in this scene, you don't want to overwork the sky. As you begin to repaint the clouds with opaque pigment, try to get the exact colors and values that you want in your finished painting. Use loose, fluid strokes that follow the thrust of the clouds. Use loose strokes, too, as you complete the foreground. Finally, tinge the sky that lies along the horizon with pale grayish blue.

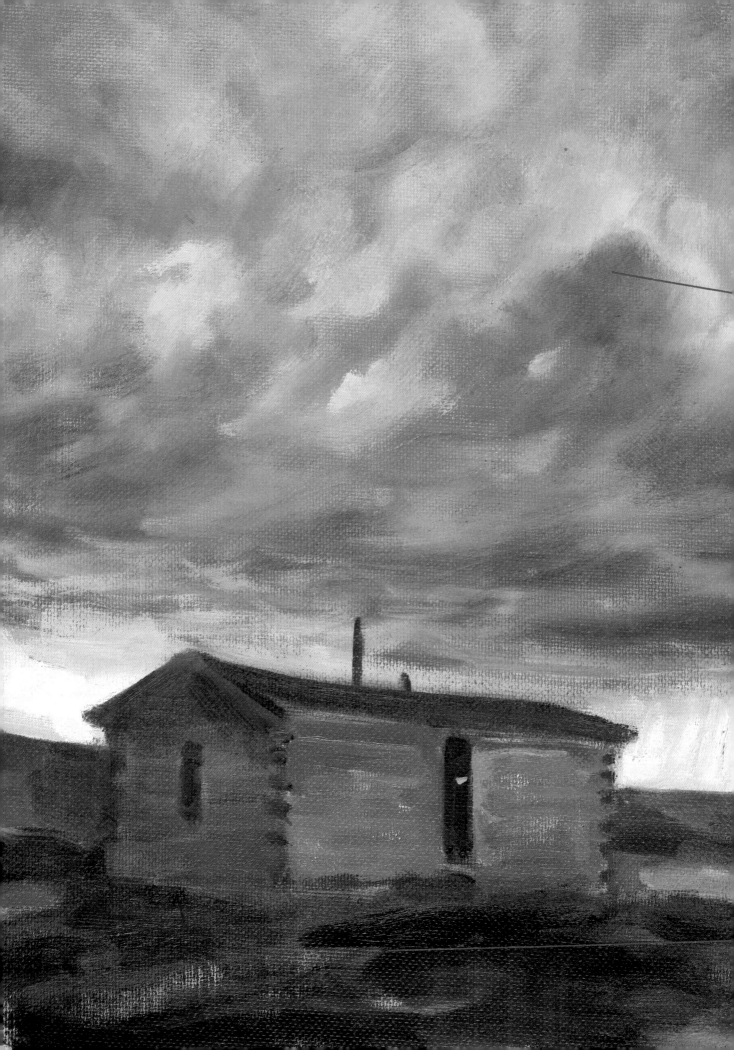

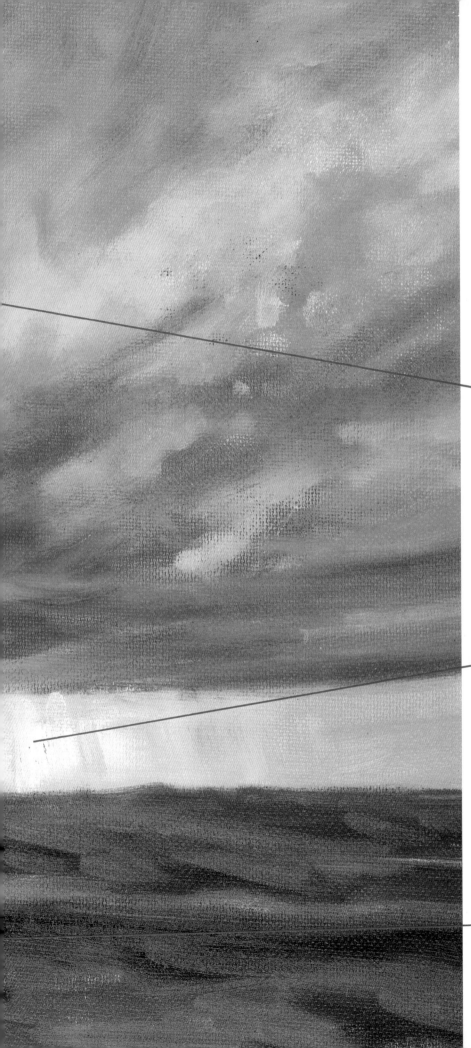

FINISHED PAINTING

Now that the darks are finished, you can easily gauge how strong the lights should be. Add a touch of yellow ocher to your white and gently paint in the remaining band of sky. Short, vertical strokes in the center of the composition get across the feel of the rays that break through the clouds and flood the ground with light.

Painted with loose strokes, the clouds have a soft, wet look—perfect for depicting a stormy sky. Note how overlapping applications of pale gray and dark gray tones are pulled together to avoid harsh transitions.

Not actually present in the scene, these rays of light were added to act as a visual bridge between the storm clouds and the foreground.

Both the foreground and the storm clouds are built up of burnt umber and cobalt blue. Because they are developed with the same colors, they pull the entire composition together.

Capturing the Abstract Beauty of Clouds

PROBLEM

The soft, ephemeral patterns that clouds form are tremendously appealing, yet there is really nothing to hang onto—each shape bleeds into the next.

SOLUTION

Follow whatever pattern exists, but don't become too literal. Instead, develop your painting as if you were dealing with an abstract subject.

☐ Work in a very direct manner. Right from the beginning, work with opaque pigment.

Analyze the sky: Are some areas lighter than others? In some places, can you see touches of violet or even yellow? Load your brush with the color that dominates the sky—very pale gray—then sweep the paint over the canvas. Now begin to add touches of lighter and darker pigment. You'll find that Mars violet is perfect for achieving the soft rosy color that washes over portions of the sky and that yellow ocher can warm up your grays. As you add new colors, don't increase or decrease your values radically; you'll find that the slightest change in value will stand out clearly against the soft, undifferentiated ground that you laid in at the start.

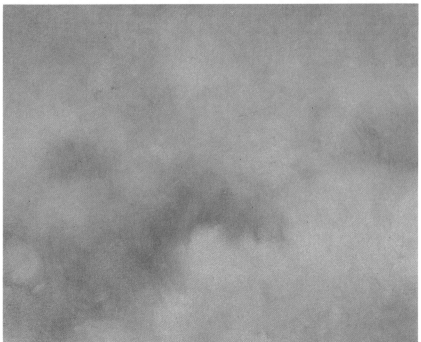

In late February, stratus clouds teem together, filling the sky with abstract patterns.

ASSIGNMENT

As you'll discover in this book, skies are rarely pure blue, yet beginning painters tend to render them with just blue and white. Experiment with other colors. Prepare your palette with a range of blues—cobalt, cerulean, and ultramarine—as well as the expected white. Next to these hues, place yellow ocher, alizarin crimson, cadmium red, Mars violet, burnt umber, and thalo green.

For several days in a row, force yourself to use at least two colors other than blue whenever you paint a sky. Don't think that you have to use these unexpected colors full force; experiment with using just touches of them. For example, when you confront a cloudy sky, use Mars violet and burnt umber for the shadowy portions of the clouds. Or, on a sunlit day, warm the sky with a touch of cadmium red. You'll find that while your skies still *look* blue, they have a new excitement to them.

Using a Wet-in-Wet Technique to Depict Backlit Clouds

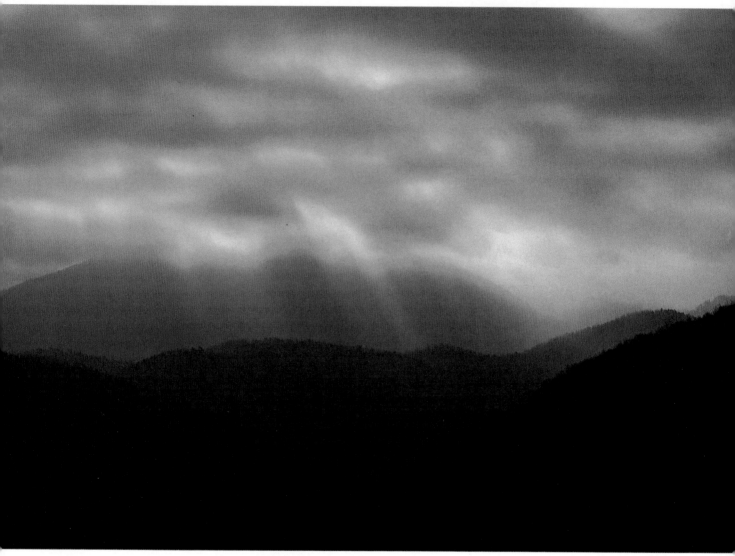

PROBLEM

There's a lot of color to these fog-covered clouds; behind them lies a brilliant sunset. You'll want to capture the effect of the fog but give the clouds a warm, rosy glow as well.

SOLUTION

Paint the sky with overlapping layers of color worked wet-in-wet to maintain a soft, gentle feel. Even in the darkest areas—the hills in the foreground—put plenty of color into your darks.

In late winter at sunset, fog shrouds the gently rolling Smoky Mountains as light breaks through the thickly layered clouds.

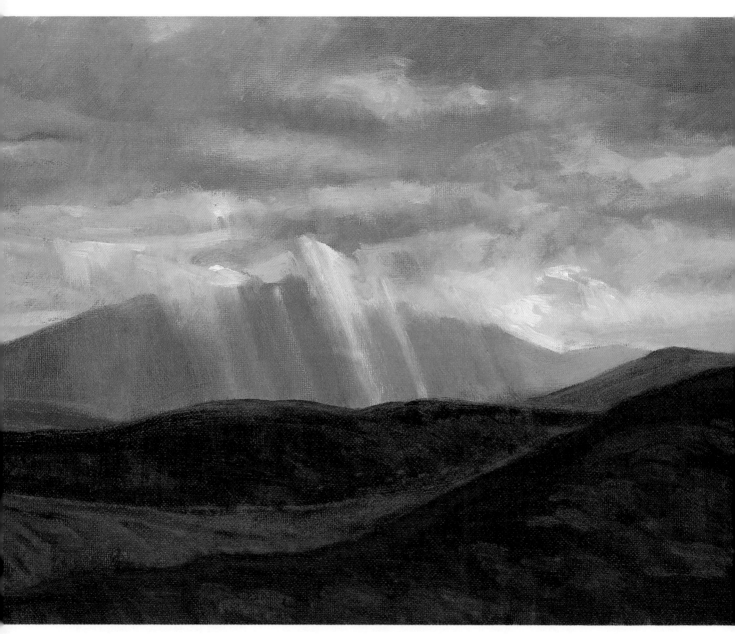

☐ Because of the simplicity of the scene, draw it directly with a brush dipped into thinned paint. Next, working with broad, loose strokes, lay in the darks of the foreground and the sky, again using thin washes of color. At this point your strokes shouldn't be too definite; what you want to capture is the general pattern of the darks.

Once the major darks have been established with turp washes, build up the foreground with opaque pigment. Keep the hills very dark, but make sure they have plenty of color in them.

Here, the use of cobalt blue, alizarin crimson, and violet brightens up the hills and keeps them from becoming too flat. As soon as you've completed the hills in the foreground, paint the distant mountain. Use the same basic mixture of cobalt blue, alizarin, and violet, but lighten it with white and add a touch of thalo green to gray it down.

Now turn to the part of the painting that matters most—the sky. Work from dark to light and wet-in-wet, applying the paint with a big bristle brush. Every time you introduce a new color, carefully work the new tone into

those that surround it. Here, the dark bands that run through the sky are painted with cobalt blue, cadmium red, and white. The light that breaks through the clouds is rendered with cadmium orange and pale yellow ocher.

Once the sky satisfies you, take a fairly dry brush and stroke pale golden paint over the canvas to indicate the shafts of light that fall over the distant mountain. Then, as a final touch, add small strokes of pale gold throughout the sky, and—if necessary—refine the silhouettes of the hills in the foreground.

DETAIL
Although they are very dark, these hills are packed with color. Note the rich bluish tinge that runs through the middle hill and the strong red tone that washes across the hill in the immediate foreground.

DETAIL
Painted at the very end, these rays of light suggest the brilliance of the setting sun that lies behind the clouds. Touches of pale gold along the horizon achieve a similar effect.

Capturing the Subtle Beauty of a Rainbow

PROBLEM

It's easy to overpaint a rainbow and make it garish. If its colors are too bright, you'll lose the rainbow's fragile delicacy.

SOLUTION

To keep the edges of the rainbow soft and misty, use a wet-in-wet approach. Soften the rainbow still further by running a fan brush over it while the paint is still wet.

STEP ONE

Sketch the scene with soft vine charcoal, then blow on the canvas to get rid of any surplus charcoal dust. Reinforce the drawing with thinned color, then freely brush in the dark trees that are silhouetted in the foreground, using a wash of thalo green. As you paint the trees, be sure to leave some areas white to represent the patches where the sky breaks through the leaves.

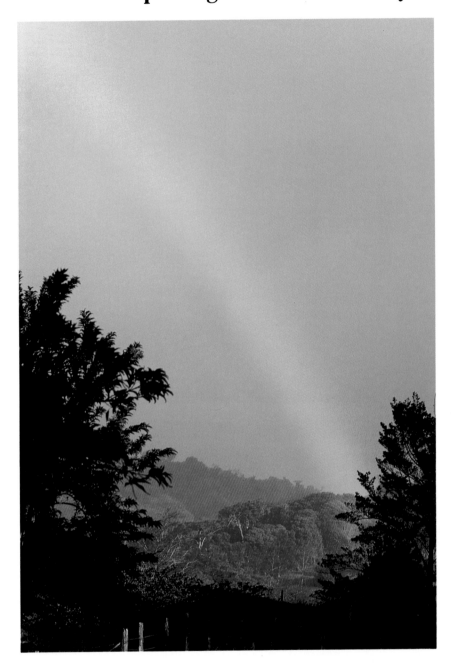

In early spring, a rainbow arcs gracefully across a pale blue sky.

STEP TWO

With heavier opaque paint, lay in the sky, taking care to capture the subtle shifts in color and value that occur. Here it's primarily painted with white and cerulean blue; in places, touches of cadmium red are used to gray down the brilliance of the blue. As you paint, avoid the area where the rainbow lies. Now, while the sky is still wet, add the rainbow. To capture its pure color, use pigment straight from the tube, softened with just a bit of white. Begin with cerulean blue, then shift to cadmium yellow, then finally add cadmium red. As you add the yellow, keep it clean. If you aren't careful in laying it in, it will mix with the blue and form green. Don't apply too much pigment—you want the color to be thin and translucent. To soften the colors still further, run a fan brush over the rainbow while the paint is still wet.

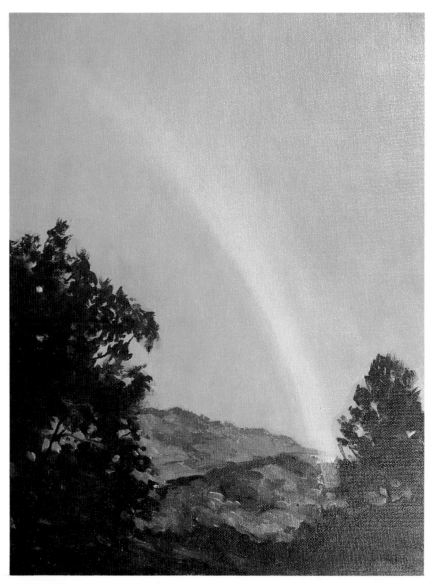

STEP THREE

Repaint the trees in the foreground with thicker, denser pigment. Try mixing together thalo green and burnt sienna; you'll find that they produce a very dark, rich green. Use short, broken strokes to capture the crisp, staccato feel of the trees and be sure to indicate the areas where the sky and the distant hills break through the dense foliage. To render the hills in the background, continue to use short, broken strokes with yellow-green and blue-green pigments. When the background is complete, quickly add the fence posts that appear in the foreground.

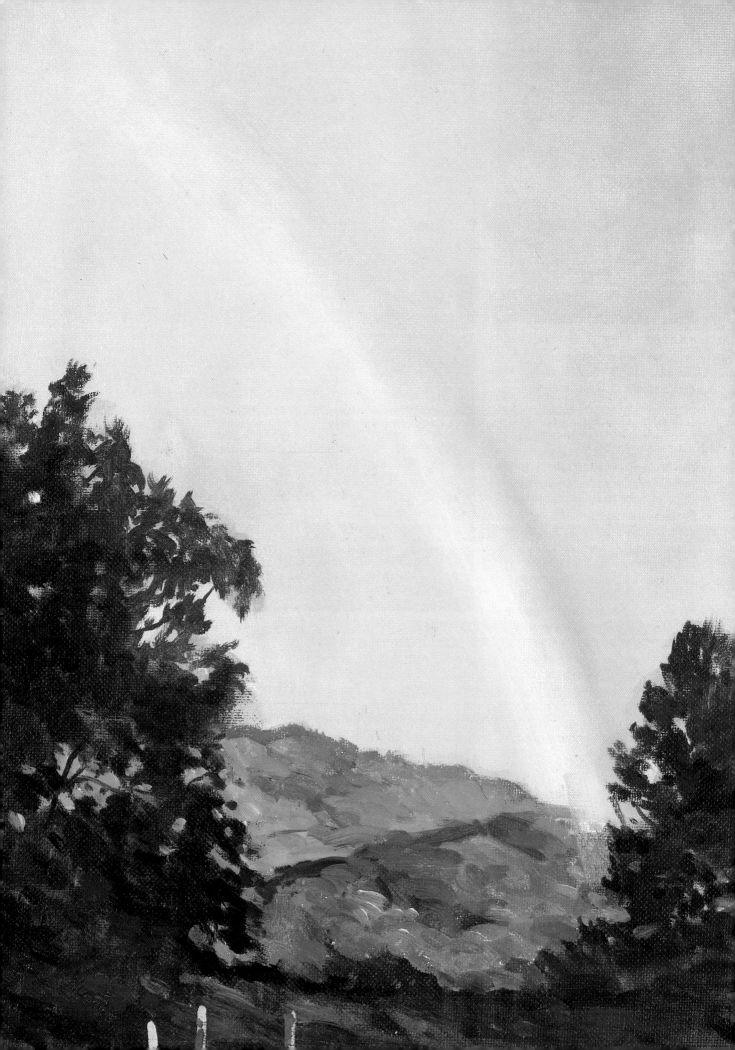

FINISHED PAINTING

In the finished painting, the strong shapes that dominate the foreground forcefully direct the viewer into the scene. The dark values in the front of the picture plane give way to slightly lighter values in the middle ground; the most distant hill is lighter yet, establishing a clear sense of depth.

DETAIL

As a final step, bright cadmium yellow pigment was added to indicate the base of the rainbow, which had been obscured when the distant hills were painted. The pigment was rapidly pulled up the canvas to maintain a translucent effect, leaving the hill clearly visible through the patch of yellow.

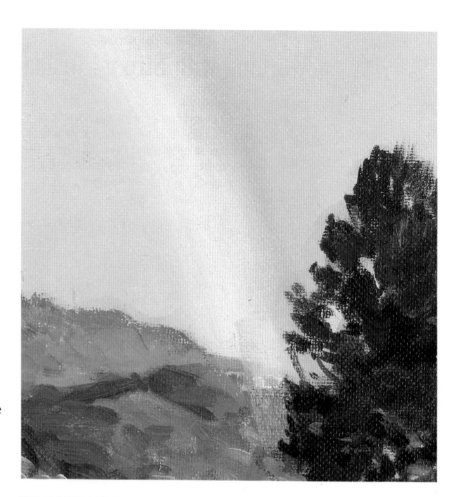

DETAIL

Seen up close, the pale colors that make up the rainbow rest effortlessly in the sky, the result of working wet-in-wet. To get rid of any brushstrokes that might interfere with the rainbow's soft, diffuse feel, a fan brush was run over the rainbow's arc while the paint was still wet.

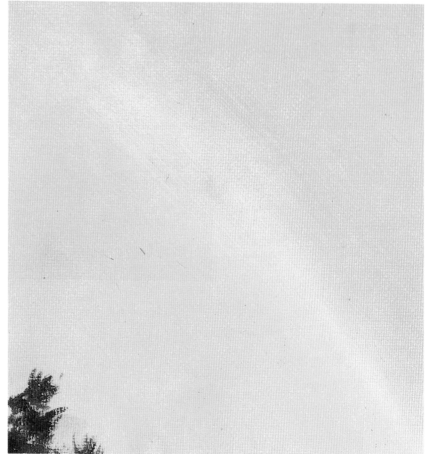

Working with Strong, Brilliant Color

PROBLEM

The golden light that permeates this scene is very strong; it tinges every area with color. Furthermore, the colors at play are all closely related in value.

SOLUTION

To infuse your painting with an overall glow, stain the canvas with a rich wash of golden yellow. As you build up the surface, work wet-in-wet to capture the soft feel created by the fog.

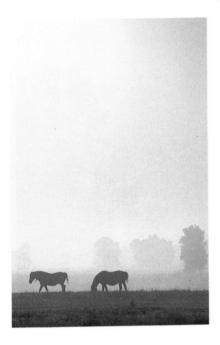

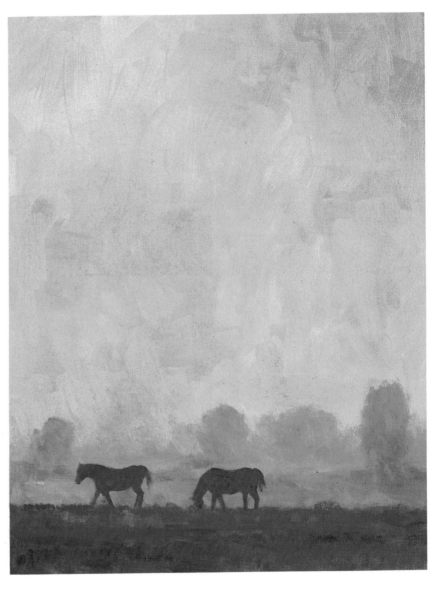

Just after sunrise, two horses graze peacefully, bathed by the deep golden light that breaks through the early morning fog.

☐ Lay in the basic lines of the composition with vine charcoal, then spray the canvas with a fixative. Once it's dry, tone the entire surface with a wash of cadmium yellow; the wash must be thin enough to let the drawing show through.

Immediately begin using heavier pigment. Don't be afraid to use brilliant yellow for the sky; if you add too much white to your pigment, you won't capture the strength of the early-morning light. To add interest to the simple foggy sky, use bold, crisp brushstrokes as you lay in the paint with a medium-size bristle brush. Let slight variations in color occur; take care, though, to brush each area into those that surround it, so no sharp edges show up in your painting.

Before you turn to the horses and ground, take a moment to analyze the sky. Are there jumps in value that seem too sudden? Are some of your yellows too pale? Make any necessary adjustments, then lay in the soft, shadowy trees along the horizon.

To complete the canvas, paint in the golden-brown foreground and the two horses. Mix plenty of yellow into your browns to relate these accents to the dominant area in the composition, the sky. Animate the grassy foreground by alternating bold brushstrokes with gentler, smoother passages of paint. Finally, when you paint the horses, don't get caught up in detail. Silhouette them boldly against the sky and you'll capture how they stand veiled by the morning light and fog.

DETAIL
The trees that lie shrouded by the fog are laid in mostly with the same gold that makes up the sky. A mere touch of brown darkens the cadmium yellow, relating the trees to the surrounding sky. In the sky, a rich mosaic of brushstrokes breaks up what could easily become a tedious stretch of unrelieved yellow.

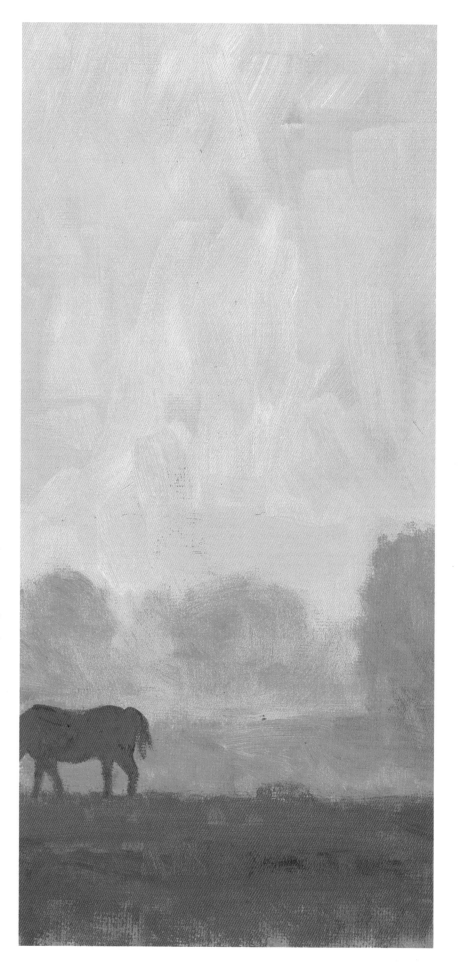

Learning How to Exaggerate Slight Shifts in Value

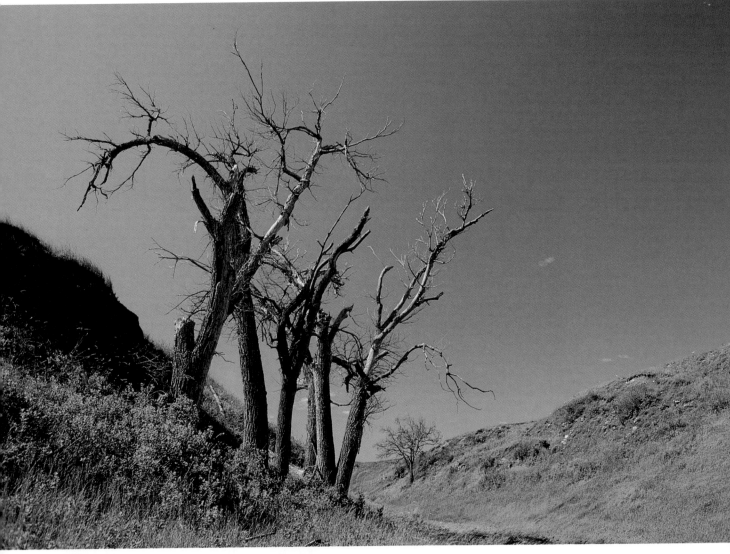

PROBLEM
This composition is fairly simple, yet it does contain potential drama. The trees are partially cast in shadow and partially bathed with sunlight, and they stand aginst a clear, undifferentiated sky.

SOLUTION
The contrast between the trees and the sky is what makes this subject interesting, so emphasize it. Keep the shapes simple, and exaggerate the stark feel of the dead trees against the bare sky.

A clear, deep-blue summer sky acts as a dramatic backdrop for the spindly, dead branches of these cottonwood trees.

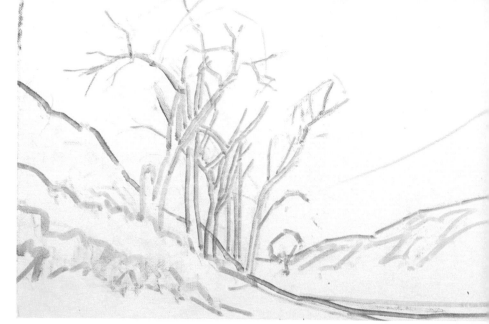

STEP ONE

Because this scene is relatively simple, there's no need for a charcoal sketch. Instead, dip a bristle brush into thinned raw umber and draw in the major lines of the composition with the edge of the brush. Your oil sketch should be fairly dark so that you can see it throughout the early stages of the painting. Remember, strong drawings can help you paint strong paintings.

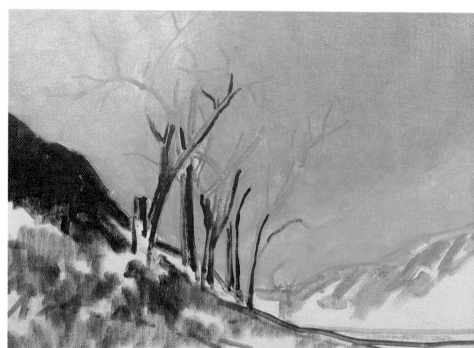

STEP TWO

Now establish major values and shapes. Begin with the very darkest area—the hill on the left. Once it's down, you can use it to gauge the strength of the rest of your values. Here it's painted with thalo green and burnt sienna. Next, lay in the blue of the sky. To capture the golden outcropping of ground on the hill in the background, use yellow ocher. The bright patches of grass are rendered with permanent green light. Finally, begin to build up the tree trunks.

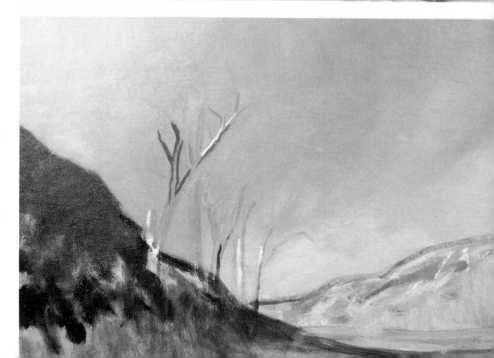

STEP THREE

Now step up the drama of the sky. Using a scrubbing motion and an almost dry brush, work the blue pigment onto the canvas. Right behind the trees, increase the strength of the blue. This deep, rich color will act as a foil for the light branches of the trees. Now develop the grassy hillsides and the shadows that fall on the foreground.

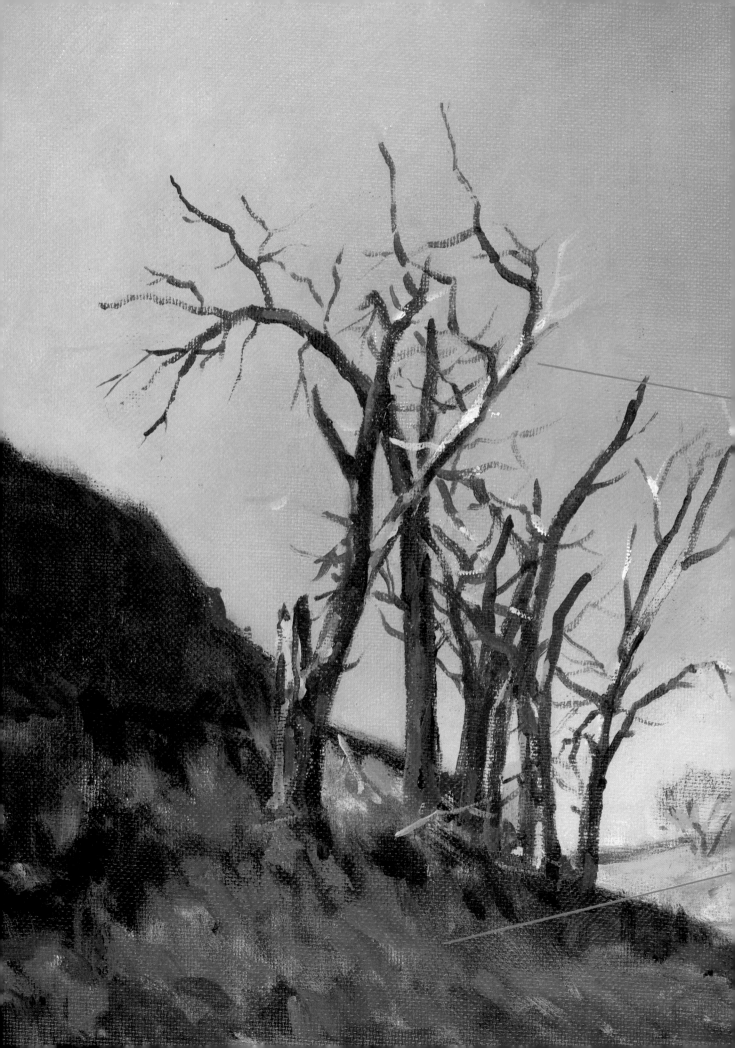

FINISHED PAINTING

After the paint has dried slightly, tackle the trees. Use deep, rich color to render the dark branches, and light brown and pure white for the highlights. Exaggerate both the lights and the darks to add emphasis to the trunks and branches, the focal point of your painting. When you begin to paint the terminal branches, use a brush that has been barely moistened with paint. Run it quickly over the canvas to achieve the rough, unstudied look you see here. As a final touch, refine the patterns that spill across the foreground.

The deep, rich blue of the sky acts as a foil for the dark and light branches. And because the sky is lighter toward the periphery of the canvas, the pool of deep blue in the center directs the viewer to the painting's focal point, the trees.

The grassy slope in the immediate foreground is painted with strong, rough strokes. The color of the grass is exaggerated, too; here it is much darker than it actually appears. The dark diagonal that results also acts as a compositional device to invite the viewer into the painting.

189

Selecting a Focal Point

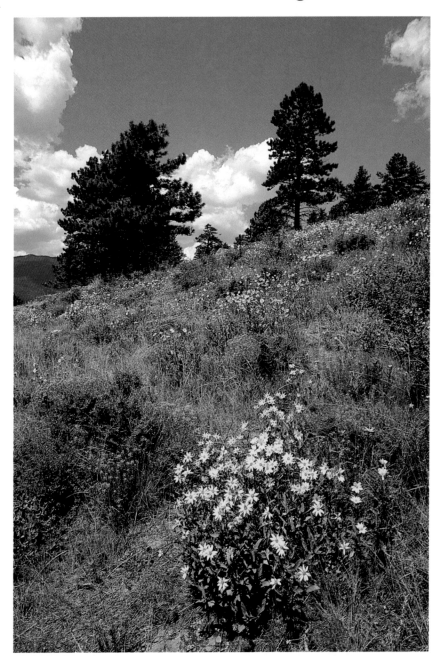

PROBLEM
Many elements are fighting for attention here. The bright yellow flowers in the foreground are tremendously appealing, but so are the trees and the clouds. Everything can't be given the same importance.

SOLUTION
Simplify the trees, then use the flowers as a compositional device to lead the viewer back to the dramatic cloud-streaked sky.

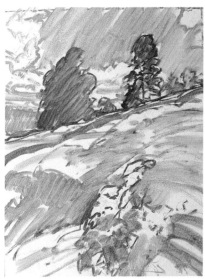

STEP ONE
Sketch the scene with vine charcoal, then reinforce your drawing with thinned color. Use thin color washes to establish the dark patterns that play over the scene—the trees and the shadowy areas of the hillside. This stage sets the overall design of your painting, so stop and analyze the lights and darks before you begin using washes. Complete this stage with a medium-blue wash for the sky.

As clouds sweep across the sky, golden asters decorate a hillside crowned with stately conifers.

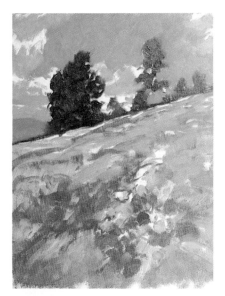

STEP TWO

Begin by laying in the trees; they are the darkest elements in the painting and you can use them to judge the rest of your values. For the time being, the whites of the clouds will represent the lightest areas in the painting. Next, turn to the sky. Keep in mind that because the hillside hides the horizon, you are looking at the darkest, richest part of the sky; so make it fairly dark. Also add pale-blue shadowy areas to the clouds. Finally, build up the foreground. Let your brushstrokes suggest the rhythmic way the hill slopes upward.

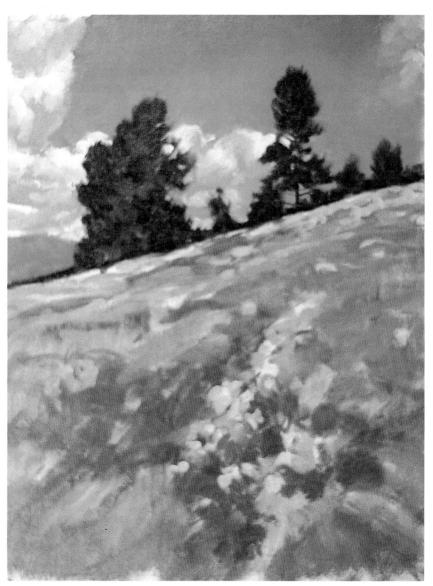

STEP THREE

Now build up the clouds. White will, of course, form their base, but don't be afraid to accentuate their shadowy areas with pale and medium shades of blue. Once you begin work on the clouds, you may want to intensify the blue of the sky. Next, finish the trees that hug the hillside.

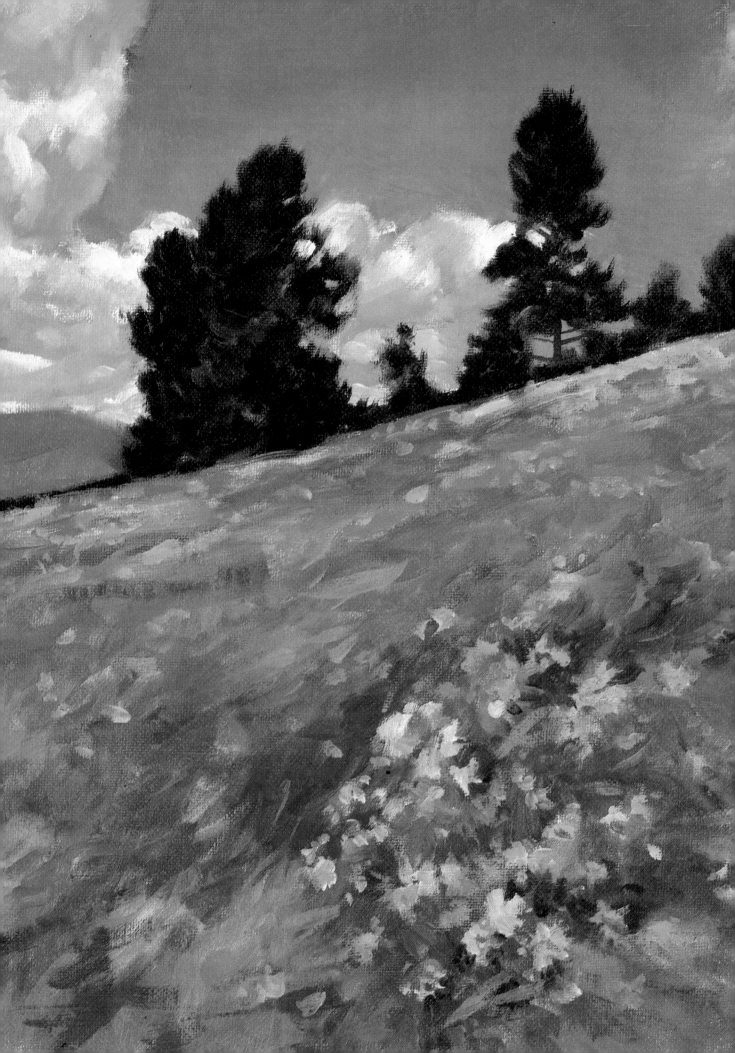

FINISHED PAINTING

Strengthen the undersides of the clouds with a dull gray hue, then turn to the foreground. Don't get too concerned with detail; if you do, you'll lose the sweep of the hillside and the drama of the flowers. To keep your touch loose, work with a medium-size bristle brush. Search for the patterns—not the details—that run over the hillside. Use the bright yellow of the flowers as accents to further suggest how the hill slopes upward.

DETAIL *(right)*

The distant hill is rendered with a cool shade of purple—a great choice when you want to suggest vast distance. Note, too, how the simplified silhouette of the tree stands out clearly against the cloudy sky.

DETAIL *(below)*

The flowers may be what you concentrate on here, but they are certainly not painted in elaborate detail. Instead, quick, fluid strokes executed with a good-sized bristle brush suggest the sweep of the hillside and the drama of the golden asters.

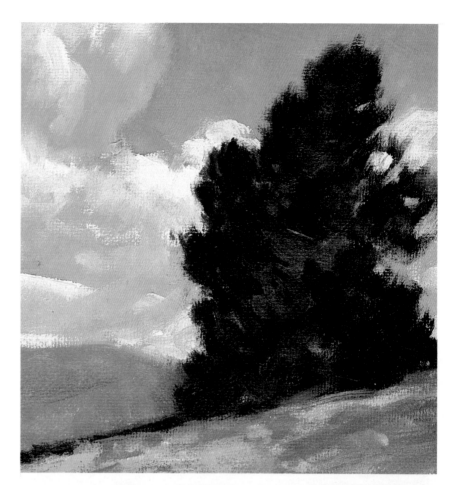

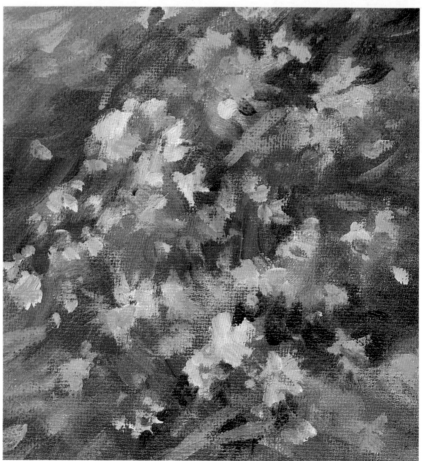

ASSIGNMENT

Capturing the three-dimensional feel of clouds is one of the most difficult aspects of painting skies. It needn't be so.

Practice painting clouds at home before you tackle them outdoors. Select pictures of cloud-streaked skies from a book or magazine. Search for the shadowy areas that sculpt out the structure of the clouds. As soon as you feel comfortable with a particular scene, paint it.

You'll be executing studies— not finished paintings—so don't agonize over your choice of colors or your brushwork. Instead, work rapidly, aiming at an approximation of the colors and values that lie in the sky. Try using unexpected colors for the shadows—grays, violets, yellows, and even reds.

Exploring the Reflections That Clouds Cast in Water

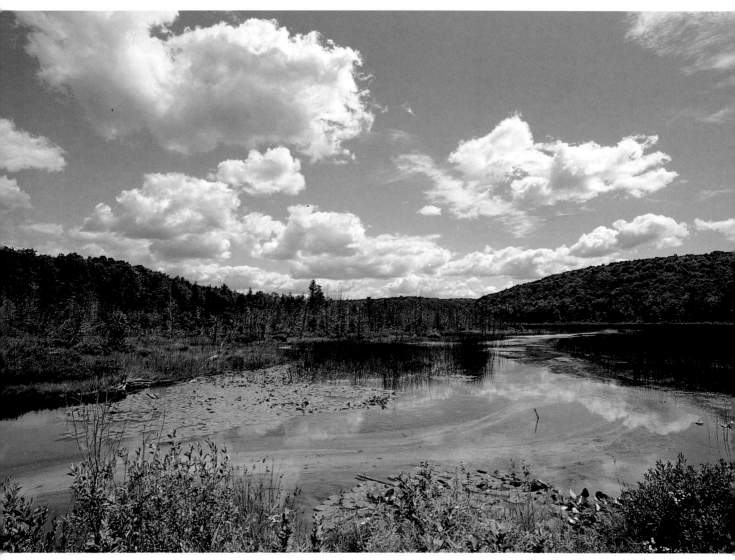

PROBLEM

In the sky, the clouds are lit from behind, making them the brightest element in the painting. The rest of the scene, including the reflections in the water, are darker and somewhat shadowy.

SOLUTION

Don't treat the water like a mirror by making the reflections as bright as the actual clouds. Instead, carefully depict what you see and render the water with darkish hues.

In July, soft fluffy clouds float lazily over the slowly moving waters of a stream.

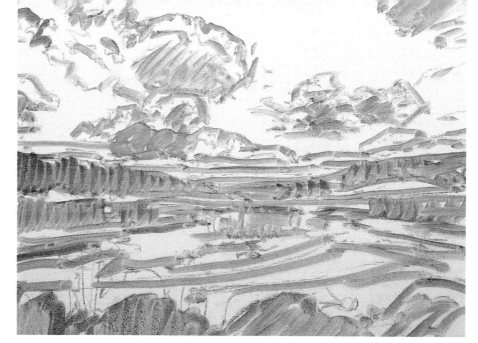

STEP ONE

Before you touch the canvas, analyze the composition. Note how everything—the water, the trees, and the reflections—sweep back toward the horizon. Sketch these major directional lines and the shapes of the clouds with charcoal, then reinforce your drawing with thinned color. Finally, begin to develop the darks, again working with turp washes.

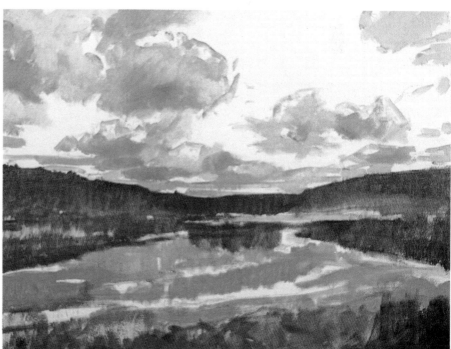

STEP TWO

Continue working with thinned color as you establish the overall color and value scheme. Start with the darkest area—the line of distant trees—then judge your other values against this dark accent. When you begin to paint the water, don't be afraid to use a strong, dark blue. Use a bright green for the vegetation in the water. For the time being, let the white of the canvas represent your lights—the clouds, the sky, and the reflections.

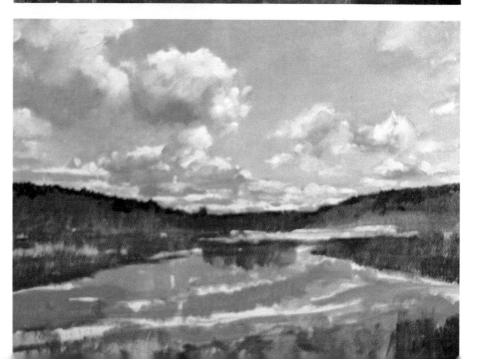

STEP THREE

Now it's time to work with thick, opaque pigment. Begin with the sky; lay in pure brilliant blue, then adjust the values of the clouds in relation to it. Note how, in many places, the shadowy portions of the clouds are actually darker than the sky. Next repaint the dark line of trees along the horizon.

FINISHED PAINTING

Now refine your work. Start with the water; mix together white and blue pigment, then gently add the reflections that are cast by the clouds. Use the same mixture of light blue paint to pull together the rest of the stream. Once the water is done, stop and evaluate your values. Here the painting was too light overall, and both the receding trees and the shadowy portions of the clouds had to be darkened. As a final touch, add bold touches of bright green to the immediate foreground.

In the clouds, strong, brooding grays contrast sharply with the crisp, brilliant white. Don't be afraid to paint strong, definite shadows when you are rendering clouds. They'll not only sculpt out the shapes of the clouds, but add a dramatic note to your paintings as well.

Added after the rest of the painting was developed, the reflections in the water are rendered with soft, delicate strokes. If they were painted more literally, they would steal attention away from the cloud-streaked sky.

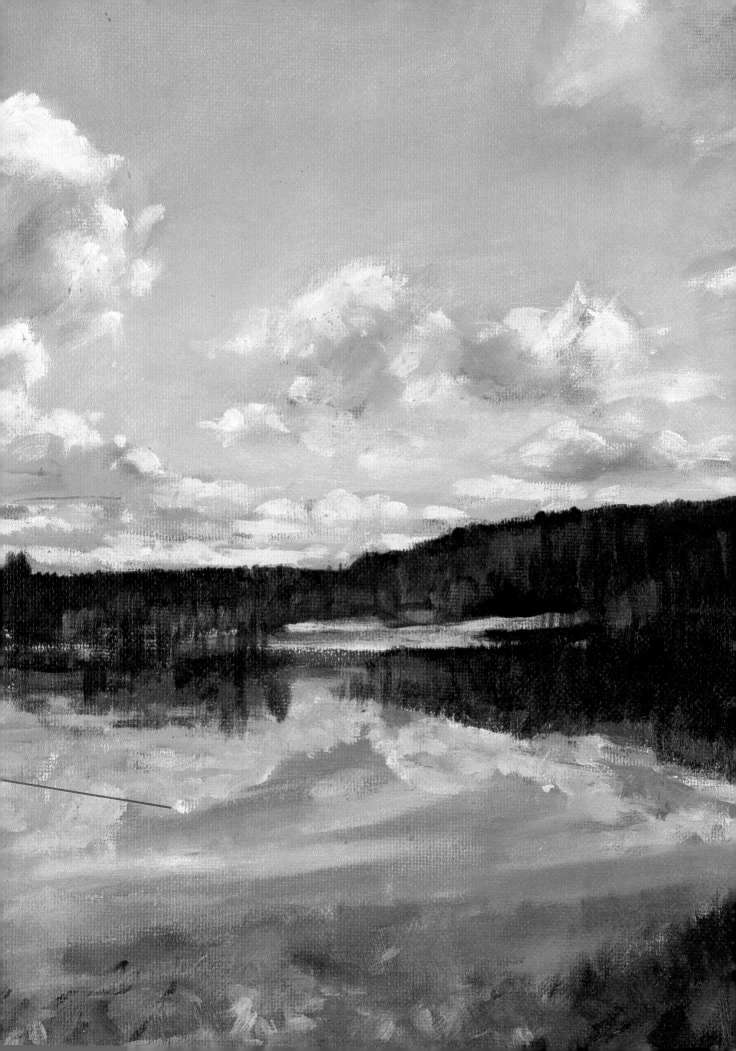

Learning How to Paint Dense Masses of Clouds

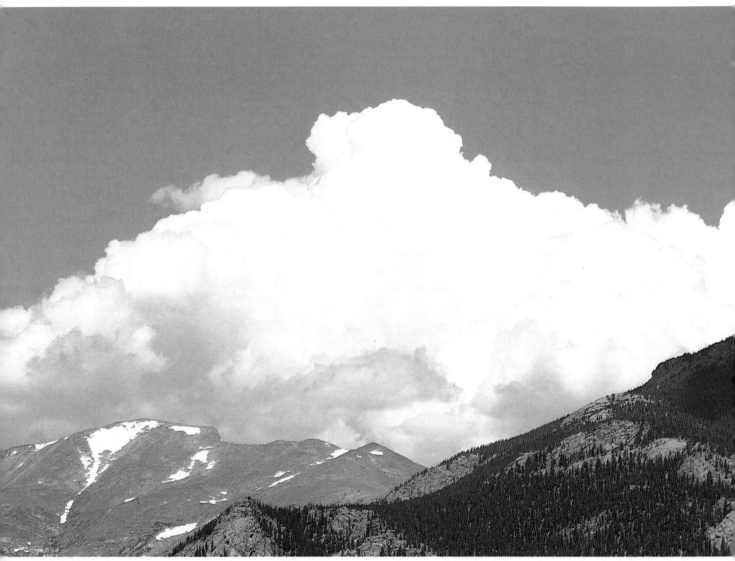

PROBLEM
The shape of the cloud mass resembles the shape of the mountaintops. This kind of similarity can result in a strong composition, but only if you carefully capture the individuality of both the clouds and the mountains.

SOLUTION
Emphasize the differences between the clouds and the mountains. First make the clouds look soft and lush. When you paint the mountains, use thick, heavy paint and strong, gutsy strokes.

In late summer, massive cumulonimbus clouds press down over the mountaintops, signaling an approaching storm.

STEP ONE
Sketch the scene with vine charcoal, then dust off the canvas. With a small brush, redraw the scene with thinned color. Continue working with thinned color as you brush in the darks of the mountains in the foreground.

STEP TWO
Before you paint the clouds and the mountains, lay in the sky. Here it's made up of cobalt blue and cerulean blue, with just a touch of alizarin crimson near the horizon. Even when a sky looks flat and undifferentiated like this one, don't mix one huge batch of paint. By mixing smaller amounts repeatedly, you can add visual interest and variety to your painting.

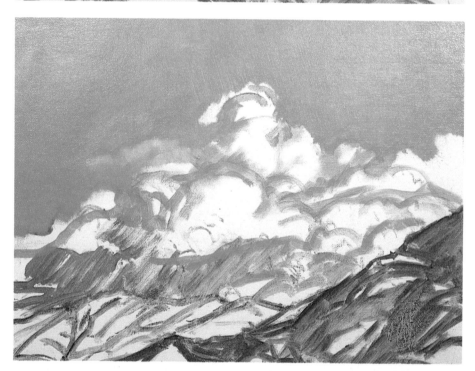

STEP THREE
Since you are emphasizing the soft feel of the clouds, paint them now. While the sky is still wet you can easily soften any harsh edges. Here the light areas are rendered with a warm creamy mix of white and yellow ocher. Tones of gray and blue make up the darks. As you develop the clouds, keep your eye on the overall pattern formed by the darks and lights.

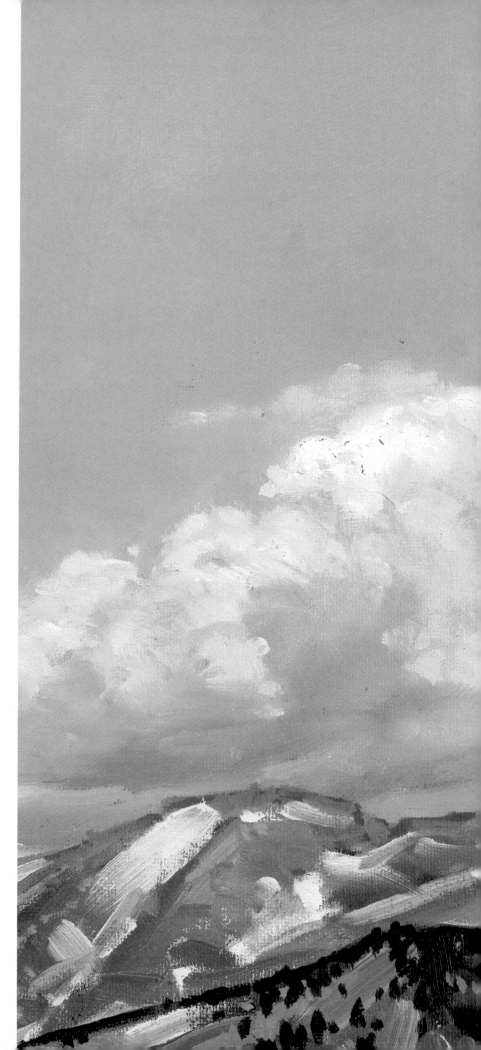

FINISHED PAINTING

As you move in on the mountains, change your plan of attack. Use a goodly amount of pigment and lay it on thickly and boldly. Exaggerate the contrast between the soft clouds and the craggy mountains with crisp, angular brushstrokes. Short dashes of dark green pigment suggest the individual conifers that line the nearby mountain. Majestic when seen up close, but dwarfed by distance, these trees also get across the scale of the scene.

ASSIGNMENT

By now you know how strongly the sky affects the feel of a landscape. To actually see the effect it has, try this: Take the mountain range shown in this lesson and experiment by painting it with different kinds of skies. First, make the sky pure blue. How does a clear sky change your treatment of the mountains? The chances are you'll want to use a softer approach on them. Next add some soft, broken clouds; use the photographs in this book as a guide to different possibilities. You may even want to paint the scene as you imagine it would appear at sunrise or strongly silhouetted by fading light at sunset.

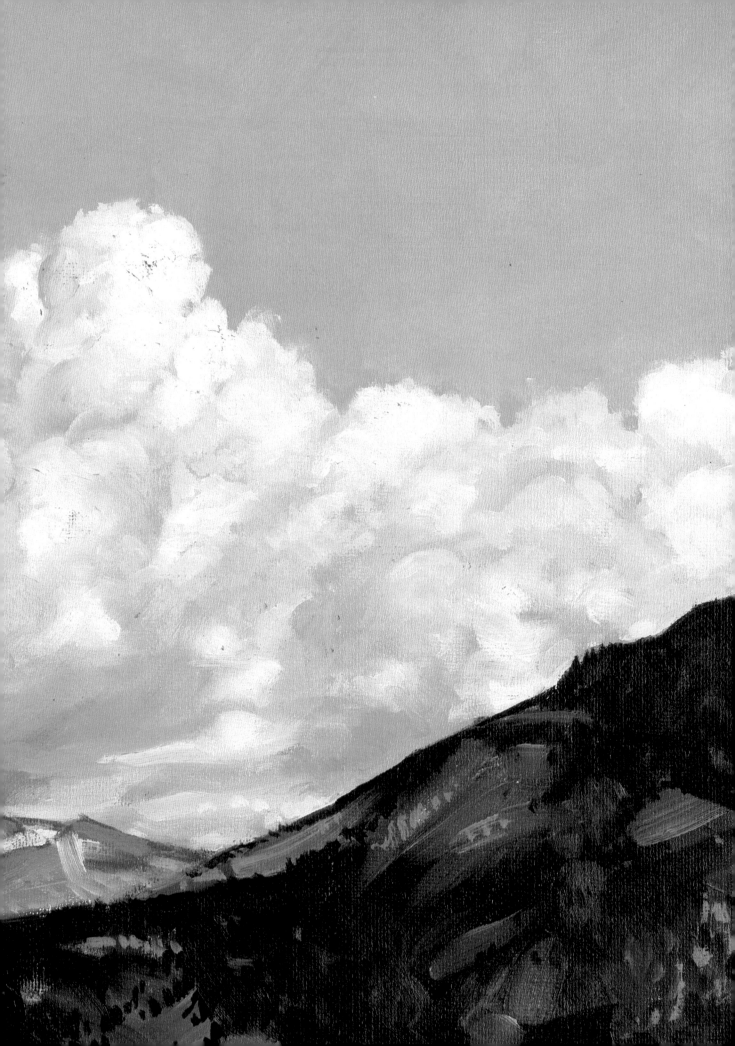

Creating a Convincing Sense of Space

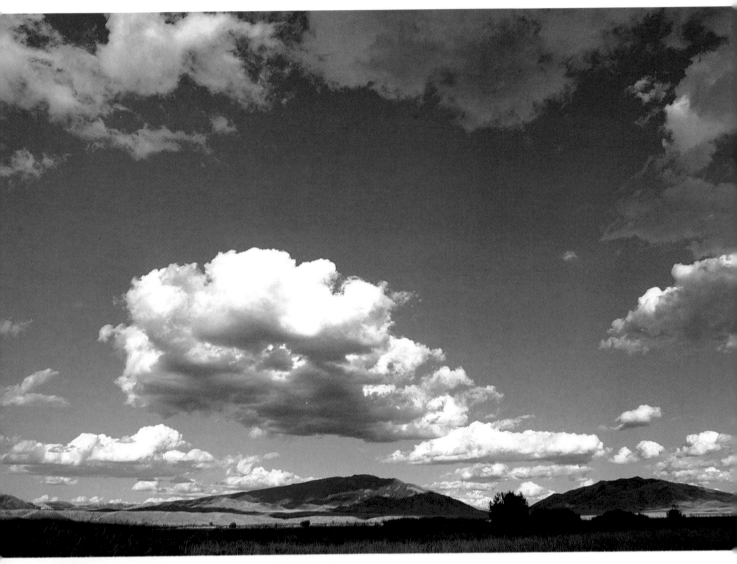

PROBLEM

The low-lying clouds are the subject of this scene—the land is incidental. The success of your painting hinges on how effectively you can portray their three-dimensional feel.

SOLUTION

Don't think of the clouds as soft, ephemeral objects. Instead, treat them as solid bodies that have real shapes. When you start to paint them, concentrate on their highlights and shadows.

In early autumn, thick, white cumulus clouds hover over the land.

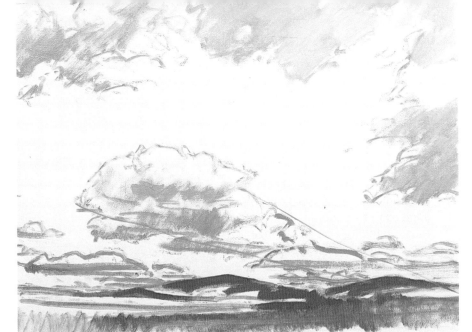

STEP ONE
In your charcoal sketch, concentrate on the clouds, then redraw the scene with thinned color. Now start to build up the volume of the clouds and the way the clouds recede into space. Throughout this stage, continue working with thin turp washes.

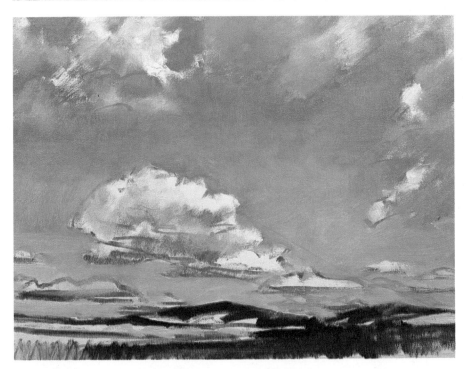

STEP TWO
The blue of the sky is the element that pushes the larger clouds forward; it has to be strong if it's going to work. Here a mixture of cobalt blue and cadmium red captures the strong hue at the top of the scene; toward the horizon, cerulean blue and thalo green come into play. Once the sky is down, turn to the ground. Working with cadmium orange and white, lay in the sunlit passages; don't mix the paint too thoroughly. Specks of orange in the pale paint will make it lively.

STEP THREE
In this step you'll start to work with thicker pigment; before you do, stop and analyze color and value. You'll see that the dark, shadowy portions of the clouds are the same value as the darkest areas in the sky; it's color that pulls them apart. Your previous work has established the volume and depth of the clouds; now gently build on what you've already done.

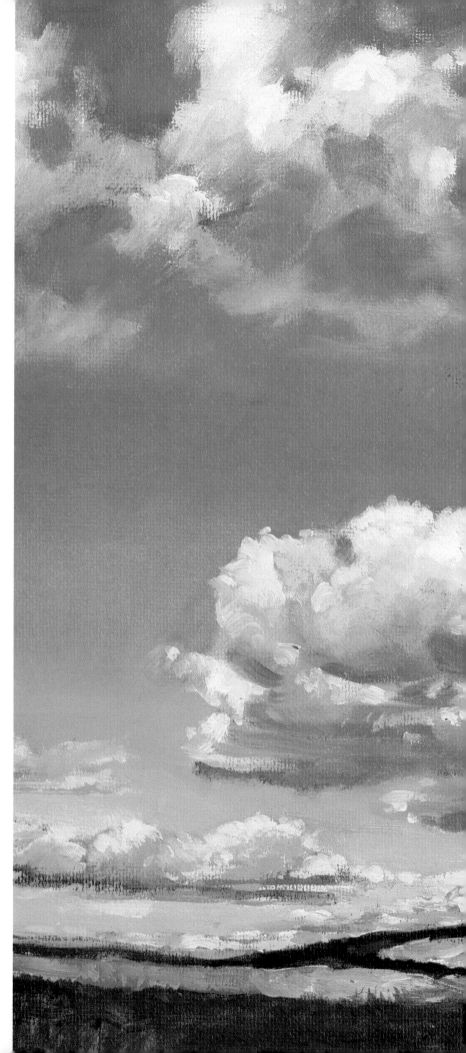

FINISHED PAINTING

Make sure that the shadowy areas in the clouds are very dark; if they're not, the brilliant light that falls onto the ground will never seem bright. Once you are satisfied with the sky, turn to the ground. Make the distant hills really dark. Next, boldly lay in the bands of color that appear in the immediate foreground. As a final touch, bits of green and orange suggest the sunlight that falls across the land.

ASSIGNMENT

Search for a flat, low-lying location, one in which you can frame a picture so that the ground occupies only a small bit of the picture space. The sky is what you'll concentrate on. Use a single canvas, 16 inches by 20 inches, and divide the area into four parts. In each part, paint a small cloudscape. Don't spend more than 20 or 30 minutes on any one; cloud formations change so quickly that spending any more time on a single study is usually futile. Paint two of the cloud formations in a horizontal format; for the other two, try working in a vertical space. When you're done, figure out which format works best for you.

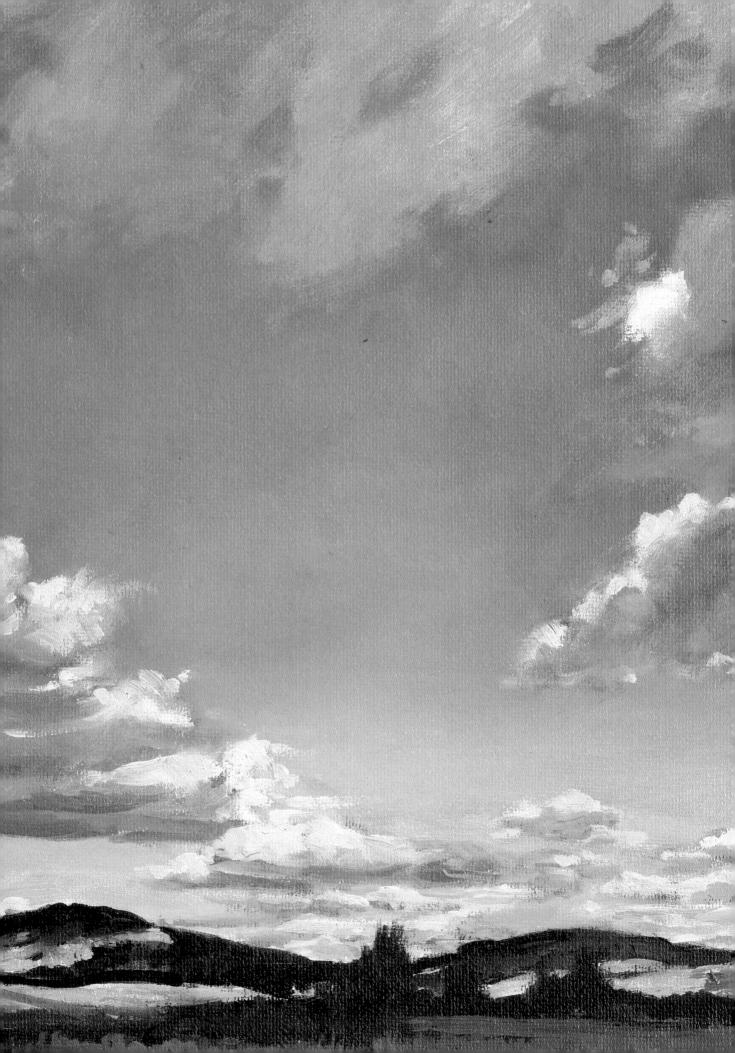

Painting Thin, Transparent Clouds

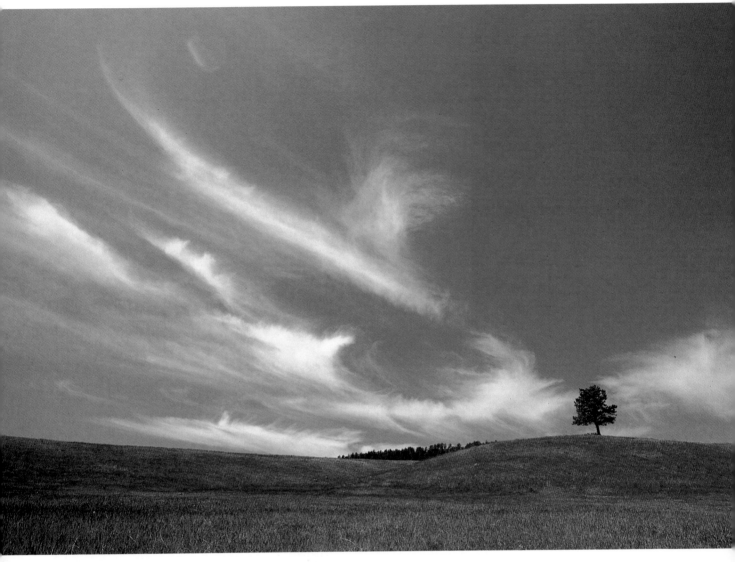

PROBLEM

The clouds make up two-thirds of this scene—they're the real subject. The challenge that faces you is capturing their thin, transparent character.

SOLUTION

Keep the foreground simple and it won't steal attention away from the clouds. When you turn to the sky, paint it in one quick session; working rapidly, you'll find that it's easy to depict the soft, airy look of the clouds.

Thin cirrus clouds streak bands of white across the deep blue sky.

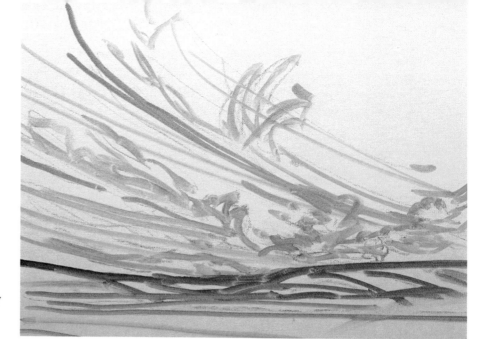

STEP ONE

In your preliminary drawing, concentrate on the strong lines that sweep through the sky. Use loose, directional movements as you sketch; you don't want your drawing to look rigid. Now loosely reinforce the lines of your sketch with thinned color.

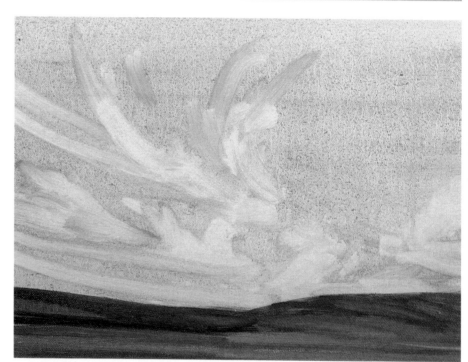

STEP TWO

Get the foreground down right away so you can devote all your attention to what matters most, the sky. With a medium-size bristle brush, pull the paint across the canvas. Use flat strokes, but do suggest the contours of the land. Now turn to the sky. Lay in a thin wash of cobalt blue and cadmium red light over the entire sky, then pull out the light areas with a dry bristle brush.

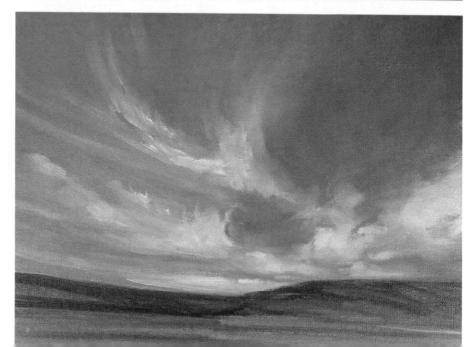

STEP THREE

Continue working with cobalt blue and cadmium red light as you begin to lay in thicker opaque pigment. Before you apply any paint to the canvas, mix together your basic blue as well as small amounts of white mixed with yellow ocher and white mixed with blue. Now start to paint. Rapidly lay in the deep, rich blue of the sky; then—following the direction of the clouds—pull your white paint through the blue sky. If any edge becomes too sharp, soften it immediately.

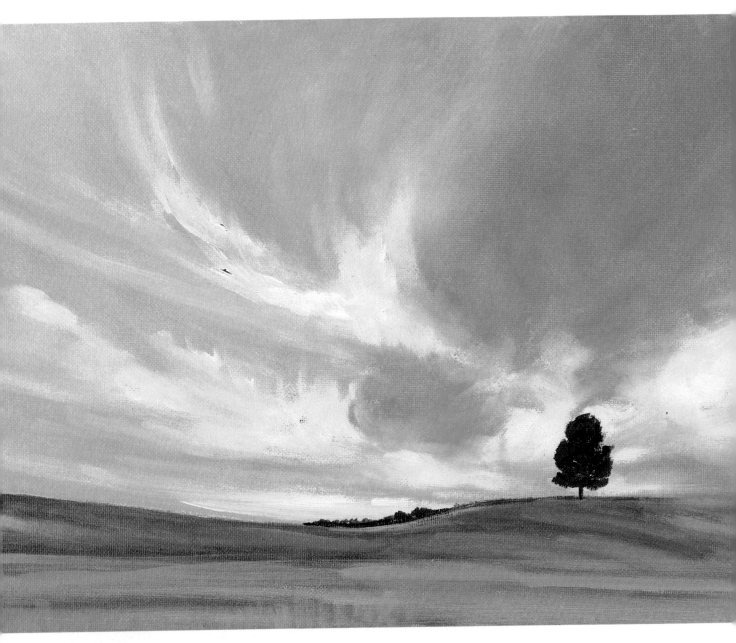

FINISHED PAINTING

To push the foreground back into space, add a line of low-lying trees to the horizon. Finally, paint the tree. Keep its silhouette simple and let tiny bits of the sky break through the foliage to create a realistic feel. In the finished painting, wind seems to pull the clouds across the sky. Their soft edges merge naturally with the dominant blue, and thick white paint contrasts powerfully with thinner passages of pale bluish-white pigment.

Working with Diffuse, Abstract Patterns

PROBLEM

These soft, misty clouds blend almost totally into the surrounding sky; they have no definite edges. In addition, they are made up of just a few colors and the value range is extremely limited.

SOLUTION

To capture the soft feel of this sky, work quickly and directly. Don't bother with a preliminary charcoal sketch; use color from the very beginning and plan to finish your painting in just one session.

☐ Because of the subject's compositional simplicity, very little preliminary work is necessary. Take a bristle brush, dip it into thinned color, then quickly draw the shapes of the major clouds and the sweeping lines that they cut through the sky.

Now turn to opaque paint. You'll need cobalt blue, black, cadmium red, and white—the black to dull the blue, the red to give it a cool purplish tinge, and the white to lighten it. Start by brushing in the darker portions of the sky, letting the white of the canvas represent the clouds. Keep your pigment thick, and don't let obvious brushstrokes interfere with the soft surface you are creating.

While the sky is still wet, add the clouds. Brush them in gently, letting your strokes follow the movement of the clouds. Soften any sharp edges immediately. Once the basic patterns have been laid in, pull the paint across the canvas in the direction that the clouds take.

At the very end, work back and forth between the clouds and the sky, making any adjustments in value that seem necessary and softening any edge that has become too sharp. In this final stage, stop frequently to gauge your progress. As soon as you're satisfied with the effect you've achieved, stop. Pushed too far, this kind of painting can become totally abstract and the suggestion of clouds may disappear.

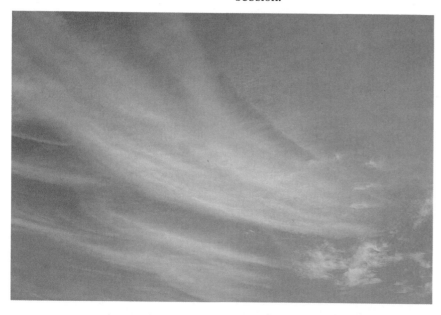

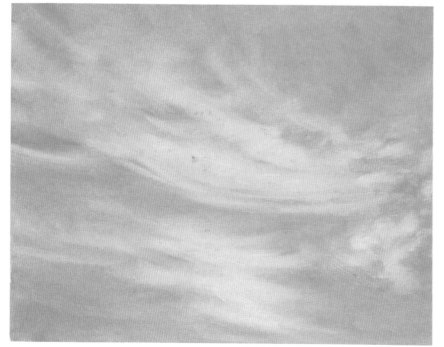

Early on a spring afternoon, pale cirrostratus clouds sweep boldly across the sky.

Rendering the Drama of a Cloudy Sunset

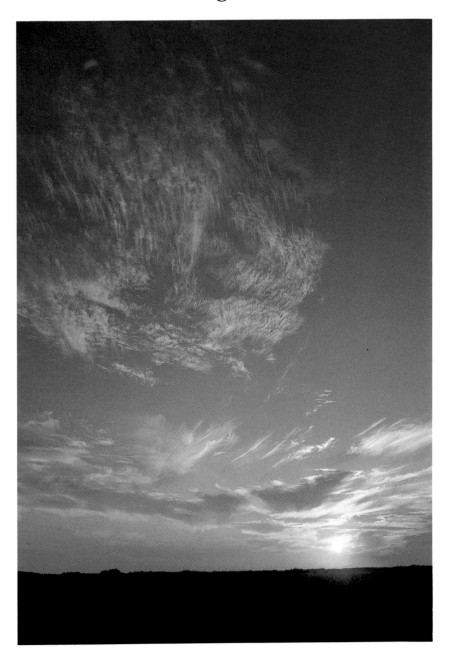

PROBLEM

When you encounter dramatic scenes like this one, you may be tempted to concentrate on the obvious and to downplay subtle points that matter. Here it's not just the brilliant colors of sunset that make the scene strong; the clouds are powerful, too.

SOLUTION

Analyze the entire composition before you start to paint. Note how the clouds that lie just above the horizon are heavy, while those higher up in the sky are thin and wispy. Paint the thin clouds rapidly, working wet-in-wet; then gradually develop the rest of the scene.

STEP ONE

With vine charcoal, quickly sketch the major shapes that fill the sky, then dust off the canvas. Next, reinforce your drawing with thinned color. Use short brisk strokes of brown to lay in the immediate foreground; use more fluid brushwork when you turn to the sky.

At sunset in the Everglades,
the bold colors of the descending sun
tinge the cloud-filled sky
with orange, gold, and blue.

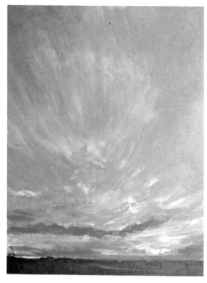

STEP TWO

Using heavier color, paint in the dark sky. As soon as it's down, turn to the thin clouds that float high above the ground. Working wet-in-wet, coax pale blue and pink pigment into the dark underlying blue, taking care to keep all the edges soft. Now add the very dark foreground and the brilliant colors of the fading sun. For the time being, use fairly thin paint to render the sunset and don't let any heavy ridges develop.

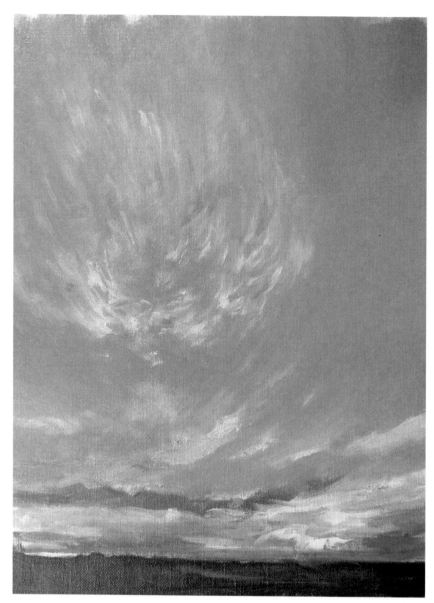

STEP THREE

Before you complete the brilliant area near the horizon line, finish the sky. Mix dark, rich blue with plenty of medium to keep the paint fluid, then carefully apply the color to the sky. Don't be afraid to use dark, intense blue; you want to indicate how the sky darkens in the evening as the sun slowly fades away. As soon as the blue is down, turn to the thin clouds; moisten a small brush with pale pink and quickly pull this through the blue.

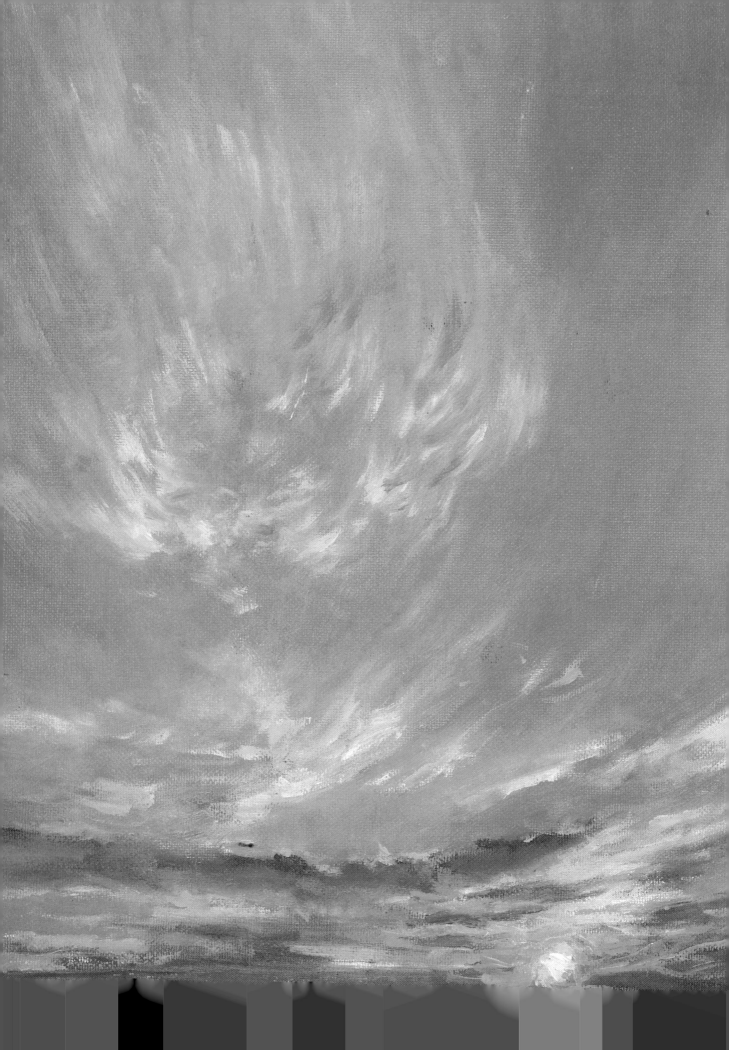

FINISHED PAINTING

At the very end, turn to the lower portions of the sky. First add touches of pure orange and gold to the canvas, then lay in the dark clouds that float in front of the sun. To achieve a bright, glowing look, don't add too much white to your strong reds, oranges, and golds. Instead, use them almost straight from the tube.

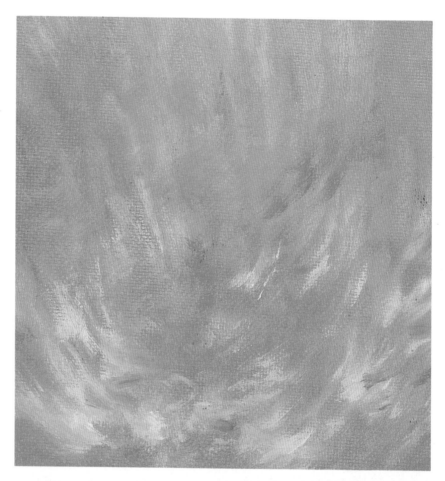

DETAIL

The wind-swept clouds that fill the upper reaches of the sky are painted wet-in-wet. While the underlying blue is still moist and pliable, touches of soft pink are quickly pulled through the blue. The soft, ephemeral look that results gets across the character of the clouds.

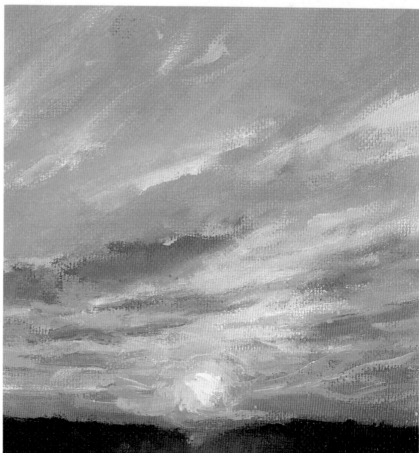

DETAIL

The brilliant gold sun and the orange-tinged sky are painted with almost pure color; just the faintest hint of white softens their intensity. The dark clouds that float in front of the sun are rendered with Mars violet and cadmium orange.

Working with Backlighting at Sunset

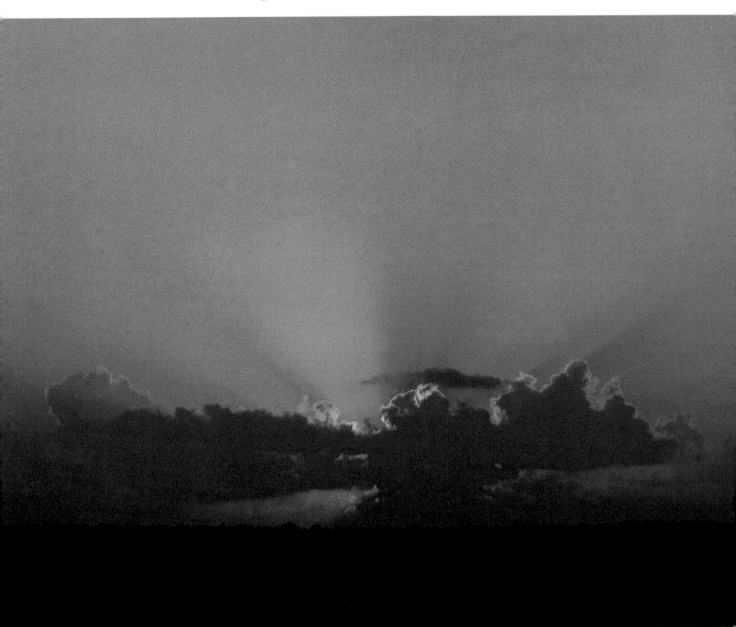

PROBLEM
The dark clouds lie directly in front of the sun. It will be difficult to convey how brilliant rays of light rim the clouds and shoot upward.

SOLUTION
Make the clouds even darker than they actually are and they'll contrast sharply with the light rays. This contrast will accentuate the brilliance of the setting sun.

☐ Execute a simple charcoal drawing, one that establishes the shapes of the clouds, the horizon line, and the rays of light that spread outward from the sun. Next, dip a brush into thinned color and redraw the basic lines of the composition. For the time being, let the white of the canvas represent your lights and concentrate on the darks.

Working with heavier pigment,

lay in the clouds. Keep your darks colorful; here they are rendered with cobalt blue and a very small amount of white. Don't use too much white—you need just the barest touch to temper the blue. Don't worry if the clouds seem too dark set against the white of the canvas. Remember that when the sky is painted, they will appear somewhat lighter in relation to the bright orange tone that dominates the sky.

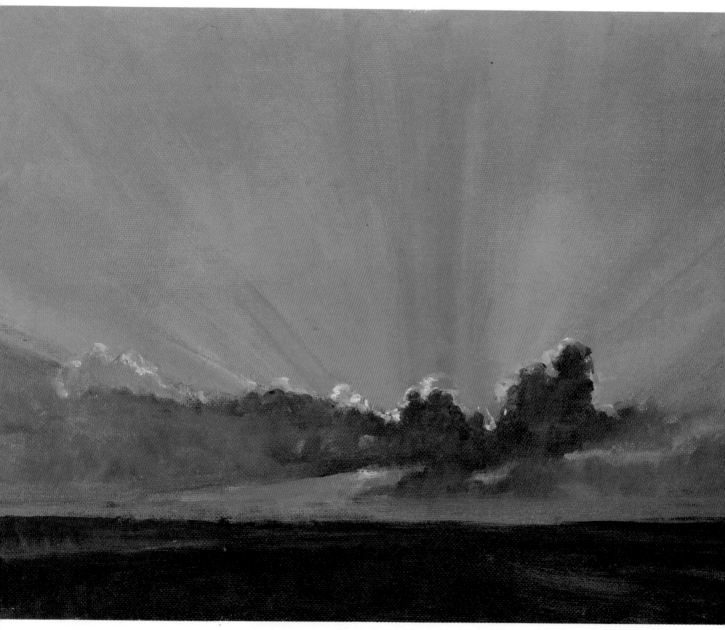

When you turn to the sky, don't be afraid to use really bright colors. Once again, if you add too much white, the brights will seem lackluster. Instead, use paint almost straight from the tube. Here the sky is mostly made up of cobalt orange. Cadmium red comes into play near the cloud formation; toward the edges of the canvas, the cadmium orange is grayed down with touches of cobalt blue.

While the paint is still wet, add the dark rays that radiate out from the cloud. Barely moisten your brush with a mixture of cadmium orange, cobalt blue, and white, then rapidly pull the brush across the canvas. When the rays are down, take a small sable brush and add the touches of bright color that rim the clouds.

The sky completed, turn to the foreground. You'll want a dark hue that is keyed to the rest of the painting, so use cobalt blue as your base, darkening it slightly with Mars violet. Keep the foreground fairly simple; it shouldn't compete for attention with the rest of the composition.

Now look at the painting as a whole. Make sure that it hangs together—that the clouds, sky, and ground are harmonious—and that your darks are intense enough to offset the brights.

Learning to Control Values

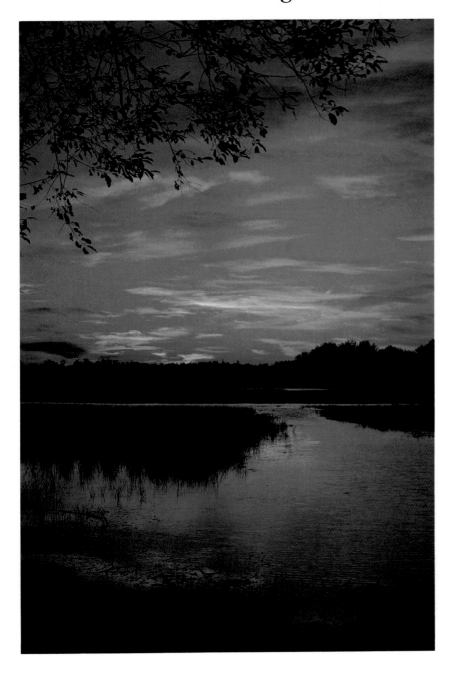

PROBLEM
Even though this scene is filled with brilliant color, it is set in early evening. If you simply concentrate on the bright colors, your painting may be too light in value. If that happens, you'll lose the special mood that occurs at sunset.

SOLUTION
Go ahead and use a broad array of brilliant hues, but keep your darks really dark. To help gauge your values, stain the canvas with a medium-value red before you sketch the scene.

STEP ONE
Start by toning the canvas. On your palette, mix together cadmium red and alizarin crimson. Add turpentine to the mixture, then sweep the color wash over the canvas. Concentrate the red wash in the upper half of the painting, where most of the bright colors lie. Now dip a small brush into a thinned but dark color and sketch the basic lines of the composition.

In early October, bands of brilliant orange sky and smoky clouds weave together as the sun slowly sets.

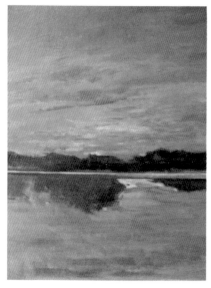

STEP TWO

You are going to be working with a vast array of colors, so make sure they are all laid out on your palette before you begin. Use these colors: alizarin crimson, cadmium red, ultramarine, Mars violet, cerulean blue, thalo green, cadmium yellow, cadmium yellow light, and white. As you lay in your darks and lights, let the stained canvas represent your middle tones. Use white sparingly; for the most part, you'll want deep, rich hues.

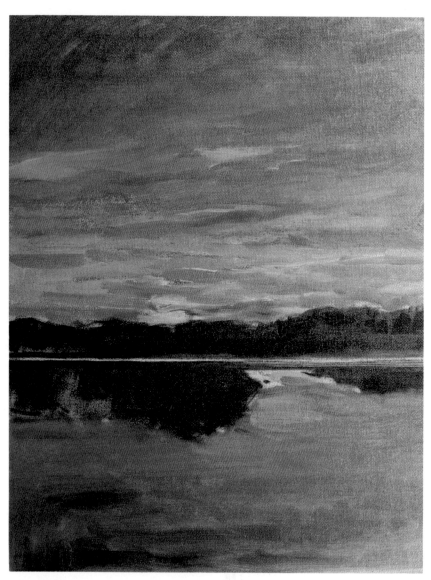

STEP THREE

Work back into the upper half of the painting, strengthening your darks and your lights and reworking the areas that until now have been covered with just the preliminary color wash. Use loose, fluid strokes, and let the layers of color blend together where they overlap. Once again, use deep, dark hues; the blue passages are, for example, rendered with pure cerulean blue.

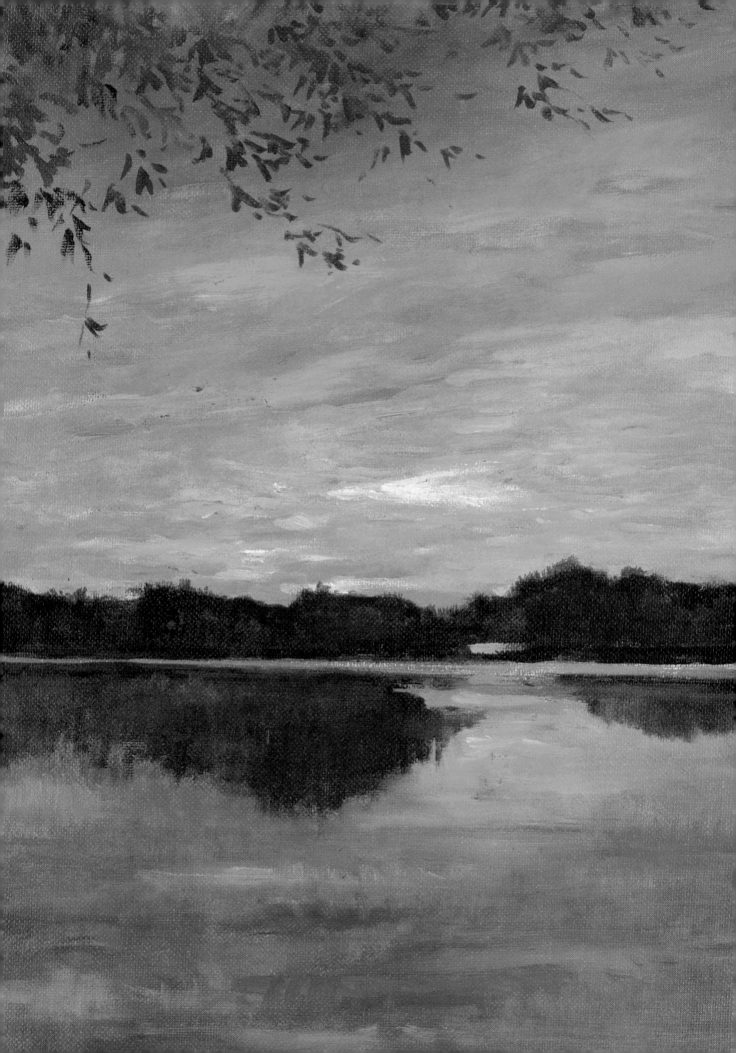

FINISHED PAINTING

Once the sky is complete, the foreground will probably look weak. Using the same colors that make up the sky, build up the dark shadows that run across the water. Keep the center of the water brightest to suggest the light of the setting sun. At the very end, paint in the branches in the upper left corner and refine the line of trees that run along the horizon. These crisp details add punch to your painting and establish a clear sense of space.

DETAIL

The sky is packed with pure, rich, vibrant color—oranges, golds, reds, and blues—yet it is dark in value because very little white was used. The middle-value red applied to the canvas at the very beginning sets the value scheme for the entire painting and makes it easy to adjust the darks and the lights.

DETAIL

A thin band of deep orange separates water from land and helps set up a convincing sense of space. The trees that lie above the band are crisply rendered; their reflections in the water are painted with looser strokes, suggesting how the reflections play upon the surface of the water.

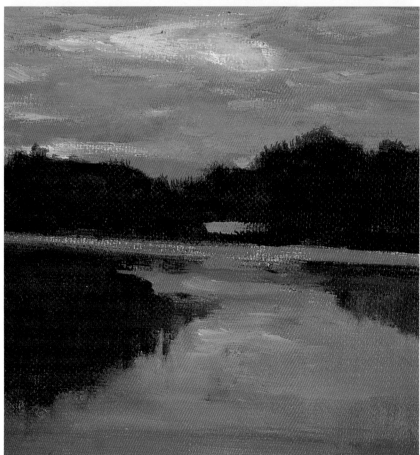

Using Varied Brushstrokes to Organize a Painting

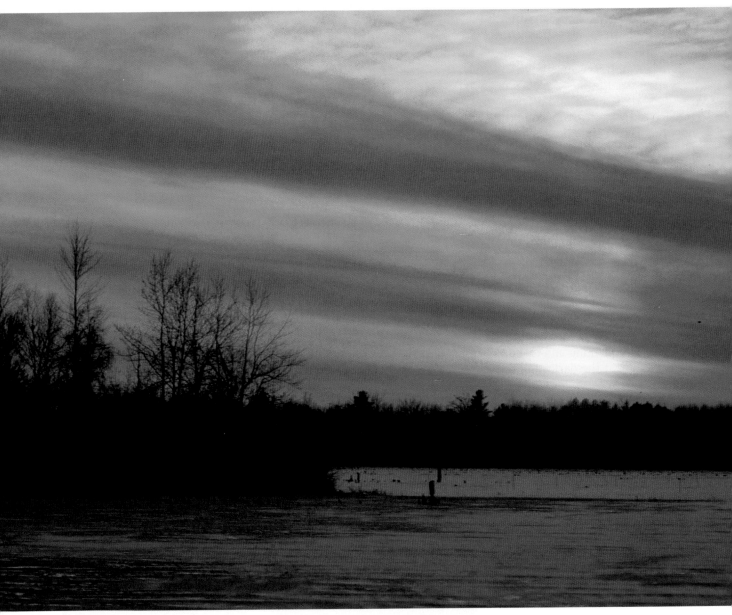

PROBLEM

The bands of color that arc through the sky clearly dominate this scene. Unless they are carefully thought through, they may overpower everything else.

SOLUTION

Divide the composition into three distinct areas: the bold bands of light and dark color in the sky, the clear sky above the bands, and the land and water beneath them. Render each area with a different kind of brushstroke.

☐ Because the composition is simple, you don't need a charcoal sketch. Instead, set down the major lines of the composition with a small brush that has been moistened with thinned color.

Now working from dark to light and with opaque paint, develop the overall color and value scheme.

To depict the horizontal bands of color, use broad, sweeping strokes. Next, lay in the uppermost portion of the sky, exaggerating its texture by rapidly

scrubbing color onto the canvas with diagonal strokes that move upward from left to right. Finally, render the water with short, broken strokes.

Once you have established the sky and the water, turn to the dark line of trees along the horizon and the island that juts out into the lake. Try painting them with a mixture of thalo green and alizarin crimson—you'll find that this mixture creates a dark, yet colorful, hue.

A lake lies frozen beneath a brilliant, light-streaked December sky.

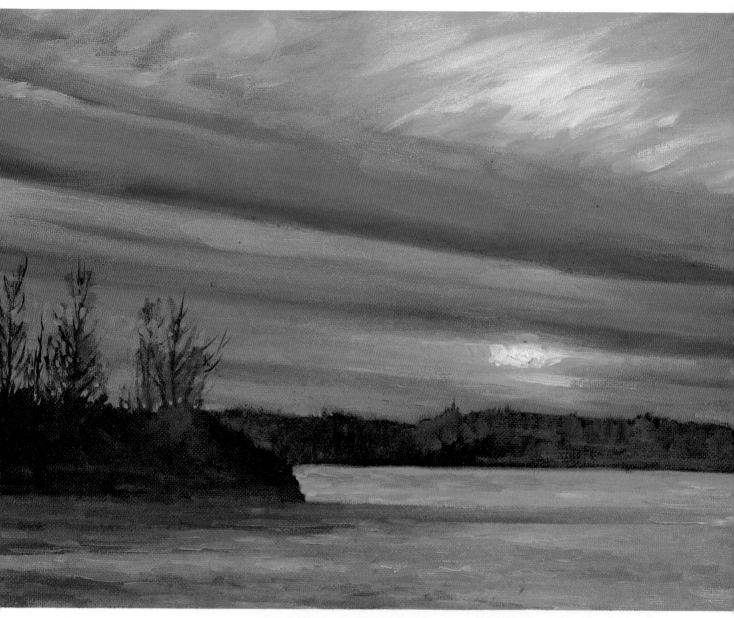

By now your painting is almost finished. Using the darks of the land as a guide, analyze the value scheme you've established. Work back into the sky, adjusting the areas that seem discordant and adding touches of pure yellow to indicate the sun. When you are happy with the sky, add the scraggly trees in the middle ground. Finally, turn to the water. To relate it to the rest of the painting, add small strokes of the gold and orange hues that dominate the sky.

ASSIGNMENT

At their most dramatic, sunsets are packed with rich, vibrant color. But color isn't everything in a sunset—patterns of dark and light matter too. To become conscious of the importance of value, try working with just black and white paint the next time you encounter a glorious sunset.

As you work, search for the light and dark patterns that fill the sky. Paint quickly, spending no more than ten or fifteen minutes on each monochromatic sketch. Don't work your studies up too much; as soon as you feel you have captured the basic configuration of the sky, move on to another study. You'll discover that within five or ten minutes, the sky can totally change.

Painting at Night

PROBLEM

Painting at night presents its own special challenges. Even if you conquer the practical ones—such as seeing what you are painting—it's easy to make your colors too light and to lose the effect you are after.

SOLUTION

Keep the sky dark and the tree even darker to set up contrast between the two and to establish the mood of the painting. As you render the sky, look for subtle shifts in color and exaggerate them to break up what could be a flat, undifferentiated area.

□ Sketch the branches of the tree with charcoal, then redraw the tree with a small brush and thinned color; make it really dark so the drawing will still be visible through opaque pigment.

Continue working with thinned color as you lay in the sky. Here it's made up of a mixture of cobalt blue and alizarin crimson. Even in this early stage, start looking for variations in color and value.

Now, working right over the darkly drawn tree, repaint the sky with opaque pigment. Try to finish the sky in one session. When the sky is completed, carefully paint in the moon; then proceed to paint the tree. A rich mixture of burnt umber and cobalt blue is perfect for rendering the tree. It is dark and dramatic, and the blue relates the color to that of the sky. Mix the two colors together on your palette, then add a goodly amount of painting medium. The paint has to be fluid if you're going to capture all of the thin, spidery branches.

Once you've painted the basic anatomy of the tree, go back and add a little modeling to its trunk. Here just a hint of white is added to the basic mixture of blue and brown, then the slightly lighter paint is quickly applied to the right side of the trunk.

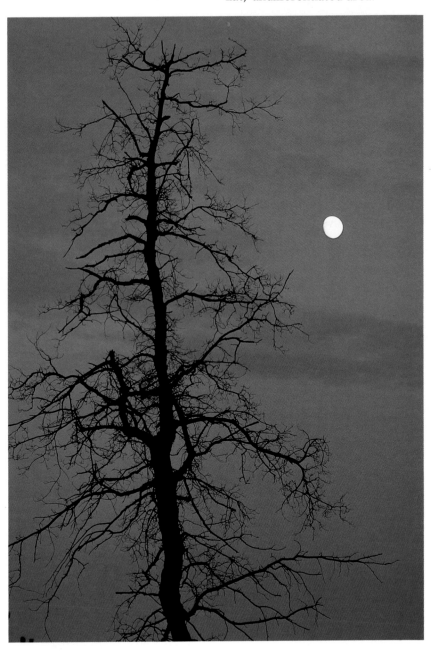

In late summer, moonlight illuminates the scraggly lines of a dead tree.

ASSIGNMENT

Try painting a night scene. Your subject doesn't have to be anything like this one. The important thing is to choose a scene that you can see from inside your studio or home.

When you start work on your painting, be sure to keep the darks really dark. If you have trouble working with very dark values, it may help to turn off the light you are working by, from time to time, and to contemplate your subject for a few minutes.

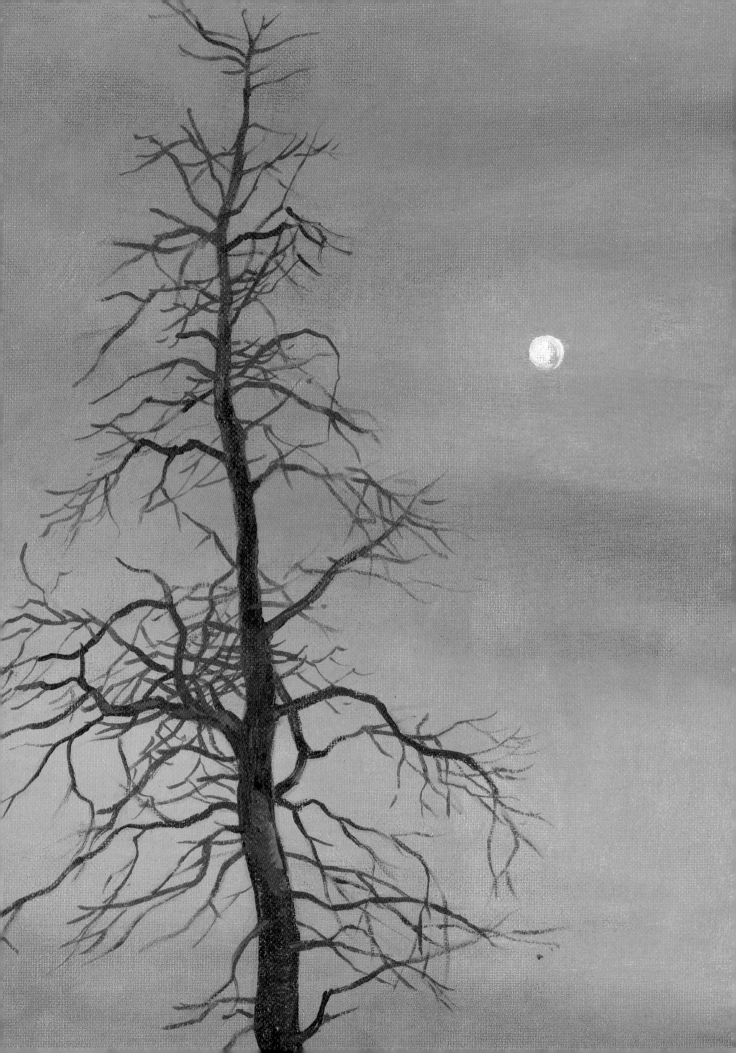

Using Texture and Bold Brushstrokes to Add Drama

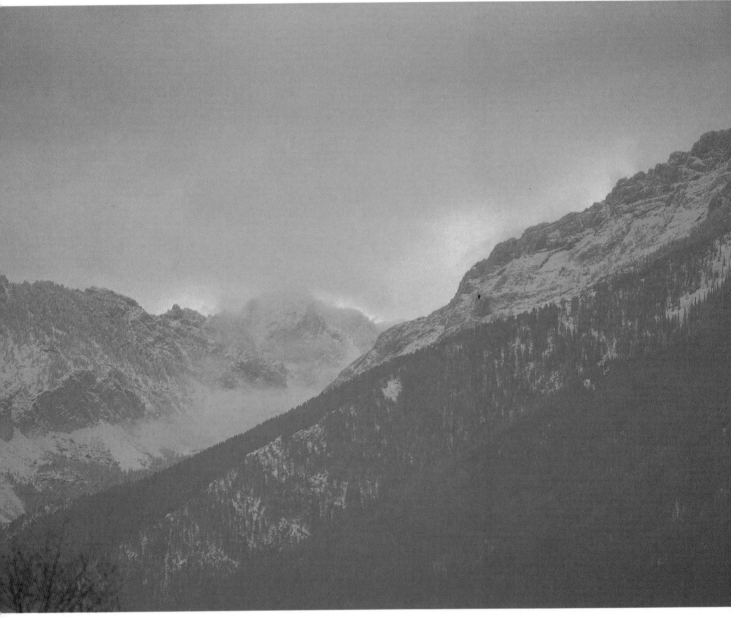

PROBLEM

This subject should be dramatic—after all, it's made up of majestic mountain peaks. The subdued light, though, produces a limited range of color and value.

SOLUTION

To add drama to your painting, emphasize the diverse textures of the mountains with bold brushwork. Next, exaggerate the darks of the mountains in the foreground to suggest the passing storm.

☐ Sketch the scene with soft vine charcoal, then reinforce your drawing with thinned color. Now quickly brush in the mountains with a bristle brush and a thin wash of paint. Keep the distant mountains light; make those in the foreground darker and more dramatic.

Once the basics are down, begin to use thicker, more opaque pigment. Start with the sky. Here

After a fierce autumn storm, light falls softly over a rugged mountain range.

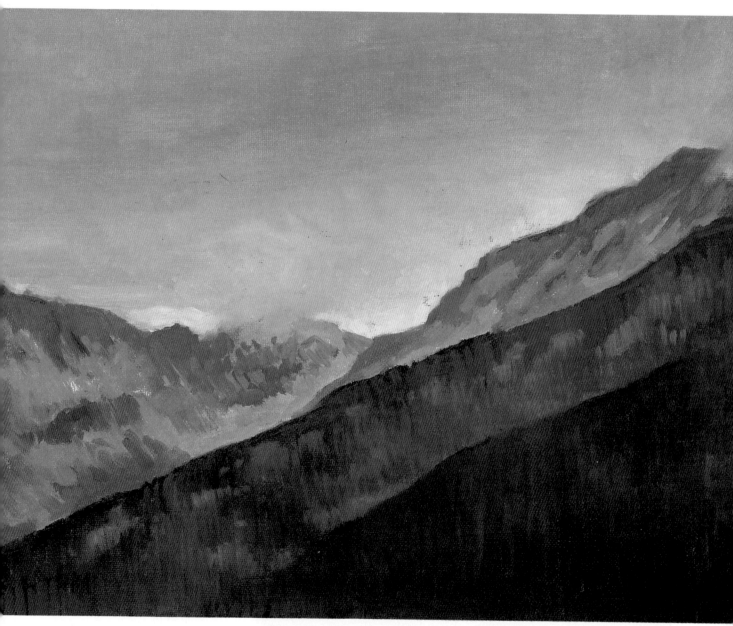

it's darkest at the top of the canvas and becomes noticeably lighter near the mountaintops—a device that effectively separates the peaks from the sky. Try using pale yellow for the light-filled strip; the yellow will stand out vividly against the blue. Take care, however, that your brush remains clean or you'll end up with green, not yellow. As you work, continuously wipe the brush off with a clean cloth.

Now develop the texture of the mountains. To suggest the patterns that the trees and snow form, work with short, brisk strokes. In the foreground, use crisp, vertical strokes and continue to keep your paint really dark; make the distant mountains paler and lay them in with looser, diagonal brushstrokes.

At the very end, you may find that you've lost the special feel created by the passing storm. If you do, try this: Add pale bluish-white paint to the lower part of the sky and pull the blue right over the central mountain peak. Right away, you'll see your work change; suddenly, it will seem as though a storm cloud has settled down softly, obscuring the distant peaks.

Discovering the Hidden Detail as the Sun Sets

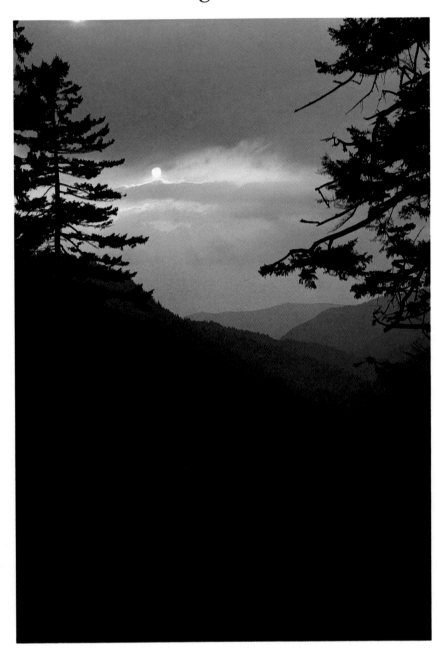

PROBLEM

When scenes are set in early evening, just as the sky darkens, it's easy to emphasize the drama of the setting sun and to treat the land superficially. If you do, your painting may well end up looking flat and uninteresting.

SOLUTION

In your sketch and later in your painting, search for the forms that lie shrouded by the failing light. Keep them clearly defined throughout.

STEP ONE

At first, concentrate on the foreground. Search for whatever detail you can find, then sketch it clearly on your canvas with vine charcoal. Now dust off and fix the canvas, and redraw the scene with a brush and thinned color. Note how the foreground shapes are drawn with a dark wash; those further back are lighter, creating a feeling of distance even at this preliminary stage.

In the Smoky Mountains, hazy air hovers near the ground while the sky fills with soft color.

STEP TWO

Quickly lay in the entire painting with thin washes of color. For the time being, let the white of the canvas represent the lightest, brightest portions of the sky. As you develop the shapes in the foreground, try to create a sense of depth. Render the trees that lie in the immediate foreground with very dark washes, and those further back with lighter color.

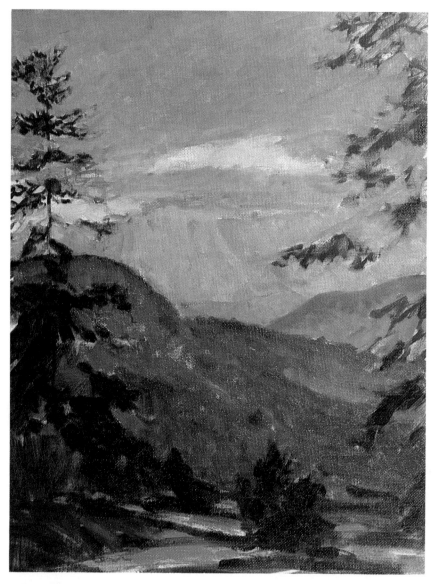

STEP THREE

Now start to use thick, opaque paint. Begin with the sky: It sets the scene's overall mood. Work wet-in-wet, beginning with the bright passages of pink and gold. As you lay in your blues, don't let the gold mix with them, or you'll end up with green. Once you're satisfied with the sky, turn to the mountains. Again, keep those in the foreground darker than those that lie further back in the picture plane.

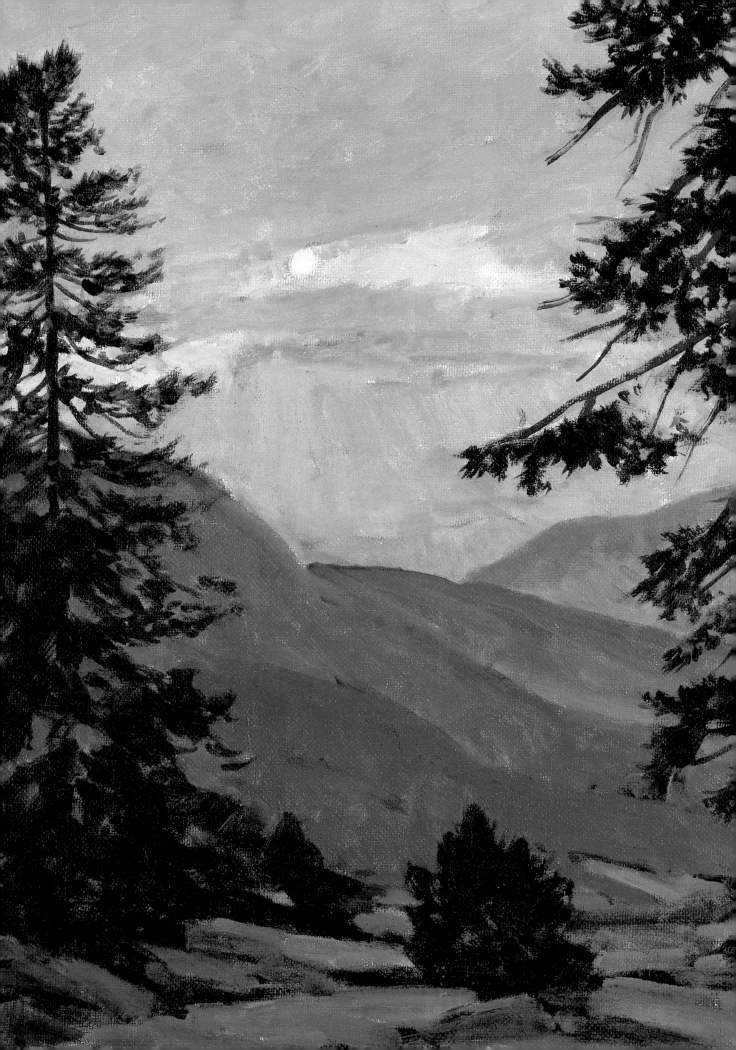

FINISHED PAINTING

At the very end, define the trees in the foreground, then build up the rest of the foreground.

DETAIL *(right)*

The trees in the foreground are rendered with a mixture of alizarin crimson and thalo green—a much more lively color than the black you might be tempted to use. The hills behind them are made up of alizarin crimson and cobalt blue.

DETAIL *(below)*

When yellow is placed right next to blue, it can be difficult to keep the yellow from becoming tinged with green. To avoid this problem, try this: After the yellow has been laid down, surround the area with a thin ring of red. When the blue is pulled close to the yellow, it will mix with the red, forming the interesting shade of purplish-blue that you see here.

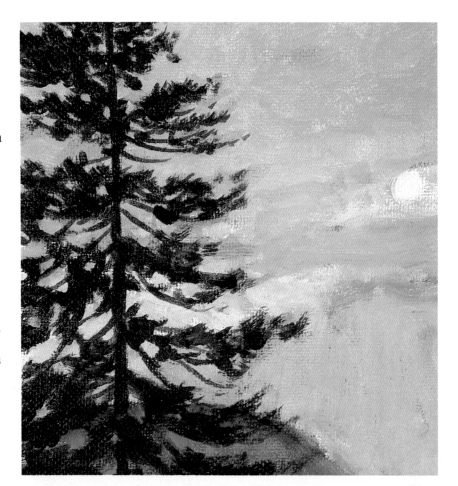

ASSIGNMENT

Effects like the one seen in this lesson are fleeting; within minutes, the sky changes and darkness veils the landscape. But just because these moments are fleeting doesn't mean you can't paint them.

Choose a subject that you know well—one that is near your home and that you've seen previously at sunset. While it is still light out, do all your preliminary work on the scene. Execute your sketch, develop the painting with thin turp washes, and even lay in portions of the composition with thicker paint. As you work, anticipate how the scene will change as night approaches. When the light begins to fade, paint rapidly. Quickly capture the configuration of the sunset, then adjust the values of the shapes in the foreground. You want them to be very dark, but to still have enough detail to make sense.

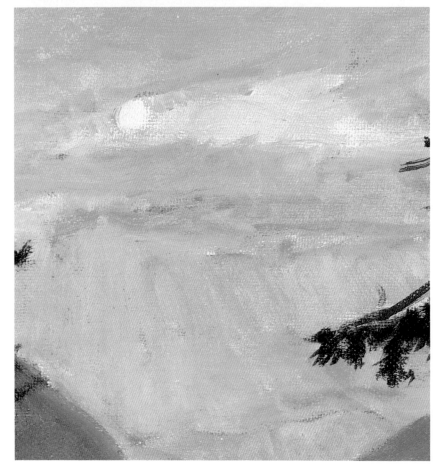

Capturing Forms Silhouetted Against a Hazy Sky

PROBLEM

This scene is dramatic, but there really isn't much interest in the foreground. The trees are silhouetted against the sky and become abstract shapes.

SOLUTION

Don't be too literal in your interpretation. Instead, try to separate the trees into different planes to create a feeling of depth.

☐ In your charcoal drawing, place the composition's main lines, then reinforce your drawing with thinned color. Separate the trees into different planes by using darker washes for the trees in the foreground and lighter ones for those further back. Now loosely brush in the sky with a wash of cadmium yellow.

When you start to develop the sky with opaque paint, add a touch of cadmium orange to your cadmium yellow. Feel free to lay in the pigment all the way down to the horizon; you'll paint the trees over the sky once the paint is dry. Don't make the sky too flat; use short, broken strokes to apply the paint, and keep the orb of the sun lighter than the rest of the sky.

Once the sky is down, turn to the trees. Start with those furthest back; to create a sense of distance, render them with almost pure orange and yellow. Now move forward and paint the trees in the middle ground. For them, mix a touch of yellow into brown.

Continue moving forward, gradually darkening your pigment. When you turn to the trees in the immediate foreground, use a dark, rich mixture of thalo green and burnt umber. To capture their crisp, sharp feel, apply the paint with a small sable brush.

At the very end, go back and add touches of yellowish-orange to the trees to suggest where the sky breaks through their foliage. That done, stop and evaluate the painting as a whole. You may find that some of the shapes seem soft and unfocused or that the shifts in color and value are too sharp. Here, for example, touches of orange were added near the base of the tree on the left to show how the bright tree in the distance is visible through the darker foliage.

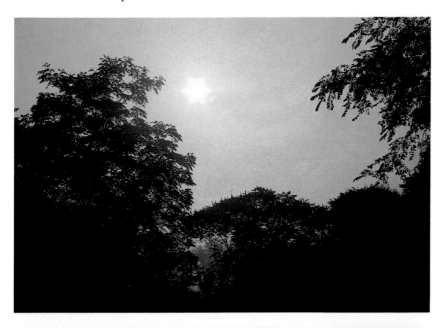

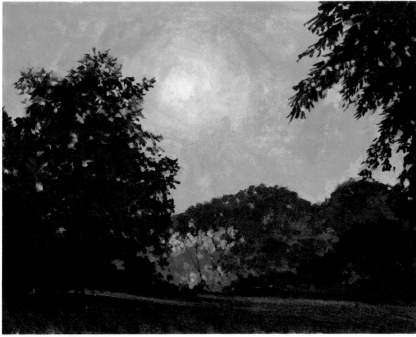

At sunrise, a warm, golden sky acts as a bold backdrop for this handsome grove of trees.

Using One Strong Element to Establish Space

PROBLEM

Once again, the light is hazy and diffused. Unless you are aiming for a flat, decorative effect, you'll have to find a way to give your painting focus and definition.

SOLUTION

Use the dark tree on the right to establish the immediate foreground. With that strong note down, it will be easy to set up the rest of the spatial relationships.

☐ When light is diffused, values are crucial, so, after sketching the scene, establish them right away in thin washes of color. Here yellow ocher forms the foundation for the sky, cadmium orange for the ground, and very light cobalt blue for the trees.

With the sky, begin using opaque paint. Break it up by using short, mosaic-like brushstrokes and warm and cool colors that have the same value. A mixture of warm and cool tones clearly conveys the feel of haze. Yellow ocher mixed with white is the most important color in the sky; in places, touches of cool, pale cobalt blue break up the dominant yellow. Use the same approach to render the distant trees, working with a mixture of white, Mars violet, and cobalt blue. With darker pigment, paint the small tree in the center of the painting. Since this tree is relatively close to the foreground, pick out its lines carefully. If the form is too soft, it will blend in with the trees that lie behind it.

Now lay in the ground, using short, vertical strokes. Start with burnt sienna and cadmium orange, then—as you near the bottom of the canvas—introduce Mars violet.

Turn to the tree. Break its color up by repeatedly mixing small batches of Mars violet, cobalt blue, and a little white. Begin with the trunk, using a small bristle brush; for the leaves, you'll need a small, round sable.

To paint the leaves, carefully dab small bits of pigment onto the canvas. Alternate medium-size strokes with tiny ones, and vary the hues that you use. Here there are touches of green and orange. What you're aiming for is a rich, lively blend of distinct and indistinct strokes—a blend that will fit in perfectly with the mosaic-like backdrop that you've created.

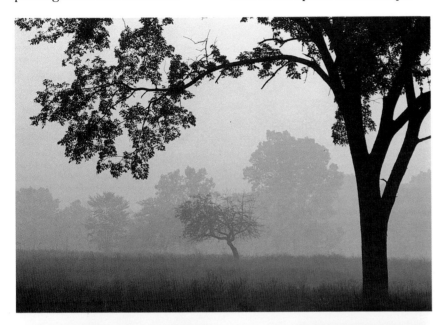

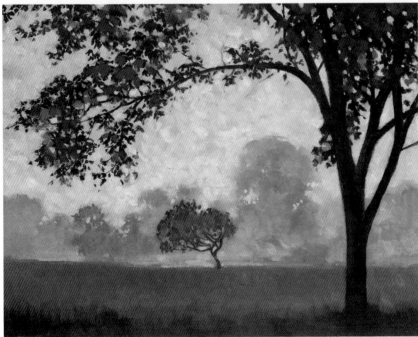

In autumn, haze steals across the land, obscuring the trees that lie in the distance.

231

Capturing the Delicacy of a Hazy Summer Morning

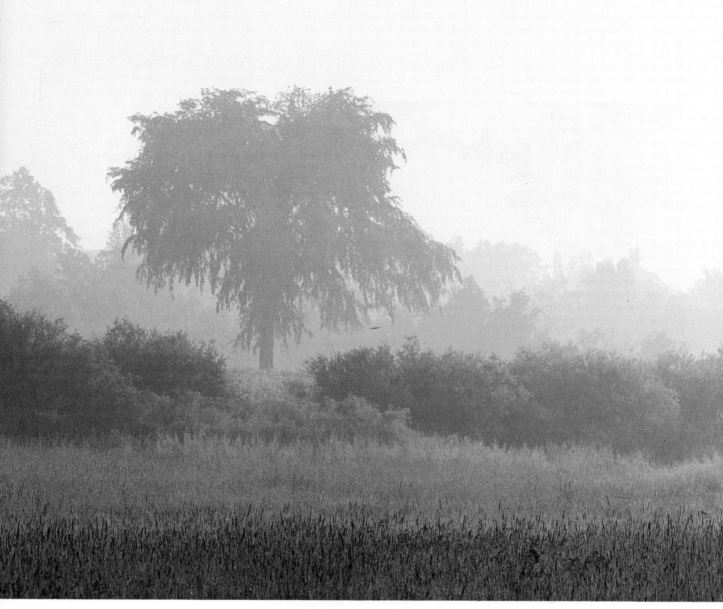

PROBLEM

The haze that envelops this scene softens the edges of the trees and reduces the strength of their colors. Yet you don't want to lose the landscape's distinctive look.

SOLUTION

To capture the particular character of this scene, let a careful drawing guide you as you paint. As you proceed, keep all the edges soft and use a very limited range of color.

☐ Carefully sketch the scene; pay special attention to the dominant tree. Now dust your drawing off, fix it, and reinforce it with a small sable brush that has been dipped into thinned color.

Continue using thin washes of color as you build up your painting. Begin with the dark shape of the central tree, here rendered with a combination of ultramarine blue and raw sienna. Use the same mixture to paint the low shrubs that hug the ground.

Move backward now, gradually making your washes lighter and lighter. When you have established a convincing sense of space, turn to the foreground and quickly lay in the grass with a wash of yellow ocher.

Now begin to use opaque pigment. As you work, move quickly and don't let your pigment dry. If it does, you may be left with sharp, harsh edges that will detract from the misty, soft feel that you are trying to achieve. Using

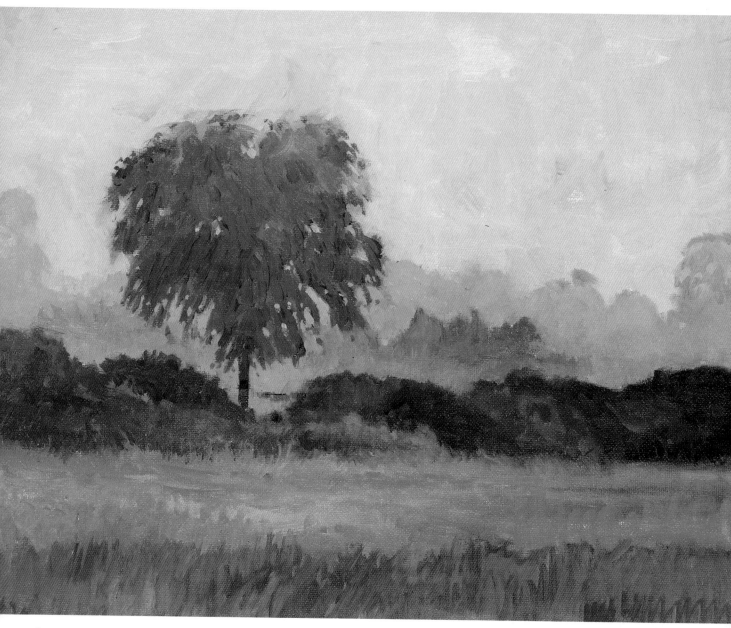

the same basic colors that you employed in your washes, go back and develop what you've begun.

As you paint, use loose, fluid brushstrokes; everything must stay as soft as possible. Once again, begin with the tree, then turn to the shrubs and the vegetation that lies beyond them. When those are built up, lay in the foreground with yellow ocher, permanent green light, and raw sienna. Use short, vertical strokes to render the grasses and don't be too fussy—what you want is a general impression, not a view of every individual blade of grass.

Next, lay in the sky with a mixture of permanent green light, yellow ocher, and white. The yellow ocher not only warms the green, it also suggests the sun that lies behind even the most hazy of skies.

When you've completed the sky, go back and break up the masses of distant trees by adding touches of yellow to them. Next, adjust any shifts in value that seem too abrupt or any shapes that seem too sharp or too soft.

In the finished painting, the low-lying bands of trees and shrubs create a calm, peaceful feel, and the horizontal strips of grass reinforce this gentle effect. The only accent note is furnished by the carefully painted central tree.

Balancing Darkness and Light

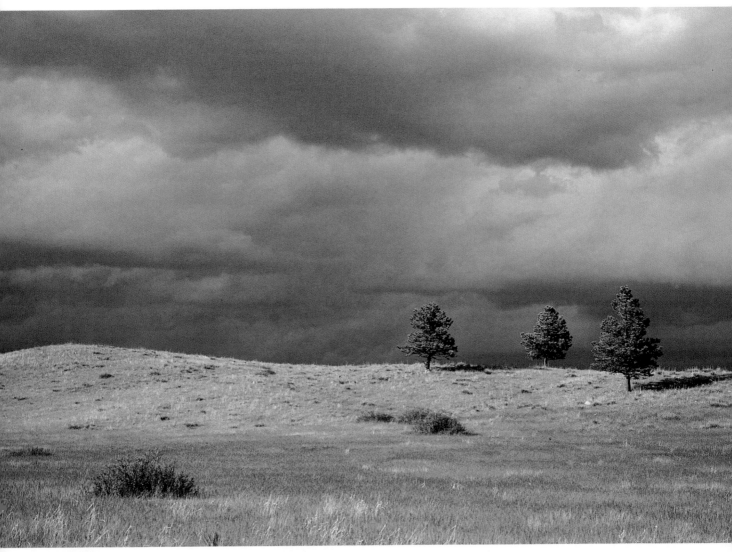

PROBLEM

The light-struck prairie seems oddly out of place here, set as it is against a dark, brooding sky. Making the two work together will be difficult.

SOLUTION

Exaggerate the contrast between the land and the sky. If the sky is dark enough and the ground light enough, you'll capture the drama of the scene.

Just before a summer storm, the rolling plains of a prairie are flooded with light.

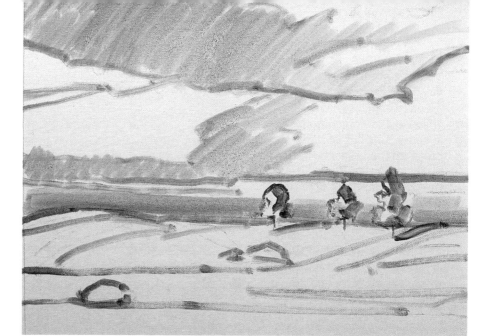

STEP ONE

When you encounter a composition as simple as this one, don't worry about sketching it carefully with charcoal. Instead, draw directly on the canvas, using a brush dipped into thinned color. Next, lay in the darkest portions of the sky with thin turp washes.

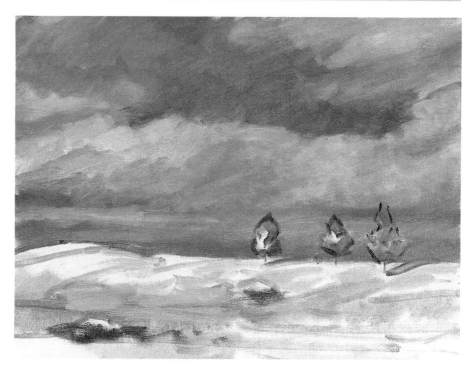

STEP TWO

Now begin to work with heavier color. Start with the sky; it will key the mood for the entire painting. As you put down your pigment, work quickly—the soft, fluid clouds must be worked wet-in-wet. Here cobalt blue dominates the sky; varying amounts of black and white darken or lighten it, and in places it is warmed with small touches of cadmium orange. The sky established, enrich the foreground with sweeps of thalo green and yellow.

STEP THREE

Before you develop the foreground, complete the sky. The touches of bright green that you have just laid in will help you gauge how dark the sky must be if it's to work. Continue working wet-in-wet; if the surface has dried, you'll probably have to rework the entire sky to keep the edges soft and to blend the subtle shifts in color and value. Once you are happy with the sky, turn to the foreground. Make your brushstrokes curl back over the hill, following the contour of the land as it dips into the horizon.

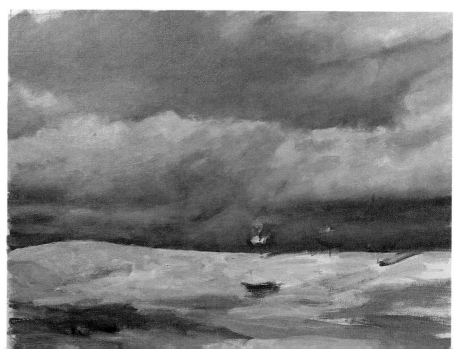

FINISHED PAINTING

With the dramatic sky completed, finish the foreground. Thalo green, cadmium yellow, and yellow ocher come into play here; in spots, touches of burnt sienna break up the brilliance of the bright yellowish-green. Next, add the trees that hug the horizon. Keep them small—their size gets across the vastness of the open prairie. Finally, use their shadows as a compositional device. Painted carefully, they show how the hill meanders upward, and how the land meets the sky.

Worked wet-in-wet, the sky is soft and fluid, without any sharp edges. Its stormy feel is captured through color; mixtures of black and white are cooled with cobalt blue or warmed slightly with cadmium orange.

The brilliance of the greens is exaggerated to set off the dark, gloomy quality of the sky. Touches of burnt sienna break up the bright-green tone that dominates the foreground; these strokes of brown sculpt out the shape of the hillside.

236

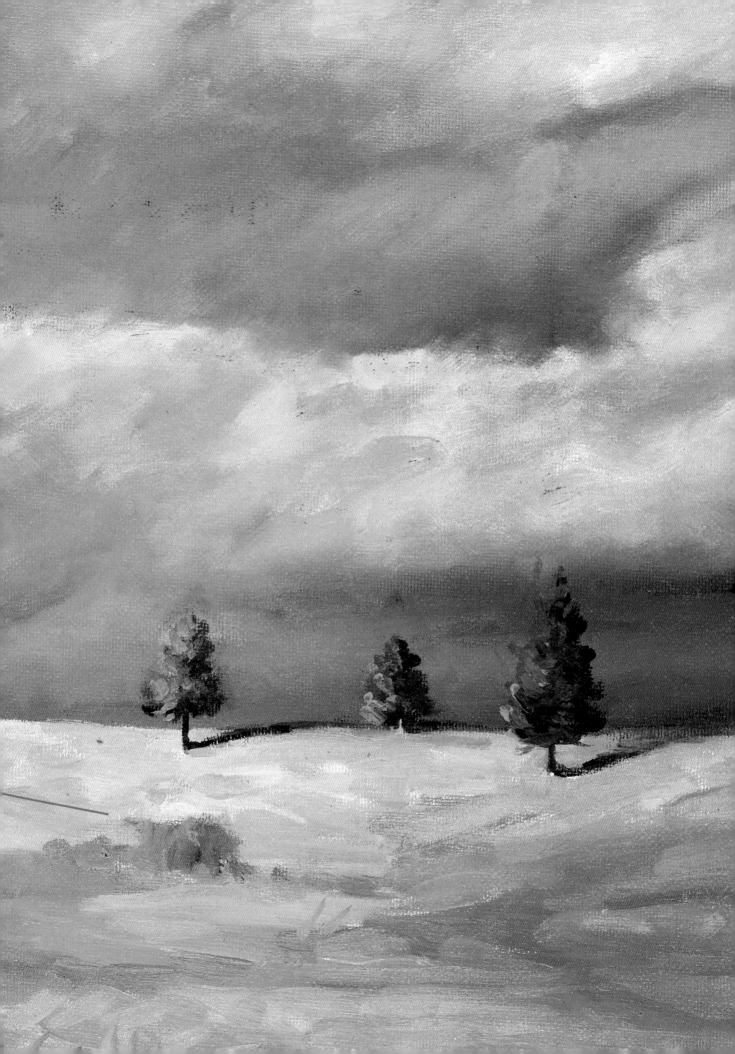

Constructing a Solid Underpainting

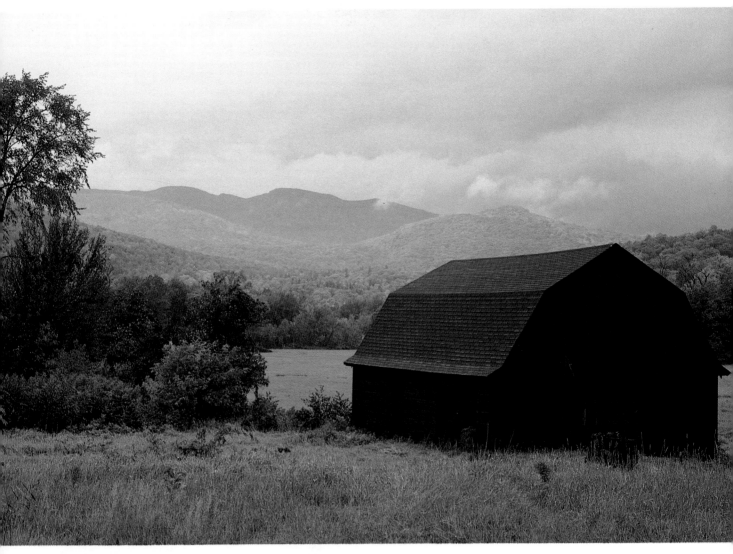

PROBLEM

Three distinct zones are present in this painting. Clear, even light bathes the foreground, storm clouds press down over the mountains in the background, and gentle mist washes over the middle ground. Your painting has to capture these different effects simultaneously.

SOLUTION

Capitalize on the clear division of space. Build up your underpainting slowly, carefully establishing each zone with thinned color. When it comes time to work with opaque color, you'll find it easy to complete your painting.

Bright green grasses surround a barn, setting off the cool colors of a stormy sky.

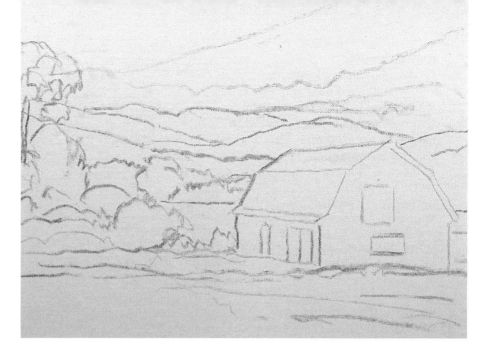

STEP ONE
Before you begin your sketch, carefully study the scene. Don't just study the obvious shapes—the barn, the mountains, and the trees and bushes—but the subtle ones as well. Try to discern the planes of the ground and the vague lines that define the clouds. When you are at home with the landscape, sketch it on your canvas with soft vine charcoal.

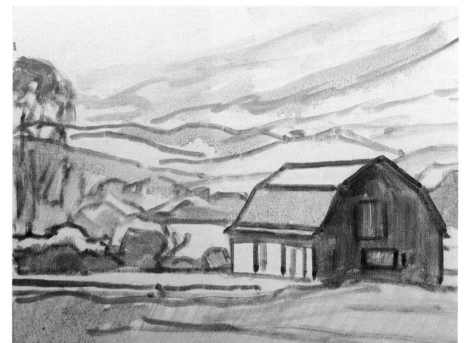

STEP TWO
Reinforce your drawing with thinned color, then continue to use thin color washes as you lay in the darks. For now, the white of the canvas can represent the lights. Even in this early stage, be conscious of shifts in color and value. Aim at getting as close to what you want to see in the final painting right from the start.

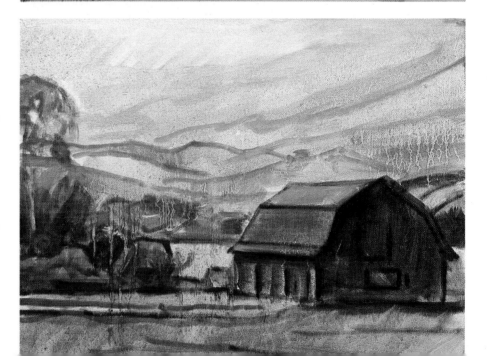

STEP THREE
You may be tempted to rush in with opaque pigment at this point—but don't. Instead, develop the entire surface with thin turp washes. You may find that your paint dribbles and runs when you are working with so much liquid, but don't worry about it. Concentrate on the overall color and value schemes. If portions of your drawing have been lost as you laid in the color washes, redraw them with a small sable brush.

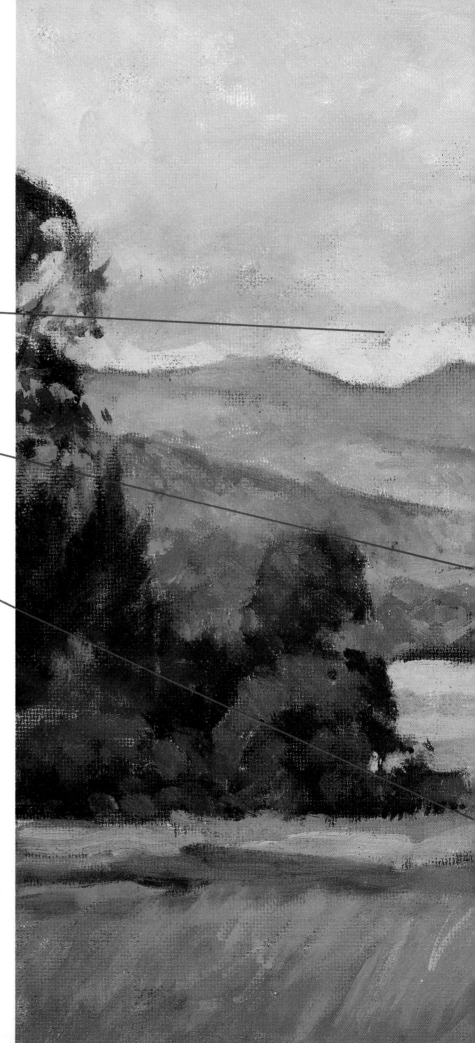

FINISHED PAINTING

It took patience to develop a complex underpainting, but now you are ready to reap the rewards that this approach offers. You'll be surprised at how quickly the painting advances when you begin to lay in opaque pigment. As you work, remain faithful to your underpainting. You've established your values—minor adjustments are all that will be necessary. What's more, your colors are well developed, too.

The clouds and distant mountains are soft and unfocused. From the very beginning, they were handled more loosely than the foreground and middle ground. And, unlike the other areas in the painting that are rendered with bright color, smoky grays and cool blues are dominant here.

When one element is as prominent in a painting as this barn is, start work on it right away. Carefully decipher its lights and darks, then slowly build them up. If you save a building for the very end, the chances are that it will look out of place in your painting and that it won't relate to the rest of the work.

Bright, vivid color dominates the foreground: It's made up of permanent green light and yellow ocher. Laid in with quick, upright strokes, the tall yellow grasses spring forward and make it easy for the viewer to enter the picture space.

ASSIGNMENT

Try this approach with one of the other compositions in this book. As you paint, forget for a while that your medium is oil paint: Think of it as watercolor. You'll be forced to solve problems in value from the very beginning and you'll become increasingly conscious of the importance of color.

Once you are comfortable with this method, try it outdoors when you are faced with a difficult composition. You'll soon discover that the pains you take initially are well rewarded in the end.

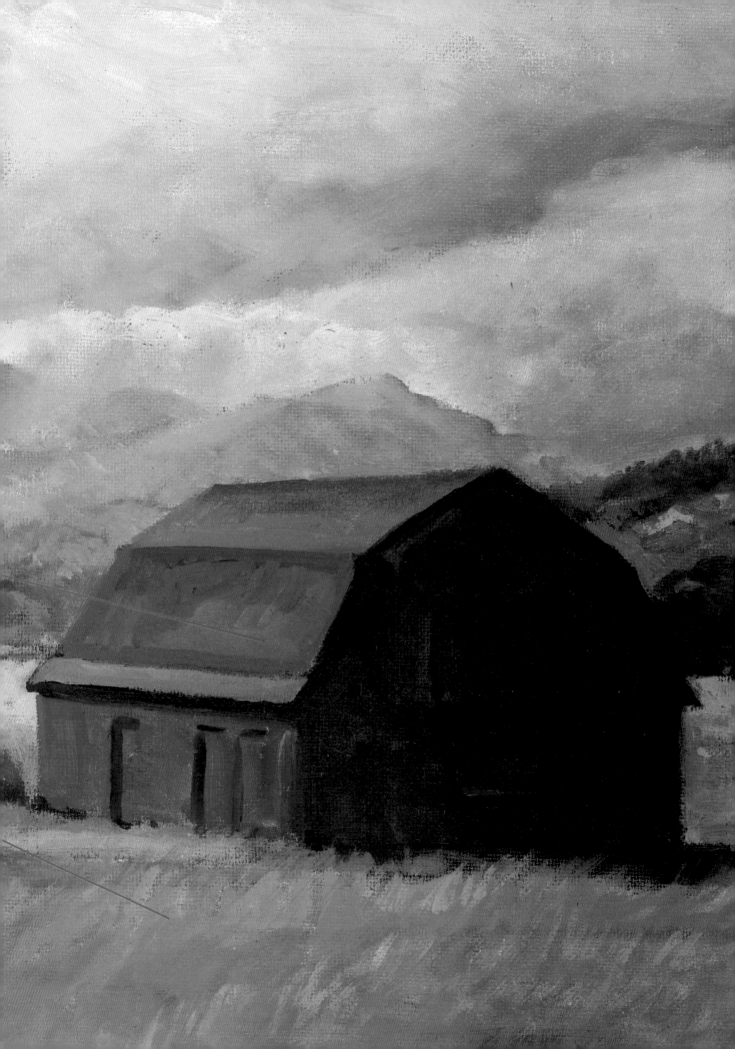

Making the Unusual Believable

PROBLEM

It's not often that you see scenes like this one. Except for the sliver of light along the horizon, it's made up of dark, brooding tones.

SOLUTION

Start with the most dramatic element, the sky. Keep its color very dark, then use it to gauge the rest of the values in your painting.

☐ With a small brush moistened with thinned color, lay in the composition. Now turn to the sky, working with opaque color. In one painting session, try to capture the effect that you want for the sky in the finished painting.

Here cobalt blue and cadmium red were mixed repeatedly together in small batches, then applied to the canvas. The shifts in color and value that result are slight, yet they animate what could become a dead, lifeless area.

Next, take a fan brush and run it over the surface of the canvas.

The foreground requires more care. Build it up slowly, introducing as much variety as possible. To link the ground to the sky, choose cobalt blue as your base. Break the blue up with touches of thalo green and yellow ocher, concentrating all the while on the contours of the ground. Downplay the patch of light that runs along the horizon; if it is too conspicuous, it won't be believable. At the very end, add the fence posts that march back toward the horizon.

When one color dominates a large portion of a painting, the rest of the work may seem unharmonious. That happened here. To tie the land into the sky, try applying blue glaze over the shadowy areas of the foreground. Let the painting dry, then mix a moderate amount of color with a good deal of painting medium. Freely brush the mixture over the shadows that play across the ground.

In the finished painting, the blue glaze applied at the very end links the prairie to the dark, dramatic sky, and the sliver of light that creeps along the horizon is bright, unexpected, and full of life.

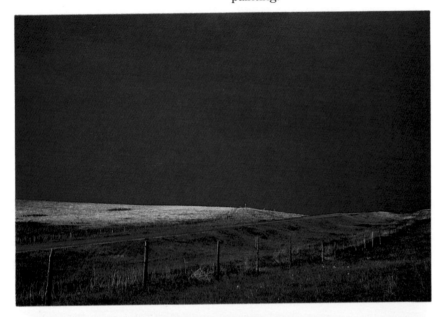

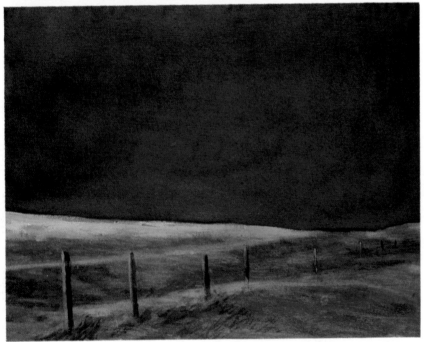

In South Dakota, a patch of light steals down upon a prairie as a dark and dramatic sky signals the approach of a summer rainstorm.

Learning How to Emphasize the Sky

PROBLEM

The sky is what matters here—
it's streaked with subtle yet
glorious color. But unless you are
careful, the dark foreground may
become the focus of the painting.
Because it's so dark, it can easily
overpower the delicate sky.

SOLUTION

Make the clouds as interesting
and lively as possible, then paint
the ground a bit lighter than it
actually is. With the ground light-
ened, the sky will dominate your
painting.

☐ Once again, the subject is sim-
ple and there's no need for a
careful charcoal sketch. Instead,
draw directly on the canvas with a
brush that has been dipped into a
thinned color. Continue working
with thin washes of color as you
lay in the darkest areas in the
painting.

Once your thin underpainting is
well developed, switch to opaque
pigment. Use a wet-in-wet ap-
proach to render the sky. Near
the top of the canvas, make your
colors blend into one another. As
you approach the horizon, lay in
stronger bands of color.

Study the foreground carefully
before you develop it. Pattern
matters here; it will break up the
dark, dense ground and make it
less oppressive. Exaggerate all
the nuances that you see; what
you are aiming for is a lively feel.

When the foreground is down,
you'll no doubt need to return to
the sky, to balance it against the
powerful darks that you have just
laid in. If it seems too light,
darken it a bit, but don't get too
fussy. As a final step, sharpen up
the area where the land meets
the sky. A clear, crisp horizon line
will pull the two areas apart
neatly.

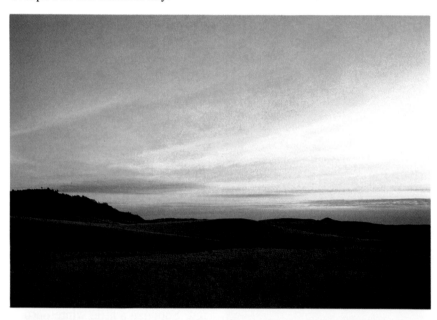

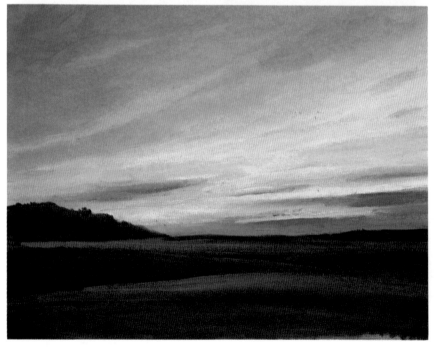

*Streaks of pale, luminous color
shoot through a cool winter sky.*

Laying in a Dark Yet Lively Sky

PROBLEM

When scenes look as simple and straightforward as this one does, it's easy to become lazy. If the sky becomes too flat, or the trees too simplified, your painting won't look realistic.

SOLUTION

Break up the sky with slight variations in color. When it comes time to paint the trees, carefully portray their individual character and keep your paint fluid so that it can glide easily over the canvas.

☐ Execute a careful charcoal drawing, then spray it with a fixative. Now lay in the sky with thin turp washes. Start at the top of the canvas, using a wash made up of cobalt blue and alizarin crimson. As you approach the horizon, gradually introduce cadmium red into your wash and reduce the amount of alizarin. Right near the horizon, add just a touch of cadmium orange. Don't worry if your wash runs and streaks during this stage; you'll eventually cover this.

When the sky is laid in, quickly brush thinned color—Mars violet and cobalt blue—over the foreground. Then reinforce your drawing of the trees with thinned color. Keep the color really dark; it has to show through when the sky is overpainted.

Now prepare your palette for the execution of the sky. You'll need the same colors you used for your preliminary underpainting. Squeeze a little white onto your palette as well. Mix small amounts of color repeatedly, not one big batch when you begin.

Starting at the top of the canvas, lay in the sky, working wet-in-wet and from light to dark. Paint right over the trees; you've reinforced the drawing so they won't become lost. Next go back and lay in the gently rising mist with a mixture of cobalt blue and alizarin crimson. Now paint the dark foreground, using Mars violet and cobalt blue. To render the long, thin tree branches, you'll need fluid pigment, so thin your color—here Mars violet and cobalt blue—with plenty of painting medium.

Paint the trees with a small sable brush, using long, unbroken strokes. Most important, be faithful to what you see: If you start to embellish the patterns of the branches, you'll lose the realistic look.

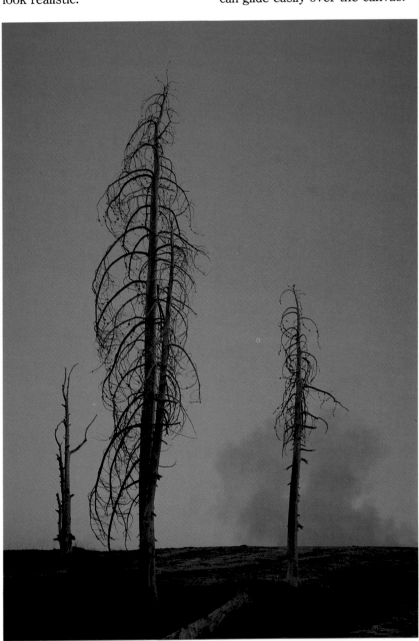

In Yellowstone Park at twilight, tall, thin lodgepole pines stand silhouetted against a cool purple sky as mist from a geyser rises behind them.

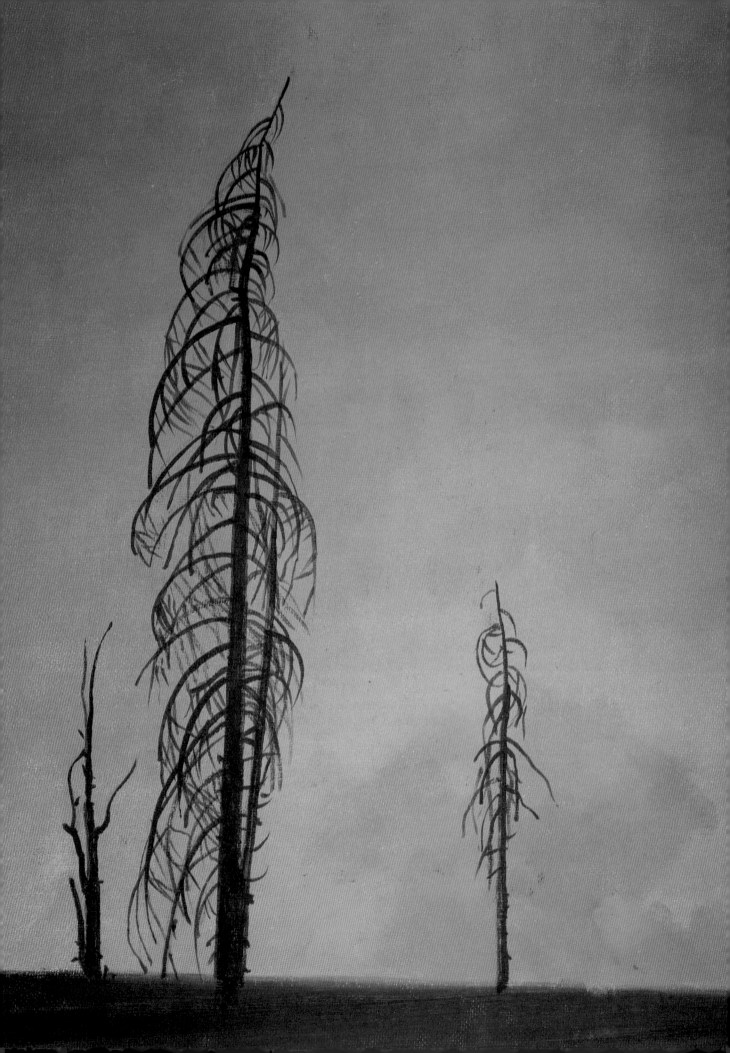

Deciphering a Landscape Partially Hidden by Fog

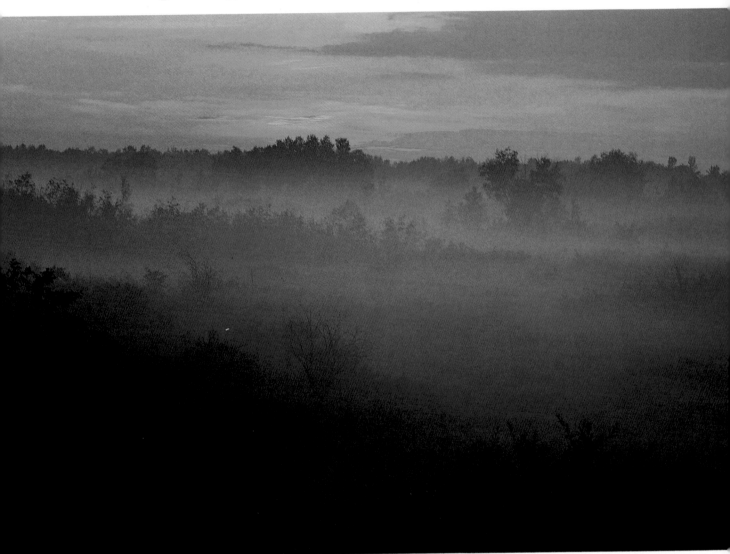

PROBLEM
Simply stated, this subject will be difficult to capture because you can't really see what you are painting: Delicate, misty fog covers most of the landscape.

SOLUTION
Simplify the major shapes in the composition, but keep them sharp enough to suggest what lies behind the fog. You'll have to use your imagination because the mist obscures most of the forms in the foreground.

As the sun slowly sets on a summer evening, soft fog floods a valley.

STEP ONE

Since there isn't much to grab onto here, don't try to capture the scene with a preliminary charcoal sketch. Instead, work directly with a small sable brush. Concentrate on the patterns that lie in the sky and the lines that separate the tree tops from the fog. Don't let your drawing become too complex; deal with overall patterns and shapes.

STEP TWO

As you begin to establish the dark patterns that run throughout this scene, paint them with very dark washes. Remember that anything you lay in at this stage is bound to look dark against the white of the canvas. To capture the indefinite feel of fog, scrub the paint onto the support with a bristle brush; the weave of the canvas will mimic the softening qualities of the mist.

STEP THREE

Move to the sky. Work back into it with thicker pigment, using long horizontal strokes to trace the shapes of the clouds. If the darks that you have already laid down are strong enough, the lights that run through the sky should be easy to capture. Next, suggest some of the foggy foreground by applying color, then pulling it down over the canvas.

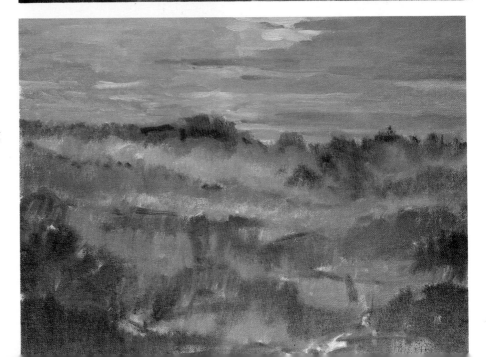

FINISHED PAINTING

As you move in to complete the foreground, let the sky key the painting's overall mood. Judge each value in relation to what you have already established in the sky. Continue working with a bristle brush, scrubbing paint onto the canvas; the soft, undefined feel that results is perfect for depicting fog. Don't let your color become too light: The foreground is much darker than the sky.

At the very end, take a small sable brush and define the area where the trees meet the sky. This sharp edge is important—it emphasizes the soft feel of the fog.

The sky is what anchors the whole scene—everything else is softened by fog. And because soft mist permeates the land, it's easy to make the sky soft, too. When you are faced with this kind of situation, play up the contrast between the two moods. Make the sky sharp and definite, laying it in with long, forceful strokes.

When you start to work on the hills, don't let your paint become too thick. The secret to capturing a gentle, misty feeling is scrubbing the paint on thinly over the canvas. When you scrub paint onto canvas, it breaks up any strong, thick passages of pigment.

248

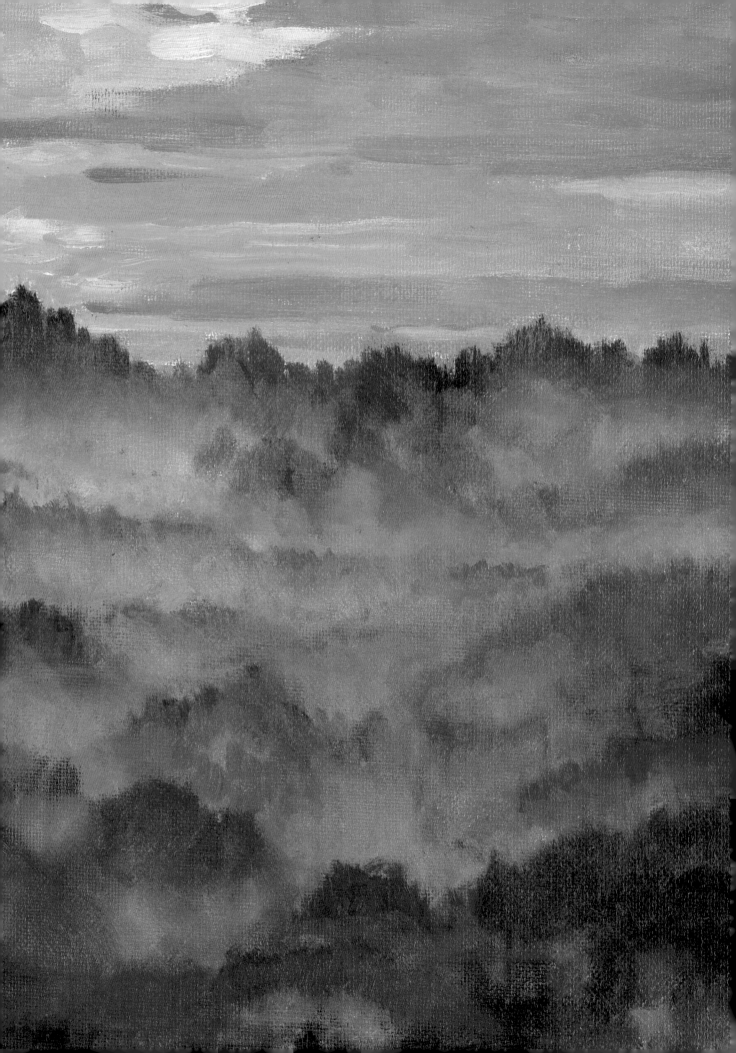

Making a Dark Foreground Spring to Life

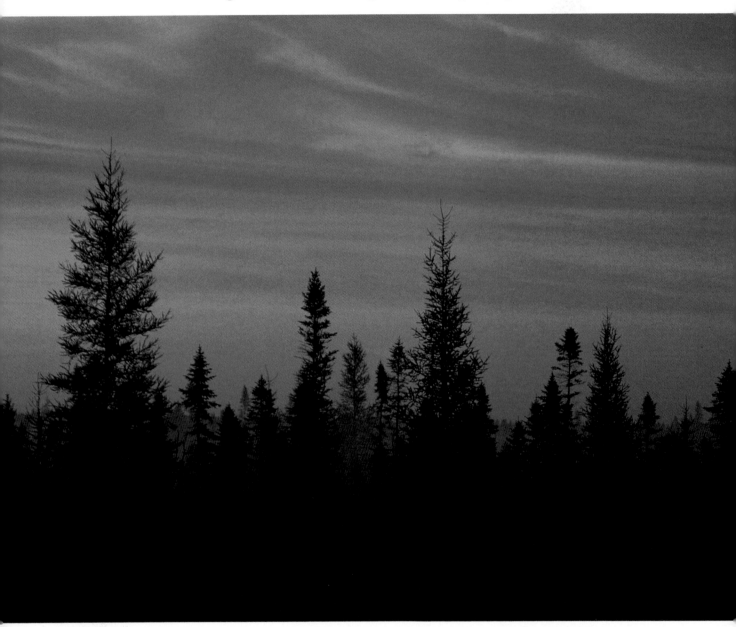

PROBLEM
The entire scene is hushed and dark. If your painting is too faithful to what you see, it will be too dark and forbidding.

SOLUTION
The key to animating a dark, flat foreground is to inject life into its darkest corners. Use subtle touches of color to break up the monotony of the trees.

☐ Sketch the scene with vine charcoal and apply fixative. Working with thin washes of color, lay in the patterns that sweep through the sky. Use thin washes to establish the darks that lie in the foreground.

Now that you've established the foundation of your painting, start to use opaque pigment. Slowly work back into the sky, moving from dark to light. At first, paint the dark patterns with a mixture of cobalt blue and

cadmium red. Once they're down, brush in the lighter areas of sky lying between the dark bands and below them. Don't add too much white to your pigment; if you do, you'll lose the intense color that pervades the sky. And be sure to cover portions of the sky that lie between the trees; it will be difficult to go back to them later and still achieve the soft, fluid effect that you want.

Now comes the step that matters most: Paint the trees. You'll

Brilliant bands of deep red spill out across the sky, boldly silhouetting tall, handsome spruce and tamarack trees.

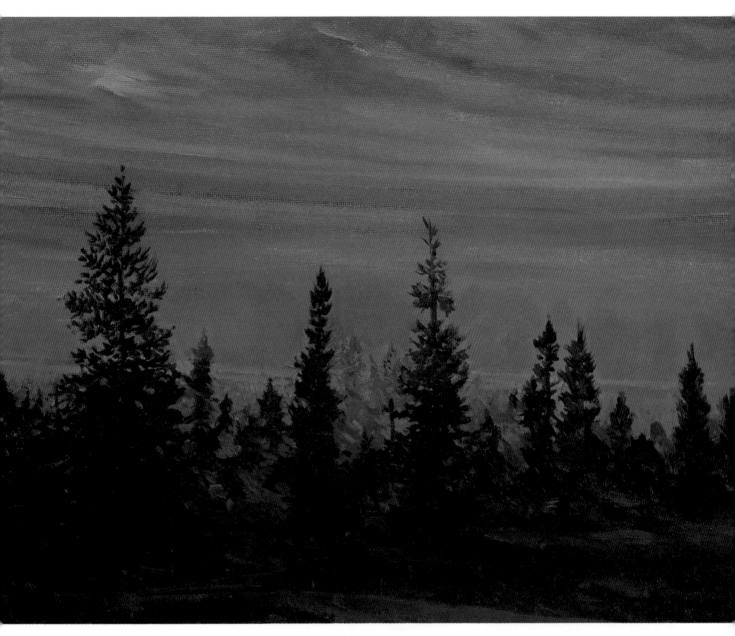

need the following colors: thalo green, alizarin crimson, cobalt blue, cadmium red, and white. Start by sweeping a pale blend of cobalt blue and alizarin over the entire foreground with a medium-size bristle brush, then slowly build up individual trees with a small sable brush.

As you work, remain conscious of the distinct layers that the trees form. For the background trees, continue using cobalt blue, alizarin crimson, and white; grad-

ually decrease the white as you move forward. When you reach the trees closest to the fore-ground, substitute thalo green for the cobalt blue. Continue working with a small sable brush—one that can pick out the individual silhouettes of each tree.

When you've established the silhouettes of the major trees, break up their dark bodies with small touches of strong color— the same hues that you used in the sky. Try mixing alizarin crim-

son with a little thalo green, then gently dab the color onto the canvas. Pick out the highlights that would be there if the fore-ground were lighter and brighter.

At the very end, evaluate how successfully you have established the different planes. The trees in the foreground should be darker and more strongly developed than those that lie further back. If the distant trees seem to meld to-gether with those closer to you, make them softer.

Learning When to Lay in Your Darkest Values First

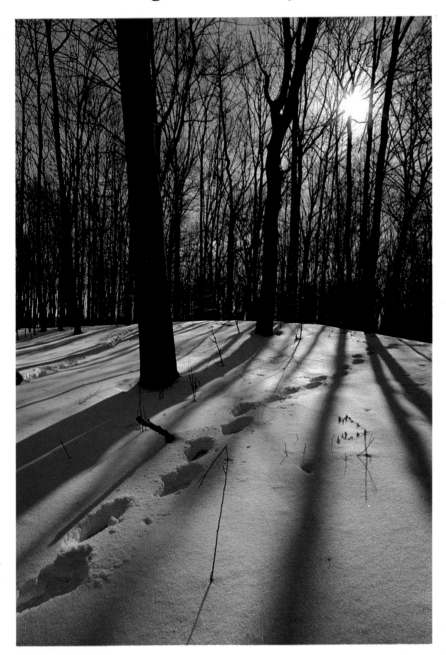

PROBLEM

There's so much action in the trees that the special feel of the cool morning sky might easily be lost. And if you lose it, you'll lose the glowing quality that makes this particular scene special.

SOLUTION

It's tempting to lay in the sky first, then to concentrate on the trees. But if you do, the sky may end up too light or too dark to offset the power of the trees. Try a different approach: Establish a few of the major trees, then move on to the sky.

STEP ONE

In your preliminary charcoal sketch, concentrate on the shapes of the largest and most important trees and on the shadows that spill across the snow. Once they're down, reinforce your drawing with thinned color.

On a cold, crisp February morning, sunlight breaks through a stand of trees and illuminates a deep blanket of snow.

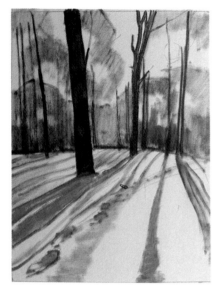

STEP TWO
Working with opaque color and very little painting medium, establish the trees that dominate the scene and the shadows that they cast. Scrub your pigment onto the canvas with a bristle brush; even though the color is opaque, it shouldn't be too dense. Now, working with paler color, lay in the overall shapes of the finer branches and twigs that make up the trees in the background.

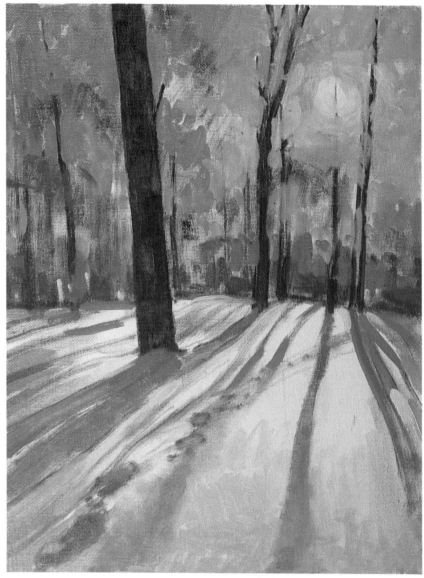

STEP THREE
Paint the sky through and around the tree forms that you have started to establish. Use fluid pigment and soft strokes that suggest the dappled quality of the light. Before you move on, turn to the broad shapes of the background trees. With a drybrush technique, soften their edges against the sky. When the sky has been painted, you'll find that small adjustments in color and value are necessary to make the snow and the shadows realistic. Adjust the shadowy portions, but for now, let the white of the canvas continue to represent the lightest areas.

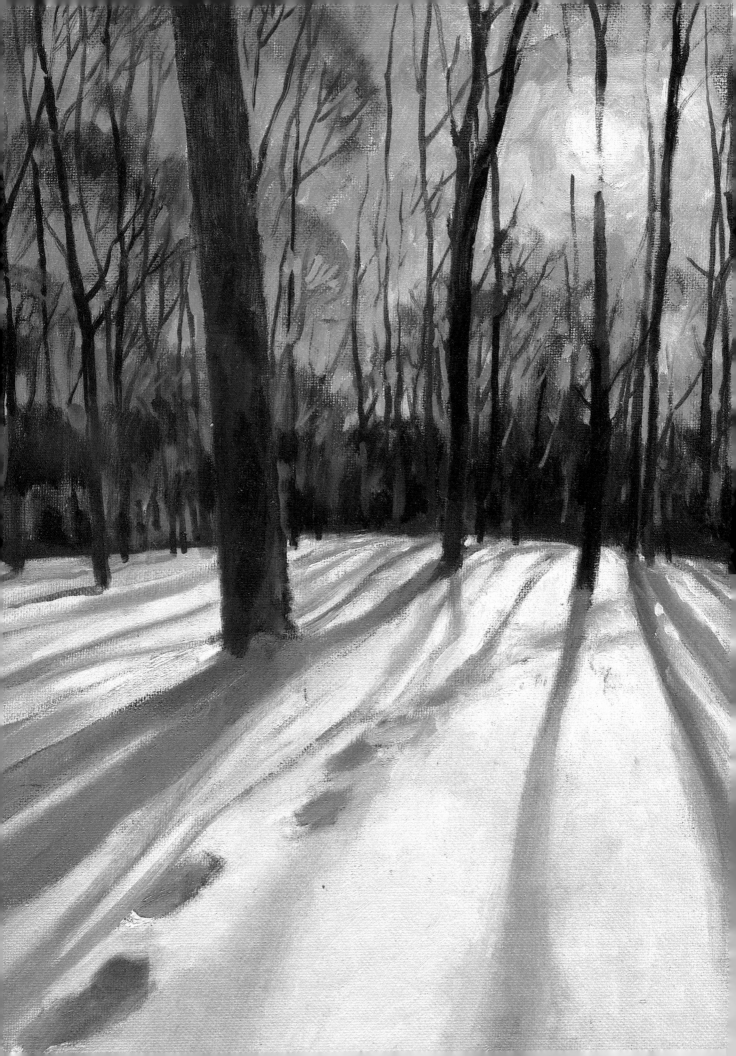

FINISHED PAINTING

At this point, all the hard work is done. The values are right, the perspective is clean and sharp, and the warm and cool colors are well established. It's time to have fun. Take a small sable brush and develop the twigs, branches, and trunks that dominate the scene.

At the very end, cover the snow-blanketed areas with a mixture of blue and white, then blend the light areas into the darker portions of the ground.

DETAIL (right)

Note how the trees and the sky weave together. Working back and forth between the trees and the sky results in a natural, unstudied effect.

DETAIL (below)

The cool blue shadows that rush forward were among the first elements painted. Along with the dark trees, they key the value scheme for the entire painting. More than just that, they direct the eye back toward the horizon and the sky.

ASSIGNMENT

It's easy to think of snow as white—after all, that is its basic color. However, snow is actually made up of many different colors, colors that the sky determines.

In winter, go outside and make quick color sketches of snowy scenes. Plan to do this assignment over several days, or at different times of day, so you can work with a variety of conditions. When the sky is cool you'll probably find that the snow seems bluish or even gray. On bright, sunny days look for touches of unexpected color—reds and yellows—in the snow.

After you've experimented with color sketches, try executing a major oil painting. Force yourself to apply what you've learned: Don't let pure white figure in your painting. Instead, use pale blues, purples, grays, yellows, and reds.

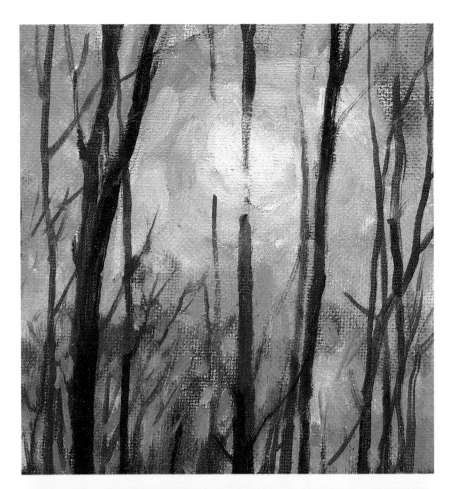

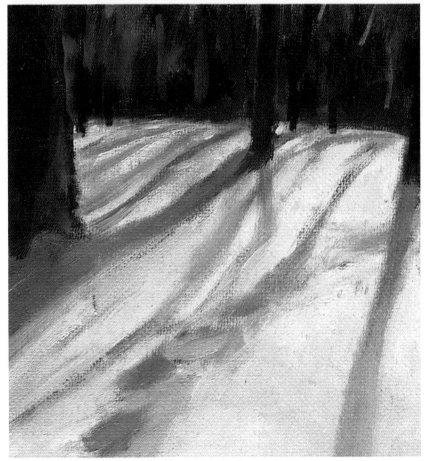

Using Glazes to Pull a Painting Together

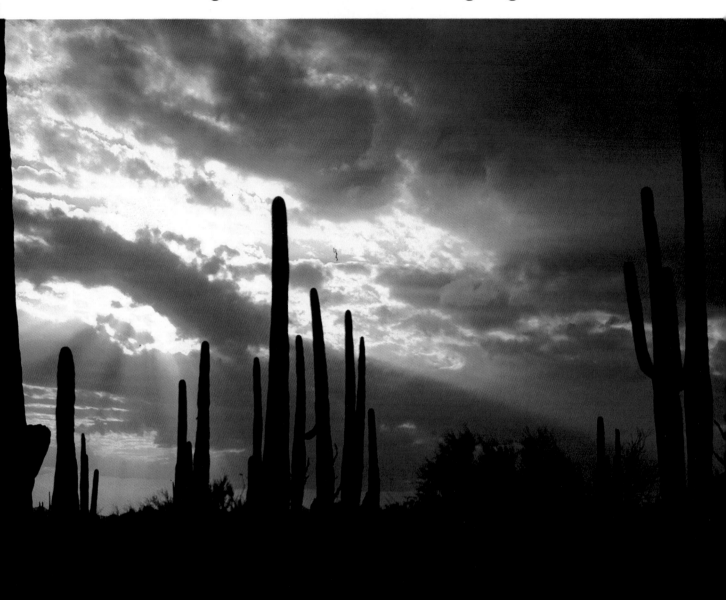

PROBLEM

This scene is mostly made up of darks, but the lights are what make it exciting. It will be important to capture the bright sun that lies behind the clouds.

SOLUTION

Keep the clouds and the surrounding sky really dark. Then, when you add the bright patches of light, the contrast between the two will be sharp and vivid. Finally, pull the sky together with a thin application of glaze.

☐ Sketch the scene with charcoal, dust off and fix the canvas, then reinforce the lines of your drawing with thinned color. In your sketch, concentrate on the patterns formed by the clouds. Don't get caught up with the cacti; their forms are very simple and can easily be added toward the end.

As soon as your preliminary work is complete, begin to paint the sky. Take a medium-size bris-

As the sun sets over the Sonora Desert, thick, heavy clouds race across a dramatic gold sky.

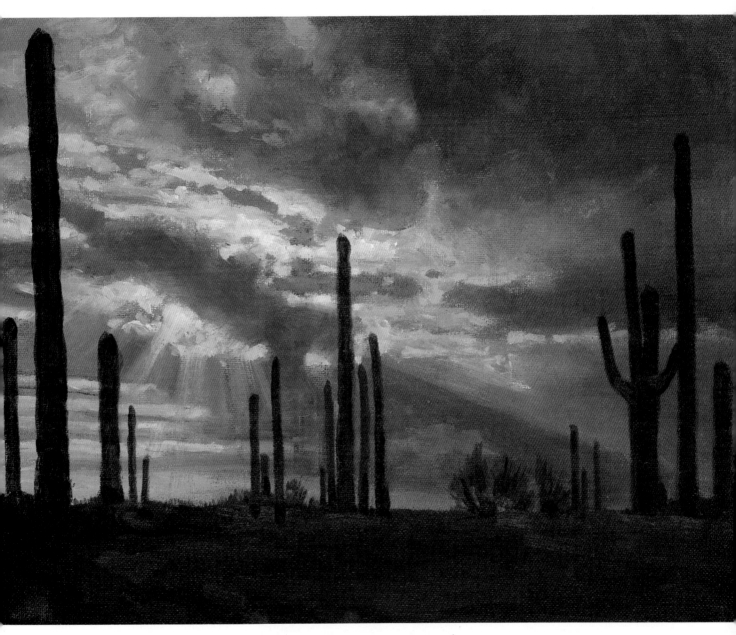

tle brush and opaque paint and scrub in the darks of the clouds. Here they are rendered with mixtures of yellow ocher and Mars violet.

Before you lay in the lights, cover the entire sky with a warm glaze of yellow ocher and cadmium orange. The glaze will pull together the dark clouds and tone the white portions of the canvas, making it easier for you to gauge your values. While the glaze is still wet, paint the light areas of the sky and the light-struck edges of the clouds. Use a wet-in-wet approach to keep the sky soft. Cadmium yellow and white come into play here; in places, cadmium orange is added to the yellowish pigment to give the lights warmth and depth. When the basic lights are down, paint the bands of sunlight that break through the lower clouds at the left by dragging light paint down.

The rest of the procedure is simple. Add the cacti, using warm, rich darks made up of Mars violet and cobalt blue. Keep as much variety as possible in these darks by mixing several small batches of color rather than one large one. Don't feel obliged to paint each and every cactus. Here, only the major plants work their way into the painting; if more were present, the drama of the scene would be diminished.

Capturing the Brilliance of the Setting Sun

PROBLEM

Ths sun is always difficult to paint. Whenever it appears in a painting, there is a tendency to paint the sky too light. And if the sky is too light, you'll lose the contrast that makes the sun seem brilliant.

SOLUTION

Consciously exaggerate the darkness of the sky. As you paint, remember how deceptive your first strokes are. Set against the white of the canvas, the color you are laying in seems much darker than it actually is.

☐ Establish the anatomy of the trees in a charcoal sketch, then dust off the canvas, leaving just enough of the drawing to serve as a guide as the painting develops. Spray the canvas with a fixative.

With thinned color, brush in the sky and establish the dark patterns that lie in the foreground. Don't let the foreground become too flat; break it up with shifts in value and color and separate it into distinct planes.

Now work back into the sky with opaque color. With broad, sweeping strokes work from the edges of the canvas toward the sun. Keep your color dark— darker than you think it should be. Near the sun, make it slightly lighter, but don't add white to your pigment. Even the smallest touch will diminish the brilliance that you want to achieve.

Before you paint the sun, build up the foreground, painting the trees up over the sky. Continue to break the trees into distinct layers; those in the distance are softer and less distinct than those in the middle ground or the foreground.

To paint the large tree that dominates the foreground, use a small sable brush that has been moistened with just a small amount of pigment. The broken strokes that result when you work with a slightly moist brush are perfect for depicting leaves and branches.

Finally, paint the sun. Here it's rendered with white and cadmium yellow. Don't mix the two colors completely; flecks of yellow in the white will make the sun seem to shimmer softly.

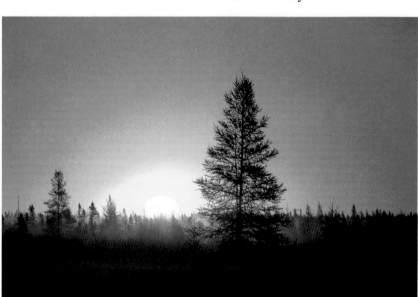

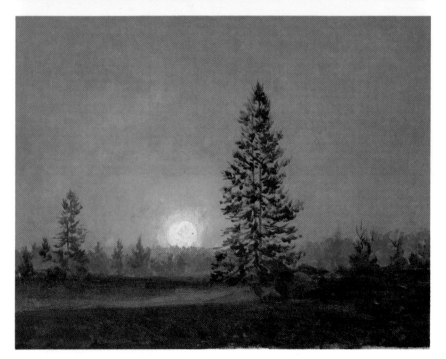

As the sun sinks below the horizon, a brilliant sky silhouettes stately tamaracks.

Working with Simple, Flat Shapes and Vibrant Color

PROBLEM
When you approach very simple subjects like this one, color is your main tool in creating an interesting painting. If you are insensitive to the colors that you see, your painting will be flat.

SOLUTION
Keep the color as rich and exciting as possible—even the dark foreground should be loaded with color. As you work, don't be afraid to develop your painting in a decorative fashion.

☐ Since the subject is so simple, skip the usual charcoal sketch. Instead, quickly draw the scene with a small brush that has been dipped into thinned color, then brush in the colors and values of the mountains and sky. Keep everything flat.

With heavier color, work back over the underpainting. At this point you have two options: Either add texture to the flat planes you've established, using strong, heavy brushstrokes; or let the hot, glowing color carry the entire painting. No matter which direction you take, keep the color hot and lively.

Next, refine any edges that are fuzzy to achieve the kind of crisp ornamental effect you're after.

At the very end, paint the sun. If you've chosen to enrich the surface with texture, you may want the sun to have a soft, gentle edge. If so, paint it while the sky is still wet. If you have chosen to emphasize color, a crisp sharp edge will probably be more at home in your painting.

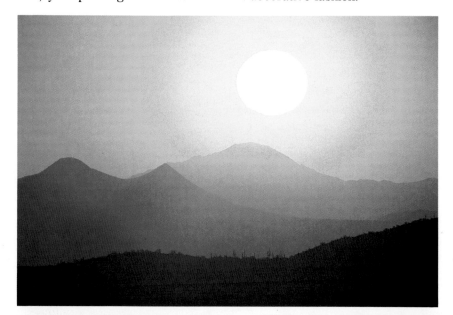

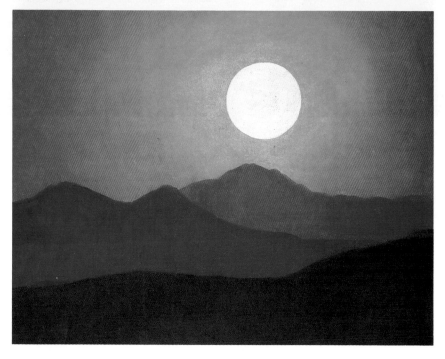

ASSIGNMENT
If you like the decorative effect that you have achieved here, apply what you've learned to another subject illustrated in this book. You'll find that reducing a scene to stark, simple lines can transform any subject, even one that is packed with detail.

Before you begin, divide the scene into distinct planes, then make sure that each one is rendered with a different value. Experiment with a variety of subjects. You'll find that misty or foggy landscapes lend themselves particularly well to this kind of treatment.

Warm golden light washes over the gently curving mountains of the Sonora Desert.

Working with Diverse, Complex Elements

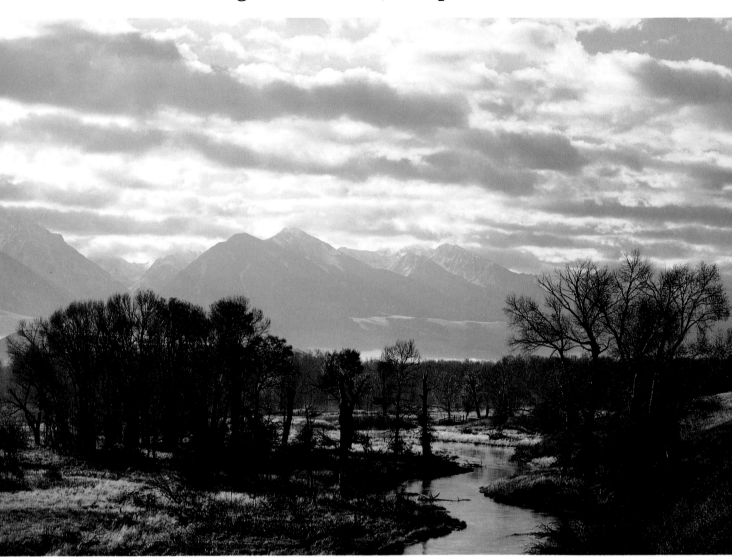

PROBLEM
A lot is going on here. Brilliant sunlight breaks through a thick bank of clouds, then spills across a complicated landscape. When you are working with so many diverse elements, it can be difficult to create a unified painting.

SOLUTION
Don't rush into your painting too quickly. Complicated subjects require careful planning. Think through your approach and execute a detailed drawing before you start to work with color.

In Montana, the Yellowstone River meanders slowly backward toward majestic mountains and a cloud-filled sky.

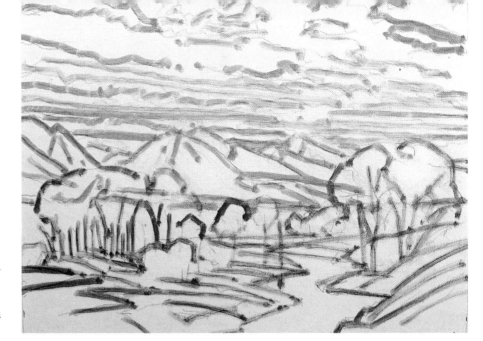

STEP ONE
Place all the elements in the composition with a careful charcoal drawing. Break all of the elements into simplified shapes. Here, for example, the trees are drawn as rough masses, disregarding their individual branches. Add the shapes formed by the shadows, too, and the contour lines that define the landscape. Now reinforce your sketch with thinned color.

STEP TWO
Instead of using thinned color to build up the painting, try scrubbing opaque pigment onto the canvas. You'll find that by using this approach, you can achieve accurate colors and values much more quickly—an important consideration in a complex scene. Don't let patches of thick color occur; really scrub the paint onto the support.

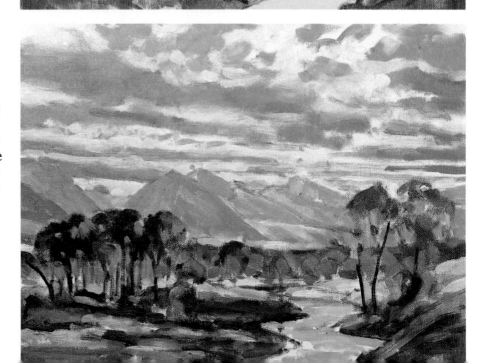

STEP THREE
Continue to develop your painting by laying in small strokes of color, one over the other. Start with the sky; it sets the mood of the entire painting. As you proceed, key the rest of the work to the sky. Don't let your strokes become too fussy; you are still trying to build up overall shapes, not details. Note, for example, how the trees are still rendered in a simplified fashion.

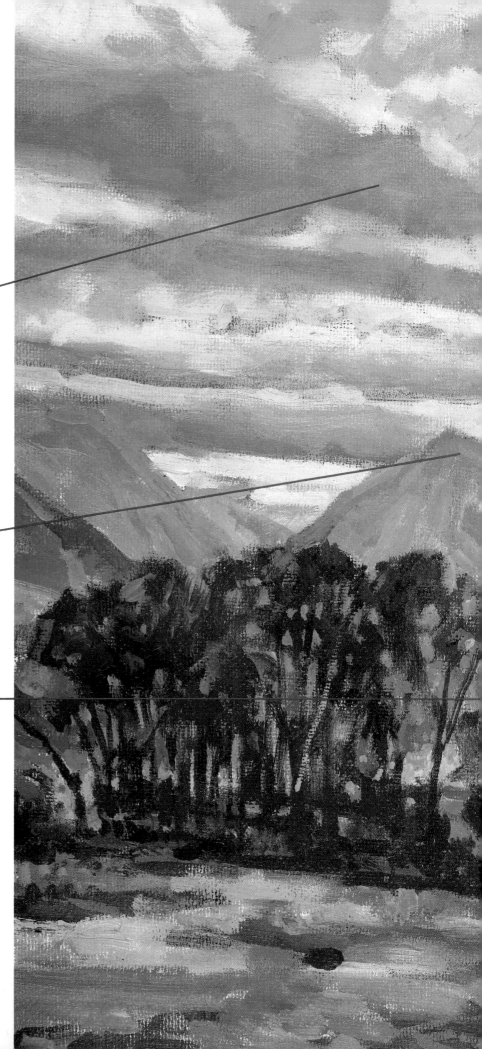

FINISHED PAINTING

At the very end, paint the white clouds, then add details, and strengthen the color and values of areas that seem weak. With a small sable brush, pick out the branches of the individual trees, then sharpen the line where the mountains meet the sky.

From the very beginning, the complex sky was simplified. First, it was broken into individual shapes in the preliminary drawing, then these basic shapes were retained as color was added to the composition. Cerulean blue mixed with a touch of thalo green and white forms the brightest portions of the sky; the darker areas are rendered with cobalt blue and cadmium red.

The simplified volumes of the mountains dominate the background. Like the sky, they were rendered slowly and carefully, with emphasis on their overall shape.

Until the very end of the painting, the trees were rendered as simple, abstract shapes. As a final touch, their individual trunks and branches were picked out with a small brush. If they were painted more elaborately, they would make the final painting overly complex and hard to understand.

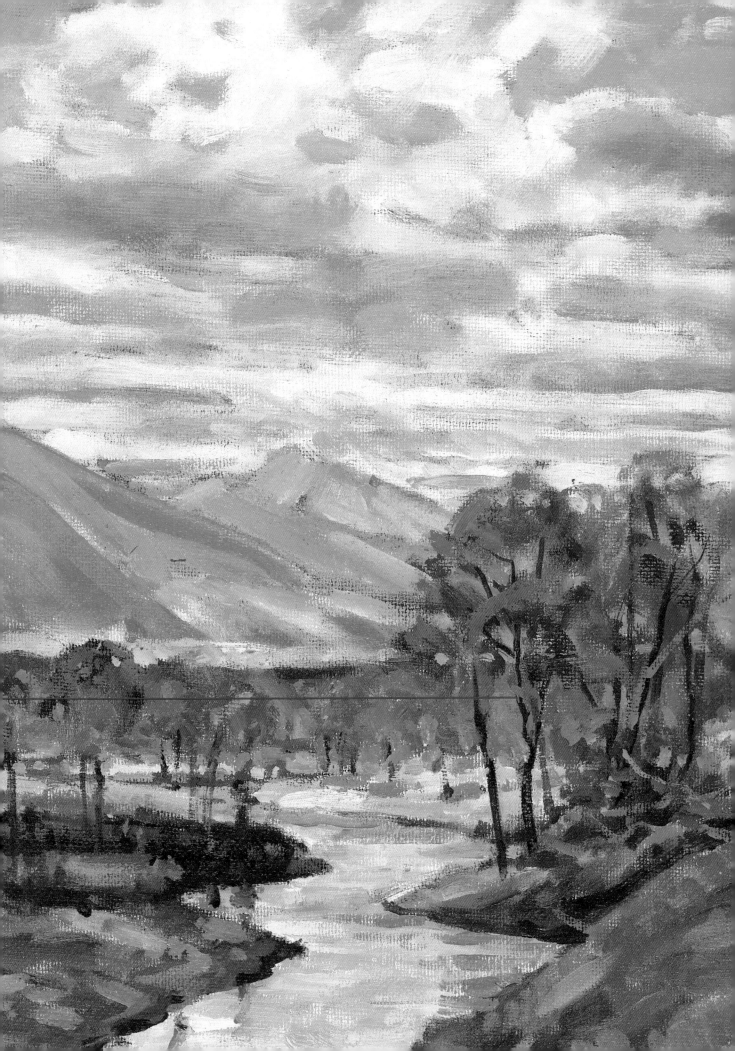

Painting a Building Set Against a Cool Winter Sky

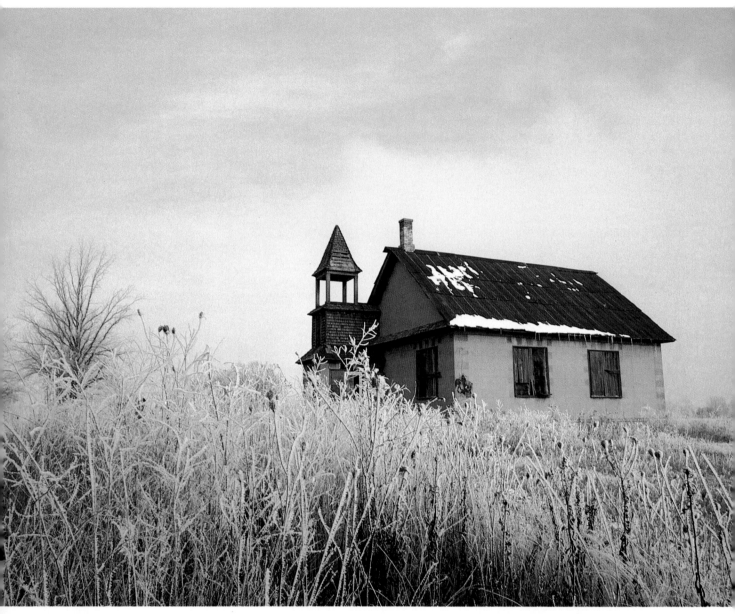

PROBLEM

You may be tempted to concentrate on the frosty grasses—after all, they dominate the foreground and set the mood of the painting—or on the church. But if you concentrate on just one part of the composition, you may lose the delicate feel that characterizes the whole.

SOLUTION

Analyze the overall effect you want to achieve and decipher all of the elements that set the scene's mood. Here they include not just the frost-covered grasses and the church, but the pale morning light, the soft clouds forming in the sky, and the shadows that spill over the foreground.

☐ Before you begin, a precautionary note: When you are working from photographs, be aware of the distortions they sometimes create. Here, for example, the vertical lines of the building slope in far more than they would in nature. If you draw them as they appear in the picture, the church will look as though it is falling over. Straighten them out in your drawing.

Use your charcoal drawing to place the major elements of the composition then strengthen its

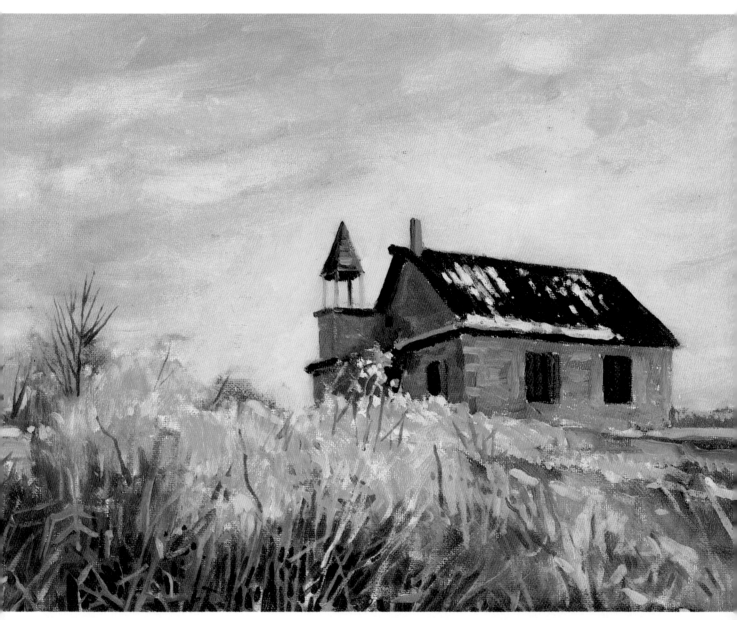

lines with a small brush moistened with thinned color. Continue working with thinned color as you lay in the dark shadowy side of the building and the dark patterns that define the grasses.

Now that the darks are down, lay in the sky. Working with opaque pigment and forceful strokes, apply the paint to the canvas. Begin with the darker blues; while they are still wet, add the lighter clouds. Your strokes should have a definite sense of direction, mimicking the way the clouds move across the sky.

To build up the foreground, pack many small brushstrokes together, working back and forth from dark to light. Don't try to paint the frost at this stage. Keep your strokes crisp and definite to suggest how close the grass is to the front of the picture plane.

All along, you've concentrated on the sky and the ground; now turn to the church. Lay in the walls and the roof with a medium-size bristle brush, then rely on a small sable for details like the windows.

All that's left to do now is to paint the frost that clings to the grasses. Use white pigment that has been subdued with a touch of brown and apply it to the canvas with a soft sable brush. Don't get too caught up in detail—if the grasses become too important they will overpower the rest of the landscape and destroy the mood that you have created.

Painting an Expansive Sky

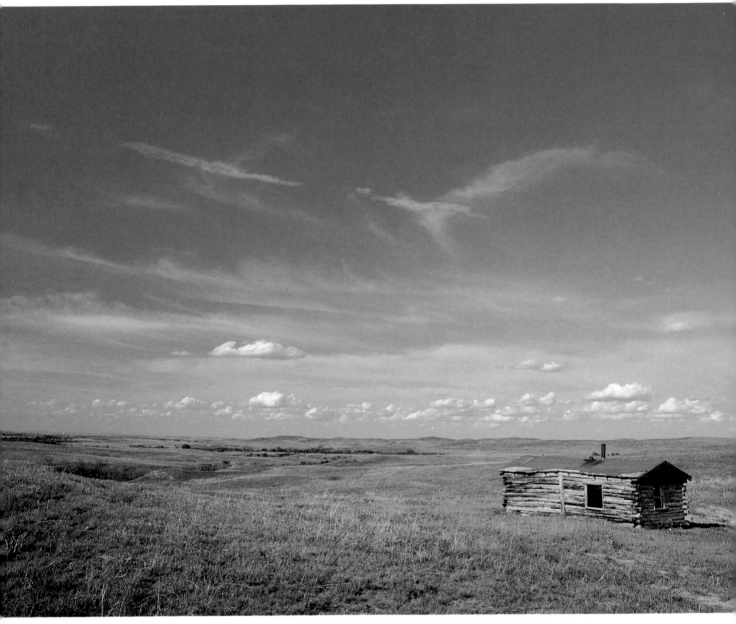

PROBLEM
The sky is obviously the main subject here—it dominates the entire composition. But you may be tempted to emphasize the cabin.

SOLUTION
Think of the cabin as an accent, one that establishes the scale of the scene. Don't let it become too large or important.

☐ After you have completed a simple charcoal sketch, begin to develop the surface of the canvas with thin turp washes. Work from dark to light, starting with the sky. In this stage of the painting, your goal is to cover the entire surface with the approximate colors and values that you want to see in the finished work. Later on, when you work back into the painting with opaque pigment, you can adjust any false color or

In June, a cabin nestles close to the ground as clouds sweep through the brilliant blue sky.

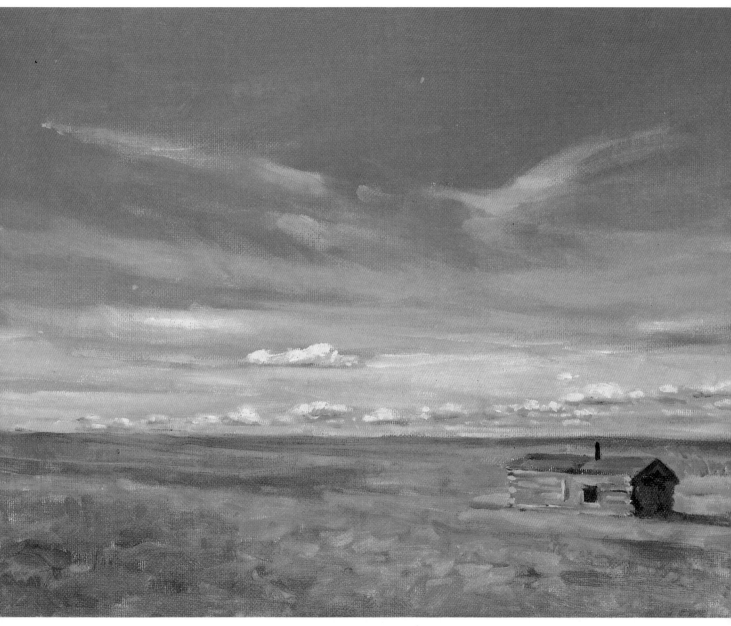

value statements and correct any errors in your drawing. After you have established the foreground, middle ground, and background, let the canvas dry.

Work back into the sky first. Use a wet-in-wet approach to paint the upper reaches of the sky. These clouds seem relatively dark because they are so thin that the sky shines through them; carefully brushing their edges into the blue sky will make them seem delicate and wind-blown. Using a wet-in-wet approach also helps separate these thin clouds from the heavier clouds on the horizon. As you move down the canvas, gradually make the sky lighter; then, with a small sable brush, paint in the low-lying clouds.

Next, turn to the foreground. Interpretation is important here because the prairie is flat and relatively uninteresting. Build it up with many short, layered strokes to suggest the feel of the grass; pick out whatever pattern you can find and emphasize it. When you are happy with the prairie, paint the cabin.

At this point, stop and analyze your painting. Does the sky carry the painting, or has too much attention been paid to the cabin? If you find that the sky seems a little timid, go back and intensify its color and value, then strengthen the clouds' shapes.

Highlighting One Element in a Complicated Scene

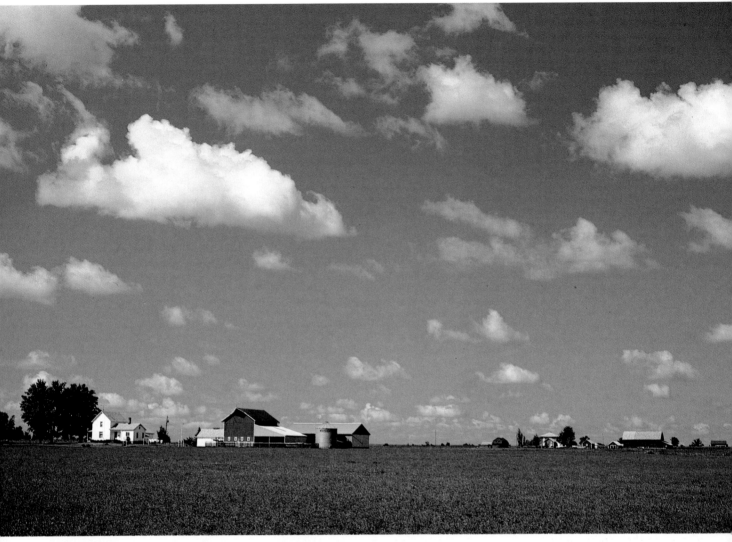

PROBLEM

Everything in this composition is small and scattered, from the farm buildings that run across the fields to the clouds that fill the sky. If you try to capture each and every detail, you'll end up with a diffuse, unfocused painting.

SOLUTION

Choose a center of interest. The low horizon line suggests that the sky be emphasized; it occupies much more space than the land. As you paint, simplify the buildings so that they don't become too important.

Farm buildings punctuate a landscape as small clouds move through the bright blue sky.

STEP ONE

With soft vine charcoal, sketch the scene, concentrating on the cloud formations. Next, dust off and fix the canvas and reinforce the drawing with thinned color. Try using raw umber. It's dark enough to make the drawing strong and it will add a little warmth to the clouds. Before you move on, brush in the dark undersides of the clouds with thinned raw umber.

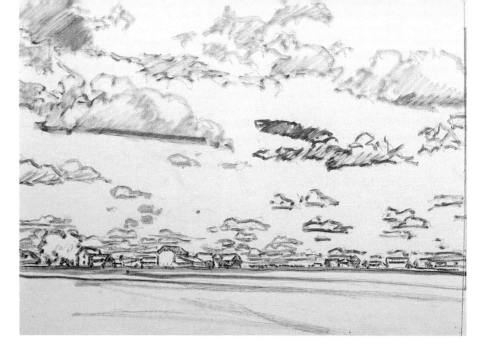

STEP TWO

Continue working with thinned color as you establish the blue of the sky and the shadowy portions of the clouds. Cobalt blue is great for the sky; make it progressively thinner and lighter as you approach the horizon. Next, quickly brush in the greens in the foreground and begin to develop the buildings.

STEP THREE

Using heavier color, work back into the sky. A wet-in-wet approach makes sense here; it will allow you to soften the edges of the clouds easily. Cobalt blue forms the basis for the sky; mixed with cadmium red, it forms a deep, rich blue that is perfect for the darkest parts of the sky. Near the horizon, switch to cerulean blue and thalo green muted with a little white.

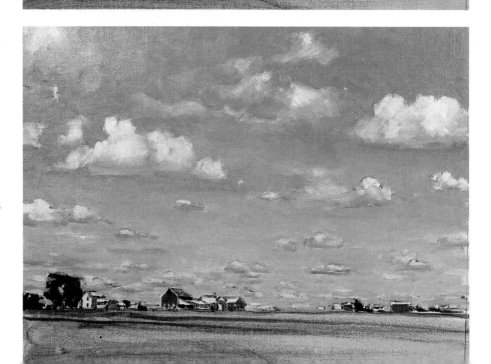

FINISHED PAINTING

Now it's time to add details to the
buildings and to the trees along
the horizon. Paint right over the
sky. Then break up the flat green
foreground, developing a pattern
of darks and lights. Finally, go
back to the clouds and refine their
shapes and their shadows.

*The deep, rich sky is made up of
cobalt blue and cadmium red. The
shadows that lie in the clouds are
rendered with raw umber, cobalt
blue, and white; their bright, light
areas are done with white tinged
with yellow ocher.*

*As clouds recede, they become
pinker and contrast less sharply
with the sky. Here the basic mixture
of raw umber, cobalt blue, and
white used to paint the other clouds
is warmed with cadmium red.*

*The farm buildings are rendered
realistically but without much de-
tail. Their crisp, simplified shapes
focus the scene and provide a clear
sense of scale.*

ASSIGNMENT

Find a place where you can see
the sky all the way back to the
horizon. Choose a time when the
sky has some action to it—
clouds pressing toward the
ground or being swept along by
the wind.

Instead of working with oils,
try drawing with pastels. Pick
two or three colors, plus white,
and work on toned paper. Spend
no more than twenty minutes on
each sketch and work on a small
surface.

Focusing in on Detail

PROBLEM

It's difficult to create an interesting painting when nothing commands attention. Here the sky is flat and the balloons are too small to provide a focal point.

SOLUTION

Make the balloons larger than they actually are and change their placement slightly to make the composition less static. To capture all the detail possible, work on smooth Masonite.

☐ Because the balloons are so important in this composition, draw them carefully, showing as much detail as possible. You may have to invent some of it; after all, the balloons are far away and hard to see. After you've sketched the scene, dust off and fix the Masonite, then go over your drawing with thinned color.

Before you begin to use opaque color, stop and analyze the sky. In reality, it's a flat shade of blue, but you can make your painting much more compelling if you use graded color. Working around the balloons, begin to paint the sky. At the very top of the support, lay in a dark, rich blue. As you move downward, gradually make the blue slightly lighter. When you are done, take a fan brush and run it over the support to get rid of any obvious brushstrokes. The smooth, unbroken field of blue that results will help accentuate the balloons.

Now turn to the focus of the painting—the balloons. To keep their edges crisp and clean, use a small sable brush. Work with bright, clear color, to make them stand out vividly against the sky, and add as much detail as you possibly can.

When you are satisfied with the effect you've achieved, move away from your painting for a few minutes, then come back and judge it critically. Make any small adjustments in color and value that you think are necessary and sharpen up any edges that seem weak and unfocused.

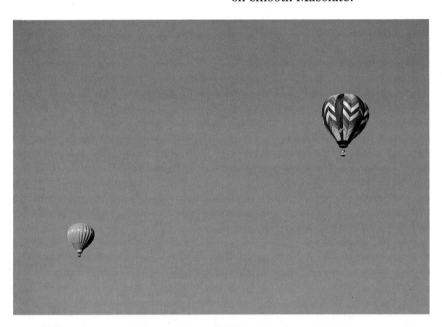

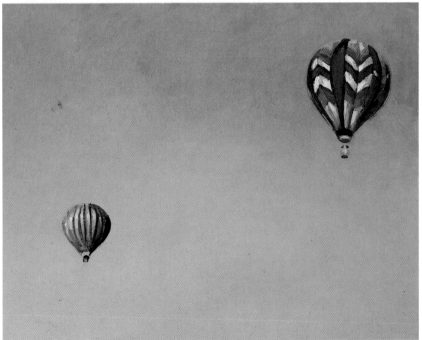

On a warm summer afternoon, two hot-air balloons drift lazily in a clear blue sky.

Making a Simple Scene Interesting

PROBLEM

Once again, you are faced with a seemingly uninteresting subject. The sky is flat blue and the plane provides the only accent.

SOLUTION

Break up the sky with soft, fluid brushstrokes and a variety of blues. To emphasize the plane, make it larger than it actually is.

☐ The size of your support is sometimes dictated by subject matter. Here, where so little is happening visually, a small support makes sense. Because the jet has to be painted cleanly and sharply if it is to stand out against the sky, work on Masonite. Here the Masonite is just 8 by 12 inches.

Start with the sky. Lay cobalt blue, cerulean blue, and white on your palette. Mix your blues in small batches to add small shifts in color to the scene. Use a medium-size bristle brush with a rounded tip and work with loose, overlapping strokes as you coax the paint onto the support. What you are trying to achieve is a rich, dappled surface, one that is packed with slight differences in color and value.

When the sky is complete, turn to the jet. Paint it with a small sable brush. You won't be able to add much detail here—the plane is too distant for that. But you can make its lines clean and sharp to pull it away from the soft sky. At the very end, add the jet trails. Near the plane, make them sharp and definite. Farther away, let them blend into the sky.

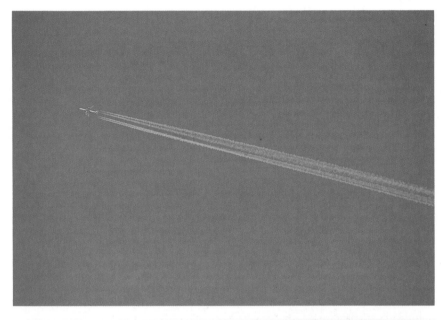

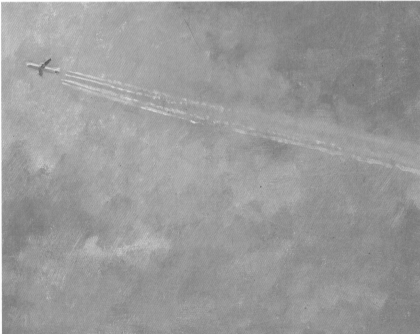

A jet shoots across the sky, leaving a stream of white in its wake.

Making Sense out of Complicated Cloud Formations

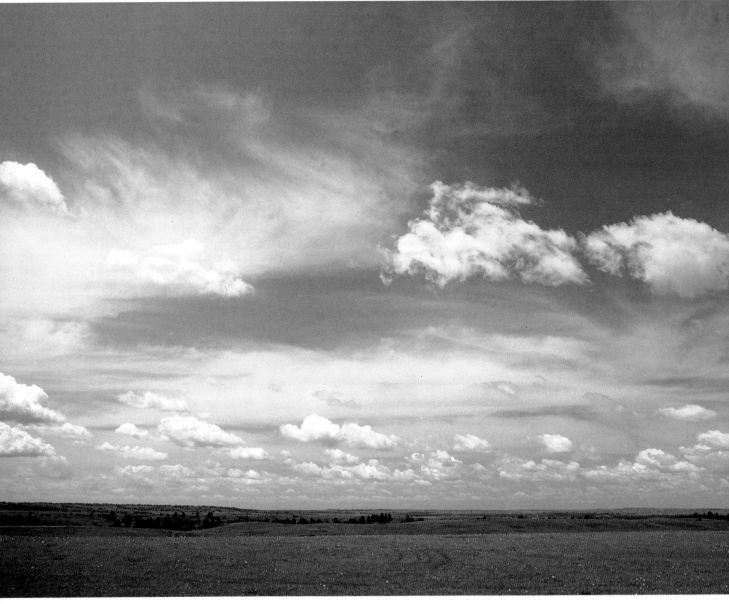

PROBLEM

Set against a lush green prairie, the sky is richly packed with complicated cloud formations, no two of them alike. Capturing all of them on one canvas isn't going to be easy.

SOLUTION

Forget about the prairie until the very end and concentrate solely on the sky. As you work, pay attention to the subtle differences that separate one cloud formation from the next.

☐ In your preliminary charcoal drawing, establish the patterns that run through the sky. Use sure charcoal strokes for the thick, dense clouds that lie in the middle of the sky; loose, gestural strokes will serve to get across the feel of the thin, airy clouds that rush through the rest of the scene.

Once your drawing is complete, you are confronted with two choices: Either reinforce the drawing with thinned color before you begin to paint, or spray your sketch with a fixative and imme-

diately begin to use broad washes of thinned color to build up the scene.

When a sky bursts with as much action as you see here, the second choice is probably the best. Right from the beginning, working wet-in-wet, you can build up the cloud masses without letting too much detail bog down your entire painting.

With a thin wash of cobalt blue tinged with ivory black, lay in the sky. Near the horizon, add a touch of cadmium red. Now wash in thinned green across the fore-

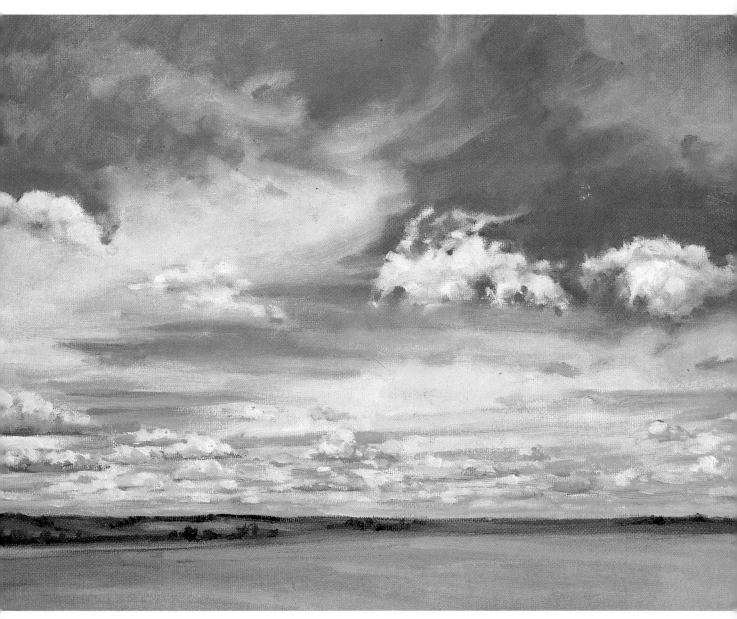

ground to establish the medium value that makes up the prairie.

That done, start working with opaque color. Continue working wet-in-wet to further develop the sky. As you paint, pay attention to the edges of the clouds: Some are sharp and well defined; others, loose and amorphous. The loose clouds seem to almost disappear where they meet the sky, so be sure to blend them well into the surrounding pools of blue. The sharper clouds call for more exact treatment to make their contours stand out clearly against the blue.

In your final development of the sky, concentrate on the heavier clouds. Make sure that they are sharply etched against the sky. For this you'll need heavier brushstrokes and thicker paint than you've used to develop the thinner clouds. Next, articulate the clouds that lie low along the horizon. As they recede in space, they become darker and pinker. Adding touches of Mars violet to these distant clouds will push them back into the picture plane.

Finally, turn to the foreground. Enrich your basic wash of green with thicker paint, then add touches of dark brownish-green along the horizon. To animate the prairie, add the thin line of trees that runs across the lower right side of the scene.

The dark brownish-green added at the end helps separate the ground from the sky. Pulling these two areas apart adds drama to the sky: In the end, it stands out sharply against the bright spring-green of the ground.

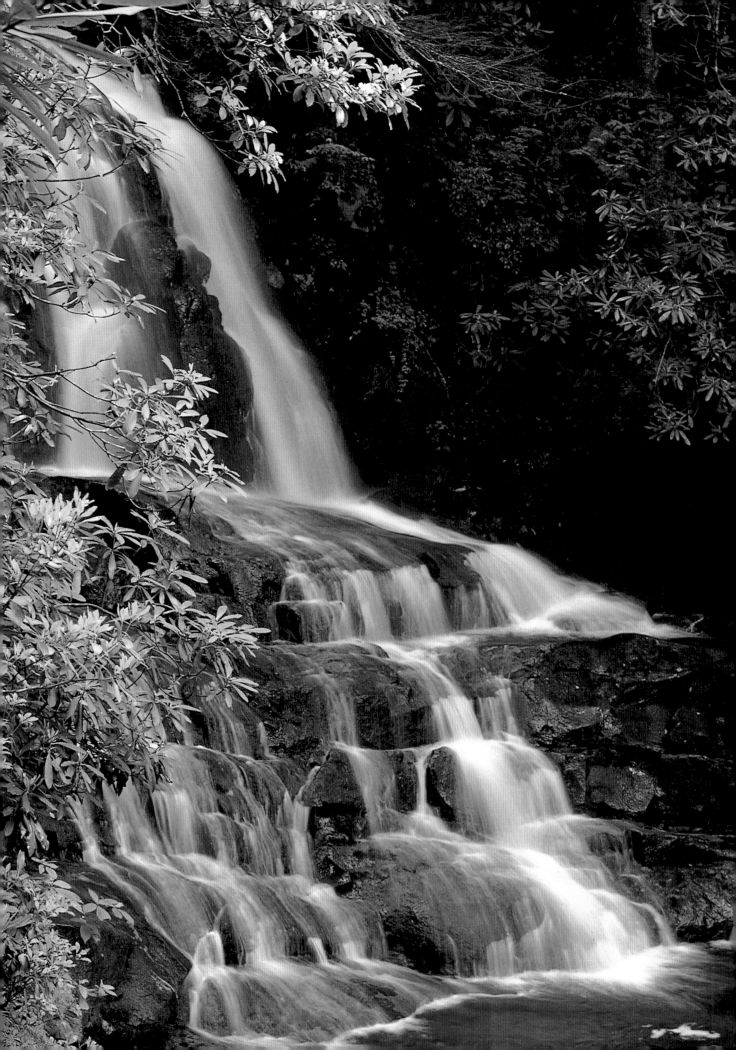

WATER

Painting Water in Winter

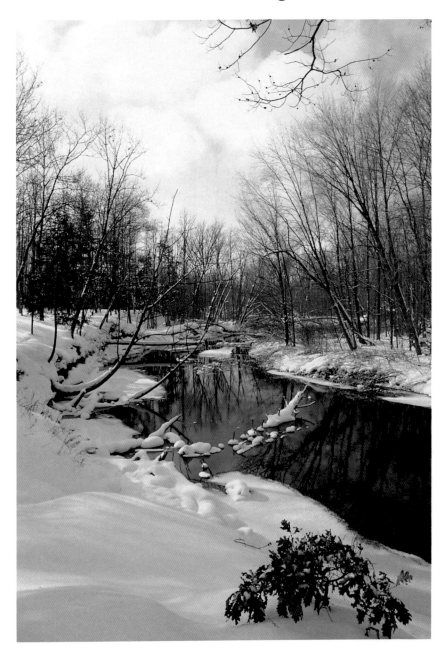

PROBLEM
Set against the crisp white snow, the stream seems even darker than it actually is. Unless the water is handled carefully, it will look flat and dull.

SOLUTION
To make the stream lively and interesting, exaggerate the reflections that animate it and simplify the patterns of the surrounding snow and trees.

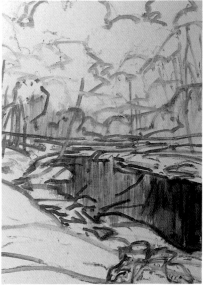

STEP ONE
Sketch the scene with soft vine charcoal, then go over your drawing with thinned color. At this point, don't clutter up your canvas with too much detail. Instead, concentrate on large shapes. Once your drawing is reinforced, establish the dark stream with thinned color to set the scene's overall mood. Use a blend of Thalo blue and alizarin crimson, with just a bit of white.

In midwinter, a stream courses through a snow-covered landscape, reflecting the myriad trees that grow near the water.

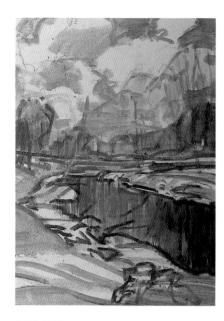

STEP TWO
Working with thinned color, start to block out large masses of color—the blue of the sky, the cool mass of trees in the distance, and the sloping, ice-covered ground. Keep your treatment simple; later on you can add more complex shapes. For the sky, use cerulean blue, white, and Thalo green. Render the trees in the distance with Mars violet. Finally, for the snowy ground, lay down cerulean blue and white, mixed with just a touch of black.

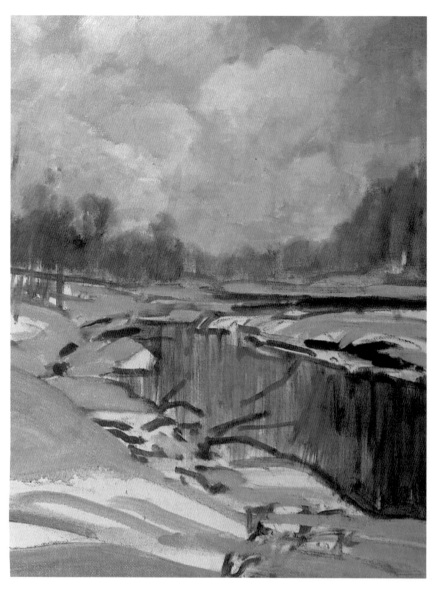

STEP THREE
The framework of your painting established, build on it with thicker opaque pigment. First paint the sky, working right over the spindly treetops; you will add them later. Here the shadowy portions of the clouds are rendered with raw umber and white, the light areas with yellow ocher and white, and the sky itself with cerulean blue, Thalo green, and white.

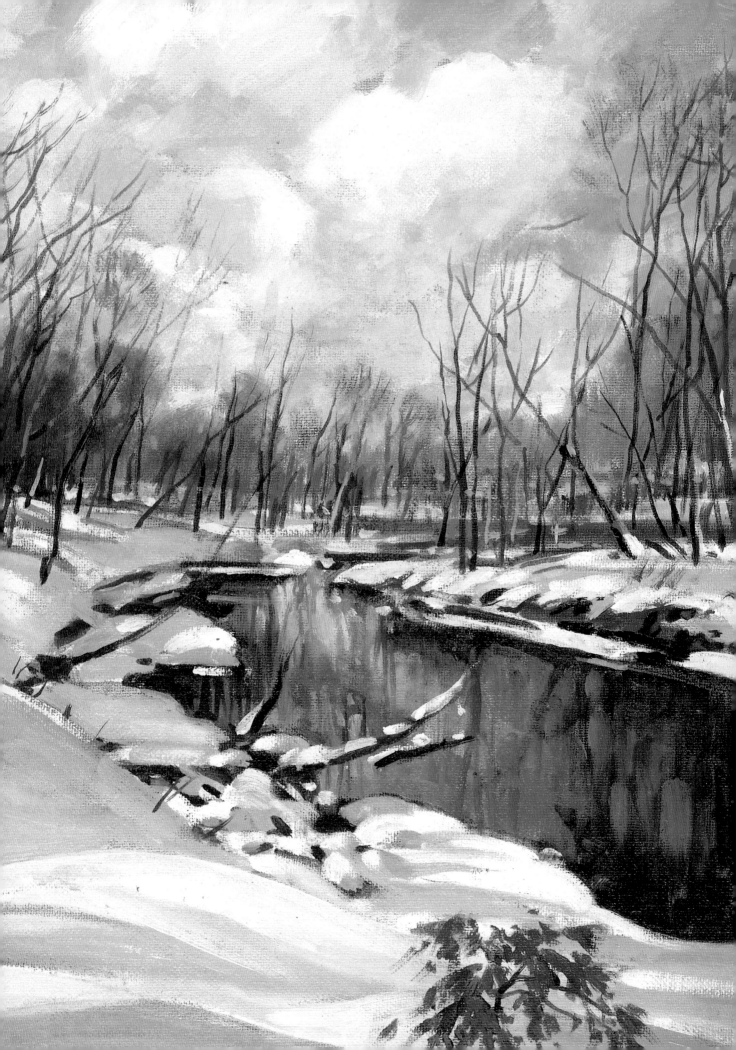

FINISHED PAINTING

To complete your painting, turn to the stream and the snow. Suggest the maze of reflections that lie in the water with a wet-in-wet approach and strong vertical strokes. In the immediate foreground, add burnt sienna to the Thalo blue to achieve a dark, dense hue.

The stream completed, evaluate the snow-filled foreground. You may want to soften the shadows with additional strokes of pale blue paint tinged with a little cadmium red. Next, strike in all of the dark trees using a small pointed brush and color thinned with a painting medium. The medium will keep the pigment fluid, allowing you to coax the color over the canvas.

As a final touch, loosely lay in the tangle of dead leaves in the immediate foreground.

DETAIL

Rendered with short vertical strokes, the water is filled with all the reflections that spill across it. Because the shadows that lie on the snow are painted primarily with blue, the snow and the water work together harmoniously.

DETAIL

The trees are built up in two stages. First, a cool violet undercoating is scrubbed onto the surface to suggest the trees in the distance. Later, individual trees are rendered with a small pointed brush and pigment that has been thinned with painting medium.

Deciphering Complex Patterns

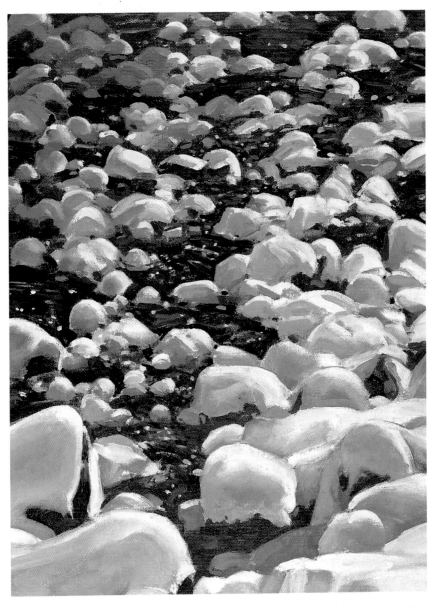

PROBLEM
All of the rocks are about the same size and shape and the water is dark and flat. Unless you compose your painting carefully it will be static and repetitious.

SOLUTION
Organize the rocks into groups, especially those in the foreground. When it comes time to paint the water, emphasize the subtle highlights that flicker over it.

☐ Sketch the scene with charcoal, paying as much attention to the spaces between the rocks as to the rocks themselves. Now redraw the composition with a brush dipped into thinned color.

Continue working with thinned color as you begin to establish the overall pattern of lights and darks. First, lay in the dark water and the shadows that fall on the snow-covered rocks. For the time being, let the white canvas represent the snow.

Switch to heavier paint and rework the water with a dark rich hue mixed from ultramarine blue, alizarin crimson, and Thalo green. In places, introduce dabs of burnt

umber and burnt sienna. Use short, choppy strokes to suggest the movement of the water. As you render the rocks, use broader, smoother brushstrokes. Here the snow is painted with cobalt blue, white, and a small touch of cadmium red.

Spend a few minutes evaluating your painting, then fine tune it. Make sure that edges are sharp and clean where snow and rock meet water and that the snow looks soft. As a final step, add dashes of white to the dark water to suggest the play of light.

Thick white snow clings to the rocks lining a stream as dark water trickles around them.

Achieving a Flat, Decorative Effect

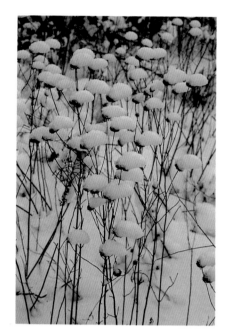

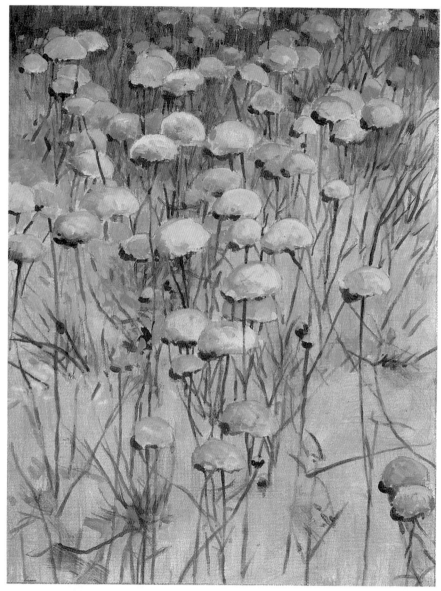

PROBLEM

This is a highly unusual subject. It is flat, monochromatic, and repetitious—yet these very qualities inject it with a handsome, abstract beauty. Capturing this flat, decorative look is the challenge here.

SOLUTION

Before you start to paint, analyze the composition, looking for a strong design element to pull it together. Here it lies in the flowers, which, overall, form an inverted triangle.

☐ When you begin work on a complicated subject filled with detail, execute a careful drawing with a charcoal pencil, then spray the drawing with a fixative so you won't lose it as you work. Now reinforce your work with thinned color.

Because the shifts in color and value in this subject are subtle, build up your painting slowly using glazes—pigment thinned with a painting medium. Start with the darkest passages—the stems and shadows—then move on to the lighter areas of the composition. As you work, gradually start to refine edges and strengthen your darks and lights.

Here the hue that dominates the composition is made up of white and black mixed together with cobalt blue. In some areas, burnt and raw umber take the place of the blue; in others, touches of Mars violet are introduced.

When your painting is almost finished, feel free to use heavy touches of opaque color to reinforce weak areas. Here opaque paint is applied to the tops of the blossoms to accentuate their crisp, bright highlights.

In midwinter, snow lies on top of dead blossoms, while their stems etch a tangled pattern against the snowy ground.

Subduing Bright Whites

PROBLEM

Except for the snow, everything in this scene is so dark and somber that you may be tempted to make the whites too bright. If you do, you'll lose the haunting, secluded feel that permeates the composition.

SOLUTION

Tinge your whites with cool blues and gray. You'll discover that treated this way, they still stand out strongly against the dark trees and water, but they aren't too sharp and disruptive.

□ Execute a loose charcoal drawing to establish the rocks in the foreground and the way the stream moves backward, then reinforce the sketch with thinned color. Continue working with thinned color as you brush in the dark trees in the background, then the water. At this stage, keep the trees as simplified as possible. Here they are made up of Thalo green and burnt sienna.

The stream is laid in with Thalo green, alizarin crimson, and white. Once you have established the overall configuration of the greenery, build it up with thicker pigment, then go back and add detail with a fine brush. Next, develop the stream with opaque pigment.

The darks down, get started on the snow-covered rocks. If the stream and the trees are dark and rich enough, it will be easy for you to gauge the value of the snow.

Working with opaque pigment, begin to lay in the snowy ground on the left and the rocks that reach out of the stream. Your basic mixture will be black and white, with touches of cobalt and cerulean blue to temper the gray.

All that remains to be done now is the immediate foreground. First paint the tall tree on the right, then, working with a small brush, articulate the snow-covered branches that radiate outward. As a final touch, add the delicate branches in the lower right corner using a drybrush technique.

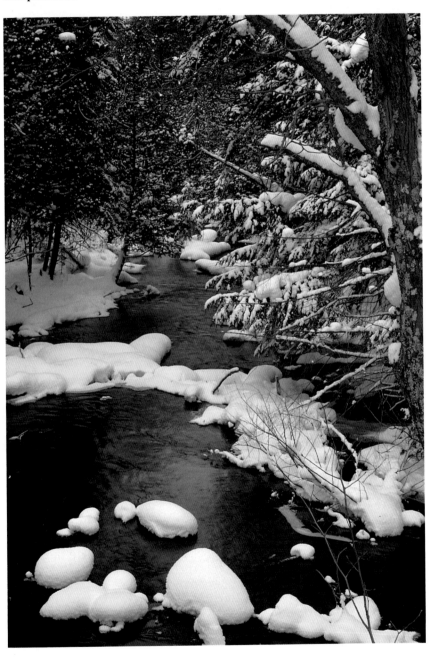

A cool, dark stream rushes through a snowy forest.

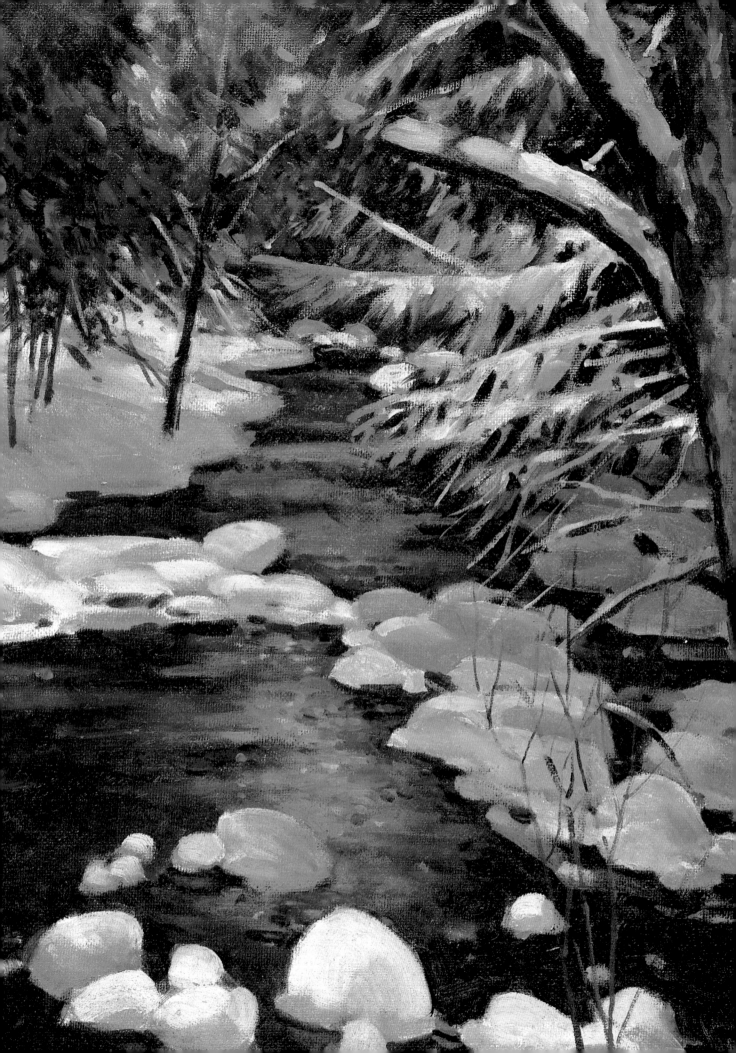

Rendering Reflections at Sunset

PROBLEM

At first glance, this scene seems lighter than it actually is. If your values are too light, you won't be able to capture the power of the reflections or the effect created by the setting sun.

SOLUTION

Exaggerate what you see and render the sky and lake with strong, deep color.

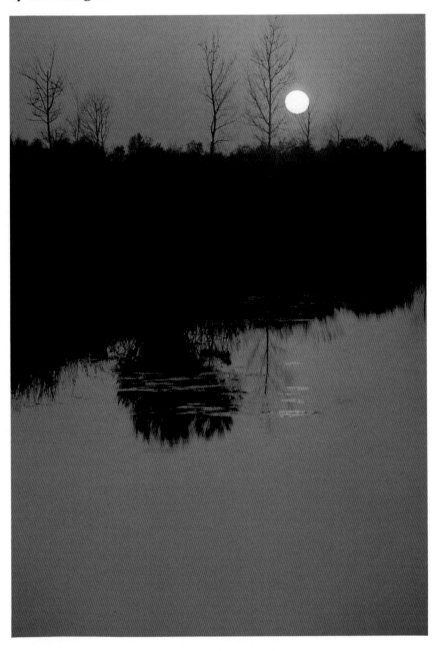

As the sun sinks toward the horizon, filling the sky with a rosy glow, reflections spill across a still lake.

☐ Because the composition is simple, there's no need to sketch the scene with charcoal before you begin to paint. Instead, lay down the major lines of the composition—the land mass and reflections—with a small brush dipped into thinned alizarin crimson. For now, don't worry about the tall, bare trees.

Right from the start work with opaque pigment. First lay in the dark land mass and its reflection with a rich mixture of alizarin crimson and Thalo green. To separate land from water, sweep dark cobalt blue across the edge where they meet, then turn to the sky and water.

The rosy glow that pervades the sky is echoed in the water. Since the two areas are the same color, paint them at the same time using strong, dark hues. Here they are rendered with alizarin crimson, cadmium red, and white, with small touches of cobalt blue added in places. Don't be afraid to exaggerate the color; it has to be really dark if the sun is going to stand out clearly.

As you paint the sky, use smooth, fluid strokes. Work from the edges of your canvas in toward the sun, and make your color lighter and lighter as you near it. For the water, lay in shorter, choppier strokes to suggest the ripples that run across it. The touches of cobalt blue that are added to the foreground pull it out toward the viewer and keep the painting from becoming flat.

Now paint the sun, using white and cadmium yellow. Don't mix the two colors together; instead, lay them in separately with heavy strokes. Finally, with a small, pointed brush dipped into alizarin crimson and Thalo green, render the individual trees that stand out against the sky and their reflections in the water.

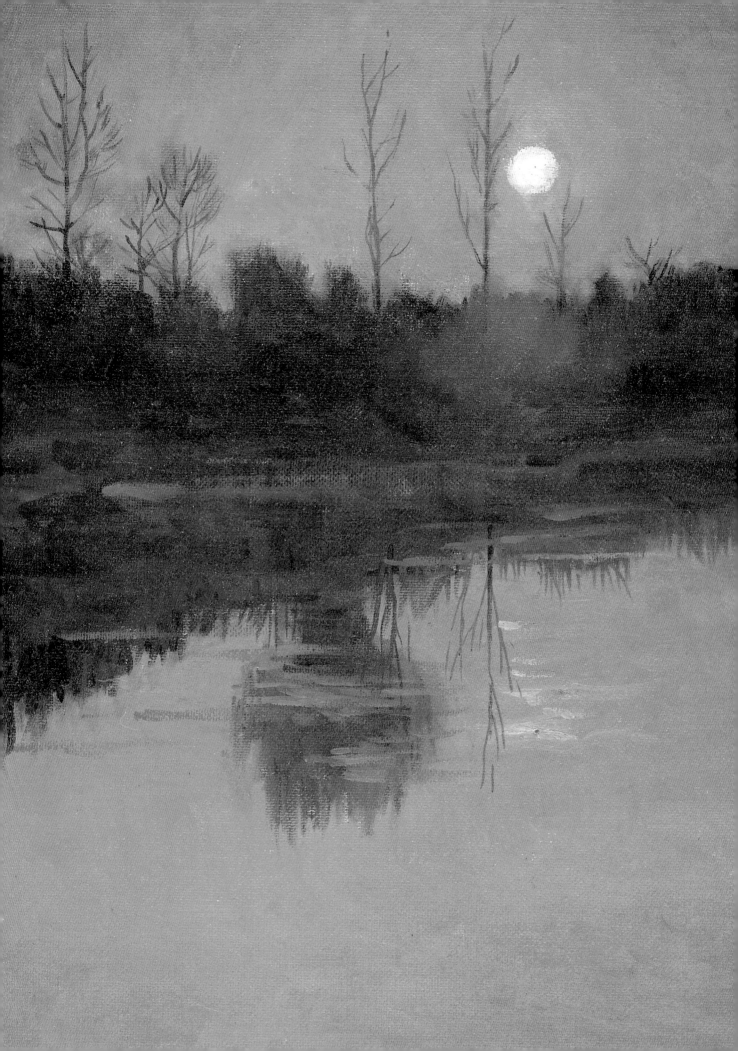

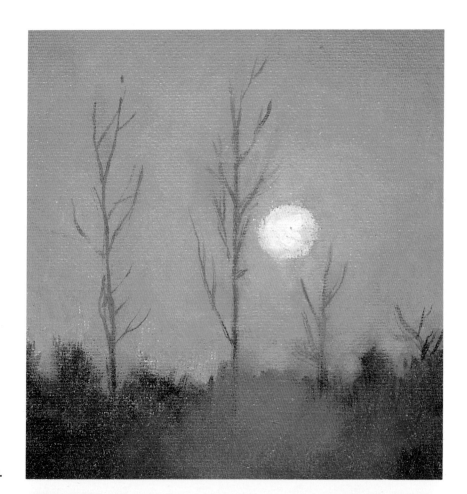

DETAIL
To paint the sun, first lay in pure white, then go back and add cadmium yellow. By mixing the colors on the canvas and not on the palette you'll increase the strength and brilliance of the sun.

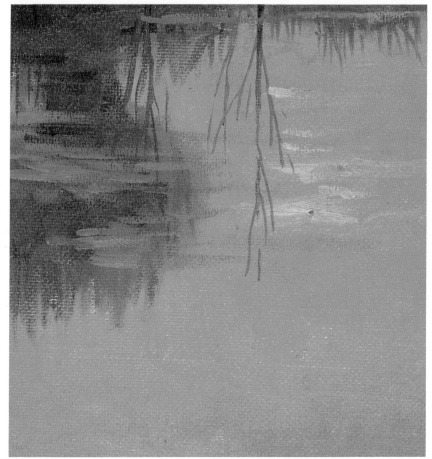

DETAIL
Slashes of rose-colored pigment run across the reflections, suggesting the movement of the water. More than just that, they make the reflections seem lighter and more natural.

Working with Fading Light

PROBLEM

Two distinct situations are at play here—the lingering light that fills the sky and lies reflected in the water, and the cool, shadowy feel of the trees and land. Both have to be captured.

SOLUTION

Pack the sky and water with all the color and light that you see, using warm hues. Render the land and trees with darker, cooler tones.

☐ Quickly sketch in the scene with vine charcoal, then go over the lines of your drawing with thinned color.

Continue working with thinned color as you begin to lay in the dark trees and their reflections. Work quickly, with dark cobalt blue, and keep the trees simple; if they become too complex, they'll steal attention away from the sky and water. Note, too, that the reflected trees are darker than the trees themselves. Now quickly brush in the water with thinned cerulean blue.

On top of your thin underpainting, introduce thicker pigment. First build up the trees with short, broken strokes of cobalt blue, yellow ocher, alizarin crimson, Mars violet, and raw sienna. Make sure your values are really dark so that the light in the sky and water stands out clearly.

Next, begin to paint the sky. Here it's made up of Thalo green, white, and cadmium yellow.

Now the fun starts—painting the water. Because you want to pack it with as much color as possible, mix small batches of color repeatedly instead of mixing it all at once. You'll find that working this way, you achieve a much richer and more lively effect. Here are the colors you'll need: cerulean blue, Thalo green, cadmium orange, yellow ocher, cadmium yellow, alizarin crimson, cadmium red, and white. Note that yellows dominate toward the rear of the painting, while blues make up most of the foreground.

The sky, land, and water down, turn to the foreground and paint the tree on the right. Make it warmer and brighter than the trees in the background, but don't let it become too sun-struck.

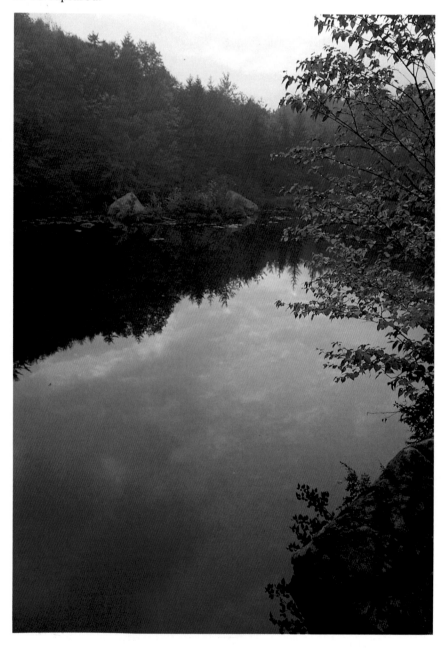

Moments after the sun has set, its warmth still colors the sky and water while trees and land are cast in shadow.

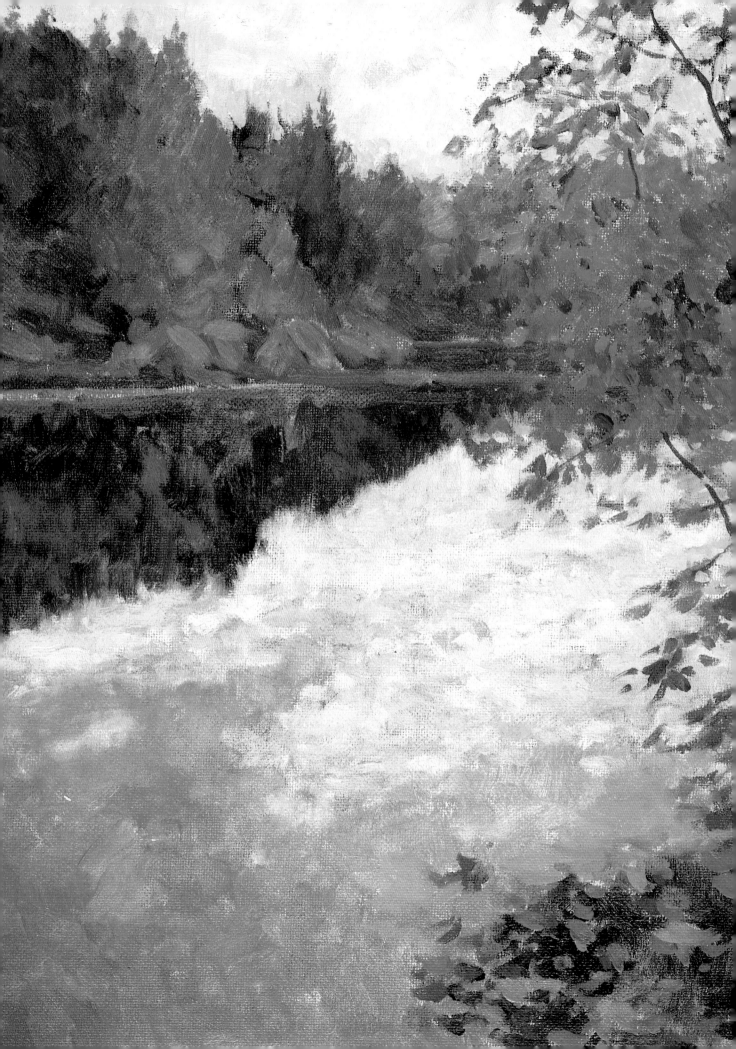

DETAIL

Beautiful color fills the water. Almost every stroke is blended individually, resulting in interesting variations in hue. Eight tones are employed: cerulean blue, Thalo green, cadmium orange, yellow ocher, cadmium yellow, alizarin crimson, cadmium red, and white.

ASSIGNMENT

Strong drawings help make strong paintings—they add structure to your compositions. If you are not in the habit of executing preliminary sketches, experiment with soft vine charcoal and discover what it can do for you. No other drawing medium can be changed as quickly; one sweep of a rag and the charcoal's gone. When you are happy with your sketch, you can dust off any loose charcoal; enough of the drawing will remain to guide you as you reinforce its lines with thinned color. The freedom this gives you is immense—you can make as many adjustments as you like without dirtying up the canvas.

When the color theme of a painting isn't likely to cause you any trouble, use a dark neutral hue to reinforce the sketch. When you're dealing with more complex color schemes, go over each area with its own local color. Working with local color quickly gives you an idea of how your finished painting will look and helps you solve any color problems from the very beginning.

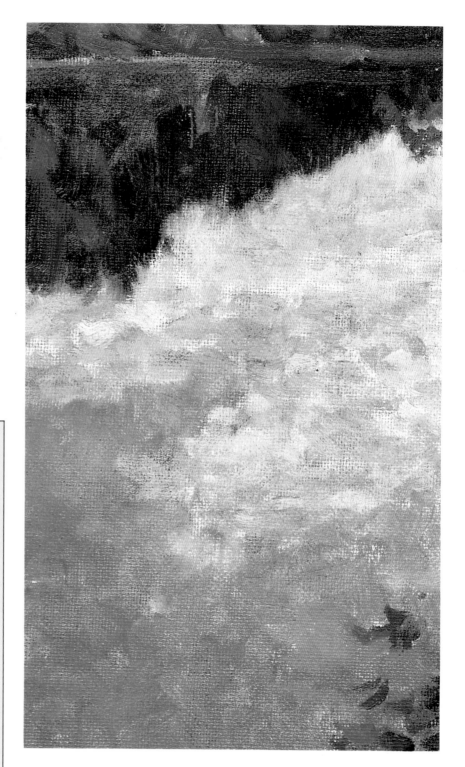

Establishing Mood Through Underpainting

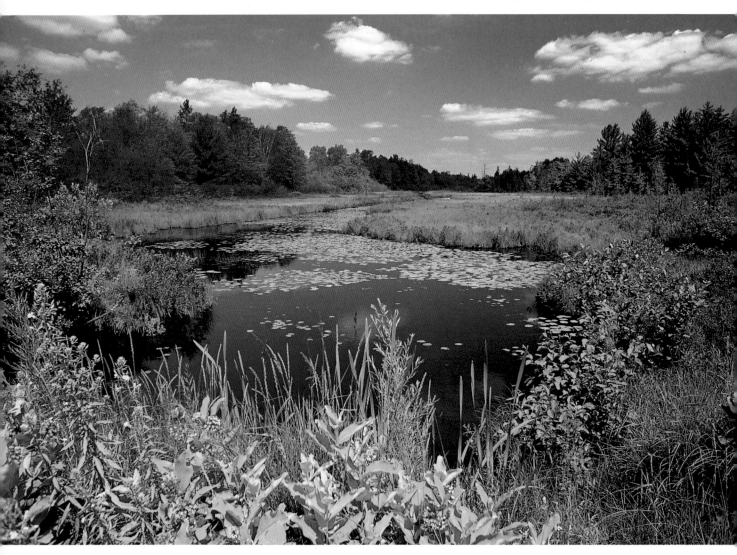

PROBLEM

The brilliant greens of trees, shrubs, grass, and aquatic vegetation all begin to look the same in midsummer. That's fine in nature, but in a painting you have to break them up or your work will be dull and monochromatic.

SOLUTION

Stain your canvas with an overall wash of green to set the color mood. When it comes time to use opaque pigment, keep as much variety as possible in the greens that you lay down.

In midsummer, rich, lush vegetation surrounds a pond, setting off the blue of the sky and water.

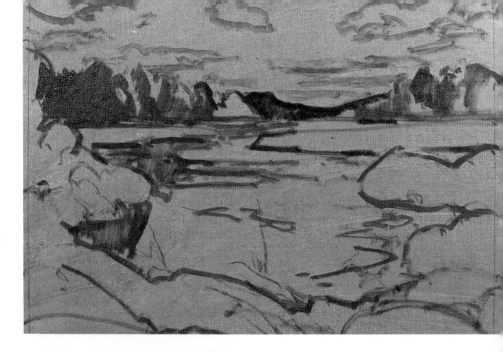

STEP ONE
Start by staining your canvas with permanent green light that has been thinned with turpentine. Let the canvas dry, then sketch the scene with vine charcoal. Now reinforce your sketch with thinned color and build up the dark areas formed by the distant trees.

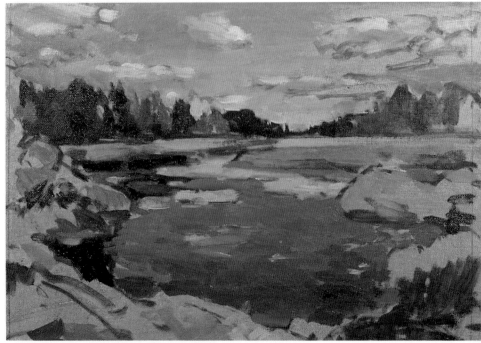

STEP TWO
The undercoating of a medium-value green gives you great freedom as you start to build up your painting. Because your mid-range values have been established, you can easily gauge the value of your lights and darks.

Working over the entire canvas, begin to introduce light and dark notes. Wherever possible, break up the mass of green with touches of other colors. Here, for example, the stream edges are developed with touches of dark brown.

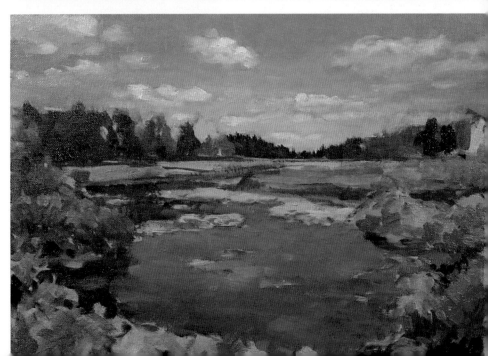

STEP THREE
Complete the clouds and the sky, then finish the dark line of trees along the horizon. That done, turn to the stream. The water itself isn't very interesting; make it come to life by developing the pattern formed by the lily pads. Now continue to develop the vegetation. Make some of it very dark—almost black—and other areas bright yellowish green.

FINISHED PAINTING

The stage is now set for detailed work. Begin by adding the grasses that dominate the foreground; to render them, use a small brush.

Next scan your painting, looking for areas that seem weak and undefined. Introduce a few additional splashes of green to the water, then paint the spindly tree that grows along the left side of the stream.

The brilliant sky, painted with cerulean and cobalt blue, white, yellow ocher, and cadmium red, acts as a foil for the lush greens that dominate the painting. Note how the sky is brightest near the horizon, and how touches of the green under-painting shine through the subsequent layers of blue.

The trees, weeds, and grasses are painted with permanent green light, Thalo green, Thalo yellow-green, yellow ocher, and—in places—with a mixture of black and yellow ocher that yields a rich silvery hue.

The dark pond is flat and uninteresting, but the lily pads that grow out of the water make the foreground lively and interesting.

ASSIGNMENT

Toning a canvas with a medium-value hue before you actually start painting can speed up the entire painting process. Experiment with the technique. Before you go outdoors, prepare several small surfaces with various colors. In the summer, try staining the canvas with a warm green, or in spring with yellowish green. In the winter, try using pale cerulean blue or light gray, and in autumn, yellow ocher.

Controlling Strong Greens

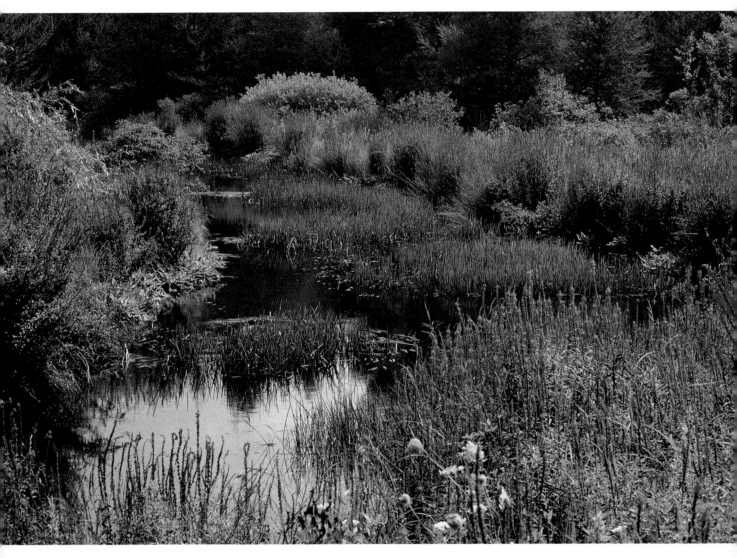

PROBLEM

At first glance, the purple flowers seem to dominate this composition. Closer study reveals that the scene is actually packed with dark, rich greens.

SOLUTION

Vary the greens as much as possible, using both warm and cool hues and light and dark values. When you lay in the flowers, do so boldly, exaggerating the patterns they form.

☐ In your preliminary drawing, get down the shape of the stream and the major shapes formed by the massed vegetation. Before you begin, analyze the same carefully. Note how some of the shrubs are round and pillow shaped, while others are treelike. Fill your sketch with as much variety as possible.

Now reinforce the charcoal sketch with thinned color and begin to lay in the greens. Start in the background. Mix a big puddle of dark wash with Thalo green and alizarin crimson. Make it really dark and it will be easier to

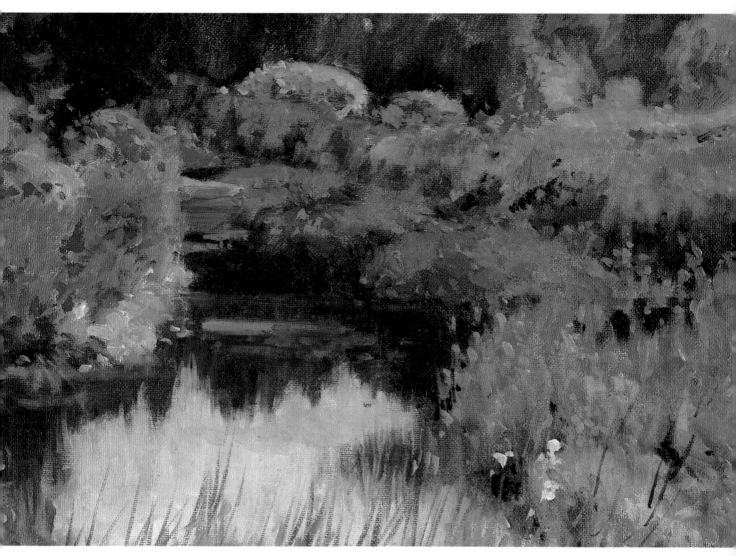

judge the rest of the values in the composition. Once the trees in the background are down, move on to the next darkest area, the reflections in the water. Again, make them as dark as possible.

The darks down, switch to thicker opaque pigment and work back into the greens. For those in the background, use cool hues and broad strokes. As you move into the foreground, use warmer greens and shorter, choppier strokes.

Now paint the water. Remember that it reflects the sky and feel free to add dabs of white to suggest clouds hovering overhead. As the stream meanders into the distance, make the water darker and cooler.

The scene is set now for the purple flowers. Mix two or three shades of purplish pink from alizarin crimson, cadmium red, white, and cadmium orange, and render the blossoms with short, broken strokes. Make the flowers in the foreground more definite than those farther back in the composition. Finally, paint the tall grasses that lie in the immediate foreground using a feathery drybrush technique.

Highlighting a Waterfall

PROBLEM

What should be the center of interest here—the waterfall—is lost among the dense foliage.

SOLUTION

Make the waterfall larger than it actually is, then break up the foliage by using a variety of dark and light greens.

☐ In your charcoal sketch, arrange the patterns formed by the foliage and indicate the movement of the water. Next, redraw the foliage patterns with different values of thinned green paint, then quickly brush in the foliage with thinned color. Work all over the canvas, but don't try to indicate any detail at this stage.

Working back over the thin underpainting, build up the dark and light patterns formed by the foliage with thicker opaque paint. You'll want to use a variety of greens—Thalo green, permanent green light, plus mixtures of cobalt blue and yellow ocher and even black and yellow ocher. Make your brushstrokes short and lively to animate the dense vegetation and suggest its texture. When the foliage is partially painted, start to paint the stream, working back and forth between the water and the plants. Let some of the foliage creep up over the stream to indicate how the water moves backward. Here the water is painted with raw sienna, cadmium red, black, cobalt blue, and white, plus small touches of Thalo green.

Now turn to the foreground. To render the confusing tangle of vegetation that dominates the immediate foreground, use crisp, definite brushstrokes. Lay one stroke over another to define the mass of vegetation and give your strokes a definite sense of direction, too.

Now stop and evaluate your painting. If the distant foliage looks too confusing, try to simplify it. If the grasses in the foreground seem too simplified, go back and define them further. Finally, add dark and light accents to the water to show how the falling water catches the light.

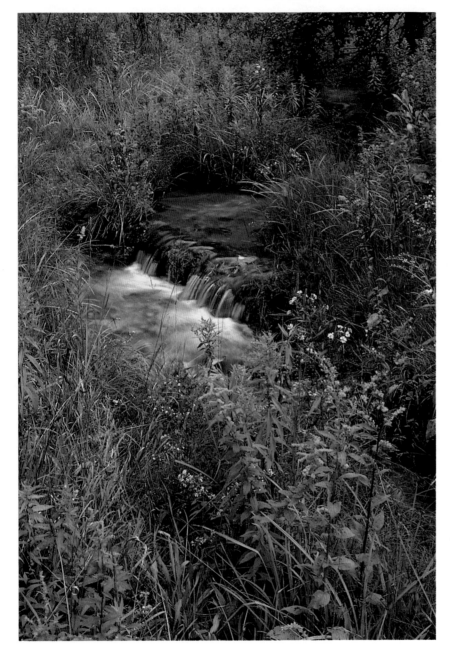

Set amidst lush green foliage and brilliant wildflowers, a rushing stream splashes over a rocky ledge.

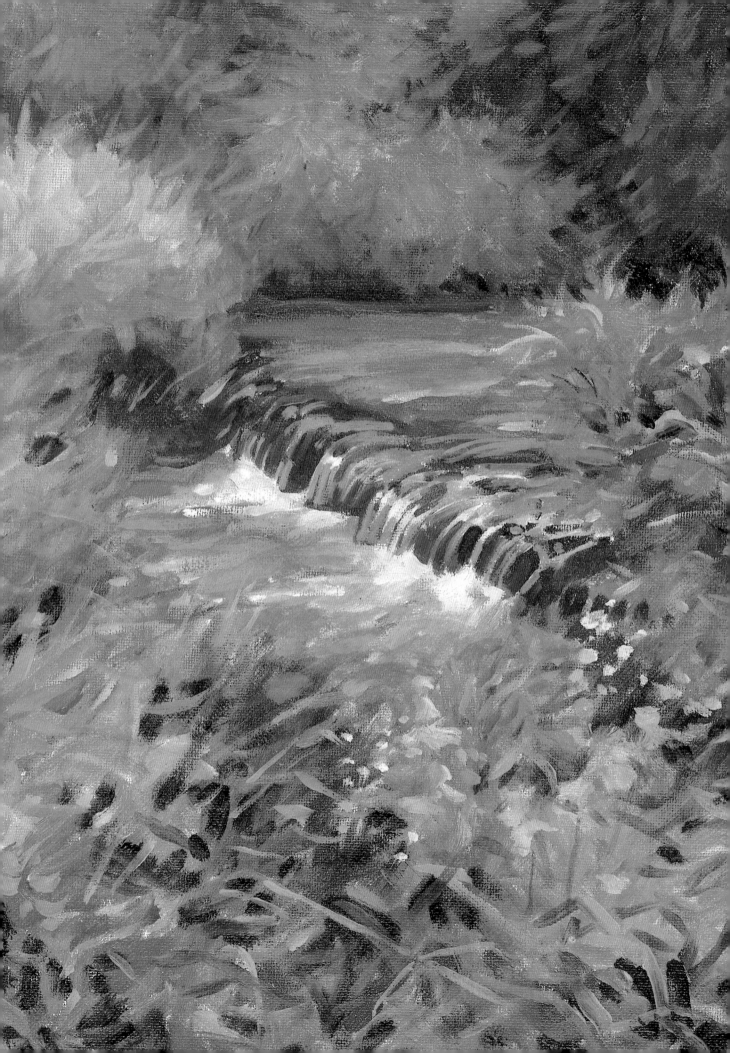

Learning How to Paint Rapidly Moving Water

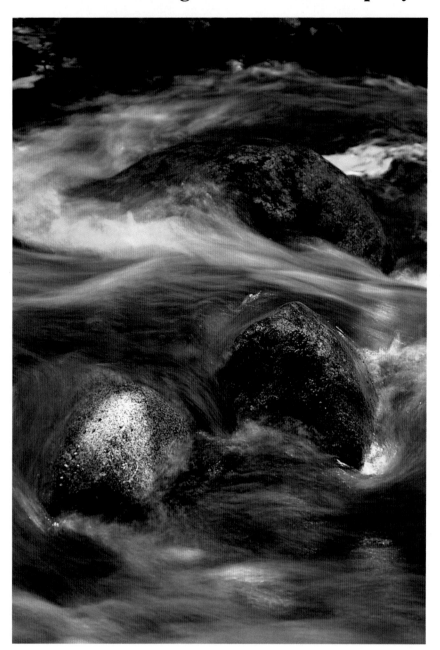

PROBLEM

The water is soft and foamy; the rocks are hard and angular. The challenge lies in capturing both qualities in your painting.

SOLUTION

Think in terms of overall pattern. In your charcoal sketch, get down the shapes of the rocks and the movement that sweeps through the water, then as you paint, work back and forth between water and rocks.

STEP ONE

Begin your preliminary charcoal sketch by placing the rocks, then rapidly draw the patterns formed by the moving water. Next dust off the drawing, then reinforce it with thinned color. Use burnt umber to render the outline of the rocks, and cobalt blue for the water.

Soft, foamy water cascades rapidly over sun-struck rocks.

STEP TWO

Using turp washes, start to plot out your colors and values. First, develop the dark, shadowy portions of the rocks with burnt umber and the dark lines that rush through the water with Thalo blue. For the time being, the white of the canvas will represent the lightest values.

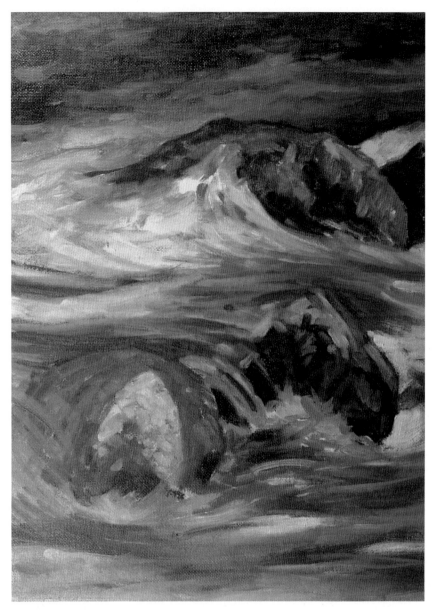

STEP THREE

Working from dark to light, and with thick opaque pigment, build up your painting. As you work, let your brushstrokes help you separate the rocks from the water. To render the rocks, use short, choppy strokes; for the water, sweep in long, fluid strokes. Keep a careful eye on the bright white foam and on the highlights that flicker across the water; they are the key to making your painting bright and lively.

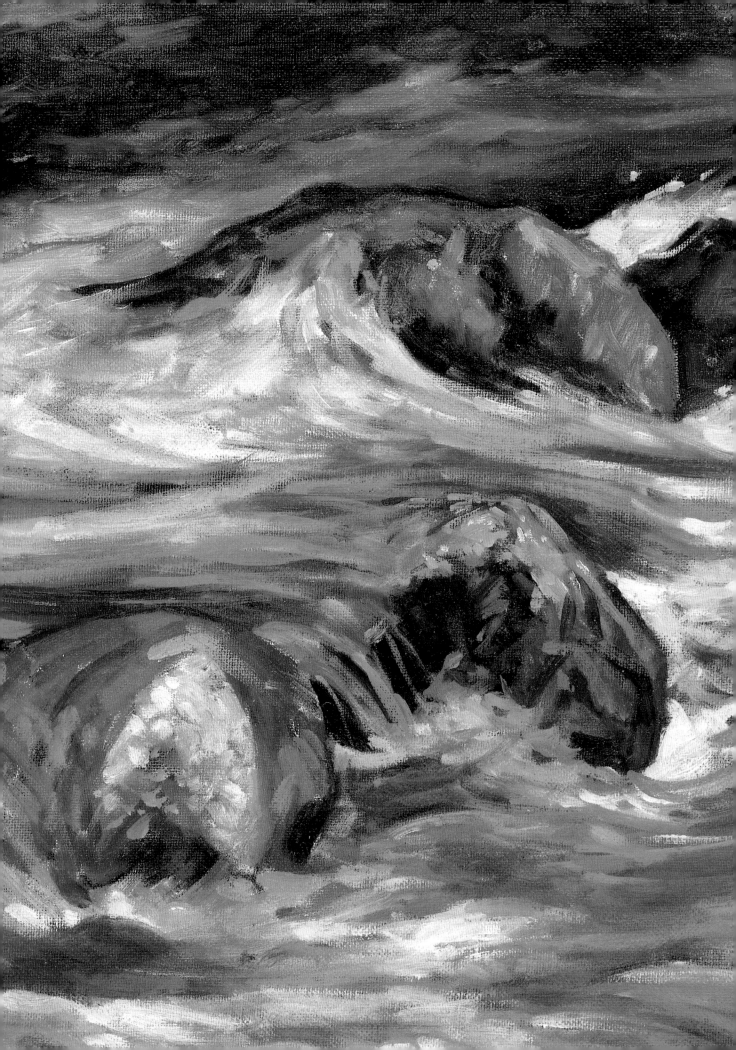

FINISHED PAINTING

Sharpen the edges of the rocks and introduce more touches of color into the water. At the very end, blend together white and yellow ocher and reinforce the foam that ebbs around the rocks.

DETAIL

The water is built up of many colors—cobalt and Thalo blue, Thalo green, cadmium red, white, Mars violet, alizarin crimson, and even cadmium orange. But it's the brushwork, not the colors, that makes the painting vibrant. Note how the strokes vary: Some are long and fluid, others short and dramatic.

ASSIGNMENT

Execute several close-up studies of water. For each study, focus in on a square foot or less of water, then draw the composition slowly and carefully, trying to capture every detail. Look for submerged rocks, bits of vegetation, and the patterns formed by the mud, stones, or weeds that lie beneath the surface. If the subject you select is likely to change rapidly, try photographing it, then work from enlargements back in your studio. Sketching these close-ups will train you to really look at what you see. You may find, too, that you like your studies well enough to translate them into full-size oil paintings.

Taming an Overly Dramatic Scene

PROBLEM

The contrast between the water and rocks is so great that it will be difficult to achieve a realistic look. The scale is odd, too. What at first seems huge is really a close-up view of a tiny rivulet of water.

SOLUTION

Simplify the rocks to lessen their drama, then use bold brush-strokes to indicate the movement of the water. In your finished painting, the water will stand out clearly against the dark, mossy backdrop.

☐ Sketch the scene with charcoal, then reinforce the drawing with a brush and thinned color. In your charcoal and oil sketches, try to indicate the three-dimensional quality of the rocks and their horizontal and vertical planes. Don't get too involved in detail, though. There will be plenty of time for that later.

Now begin to work with opaque color. First study the scene. Note how the vertical rock surfaces are dark and cast in shadow and how the horizontal rock surfaces reflect the sunlight. To render the vertical planes, use cool hues; for the horizontal planes, rely on warmer colors. Once you've established the basic rock shapes, quickly brush in the rushing patterns formed by the water.

Now turn to the moss that clings to the rocks. You don't want to paint every detail; if you do, you'll steal attention away from the water. Instead, simplify the greens you see, and use short, broken strokes to suggest the texture of the moss.

Once you've completed the moss, turn to the water. You've already laid down its basic pattern; now embellish what you've begun. First, suggest the rocks that lie beneath the falling water by dragging touches of cerulean blue and Mars violet over the white. Next, intensify the patterns of the water in the foreground. Load your brush with color, then quickly pull the brush over the canvas, following the motion of the water. Toward the edges, soften the white with touches of violet and blue.

As a final step, sharpen the edge of the large rock in the right foreground, then soften the edges of the splashing water.

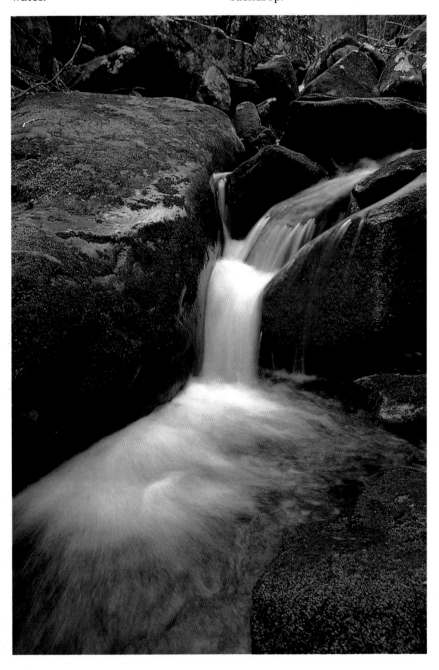

A rivulet of glistening white water rushes over moss-covered rocks.

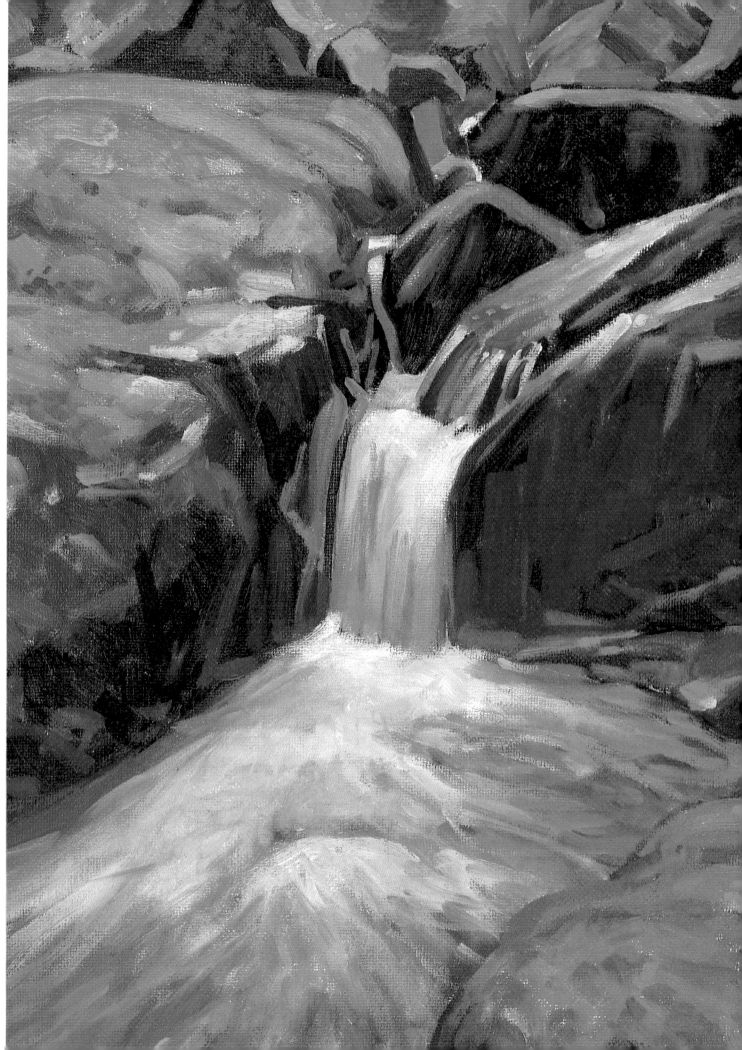

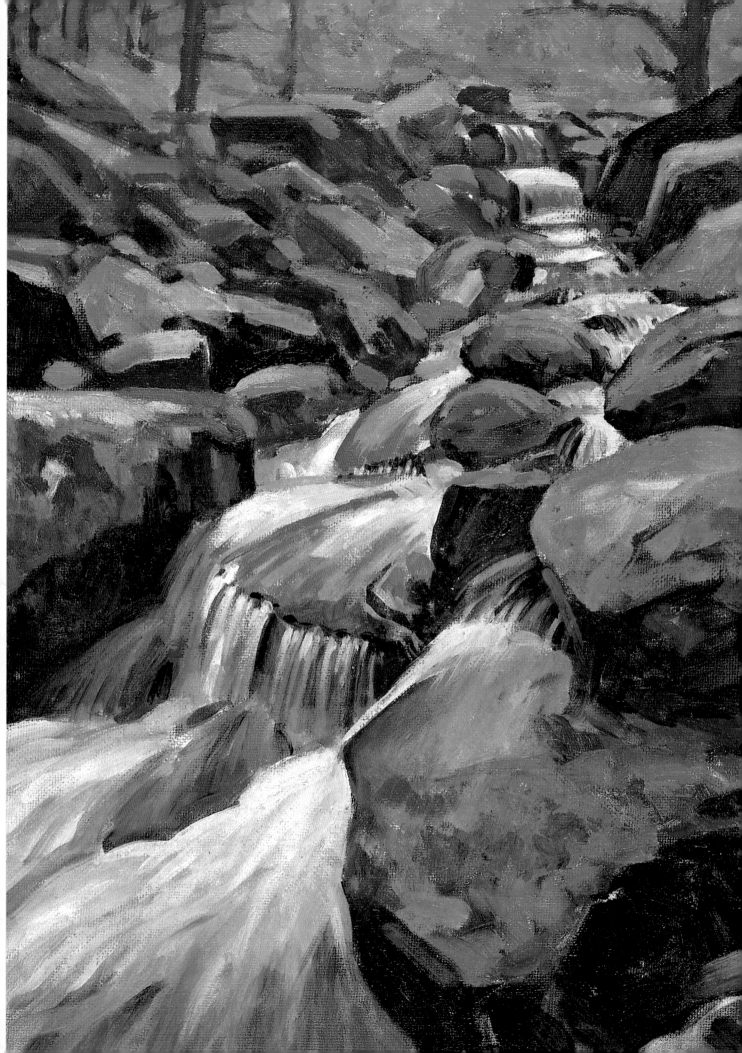

DETAIL

The water is painted in stages. First the lights are brushed in with pure white, then the darks are added with blue and white. Next, touches of yellow ocher subdue the strong white passages, and the underlying rock surfaces are laid in with earth tones. At the very end, when the surface is almost dry, touches of dark brown pigment are added to indicate the point where the water starts to pour over the rocks.

DETAIL

Rocks and trees in the background are simplified to help organize the busy landscape. Simple, single brushstrokes are used to apply neutral tones—not too dark, not too light. Details are minimized, and some, such as the leafy branches, have been eliminated entirely. Bright greens and white highlights used elsewhere to attract attention are reserved for the foreground and a few selected spots.

Painting a Delicate Waterfall

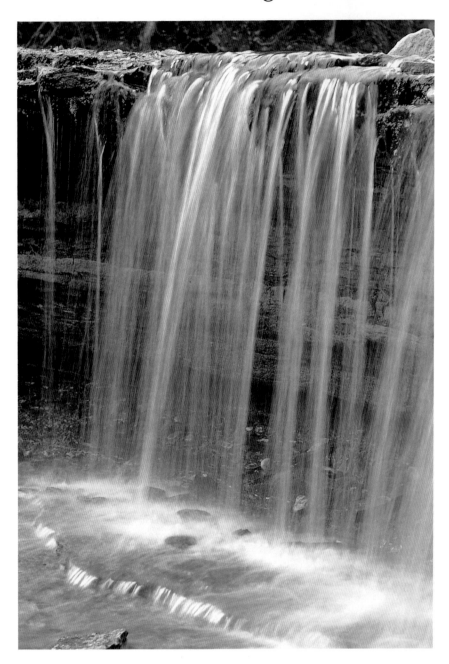

PROBLEM

The wall of rock that lies behind the waterfall can be easily seen through the water. To create a painting that works, you'll have to successfully depict the transparent nature of the water.

SOLUTION

Paint the water carefully, faithfully following what you see. Before you begin, execute a detailed charcoal sketch of the waterfall, then use it as a guide when you start to paint.

STEP ONE

Sketch the scene, concentrating on the waterfall. Before you begin, analyze the scene and try to pick out each strong stream of water. When your sketch is completed, go over it with thinned color. At this point, start to brush in the dark rock behind the waterfall, again working with thinned color.

Gently falling water forms a broken curtain of white over a dark rocky cliff.

STEP TWO

Working all over the canvas, establish your basic colors, values, and shapes. Throughout this stage, continue using thinned color, and make sure that you don't lose the underlying drawing. When you come to the waterfall and rocks, work back and forth between the two. Don't let the individual streams of water become too regularly spaced, either.

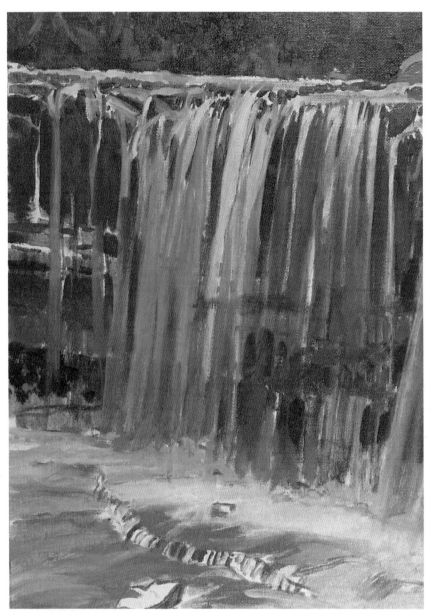

STEP THREE

Now strengthen the waterfall. Mix your pigment with plenty of painting medium, then softly apply these glazes of color over what you have already established. At the same time, build up the rocks that lie behind the wall of water. To really capture the transparency of the water, you'll have to apply several layers of glaze. After you apply each layer, let it dry for a minute or two before you move on.

Finally, strengthen the foliage at the very top of the canvas with opaque color and start to build up the pool of water beneath the falls.

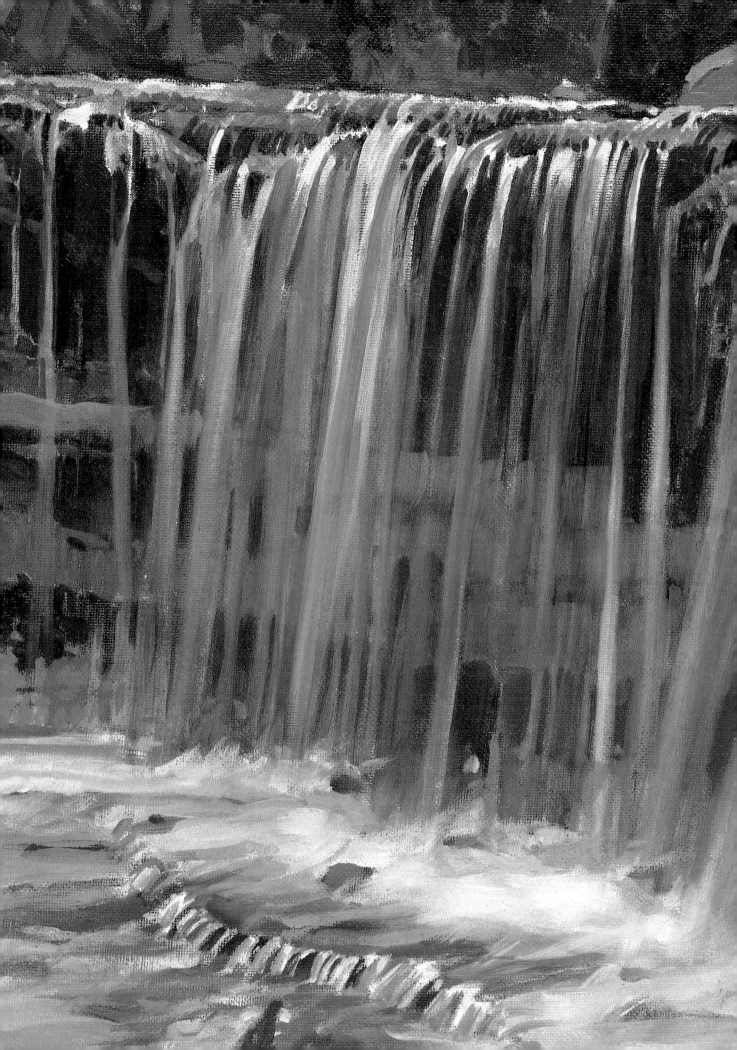

FINISHED PAINTING

The brightest, lightest areas in this composition are made up of highlights formed where sunlight hits the water. Sharpen these areas now. Mix white pigment with the barest touch of cobalt blue and bring the highlights of the waterfall and those at its base into focus.

As a final step, develop the patterns that lie in the rushing water in the foreground.

DETAIL

Instead of working with thick pigment, try using thin, delicate glazes the next time you paint a waterfall. Here each stream of water is carefully laid onto the canvas with a long liquid stroke. Through these strokes, you can see those that were applied earlier. The end result: the feel of glistening, transparent water, struck with brilliant white highlights.

Capturing the Movement in a Shallow Stream

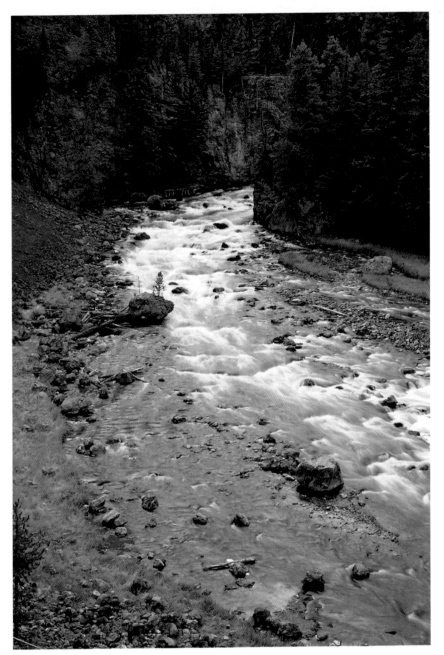

PROBLEM

All of the excitement in this scene comes from the glistening, rushing water. You can't pay too much attention to the dark trees that border the stream.

SOLUTION

Simplify the dark trees in the background and the bright golden grass on the left, then add as much detail as possible to the water.

STEP ONE

Work out all the compositional details in your preliminary sketch. Working with soft vine charcoal, loosely lay down the contours of the stream, then establish the shapes of the trees and the shoreline. Finally, indicate the subtle depressions and elevations that mold the stream bed and the major rocks.

In autumn, a shallow stream rushes quickly over rocks and stones.

STEP TWO
Dust off the canvas, then reinforce your drawing with a small bristle brush that has been dipped into thinned color. Use the local color that dominates each area of the composition to set the color mood of your painting: yellow ocher and burnt sienna along the stream, cobalt blue in the water, and permanent green light for the trees. Now quickly brush in the large masses of dark color, again with thinned color. For the time being, let the white of the canvas represent the lightest values.

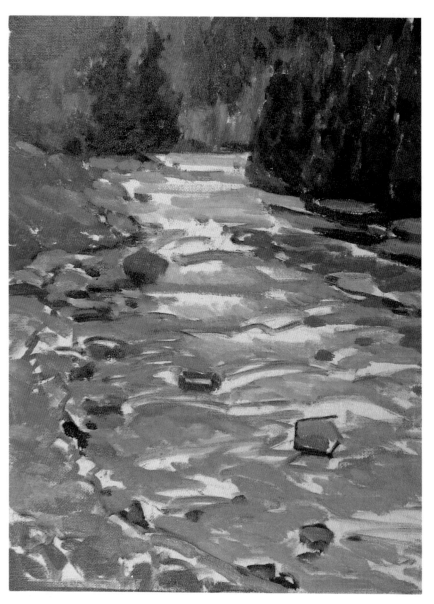

STEP THREE
Working from dark to light and with thick opaque paint, go back over your color sketch. In this stage, aim at capturing the exact colors and values that you want to see in the finished painting. Start with the trees in the background, then move on to the stream banks. Finally, turn to the water. As you render it look for large shapes and patterns. Here, yellow ocher and cadmium orange suggest the ground, and the trees are established with Mars violet, white, cobalt blue, Thalo green, permanent green light, and yellow ocher.

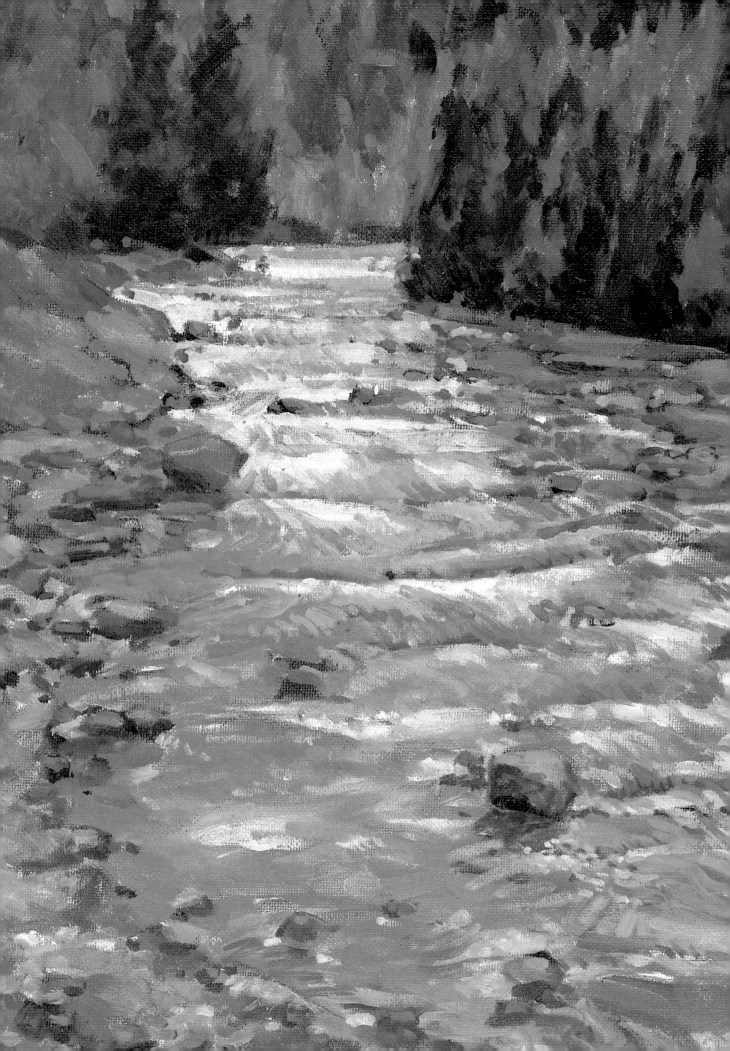

FINISHED PAINTING

Add detail to the water and to the land that surrounds it. For the water, mix together a light hue of gray, then tone it with Mars violet, cerulean blue, and cobalt blue. Apply a good-size dab of pure white to your palette, too. As you work, move back and forth between the whites and the blues, and use loose, overlapping strokes that follow the direction of the rushing water.

Now stop and evaluate your painting. Pay special attention to the ocher grasses in the foreground. If they are too light, they will run into the water visually. Remember, the highlights in the water should be the brightest, lightest areas in the finished painting. If they are too dark, go back and reinforce them with splashes of pure white, then pull touches of pale blue and purple over the edges of the white strokes to integrate them into the rest of the painting.

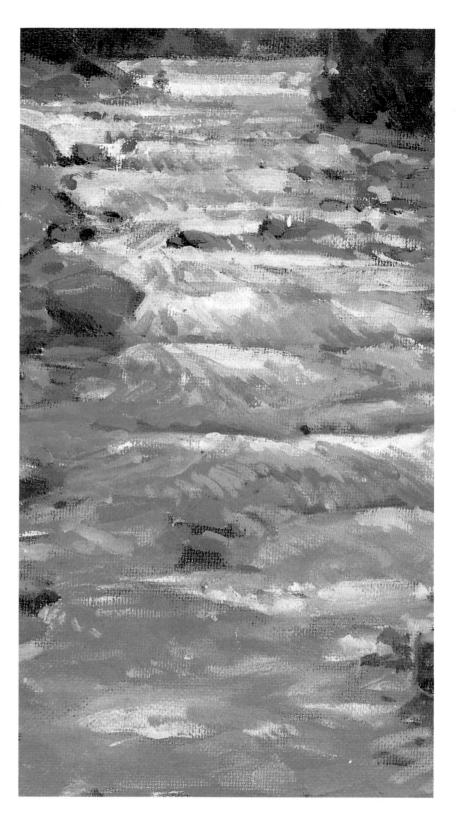

DETAIL

Flickers of white dance over the top of the water. Throughout the entire painting process, areas of white canvas are left clean to indicate the lightest, brightest portions of the composition. The highlights are painted at the very end, then toned down slightly with overlapping strokes of pale blue and purple.

Mastering Soft, Gentle Mist

PROBLEM

The mist may be delicate, but the rest of the scene is full of stark contrasts. If you render the composition too realistically, the mist will be lost.

SOLUTION

To capture the special feel of this scene, downplay the drama of the overall landscape.

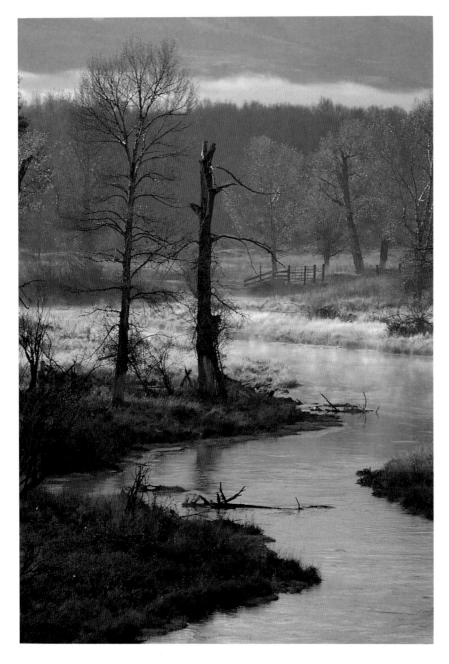

In fall, as the temperature dips, mist rises as a warm river meets the cold, frosty air.

☐ Using vine charcoal, establish the movement of the river. Make sure that it looks realistic by concentrating on the way it moves back into the landscape. Now sketch the distant trees loosely, without adding too much detail. Finally, add the trees in the foreground. Dust off the loose charcoal and redraw the composition with thinned raw umber.

Now go over the entire canvas with thinned color, establishing the overall mood of your painting. Get the darks down first; on a white canvas, any color looks dark, so rendering the very darkest values right away makes it easier to gauge your light and medium tones.

Switch to heavier color now and start to build up the darks. First scrub in the tree-covered hills in the distance, then slowly build up the browns of the land. As you paint, let your brushstrokes mimic the contours of the land. When you approach the central portion of the canvas, work with lighter color: Doing this, you'll pull attention toward the water and the rising mist.

Lay in the water. While the pigment is still wet, take a dry bristle brush and scrub the paint upward, over the river banks to capture the feel of the mist. If necessary, add a little white to the canvas to make the floating mist seem lighter still.

Finally, add the dark trees in the foreground. When it comes time to lay in all the small branches that spring from them, use a small, round, pointed brush and add plenty of painting medium to your pigment.

At the very end, use a drybrush approach to suggest the small branches and leaves that radiate outward from the branches.

Painting Water in Early Morning Light

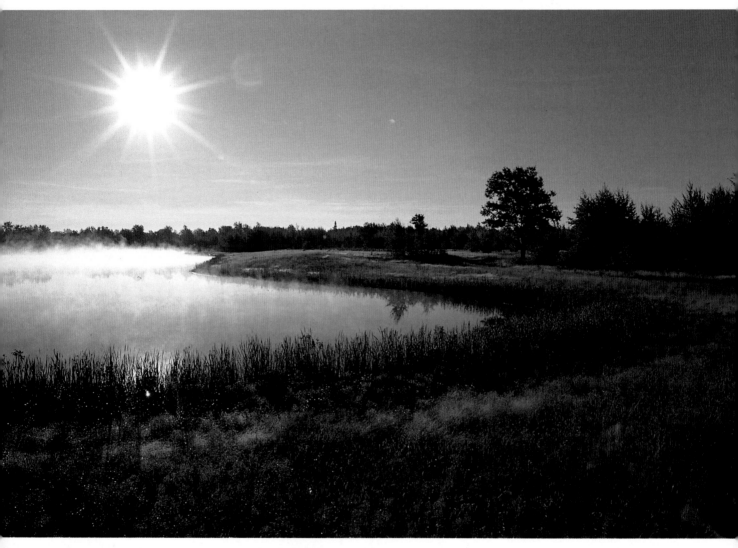

PROBLEM

Two things make this scene arresting—the golden summer light and the soft mist. They have to be the focus of your composition.

SOLUTION

Lighten the foreground so that it doesn't overpower the rest of the scene, and carefully control all of your colors and values.

In early morning, a summer sun explodes over the clear blue water of a pond, and a gentle mist rises in the distance.

STEP ONE

Execute a rapid charcoal sketch to establish the overall composition. Concentrate on the sweeping line of the shore and the patterns that run through the sky and the water. Don't get bogged down with detail—the scene is really very simple.

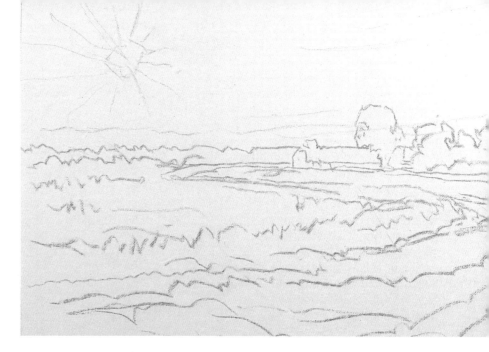

STEP TWO

Dust off the charcoal and redraw the composition with thinned color, quickly establishing the local color of each area. Use Thalo green for the trees, cobalt blue for the water, and burnt sienna for the ground. Now brush in the darks of the distant trees and the grasses that line the shore. At this point, you should have a good idea of the overall color mood of your painting and the way the colors are balanced within the composition.

STEP THREE

With heavier color, paint the sky, working loosely around the trees that run along the horizon. If you cover up part of the trees, don't worry; just go back and add them later on. Here the sky is rendered with cobalt blue, Thalo green, and cerulean blue. Near the horizon, a mixture of yellow ocher and white is introduced. Now paint the trees with Thalo green and alizarin crimson, the distant shore with yellow ocher, and the foreground grasses with Thalo green, cadmium orange, burnt sienna, and yellow ocher. Finally, paint the water, using the same colors that you used for the sky. While the paint is still wet, pull it up over the trees to suggest the rising mist.

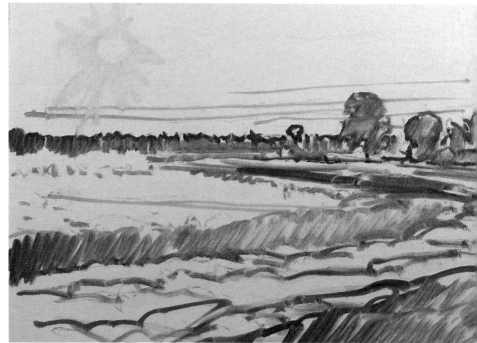

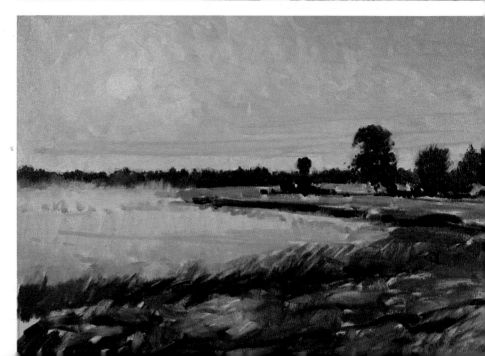

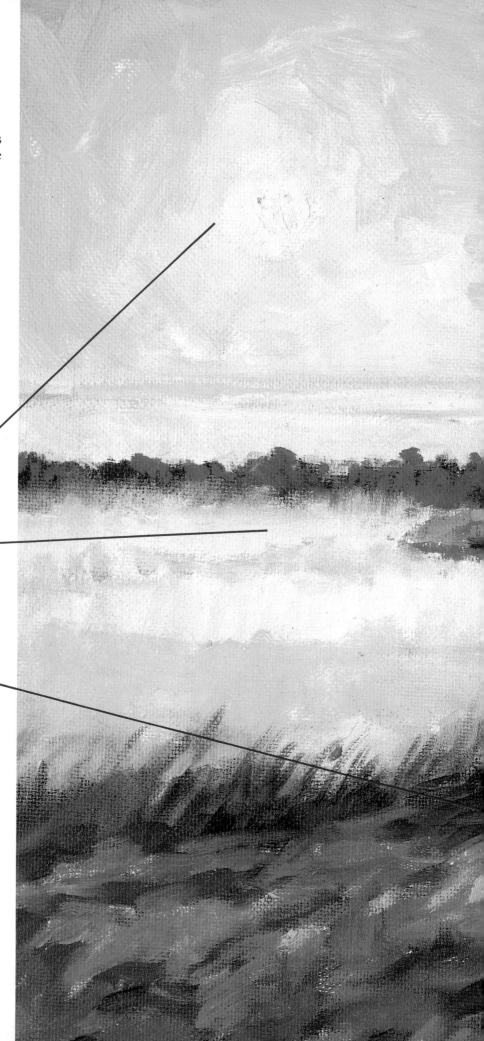

FINISHED PAINTING

Moisten your brush with a pale mixture of cadmium yellow and white, then render the sun. Here it's painted simply, but if you prefer, make it as dramatic as it is in the photograph. Now, using the same hue, add the reflected golden glow to the water.

Now look at the painting as a whole. Here the sun seems to float unnaturally against the sky, so soft strokes of cerulean blue, cadmium yellow, and white were added around it, helping it to blend in with the rest of the composition.

All around the sun, gentle strokes of cerulean blue, cadmium yellow, and white have been added to act as a transition between the yellow of the sun and the blue of the sky.

While the water was still wet, the pigment was dragged up, over the trees, to suggest the rising mist. Later, touches of cadmium yellow and white were added, flooding the water with the same warmth that bathes the sky.

The colors in the foreground are strong and rich, but they don't detract from the power of the water and the sky because their values are controlled. Note how much lighter they are in the painting than they actually appear in nature.

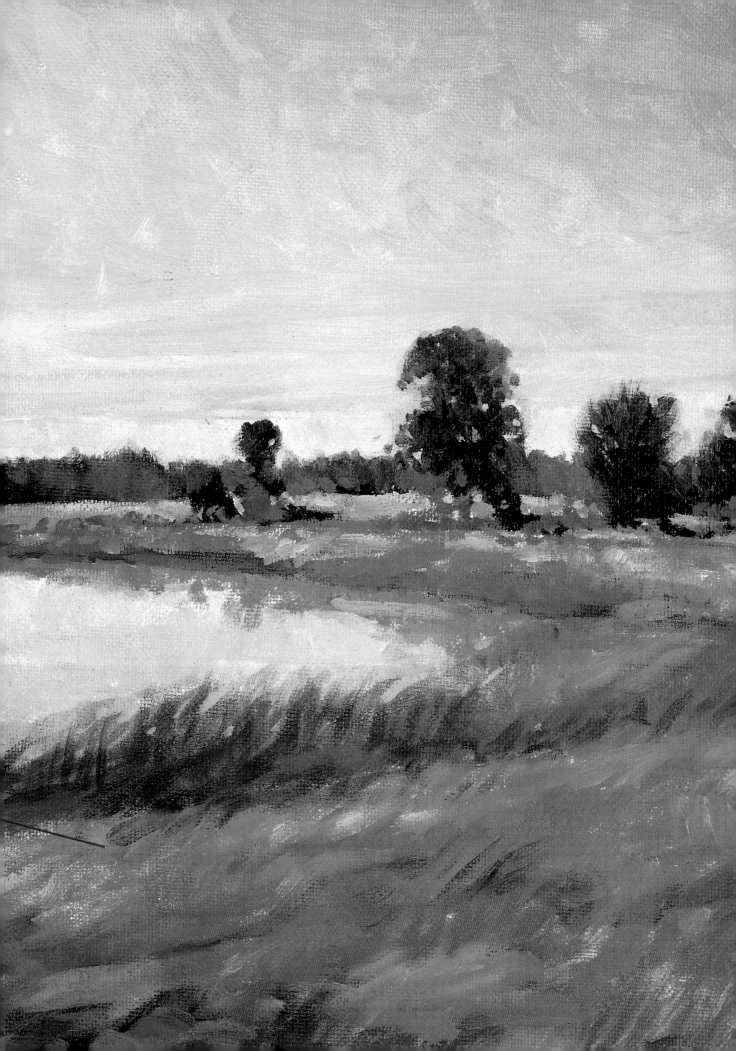

Experimenting with Fog

PROBLEM

Fog softens forms and reduces color and value. Any harsh note—a color that's too strong or a value that's too dark—can make your painting look artificial.

SOLUTION

Work wet-in-wet with just four or five colors, and divide the composition into three distinct zones—background, middle ground, and foreground. Constantly examine your values as you paint.

☐ Execute the simplest of sketches; just indicate the outlines of the trees, then go over your charcoal drawing with a wash of pale blue.

Now prepare your palette. Squeeze out cerulean and cobalt blues, plus black and white, yellow ocher, and a little cadmium red and Thalo green.

Using washes of thinned color, lay in the rows of trees. Start in the distance with the lighter trees, then slowly move forward. Don't try to show any modeling—you wouldn't see any on such a foggy day.

Thick, cold fog presses down against the land, obscuring the trees that grow along the shore of a lake.

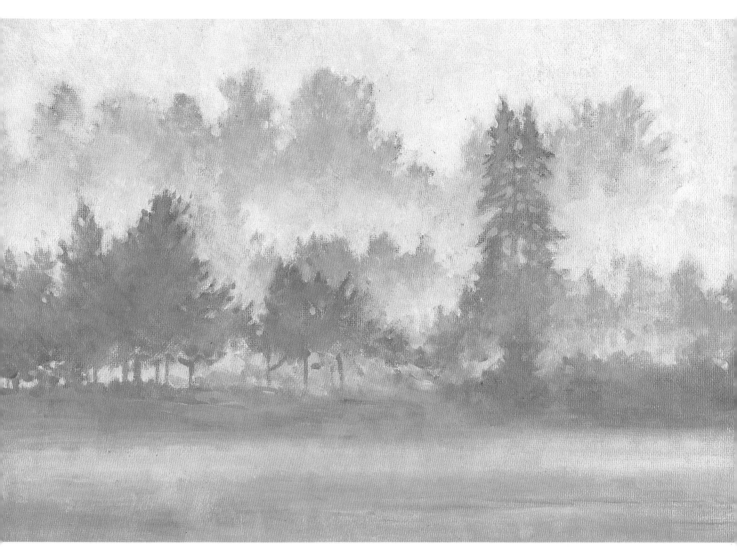

Switch to opaque pigment. Apply the color with short, choppy strokes, and vary the color within each area to add an atmospheric mood. To suggest the fog, try scumbling lighter colors over parts of the trees.

Check now and make sure that your painting makes sense. Since you've been working wet-in-wet, it may be too loose in places. If so, refine the shapes of the trees, but don't introduce any sharp lines.

Finally, paint the water in the foreground with long, sweeping horizontal strokes.

ASSIGNMENT

A variety of supports are available to the oil painter other than prepared canvas boards. Smooth Masonite is great when you are painting an intricate detail and don't want the weave of canvas to interfere with your subject.

Or try working on watercolor paper. Its texture can help you capture a variety of effects. Prime the paper with thinned acrylic mat medium, let the paper dry, then start to paint.

You can also stretch your own canvases. It's less expensive than using boards and lets you to select any weave you want, from the smoothest to the roughest.

Balancing a Soft Background and a Focused Foreground

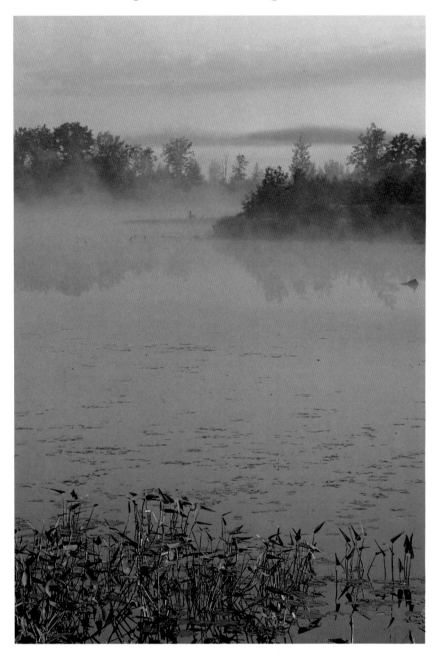

PROBLEM

In the distance, soft mist obscures the landscape, while closer to shore, everything is crystal clear. How can a painting look unified if it contains such different elements?

SOLUTION

Let the water act as a bridge between the two areas. In the background, keep it soft and light, then as you move forward, make it darker and richer.

STEP ONE

Sketch the scene, then go back over the lines of your drawing with thinned color. Next, working with thinned color, lightly brush in the flat shapes of the distant trees and their reflections. Working with a small bristle brush, suggest the grasses in the foreground and the patterns in the sky.

In midsummer, cool morning mist rises from the surface of a pond.

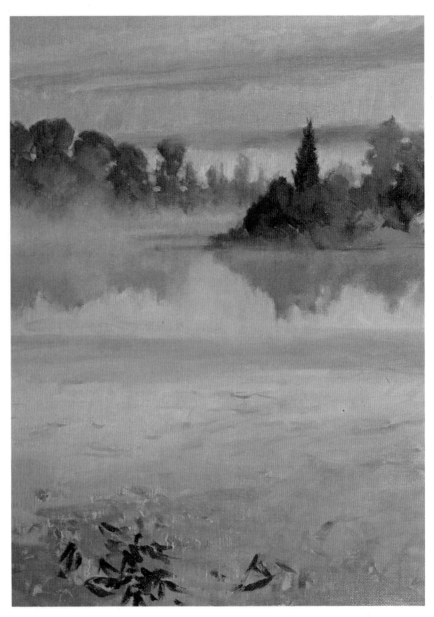

STEP TWO

Establish the rest of the painting with thinned color. Since you are working with turp washes, don't worry about obscuring what you've already done; you'll find that the diluted pigment floats easily over your preliminary work. Work with just three colors, cerulean blue, cobalt blue, and Mars violet. Now let the surface dry.

STEP THREE

Working wet-in-wet, with opaque pigment, reinforce what you've done in Step Two. Continue working with cerulean blue, cobalt blue, and Mars violet, but add streaks of permanent green light and cadmium yellow to the sky, and touches of permanent green light to the water. For the trees, blend Mars violet together with the green and gently dab the paint onto the canvas. Keep the reflections of the trees lighter than the trees themselves; the fog makes them even lighter than they would usually be.

FINISHED PAINTING (overleaf)

Lighten the sky with long horizontal strokes of cadmium yellow and permanent green light, then mix a little white into your yellowish-green pigment and sweep the color into the water around the reflections of the trees.

Finally, add the vegetation. Working with Thalo green, permanent green light, and a little burnt umber, and with a small brush, carefully paint the stems and the leaves in the foreground. At the very end, add dashes of dulled green to suggest the leaves that float behind the vegetation in the immediate foreground.

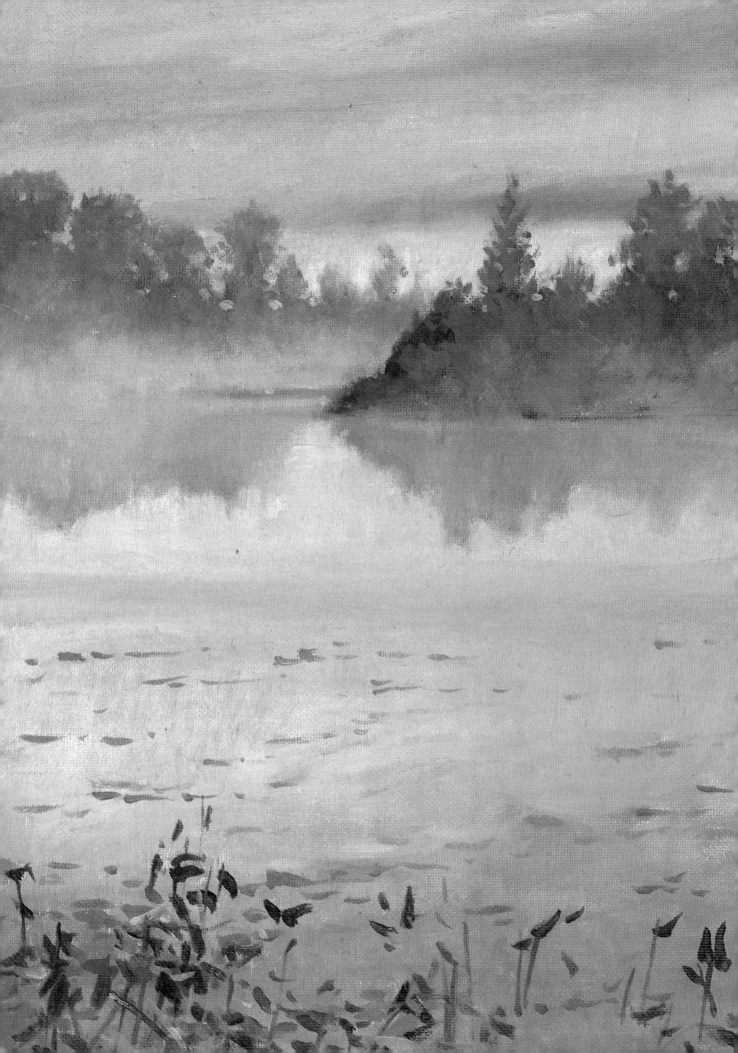

Enlivening Monochromatic Greens

PROBLEM

What at first glance may look like a mass of monochromatic green is actually rich in color. What's more, the pattern formed by the grasses is extremely complex.

SOLUTION

To capture the complexity of the grasses, execute a detailed drawing. Then, when you start to paint, try to capture every small shift in color and value.

☐ With a charcoal pencil, create a careful drawing of the swirling grasses, then spray the canvas with a charcoal fixative. Now tone the entire canvas with a wash of thinned permanent green light, let the surface dry, and then strengthen the drawing with a small pointed brush and a darker shade of thinned green.

Prepare your palette with permanent green light, Thalo green, cobalt blue, cerulean blue, cadmium orange, and yellow ocher; then, with opaque pigment, work back over the toned canvas, developing the surface of the water. Work into the area occupied by the grasses, but try not to cover up too much of your drawing.

Now it's time to turn to the vegetation. At first, try to isolate overall shapes, and lay them in loosely. When they are down, start work on individual blades of grass. Try using a special brush, a fine, long-haired, round one called a rigger or scriptliner. It's perfect for capturing the sinuous lines of the grasses, both because of its shape and because it will hold a good deal of paint. Add plenty of medium to your pigment to keep it pliable, then start working. Layer your strokes over one another, working back and forth between the grasses and the water. To keep the greens lively, repeatedly mix small amounts of color, varying each batch slightly.

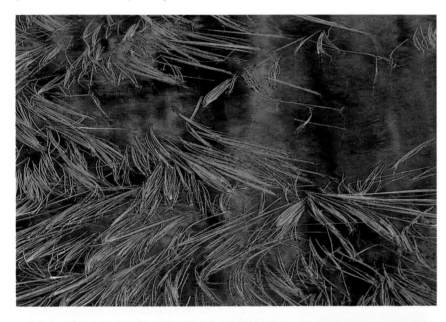

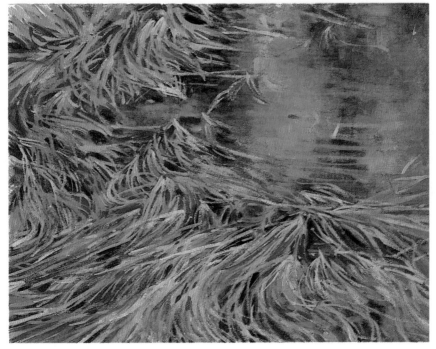

In late summer, vegetation forms an elegant, undulating pattern as it floats on the surface of a pond.

329

Making Sense out of Abstract Patterns

PROBLEM
The patterns formed by the ripples are extraordinarily complicated. Deciphering what you see, then translating it into a painting, will be extremely difficult.

SOLUTION
Work slowly, concentrating on overall pattern. Don't try to copy what you see slavishly—use it instead as a general inspiration.

☐ Softly lay in the large lines formed by the ripples with soft vine charcoal, ignoring all the details. Next, spray the sketch with a charcoal fixative and stain the canvas with a thin gray wash.

With heavier color, begin to build up the lights and darks. Don't let the patterns become too regular! For the time being, the toned canvas will stand for all your medium values.

The overall composition roughly laid in, start to fine tune your work. Work wet-in-wet, moving back and forth between the lights and the darks. While the surface is still wet, take a dry brush and sweep it horizontally across the canvas to suggest the action of the water and to soften any harsh lines.

Now stand back from your painting and examine the value scheme. If the lights get lost amid all the pattern, strengthen them. During this final step, use a dry-brush technique to keep the soft feel that you've established.

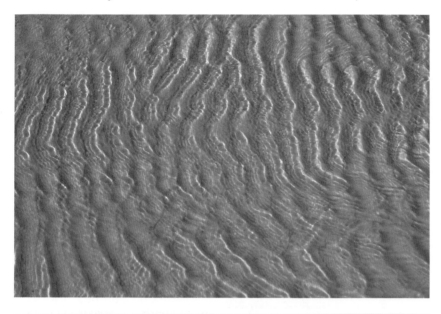

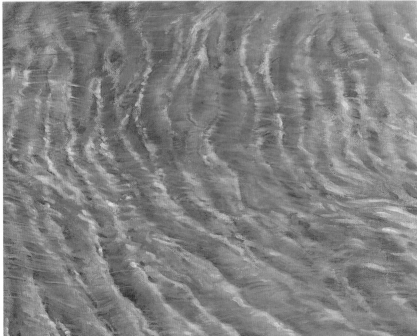

ASSIGNMENT
Try adding an identifiable object to a painting like the one explored in this lesson. It could be a piece of driftwood, a beach ball, or even a pail. Pay attention to perspective—the ripples are seen from above, and whatever you add will have to be viewed from the same angle.

Surf washes slowly over sand, forming intricate, gentle, abstract patterns.

Evoking the Feeling of Soft Surf

PROBLEM

The success of your painting rests on your ability to capture the color, value, pattern, and movement of the water. If one of these elements is off, your painting won't make sense.

SOLUTION

Analyze the anatomy of the water and capture all of its detail in a good, strong drawing. When you start working with color, build it up slowly and gradually.

☐ Draw the scene with care, concentrating on every little detail. Don't rush this stage; there is a real underlying structure to the water and it's vital that you capture it right from the start. When you are happy with what you've done, go back and reinforce your work with thinned color.

Still working with thinned color, brush in the sand on the right and the darkest areas visible through the water. Let the white canvas represent the light foam.

Lay the following colors onto your palette: black, white, permanent green light, cobalt blue, Mars violet, cadmium yellow, yellow ocher, and cadmium red. A pale gray mixed from the black and white will be the backbone of your painting, but throughout it will be tinged with the other hues.

Now start mixing small batches of grayish blues, violets, greens and yellows, then add painting medium to them to form thin glazes. Slowly build up the pattern of the water, working back and forth between the sand and the foam. Use heavier color for the roll of foam at the edge of the wave. Throughout, use short, broken strokes to suggest how the light plays upon the water, and how the water breaks into small areas of color.

Finally, with a small pointed brush, add the stone, the grasses, and the shadows that they cast.

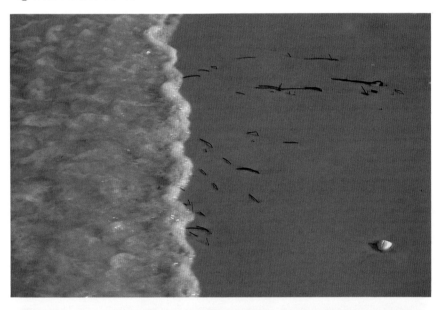

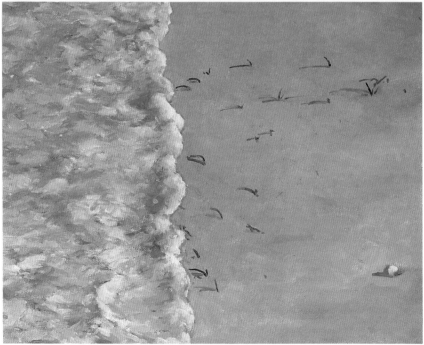

After surf surges over the sand, the water quietly retreats, leaving the sand, a few blades of grass, and a smooth stone behind.

Capturing the Subtle Colors of Wave-washed Rocks

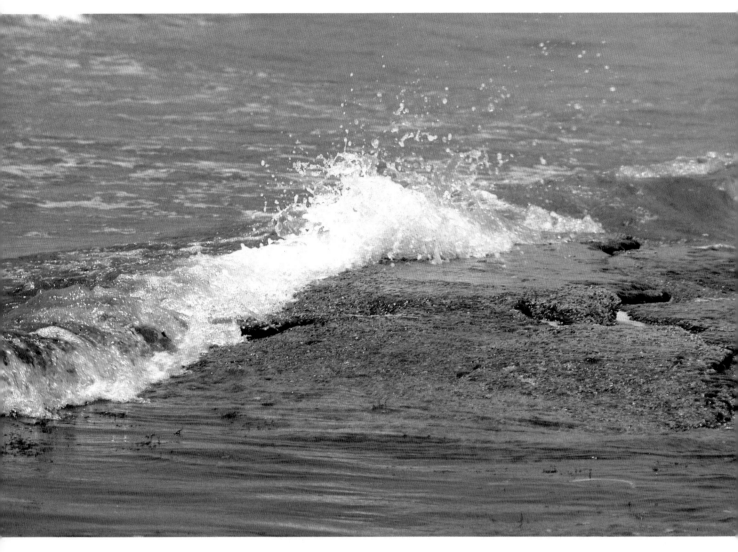

PROBLEM

The breaking wave may be the first thing that springs into view, but it won't be the most difficult element to paint. Capturing the color and brilliance of the rocks is the real challenge here.

SOLUTION

As you establish your color scheme with thinned pigment, loosely brush in the rock formation with rich brownish hues. Later, to capture the warmth of the water that rushes over the rocks, tinge it with Thalo green.

☐ Place the composition on the canvas with charcoal, then redraw it with a small bristle brush and thinned color. Vary the colors that you use to separate the surf, rocks, and water.

Working with thinned color, and from dark to light, block out the color and value schemes. To keep drying time to a minimum, let the white of the canvas represent the pounding surf.

With heavier pigment, start to

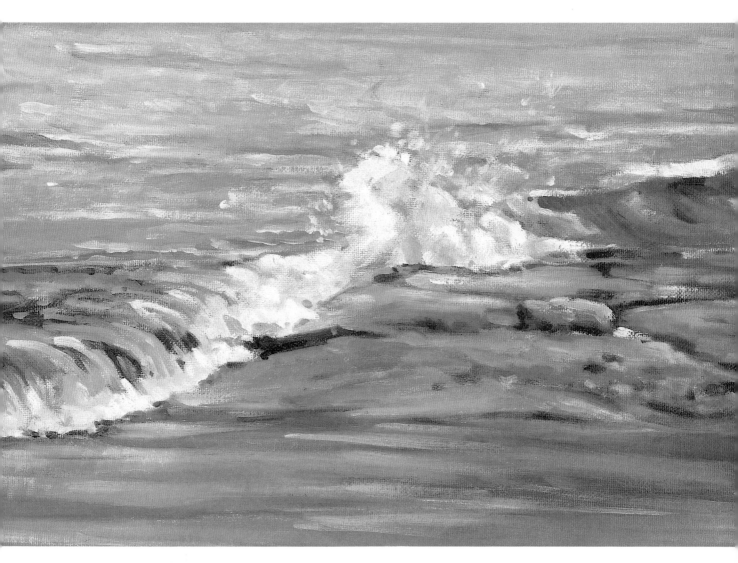

build up the patterns in the water. Use a variety of colors: cerulean blue, cobalt blue, Thalo green, Mars violet, yellow ocher, cadmium red, and black and white. To create a sense of depth, let green dominate the background and violet the foreground; throughout, don't let the water become an uninteresting blue. To render the rocks, use burnt umber, yellow ocher, and touches of cadmium orange. For the water that rushes over them, make Thalo green the principal color.

Finally, turn to the breaking wave. Study it carefully, noting how it has both a light and dark side, then begin to paint it with white, yellow ocher, and a variety of blues and greens.

Finish the painting by adding any necessary accents to the wave and the rocks.

Indicating Bold and Subtle Elements Simultaneously

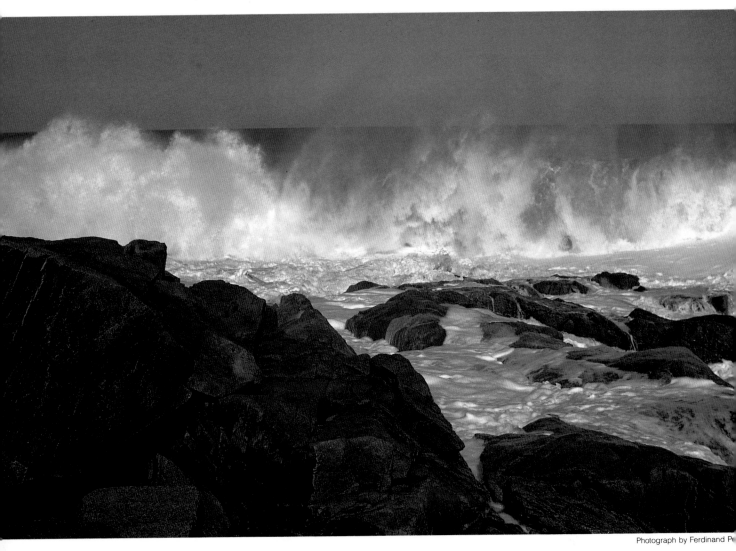

Photograph by Ferdinand P

PROBLEM
Massive, dramatic rocks dominate the foreground; behind them, soft, misty, wind-blown surf shoots upward. Both elements count and have to be captured.

SOLUTION
Emphasize the difference between the two areas. Make the rocks even bolder than they actually are and the surf softer and lighter than it is in reality.

A curtain of water explodes as waves pound against dark, dramatic rocks.

334

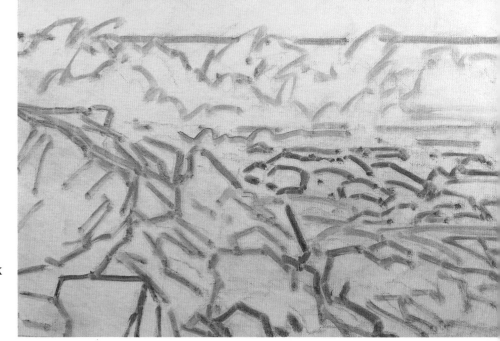

STEP ONE

In your preliminary charcoal sketch, carefully indicate the contours of every rock and the silhouette of the surf. Next, go back over the lines of your drawing with thinned color. Here raw umber is used for the rocks and cobalt blue for the water.

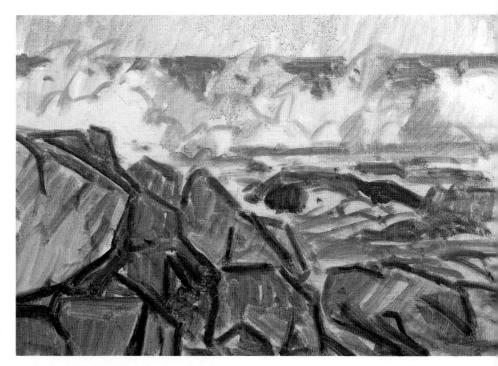

STEP TWO

Working with all the browns on your palette, and touches of yellow ocher as well, start to paint the rocks with thinned color. By using different shades of brown, you'll break the rocks apart from one another and more clearly indicate their overall structure. Next, sweep washes of dark and middle-value cobalt blue onto the canvas to represent the water and the sky.

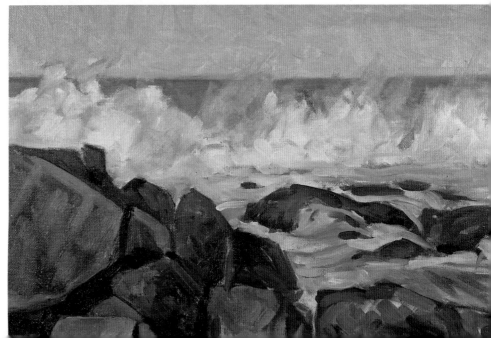

STEP THREE

Switch to heavier opaque color and begin to search for the exact colors and values that you want in the final painting. Continue using a wide range of colors for the rocks—even touches of blue—and render them with strong, assertive brushstrokes. Paint the sky with cerulean blue, cobalt blue, and, near the horizon, a touch of alizarin crimson. When the sky is dry, scumble the surf up over it, then add the water in the foreground that eddies around the rocks.

FINISHED PAINTING

If they are to stand out clearly against the water, the rocks have to have sharp, clean edges. Spend a few minutes refining them, then turn to the surf. To make it softer and subtler, try subduing it with pale hues. Here it is rendered with mixtures of white and yellow ocher, white and Thalo green, white and cobalt blue, and white and alizarin crimson.

A streak of alizarin crimson separates the sky from the water, pulling attention back into the composition, away from the rocks.

After the water in the background has dried, the pounding surf is scumbled up over it. Later it is reinforced with thicker pigment.

The rocks in the foreground are warmer and lighter than those in the middle ground. All of them are painted with a wide variety of browns, plus yellow ocher, cadmium orange, and cobalt blue.

ASSIGNMENT

Capturing the power and drama of waves is one of the greatest challenges facing the landscape artist. Waves are in a constant state of flux, which makes them difficult to depict.

The easiest way to become adept at painting them is to sketch them as often as possible. On a day when the surf is strong, bring newsprint, charcoal, and pencils to the beach. With your eyes fixed on the water, loosely lay down the sweeping power of the waves. As you draw, use your entire arm—don't get caught up in small details.

First draw the low swells in the distance. Next, sketch the waves as they crest closer to the shore, following the way they rise then begin to topple over. As they begin to break, record how they turn over and start to explode in spray. Finally, sketch the waves as they crash toward the shore. When you are acquainted with the dynamics of the surf, you'll be delighted at the difference this knowledge brings to your seascapes.

Dramatizing Heavy Surf

PROBLEM

Like most exciting seascapes, this one contains an almost overwhelming amount of visual information. How can you sort it all out, and emphasize what matters most?

SOLUTION

Let the dark wall of water that rises on the left act as a focus for your painting. Make it dark, clean, and sharp, and the rest of the composition can revolve around it.

☐ If you're excited by the motion of the scene and confident about your drawing skills, try working from the very start with thinned color—it will help you work loosely and freely and with as much energy as the scene calls for. Or, if it will make you feel like you have a firmer starting point, sketch the water with charcoal, then go over the lines of your drawing with a turp wash.

After your preliminary work is completed, develop the scene with thinned color; let the white canvas stand for the brightest, lightest whites. Let the canvas dry, then look at what you've done. If you've lost any of your initial drawing, or if you feel that you need more definition before you proceed, get it down now before you continue painting.

Since drama is what you are after, don't weaken your colors with painting medium. Use the pigment straight from the tube as you begin to adjust colors and values. Start with the darks. Here the dramatic wave on the left is painted with Thalo green and alizarin crimson.

For the rock in the foreground, use burnt umber and Thalo blue for the darks, and burnt sienna and cadmium orange for the lights. The sky is painted with cobalt blue, blended with cerulean blue closer to the horizon.

To capture the brooding quality of the water, gray down your color with ivory black. Mix it with Thalo green, cobalt blue, and cadmium red, and add touches of burnt umber to the foam.

Now sharpen your image. Get the edge of the dark wave down as crisply as possible, and strengthen the silhouette of the rock in the foreground. Finally, if your painting seems too dark overall, go back and make the pounding surf brighter and lighter.

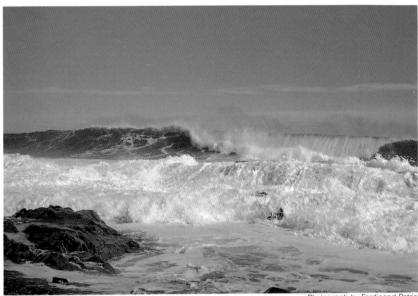

Photograph by Ferdinand Petrie

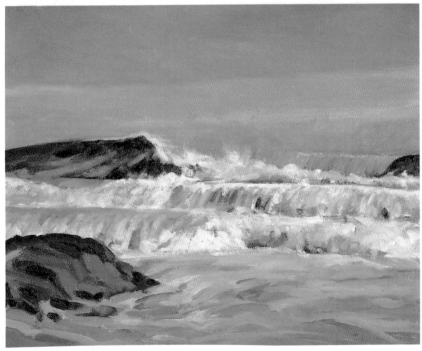

In the distance, dramatic waves rise and fall; closer to shore, calmer waters pulse toward the land.

Working with Complicated Patterns

PROBLEM
The rocks stand dark and imposing against the blue of the water and sky and the white of the surf. To make matters still more complicated, the whole composition is filled with elaborate pattern.

SOLUTION
Don't let the water or the sky become too light—they have to be dark to balance the power of the rock. More important, use the patterns in the foreground to lead the viewer's eye into the picture.

☐ Sketch the scene with charcoal, then simplify your drawing with a bristle brush and thinned color. During this stage, pay special attention to the patterns formed by the moving water, and to the masses of rocks.

Continue working with thinned color as you establish the dark mass of rocks in the foreground, then lay in the sky and the darks of the water. The sky's the easiest area in this composition; turn to it now, using opaque pigment. Try to finish it rapidly, in one session, using a wet-in-wet approach.

The sky done, build up the patterns that lie in the rocks. Use crisp, clean strokes to suggest their rough planes. Force the contrasts that lie in the rocks! They're what give this seascape power.

Now, at last, turn to the water. First lay in the darks, then drag white through the darker hues to establish the brilliant foam. To render the waves that crest and foam in the background, use a drybrush approach, pulling the white pigment up over the sky.

As a final touch, go back to the rocks and clarify their contours. They have to be clean, crisp, and sharp, or they won't stand out against the blues of the water.

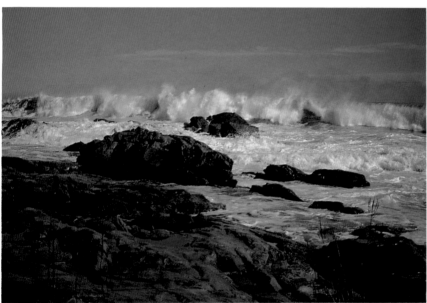

Photograph by Ferdinand Petrie

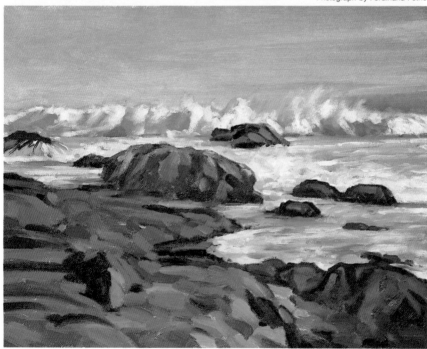

Water slams against the rocks and sand, then eddies slowly toward the shore.

ASSIGNMENT
To better understand the anatomy of crashing waves, photograph the same seascape in rapid succession—take at least 24 exposures. Capture how one wave breaks and rolls into the shore as another starts to build. When your pictures are developed, study them in sequence and you'll learn how the waves build up, crest, crash, and then, in the distance, begin to build up again.

Catching Flickering Highlights

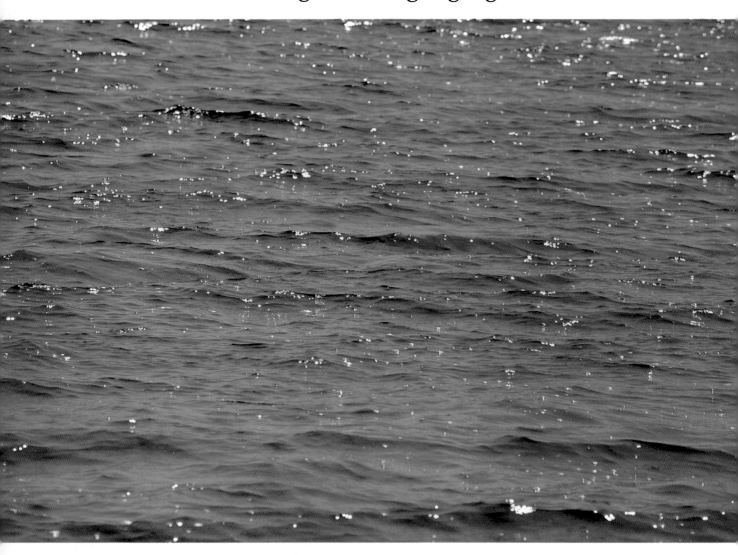

PROBLEM

There's nothing here to disturb the feel of water—that's all you see. But moving in on water alone has its own challenges. Making your painting powerful—and believable—depends upon your ability to capture the overall pattern of the scene and all the nuances that it holds.

SOLUTION

At first, concentrate on the dark and light patterns that lie in the water. Then, when they are fully established, lay in the flickering highlights.

As wind rushes over the water, tiny crests form, catching flickers of brilliant sun.

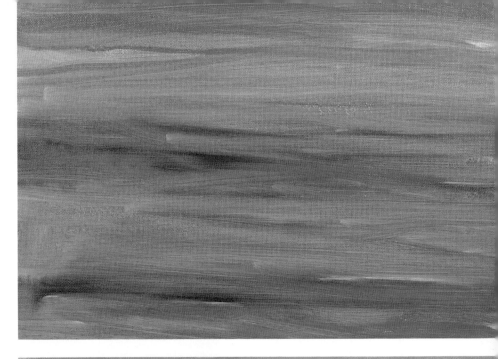

STEP ONE

Prepare your palette with Thalo blue and cobalt blue, as well as Thalo green and alizarin crimson, then right away, start laying in broad, sweeping strokes of color, using a large brush and thinned pigment. From the beginning, keep a sharp eye on values as you lay in the general pattern of the ripples that move across the lake. At this stage, think of the scene as an abstract composition.

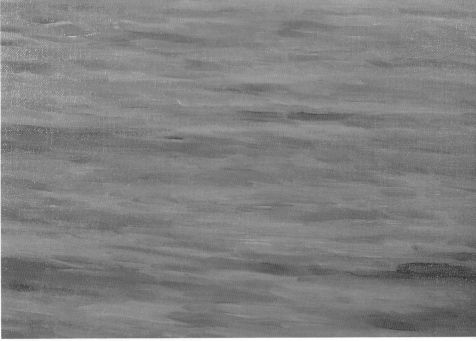

STEP TWO

Now work back over the thin underpainting with thicker color. To make the water seem as dark and intense as it really is, use short horizontal strokes; you'll find that they add mass to what could become loose and flimsy. To make the foreground spring forward, lay it in with larger strokes and darker hues. Most important, don't try to follow your subject too literally—go after its spirit instead.

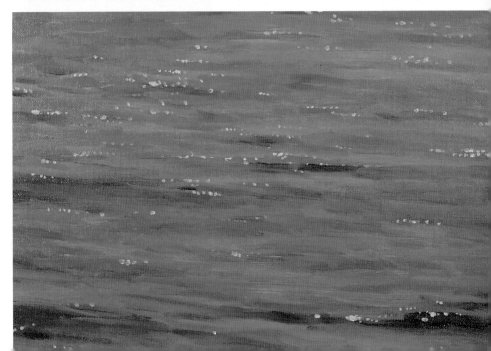

STEP THREE

Once you have built up the pattern of the waves, turn to the spots of color that suggest the highlights that move over the water. To render them, use white, yellow ocher, and a touch of Thalo blue and raw umber. Work over the entire canvas, and don't let the pattern become too regular. To create a realistic sense of depth, make the highlights a little larger in the foreground.

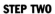

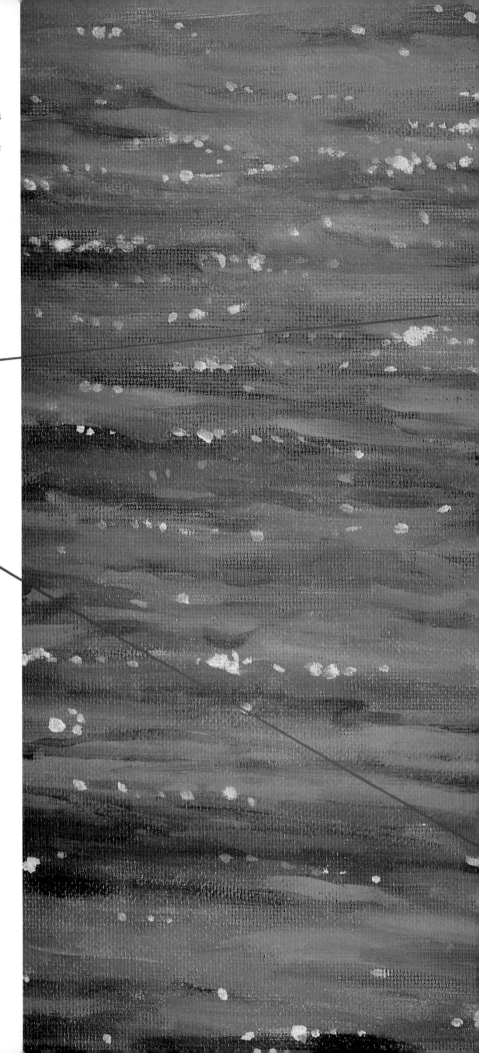

FINISHED PAINTING

Once you've gotten down the basic pattern of the highlights, move away from your canvas for a while. Study it at your leisure, looking for spots that seem a little off and for areas where the pattern of the highlights seems too regular. At this point, let the needs of your painting take over—don't try to copy the scene slavishly. Figure out what it needs, then sharpen your composition.

The water's deepness, movement, and transparency are created by applying layers of ever-thicker paint, first in broad, sweeping strokes, then in large, clear brushstrokes, and last with quick dabs for the highlights. The trick is to allow the previous layers to show through.

The dark blues in the bottom of the canvas are stronger and deeper, and the white highlights crisper, brighter, and bigger. This establishes a definite foreground, giving an almost abstract picture a feeling of perspective.

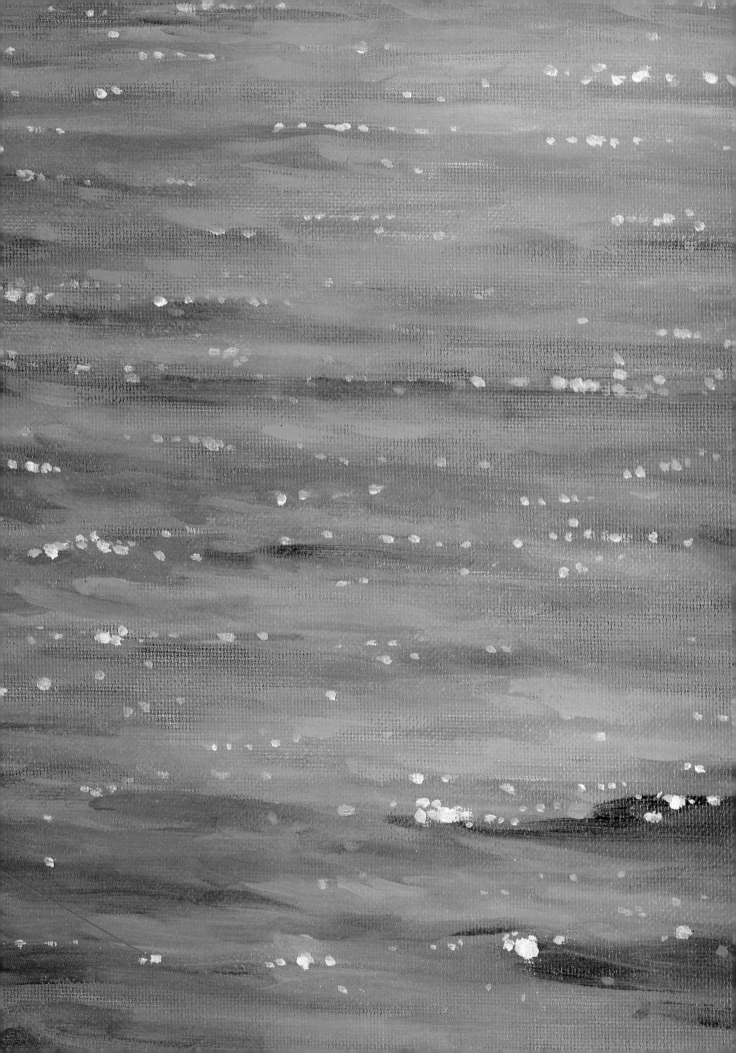

Moving in Close on Detail

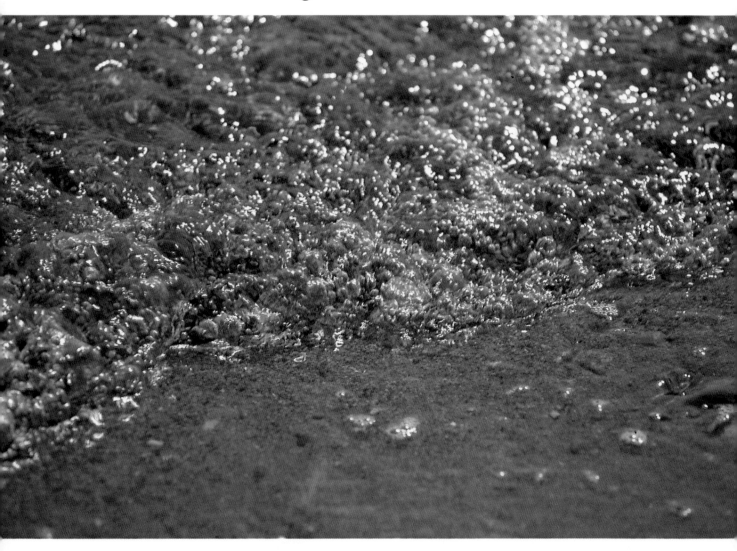

PROBLEM
There's a complex mass of visual information here, but there's nothing much to hold it together. Organizing what you see and making it seem real is the key to creating a dynamic painting.

SOLUTION
In the early stages of your painting, concentrate on abstract patterns. Once they've been established and the composition has begun to develop, start adding detail.

☐ When a scene is as ephemeral as this one, don't bother with a charcoal sketch. Instead, lay in an overall wash of thinned color, here made up of raw umber and white. As you paint, vary your values; keep the glistening water at the top lighter than the sandy beach below. Now let your canvas dry, then go back over it with a small bristle brush and thinned color, getting down the major design elements that you see. Concentrate on the edge of the rolling water and on the patterns that the surging water creates.

Begin working with thicker pigment. Using a short bristle brush, build up the lights and darks of

Rushing water rises toward the shore, then retreats, forming a rich mosaic of color and light.

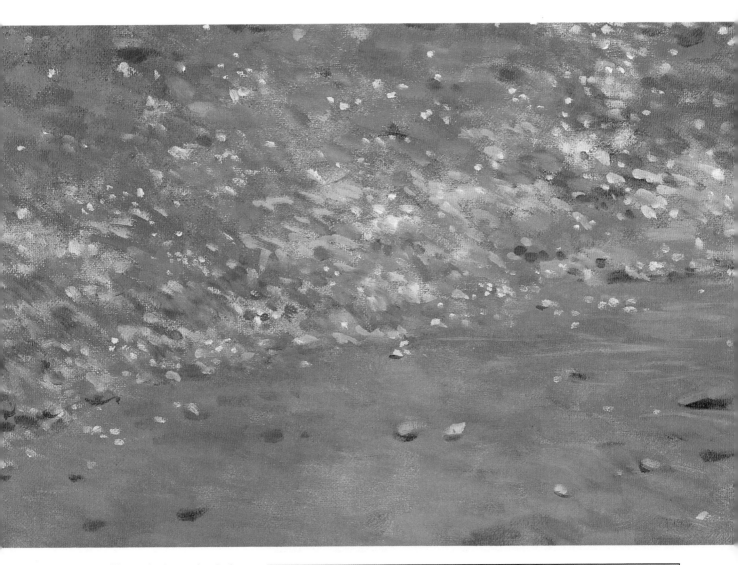

the water. Here dashes of cobalt blue lie interspersed with touches of raw umber, white, Thalo green, and yellow ocher. When you turn to the shore, use broader strokes, and add a little Mars violet to your palette. Finish the shore in one step—when it's done, you can go back and concentrate on the water.

Now continue building up the patterns in the water, layering one stroke over another. All the while, keep an eye on values and color! Make the darks dark, the lights light, and throughout the painting, don't let your colors become flat.

ASSIGNMENT

If landscape painting is what you love, what's the point of painting these intricate details that close in on just a few feet—or inches—of water or ice?

These subjects can give you a new freedom when you go back to painting rushing surf or the beauty of a lake at sunset.

After you've mastered how to depict water lapping slowly onto a beach, you'll find that all your seascapes have more authority. Even when you are painting a group of children at play on a beach, you'll be able to get the background down correctly. When you approach a confusing winter scene, filled with snow, ice, and frost-covered vegetation, you'll feel more at home than before, too, if you've closed in on just a few blades of snow-covered grass and worked with them closely.

Rendering a Stark Silhouette at Sunset

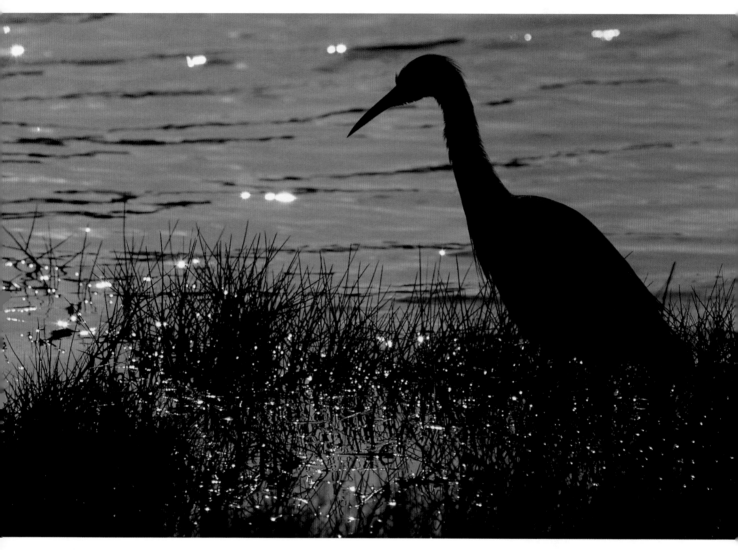

PROBLEM

The contrast between the bird and grasses and the water is so strong that you could easily lose what matters most here—the effect created by the shimmering water.

SOLUTION

Keep the dark elements as simple as possible, and save them for the very end. Concentrate, instead, on the water.

☐ Place the composition on your canvas with a simple charcoal sketch, then go back over it with thinned color. Don't just draw the bird and grasses—try to capture the patterns in the water, too.

Switching to opaque pigment, work wet-in-wet and begin to build up the water. Pay careful attention to its color. If you study it closely, you'll find that it's made up largely of green, not blue. Try using Thalo green and cobalt blue, plus white and alizarin crim-

As the sun sets, a little blue heron wades warily into the lapping water of a Florida inlet.

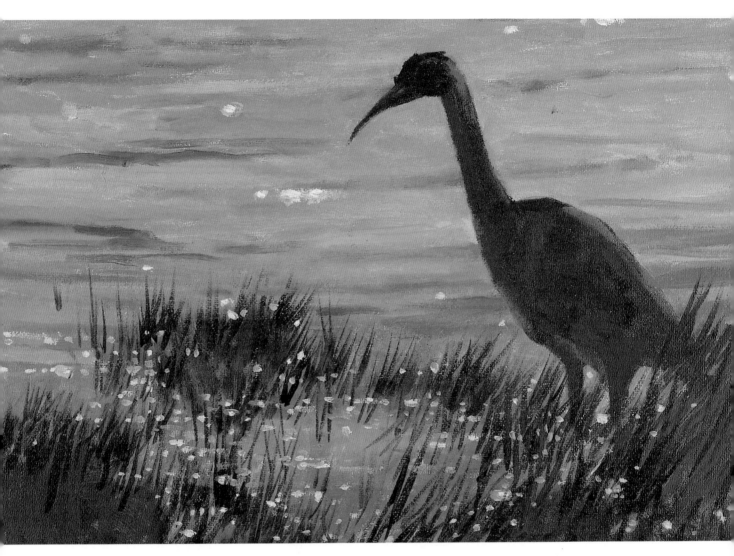

son to render it. And keep your values dark; they have to be to make the highlights that move across the water stand out. During this stage, paint right over the grasses in the foreground. You'll go back to them a little later.

When you are happy with the water, turn to the bird. Keep it simple, adding just a little modeling so that it doesn't seem pasted to the canvas. For the grasses, add plenty of painting medium to your color to keep it fluid, and lay in your strokes with a long-haired rigger brush.

Finish the painting by adding the spots of light that lie across the water. Don't use pure white! Keep some color in these highlights, and they'll blend in easily with the rest of your painting. Finally, make the highlights in the center of the composition brighter and lighter than those closer to the edge.

Painting Ice

PROBLEM

How can you render ice? After all, it's transparent, and at first doesn't seem to give you anything tangible to work with.

SOLUTION

When you begin your painting, forget about the ice. Think, instead, about the dark water that's visible beneath it and around the stone.

☐ Sketch the composition with soft vine charcoal, then redraw it with thinned color, paying special attention to the darks and lights of the underlying water. For the time being, let the white canvas represent the white edge of the ice.

Now, working with heavier color, develop the darks that run throughout the scene. Use a wet-in-wet approach, brushing small bits of color into each other. Don't let any one area dominate. When you move closer to the broken ice that surrounds the stone, use the same hues, but lay in your color with smoother strokes. Keep the stone simple— if you pay attention to its lights and darks, you'll capture its mass and its round shape.

Now step back from your canvas. If your values are too light, make them darker and richer, but keep the colors mottled and subtle. That done, add the light film that rims the broken ice, keeping it crisp and light.

At the very end, go back and add the dark accents that you need. In particular, surround the brightest lights with a thin ridge of dark color to make the lights really stand out against the darker ice.

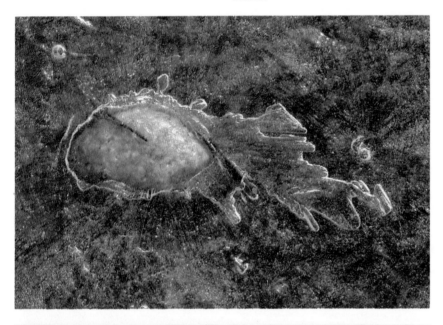

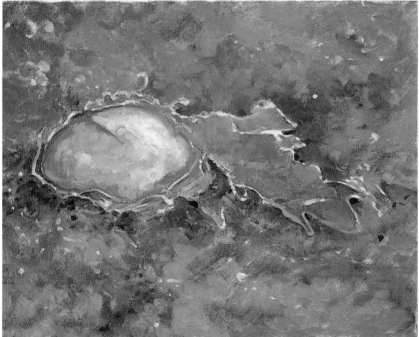

A rock lies in the middle of a frozen stream, with the ice surrounding it forming a rich, glistening mosaic of color and light.

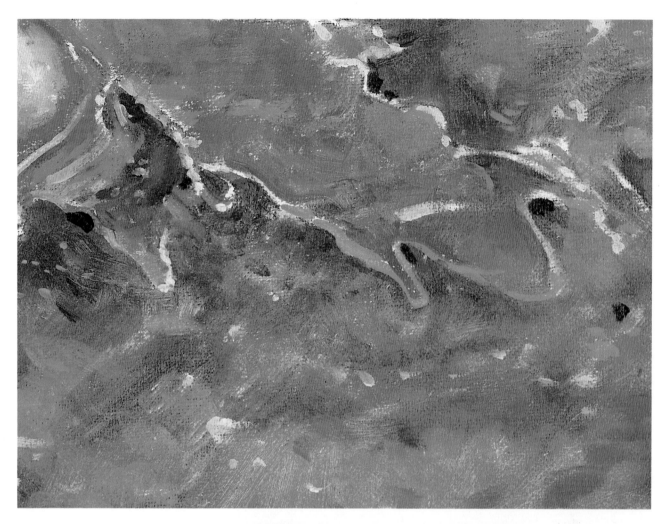

DETAIL

Mostly gray in nature, in this painting the ice is transformed into a web of interweaving colors. A light gray hue, mixed from black and white, is toned throughout with brown, violet, and blue. Because the colors are based on gray, and laid in wet-in-wet, with overlapping strokes, the end result is a subtle mix of closely related hues and values.

ASSIGNMENT

Don't get locked into any one particular way of viewing a scene. If your bent is toward the abstract, try working more realistically. On the other hand, if you are always concerned with capturing the particulars of a composition, try instead to establish its underlying structure. Working with an approach that's alien to you can give you a deeper understanding of your own style—why you like it and why it works for you. More important, you may find that working in a controlled fashion gives structure to your abstract works, or that working loosely enlivens your realistic paintings.

Capturing the Feeling of Opaque Ice

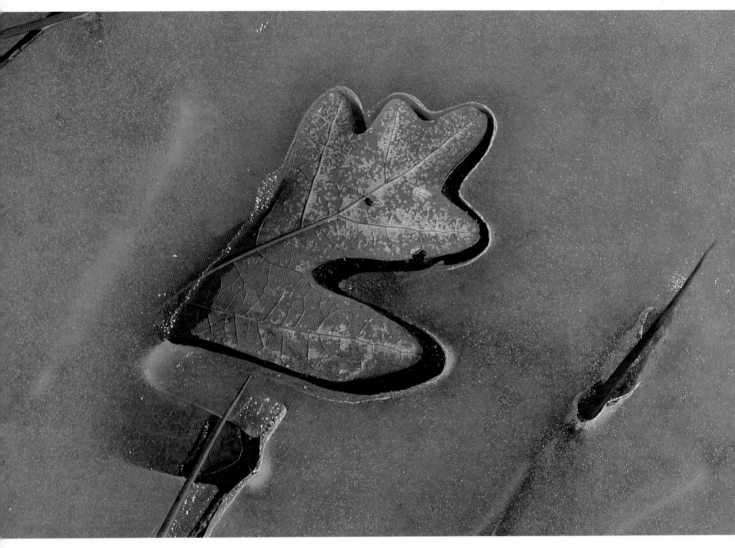

PROBLEM

What seems simple at first can actually be very difficult to render. Here you have to capture the feel of the ice and the fact that the leaf lies trapped in it.

SOLUTION

Lay in the ice gradually, scrubbing thin layers of pigment onto the canvas, then go back and paint the leaf as realistically as possible.

An oak leaf and two blades of grass break through a thin layer of opaque ice.

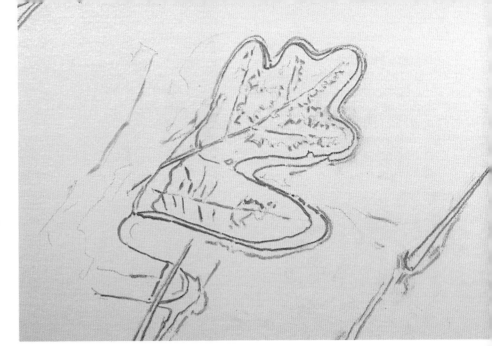

STEP ONE

With a sharpened charcoal pencil, carefully draw the leaf; keep its lines crisp and clean, then redraw it with a small pointed brush and thinned color. Don't just try to capture the silhouette of the leaf; instead, add some of its texture as well. The thin washes of color that you'll be using later will let these nuances shine through.

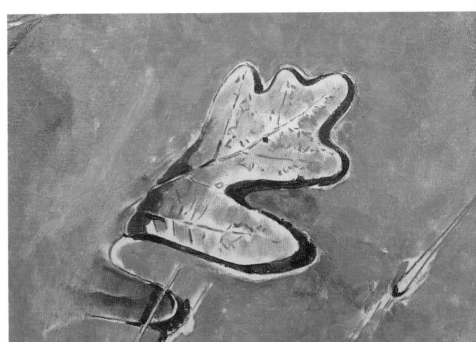

STEP TWO

Begin to build up the background working with a bristle brush and very little painting medium. Scrub the color onto the canvas, and make each stroke blend smoothly into those that surround it. To keep the ice interesting, mix small batches of color repeatedly, then lay them down. Don't let any sharp edges appear; the soft effect you're after is especially important where the leaf breaks through the ice.

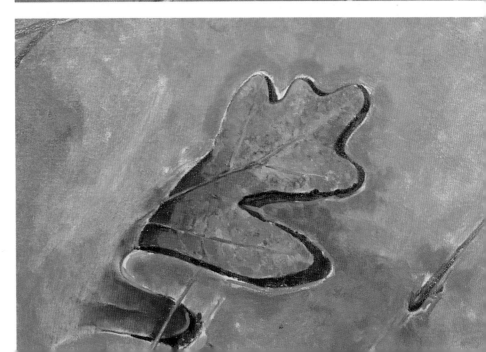

STEP THREE

Develop the color and the texture of the leaf, using mixtures of yellow ocher, raw sienna, and Mars violet. Small, stippled strokes suggest the crinkly texture of the dry leaf. To render the thin, delicate veins and the icy rings that surround the leaf, use a rigger brush. Now strike in the thin blades of grass, and make any necessary adjustments in the color and value of the ice.

FINISHED PAINTING

Fine tune your painting. Bring out the lightest portions of the leaf with yellow ocher, then lay in the sparkling highlights that flicker across the ice. As a final touch, strengthen the dark shadow beneath the leaf.

Subtle shifts in color run through the ice and help suggest its opacity. The pigment is scrubbed onto the canvas with a bristle brush.

The sparkle of ice that rims the leaf is rendered with yellow ocher and white. The two hues are loosely mixed together, so flecks of gold stand out clearly.

ASSIGNMENT

If abstract paintings fascinate you, yet you shy away from executing them yourself, try using something real—ice or water—as a point of departure. Choose a subject made up of complex patterns: ice forming around a submerged leaf or rock, wavelets rippling over tightly packed sand, or an icicle hanging from a tree.

As you sketch the scene, don't look at the canvas; aim at coordinating your hand and your eye. When you begin to lay in thin turp washes, continue to refer to the canvas as little as possible. Then, as you build up thicker color, work loosely, concentrating on overall pattern.

When it comes time to add finishing touches to your work, you may find that what you've done doesn't really resemble your subject—just the effect you wanted! Instead of pulling the painting into focus, try emphasizing the abstract shapes that appeal to you the most.

352

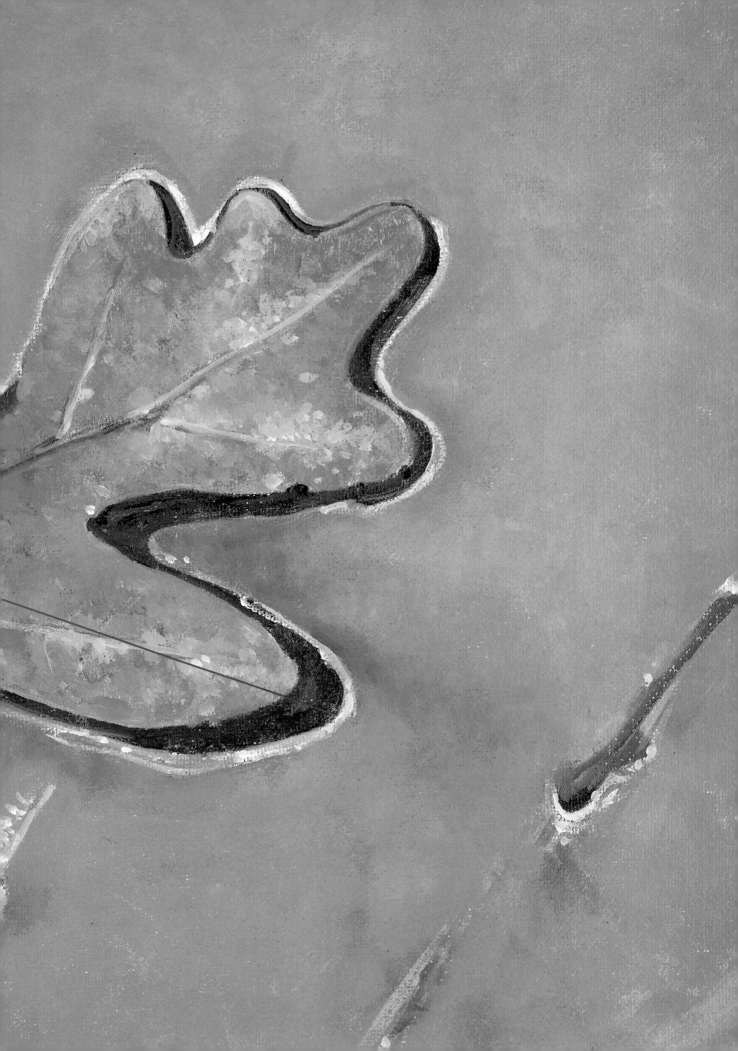

Exploring the Structure of Ice Crystals

PROBLEM

It's just what makes this composition so stunning that will make it so difficult to capture in paint: The structure of the ice crystals is incredibly complex.

SOLUTION

Work back and forth between the dark background and the light crystals, constantly keeping your eye on the pattern the crystals form.

☐ A thorough drawing will be the backbone of your painting, so take your time getting down everything you see with a charcoal pencil. Fix the drawing, then go back over it with thinned color. Continue working with thinned color as you establish the dark background and the leaf.

Switching to heavier color, further develop the background, then with short, light strokes, add the bits of blue that lie within the frosty crystals. Using yellow ocher and burnt sienna, render the leaf, paying special attention to its shape. Finally, lay in the crystals with a rich creamy mixture of yellow ocher and white.

With a small, pointed brush, define the edges of the frost, working back and forth between the crystals and the background. When you are satisfied with the structure of the ice, gently dab touches of medium-value blue onto the canvas to suggest the ice crystals that spread out from those in the center of the composition.

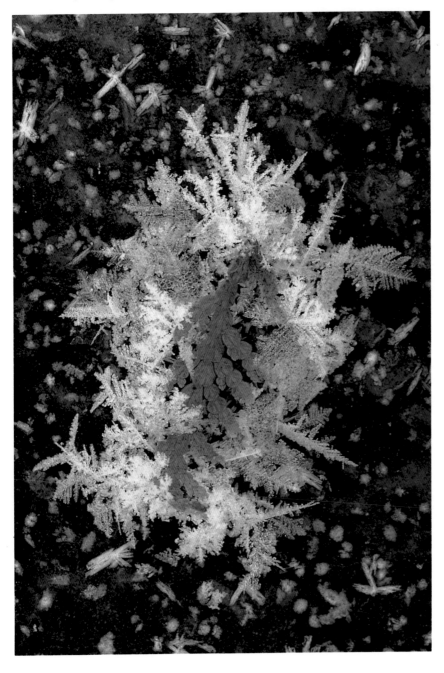

Feathery white ice crystals spread outward from a delicate golden-brown leaf.

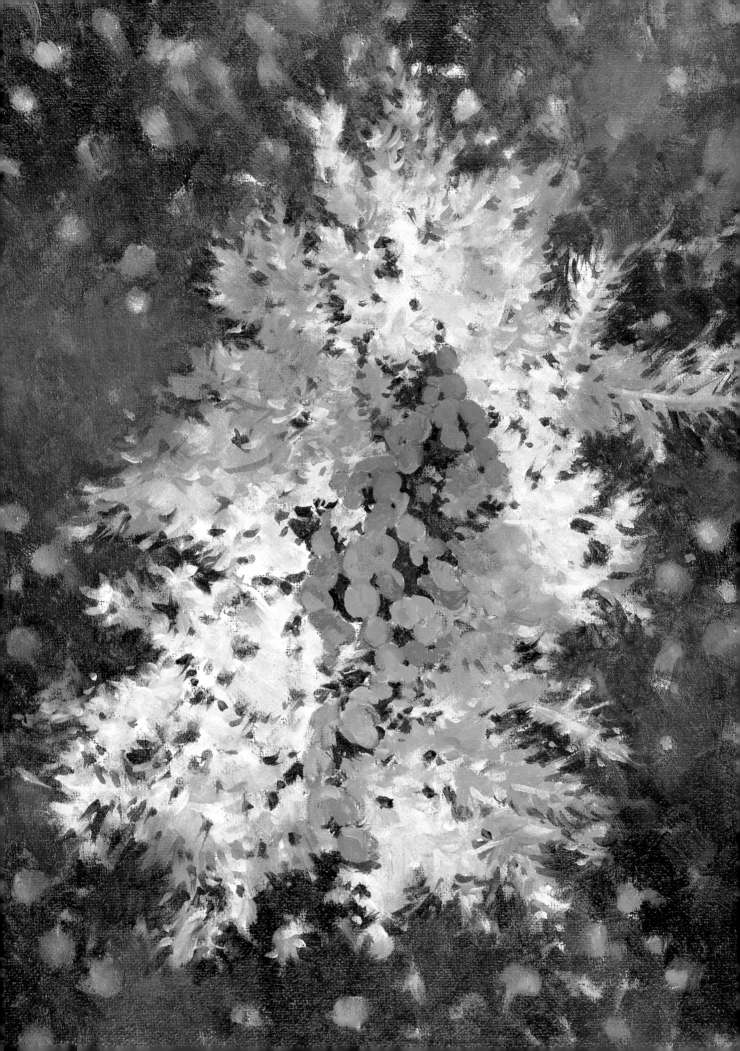

Handling Diverse Textures

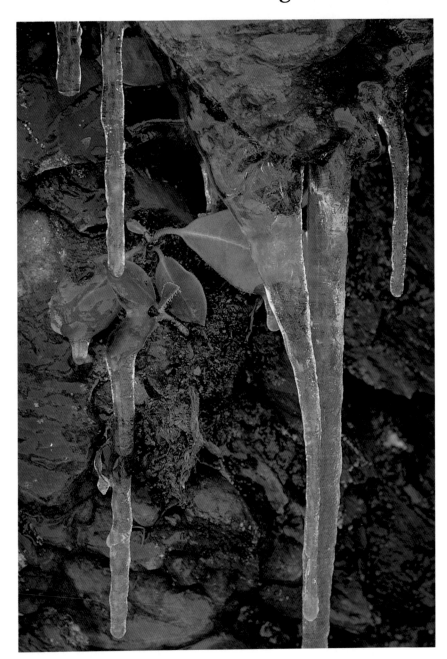

PROBLEM

Many elements fight for attention here—the thick icicles, the rough rocks, and the smooth leaves. If they are all given equal attention, your painting will probably be confusing.

SOLUTION

Simplify the rocks as much as possible to set off the glistening ice.

STEP ONE

In a careful charcoal drawing, record the shapes that crowd this composition. Don't just follow the outlines of the icicles and leaves. Instead, try to capture the little details that suggest all the different textures that you see.

Strong, thick icicles hang from a rough sheet of rock and encase smooth mountain laurel leaves.

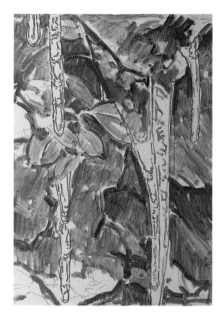

STEP TWO

With thinned cobalt blue, reinforce the lines of your drawing, then start to establish your overall color scheme. Continue using thinned color as you brush in the green of the leaves, the blues that rush through the icicles, and the browns, blues, and grays that make up the rocks. During this stage, start to simplify the background, breaking the rocks into large abstract areas of color.

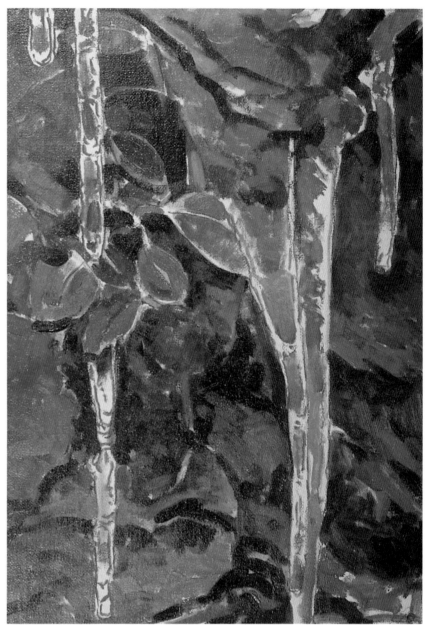

STEP THREE

The cool, dark rocks spring into focus as you begin to build them up with opaque pigment. Keep their shapes strong, but simple, and their values good and dark. Now using the same hues, paint the dark shadowy portions of the icicles. Remember—you are actually looking through the ice, and not at the ice itself. Finally, paint the smooth green leaves.

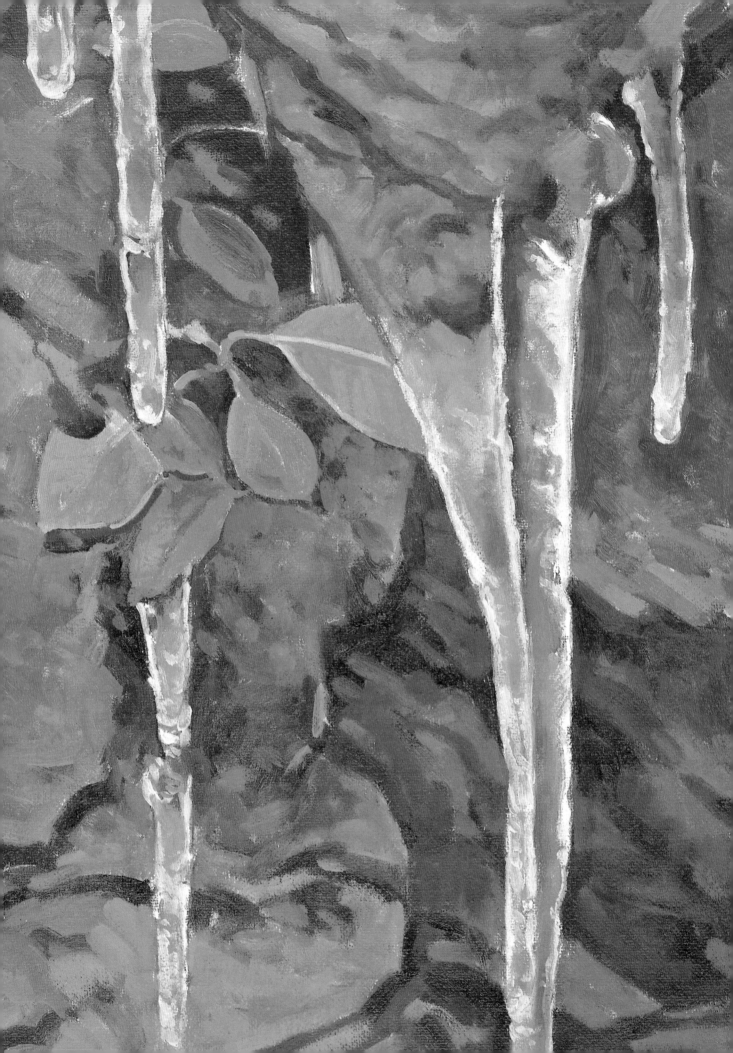

FINISHED PAINTING

In the final stages of your painting, concentrate on the icicles. Crisp, clean touches of white bring up the highlights that animate the ice, while softer strokes of dull bluish-gray and brown further develop the shadows. Once you are satisfied with the icicles, scan the rest of your painting, looking for areas that need definition. Carefully render the leaf stems, and any other details that you may have overlooked.

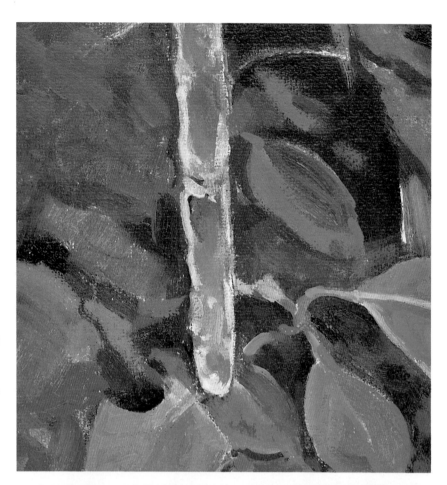

DETAIL

Many colors come into play in this painting, yet they work easily together, in part because they are closely related in value and in part because they are laid in with large, loose strokes. The dark hues that make up the rocks set the stage for the brilliant highlights of the icicles.

DETAIL

Crisp strokes of pure white define the edges of the icicles and set them off from the dark background. Note the number of colors used to render the icicles— white, ocher, browns, blues, and even touches of green where a leaf lies hidden behind a column of frozen water.

359

Working with a Limited Palette

PROBLEM
When only a handful of colors make up a subject, a painting can easily become static and dull.

SOLUTION
Let contrasting values animate your painting. Start out by staining the canvas with a medium-value blue, then concentrate on the strong lights and darks.

☐ Capture the flowerlike configuration of the moss and ice in a careful charcoal drawing, then spray the canvas with a fixative. Now mix a thin wash of cobalt blue and apply it to the entire canvas. While it's still wet, take a rag and wipe out the brightest lights. Finally, strengthen the dark lines of your drawing with thinned cobalt blue and black.

Working back over your drawing, begin to paint the darks of the background with opaque pigment. Before you begin, stop and study the icy formations. Note that they resemble flowers and keep their structure in mind as you paint.

First lay in the dark blues, then the green leaf and the brown branch. The darks down, gradually build up the medium values, then turn to the lights. Lay in the highlights, then go back and reinforce their edges by strengthening the darks that surround them. At the very end, study the overall painting, looking for areas that seem too light, too dark, or too weakly defined.

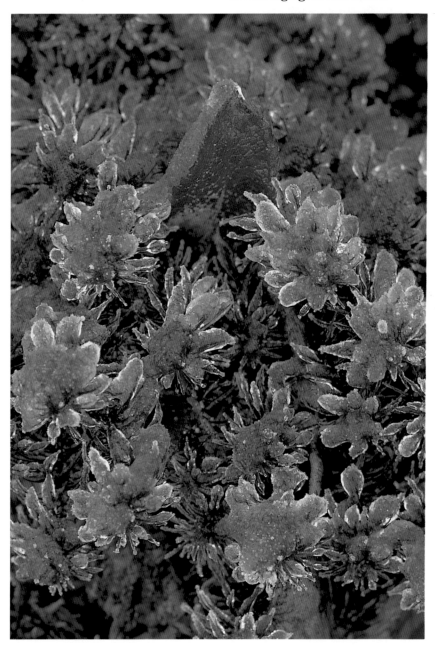

ASSIGNMENT
Find subjects like the one explored in this lesson using a camera. Looking through a camera's viewfinder is an easy way to isolate interesting details that you might otherwise miss. Or try this: Cut rectangular viewfinders out of heavy cardboard and use them to frame interesting details.

Crystals of ice grow in flowerlike formations, mimicking the moss that lies beneath them.

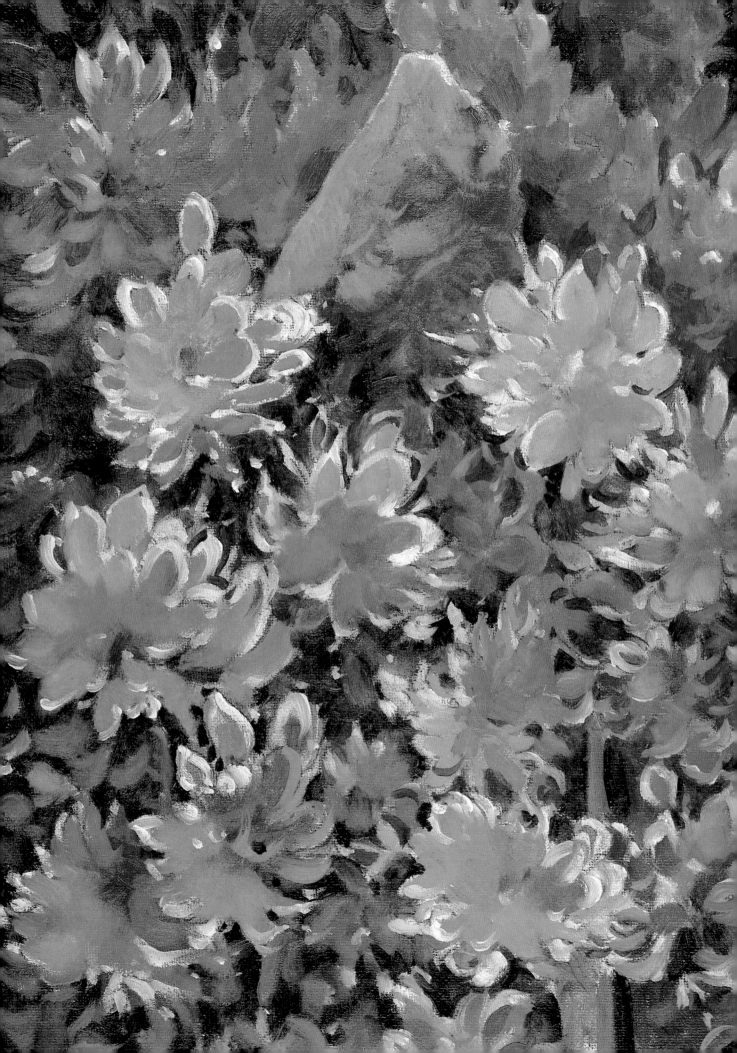

Depicting a Delicate Fringe of Frost

PROBLEM

Strong reds and greens vie for attention with delicate frost. Somehow you have to balance these dramatic and subtle elements.

SOLUTION

Keep the background and the leaves dark enough, and the frost will spring into focus.

☐ Sketch the scene with a charcoal pencil, fix the drawing, then reinforce it with thinned color.

Now go to work on the background, using opaque pigment. Don't add any painting medium—you want your colors and values to be intense—and scrub the pigment onto the canvas to create a soft, unfocused feel.

Using smoother strokes, lay in the leaves and the flowers. To keep the red really vivid, add as little white as possible. For the time being, let the white of the canvas represent the frost.

Once the major forms are established, go back over your painting adding details, such as the veins that line the leaves.

Finally, tinge white pigment with alizarin crimson and Thalo blue, then paint the frost with gentle, feathery strokes.

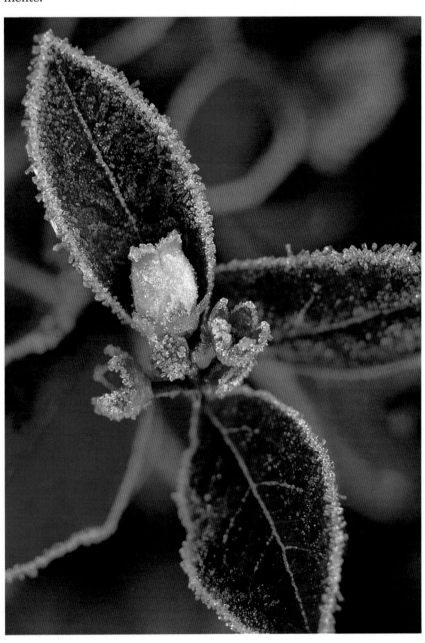

The bell-shaped flowers of a blueberry bush are dusted with minute crystals of ice.

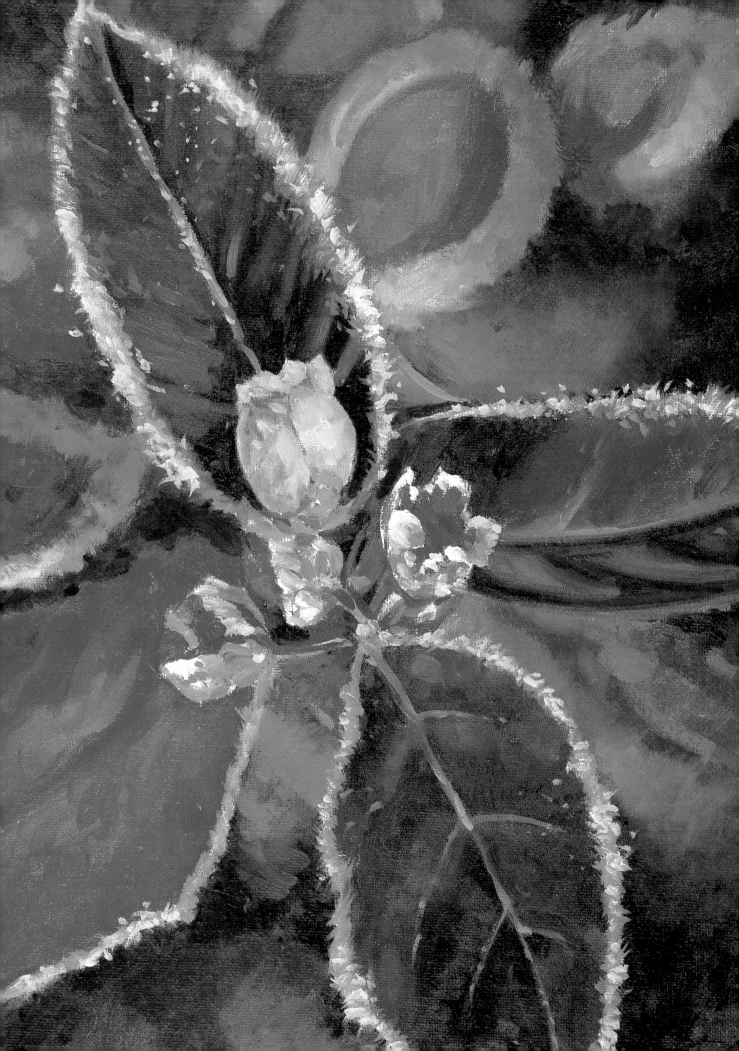

Learning How to Paint Transparent Drops of Water

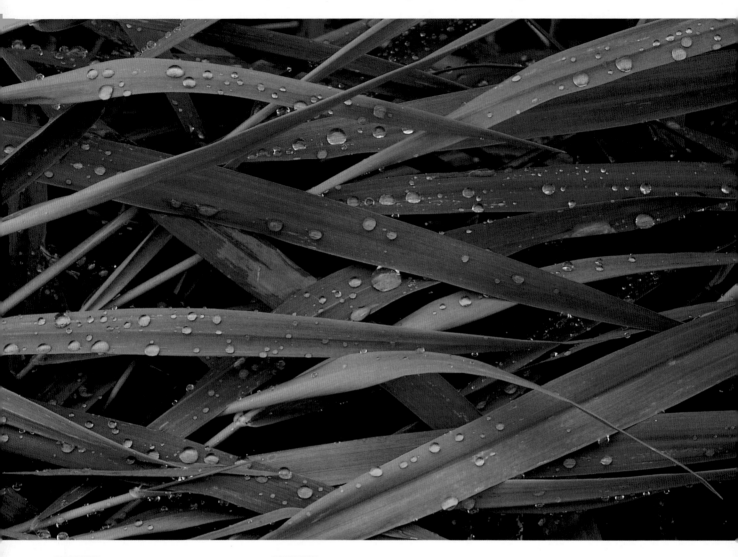

PROBLEM
Two challenges confront you here:
the patterns formed by the
grasses and the delicate nature
of the raindrops. Both must be
captured.

SOLUTION
Deal with one problem at a time.
First develop the blades of grass,
then paint the raindrops right over
them.

*Raindrops glisten on interwoven
blades of rich green grass.*

364

STEP ONE

Precise subjects like this one call for strong drawings, so spend as much time as you need to record the anatomy of the grass. Next, spray your drawing with a fixative, then apply a thin wash of permanent green light to the entire canvas. When the surface is dry, reinforce your drawing with thinned color and a small pointed brush.

STEP TWO

Your pigment has to be fluid when you start to build up the grasses, so add plenty of painting medium to your color before you start. Get the darks down first with a rich blend of Thalo green and alizarin crimson, then turn to the medium values, rendering them with Thalo green and permanent green light. Use long, clean, sweeping strokes, and make sure that the edges of the grass blades stay sharp.

STEP THREE

As you begin to reinforce your underpaintng with opaque pigment, vary your colors as much as possible. Add touches of cobalt blue and yellow ocher to your greens, and even bits of cadmium yellow. Vary temperature, too. Here warm, vibrant passages stand next to cooler areas, creating a sense of depth. When you are totally satisfied with the grass, start to render the raindrops.

FINISHED PAINTING

It's capturing the play of light on the raindrops that will make them convincing. Each drop is made up of a highlight and a shadow. First, using small, circular strokes, lay in dabs of white. While the pigment is still wet, go back and work in tiny bits of pale bluish-green, pulling the darker pigment through the white. As you work, keep your eye on the direction that the light takes.

Warm and cool hues and dark and light values separate the individual blades of grass and add drama to the pattern that they create. Very little suggestion of the painting process is evident in the finished work because the pigment has been thinned with a generous amount of painting medium.

Almost every raindrop is made up of a highlight and a shadow. First, pure white is dabbed onto the canvas, then a pale hue of bluish-green is run through the white to place the shadow.

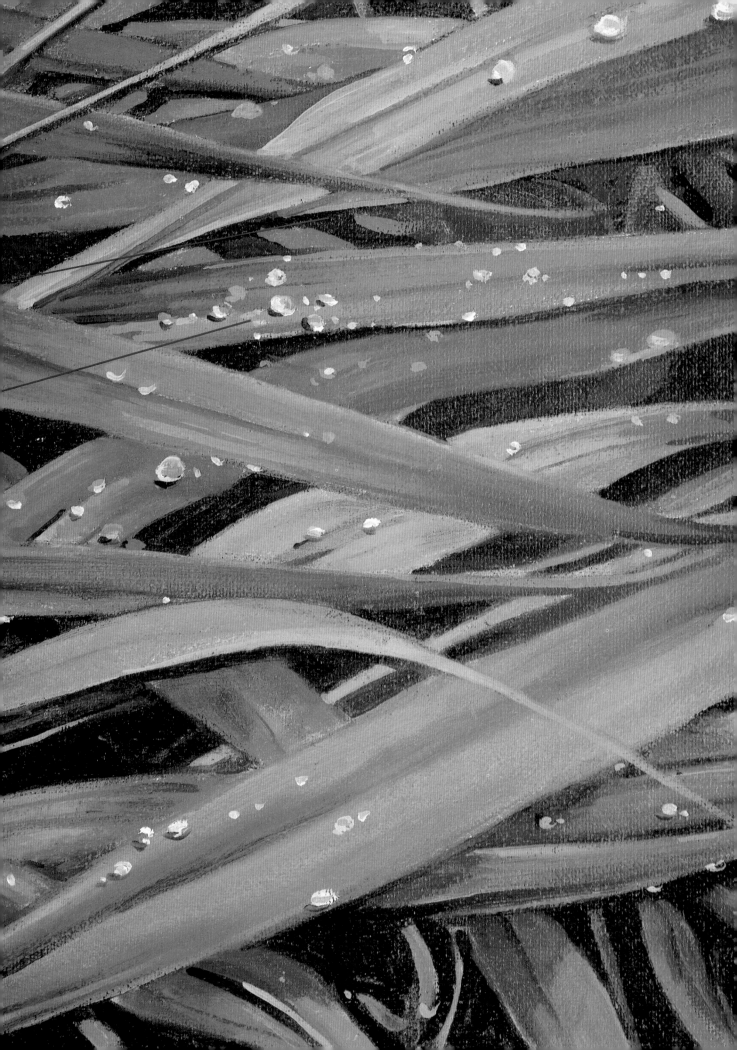

Choosing a Small Support

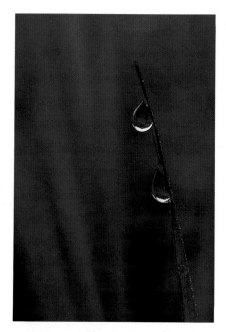

PROBLEM

The success or failure of your painting rests entirely on your ability to paint the dewdrops. They're obviously the focus of the composition.

SOLUTION

Don't make matters even more difficult by working on a grand scale. Instead, choose a small support, one about eight by ten inches.

☐ Because of the simplicity of the composition, try a new approach. Work up the background thoroughly, without any preliminary drawing, then let the canvas dry and add the dewdrops. Mix together a dark, dull shade of green and lay it in all over the canvas with firm strokes. To make it a little more interesting, work touches of yellow ocher into the green. Now let the surface dry.

Using soft vine charcoal, carefully sketch the grass blade and the drops of dew, then go over the lines of your drawing with thinned color. With a small pointed brush, render the grass; remember to pull out the tiny highlights that lie along its edge and to inject the blade itself with as much color as possible. The grass done, turn to the focus of the composition, the dewdrops.

First get the darks down, using the same colors that make up the background. Now add even darker touches of color near the top of each drop and down its side.

Finally, add the bright highlights that shimmer at the base with a mixture of yellow ocher and white, and run a little pale blue around the sides of the drops to separate them from the dark green background.

Two dewdrops hang from a lone blade of grass.

Animating Dark Water

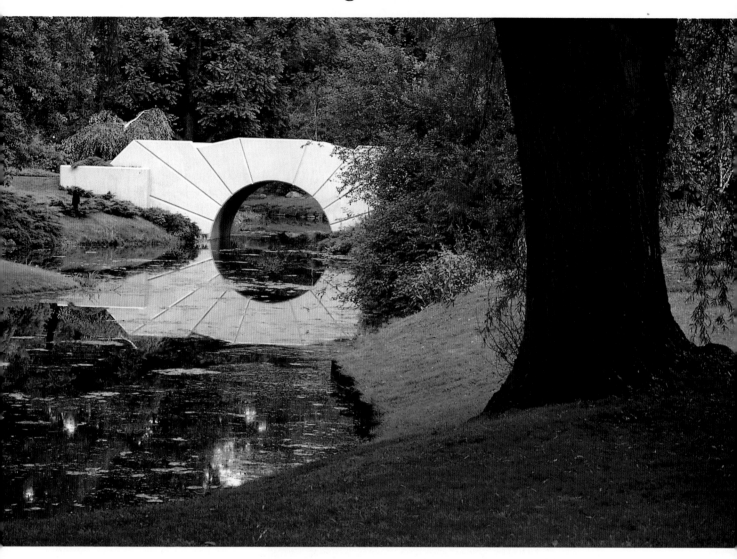

PROBLEM

At first glance, this landscape seems perfectly straightforward. And in a way it is. But if you follow what you see literally, you'll end up with a mass of medium-value green. Surely there's a more exciting way to work out your painting.

SOLUTION

Add as much variety as possible to the greens, darken the foreground, and transform the still green water into an exciting mixture of blues.

A bold white bridge spanning a pond is mirrored in the dark green water that lies below.

STEP ONE
Do a quick charcoal sketch of the scene, then reinforce your drawing with thinned Thalo green. Now sweep in the dark foreground and the tree, and you'll immediately establish a sense of depth.

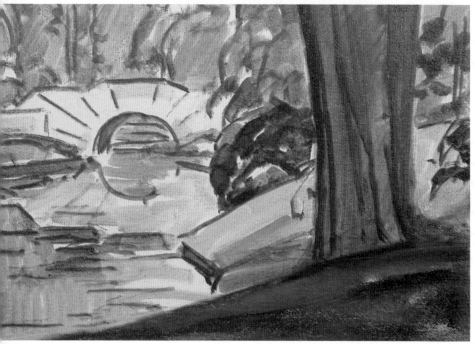

STEP TWO
Now's the time to set up your color scheme and your value scheme with thinned color. Loosely indicate the dark foliage in the background, then lay in the brilliant green bank on the right. Finally, get down the blue of the water and the pale gold reflection of the bridge.

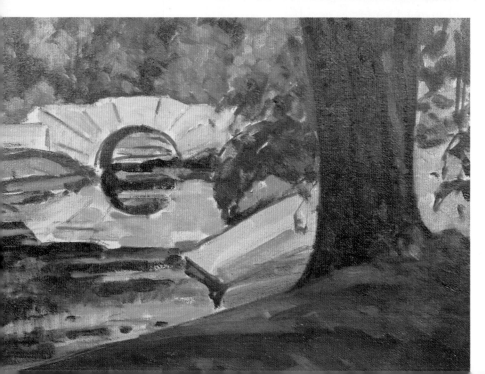

STEP THREE
By now, the basic framework of your painting is completed. All that remains to be done is to articulate your underpainting with opaque pigment. Just as before, use a broad range of greens to render the foliage. As you paint the water, follow the dark and light patterns that wash over it. Pause from time to time and make any necessary adjustments in color and value. Toward the end, complete the bridge and its reflection.

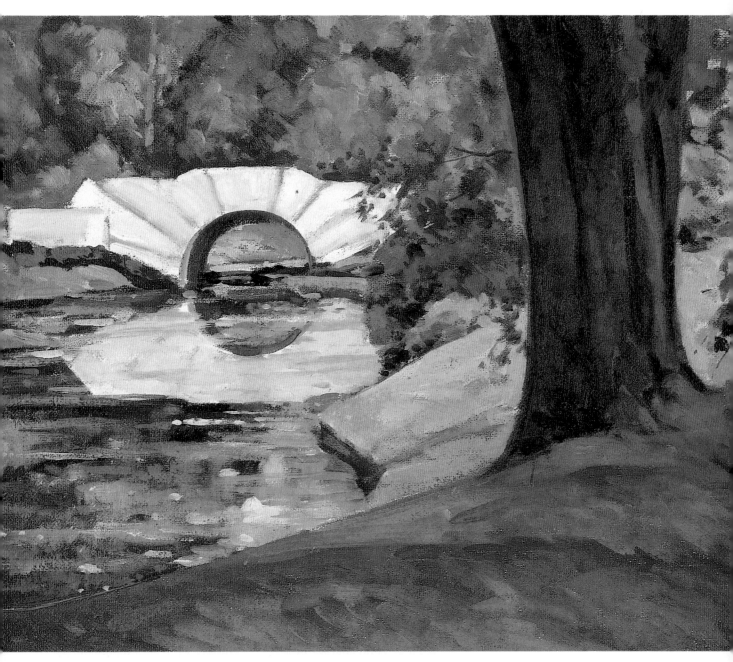

FINISHED PAINTING

Move away from your painting for an hour or two, then come back and look at it afresh. No doubt you'll find areas that need definition. Here, for example, the water seemed lackluster. By increasing the strength of the darks and adding a few additional lights, the foreground became much stronger. As a final touch, strokes of brilliant burnt sienna were added to the base of the tree to pull that area forward, and the golden-green of the bank on the right was intensified.

Analyzing Light and Dark Values

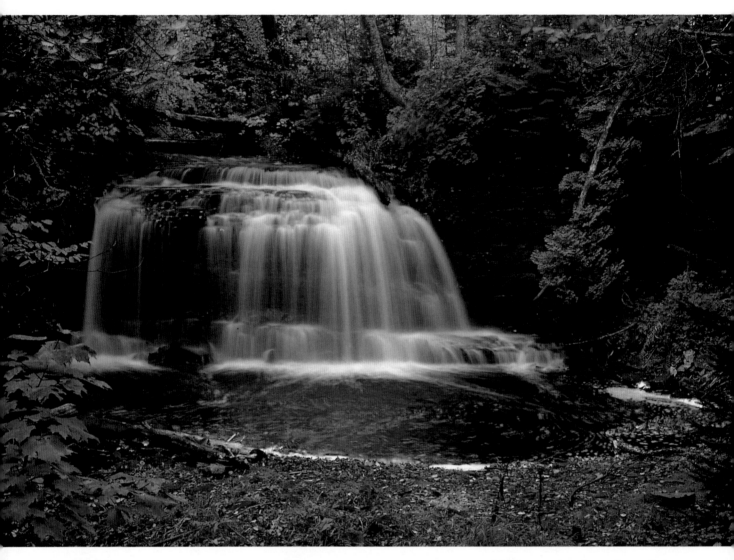

PROBLEM
The frothy white water stands out dramatically against the dark greens and golds that make up this scene. You could easily over-emphasize the whites, and make the water look artificial.

SOLUTION
Analyze how the water actually looks. Note that it forms definite planes; at the top of each rock, the water is brilliant white, but as it falls, it becomes darker and duller.

☐ In your drawing, place all the elements of the composition with vine charcoal.

The drawing done, go over it with thinned color. Continue working with diluted pigment as you start to build up the painting. Make sure your darks are dark enough; at this stage, everything looks dark against the white canvas and you can easily work too lightly.

Here the foliage is rendered

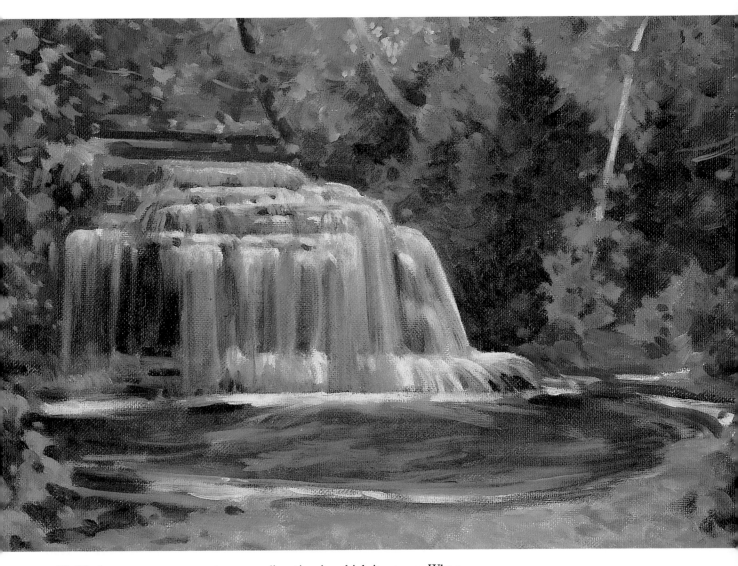

with Thalo green, permanent green light, yellow ocher, cadmium yellow, and cadmium orange. In places, touches of burnt sienna darken the greens. The water is made up of Mars violet, Thalo blue, Thalo green, cobalt blue, alizarin crimson, black, and white.

With heavier color, develop the dark areas around the falls. Use short, choppy strokes as you lay in the foliage, and follow the direction in which it grows. When you turn to the water, lay the paint down with longer, softer strokes. Begin with the dark vertical streaks of color that lie beneath the glistening whites. When they are down, go back and gently lay in the frothy whites.

As a final step, add dashes of Mars violet to the pool of water under the falls, then touches of white to the edges of the pool.

Balancing Many Diverse Elements

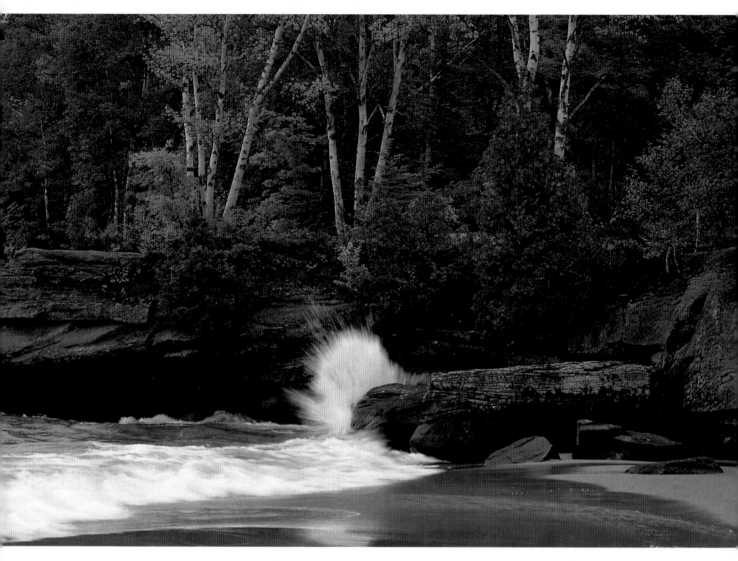

PROBLEM

There's no single problem here, yet this composition will surely test your abilities. It's made up of many diverse elements—the rocky shore, sandy beach, and surf, plus a magnificent autumn landscape.

SOLUTION

Start with a detailed charcoal drawing, then use a traditional dark-to-light approach. Let your brushstrokes help separate the different areas, too.

☐ With soft charcoal, sketch the scene. Work freely, and don't be afraid to use a lot of lines as you feel your way through the composition. Now dust off any loose charcoal and reinforce the sketch with thinned color. Let the surface dry.

With thinned color, start to paint the darkest areas. Make the rocks really dark—since they form the darkest value in the scene, they can help you gauge the rest of your values.

The dark rocks in the center of

In autumn at Lake Superior, water washes toward the shore, exploding as it crashes into a rock.

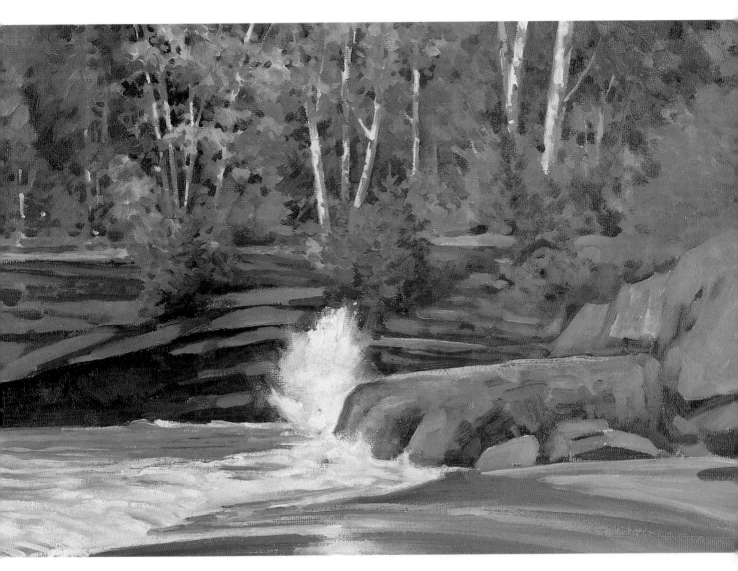

the composition are rendered with Mars violet, raw sienna, and alizarin crimson. Those in the foreground are made up of the same hues mixed with white and black.

Because the trees are built up of many different colors, it's easy to establish their individual shapes. Get them down with thinned color, then start to develop them with thicker pigment and short, choppy strokes. Here they are rendered with Thalo green, yellow ocher, cadmium yellow, cadmium orange, and cadmium red. As you lay in the lighter trees, work back and forth between the dark green foliage in the background and the brighter leaves.

Finally, lay in the sandy shore with broad, sweeping strokes of yellow ocher and burnt sienna. For the water, glide a mixture of cobalt blue and white onto the canvas. Finally, dab white and yellow ocher down to indicate the crashing surf.

Mastering Soft, Unfocused Reflections

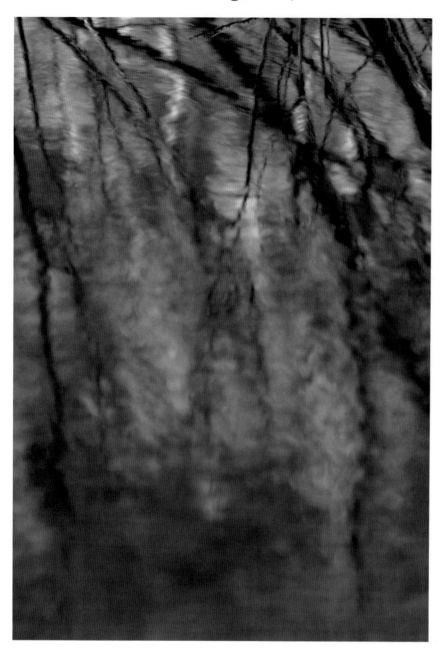

PROBLEM
There's very little to hang onto here. The shapes are soft and unfocused and the colors are indistinct.

SOLUTION
Work loosely, following what you see as closely as possible. Throughout, work wet-in-wet to maintain a soft, lyrical feel, but use vigorous brushwork to give a little energy to your painting.

STEP ONE
When you approach an abstract subject like this one, there's no need to execute a preliminary sketch. Instead, start painting right away. With thinned color and rapid, calligraphic strokes, start laying in color—Thalo green, permanent green light, cadmium yellow, burnt sienna, burnt umber, and cobalt blue.

Wind stirs across the surface of a pond, softening reflections of brilliant spring-green foliage.

STEP TWO
Working wet-in-wet, and with
heavier color, continue to build up
the patterns formed by the reflec-
tions. As you work, brush one
color into the next, continually
softening edges to keep the im-
age unfocused. Adding a little
extra painting medium to your
color will make it easier to work
loosely.

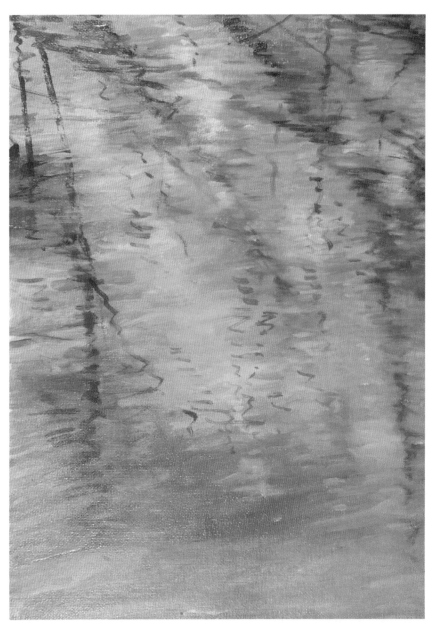

STEP THREE
Gradually introduce lighter shades
as you continue building up the
painting. Your strokes should
have a strong sense of direction,
following the motion of the water.
If the branches stand out too
sharply against the rest of the
colors, soften them by running
small touches of color back and
forth over them.

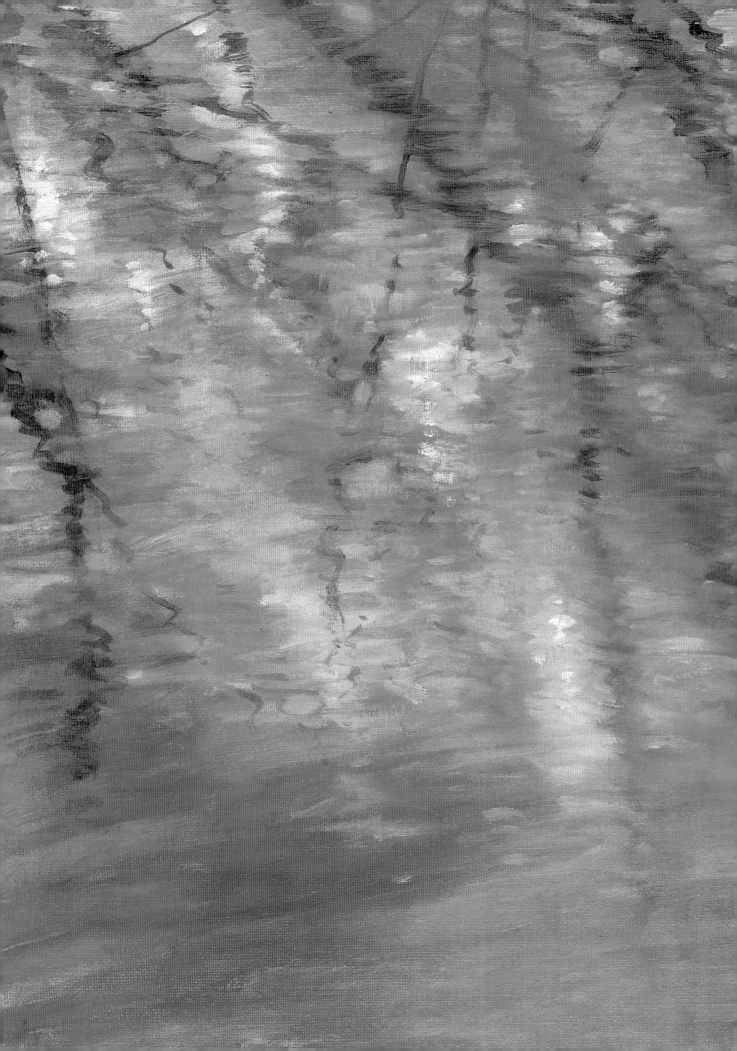

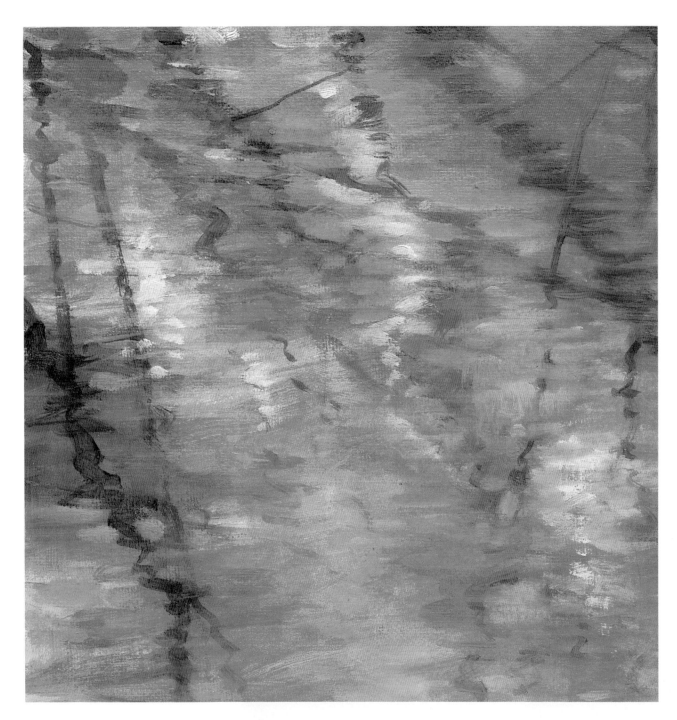

FINISHED PAINTING
Let the surface dry slightly. While
you are waiting, analyze your
painting. Are the branches too
dark? Are some of the colors too
bright? Are there sharp edges
present? Now go back and make
any adjustments that you think
are necessary.

DETAIL
Seen up close, the many hues
that make up the water become
apparent. Yet, because they are
laid in wet-in-wet, they blend
together easily. More important,
this basically soft subject is made
stronger and more dramatic by
energetic brushstrokes.

Working with Bold Color

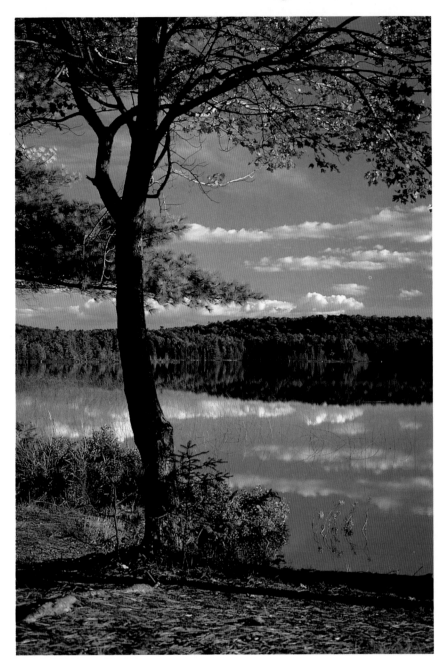

PROBLEM

This subject is straightforward. Only one problem is likely to occur: underemphasizing the bold color and the distinct shifts in value.

SOLUTION

Force yourself to use colors that are a little bolder than those you would customarily select. Then, as you paint, lay in the colors with strong, dramatic brushstrokes.

STEP ONE

Beginning with the tree, sketch the scene with vine charcoal. The tree down, fit in the rest of the shapes in the background. Now strengthen the drawing, making any necessary corrections, with thinned color. At this stage, working with a deep, dark hue will help you create a stronger, more dramatic painting.

In autumn, as leaves begin to turn brilliant shades of orange and red, a deep blue cloud-streaked sky is reflected in a placid lake.

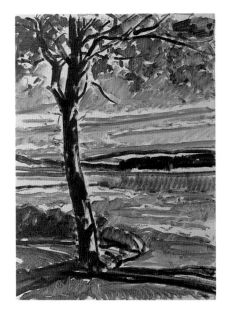

STEP TWO

Working over the entire canvas, brush in the colors and values with thinned color. Let the white canvas represent any light areas. One major compositional change takes place in this step: The large green tree on the left is omitted because not enough of it is present to explain its form.

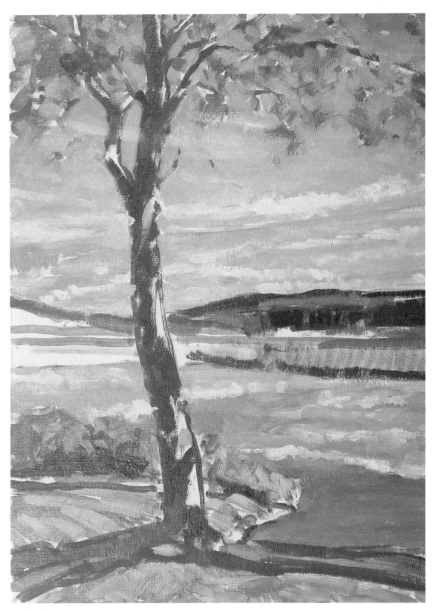

STEP THREE

Working with heavier color, move back and forth between the tree and the sky, painting the sky through the tree and the tree over the sky. Keep the contrast between the two strong. Alongside the strong reds that make up most of the foliage, introduce a few dabs of green and you'll achieve a more realistic look.

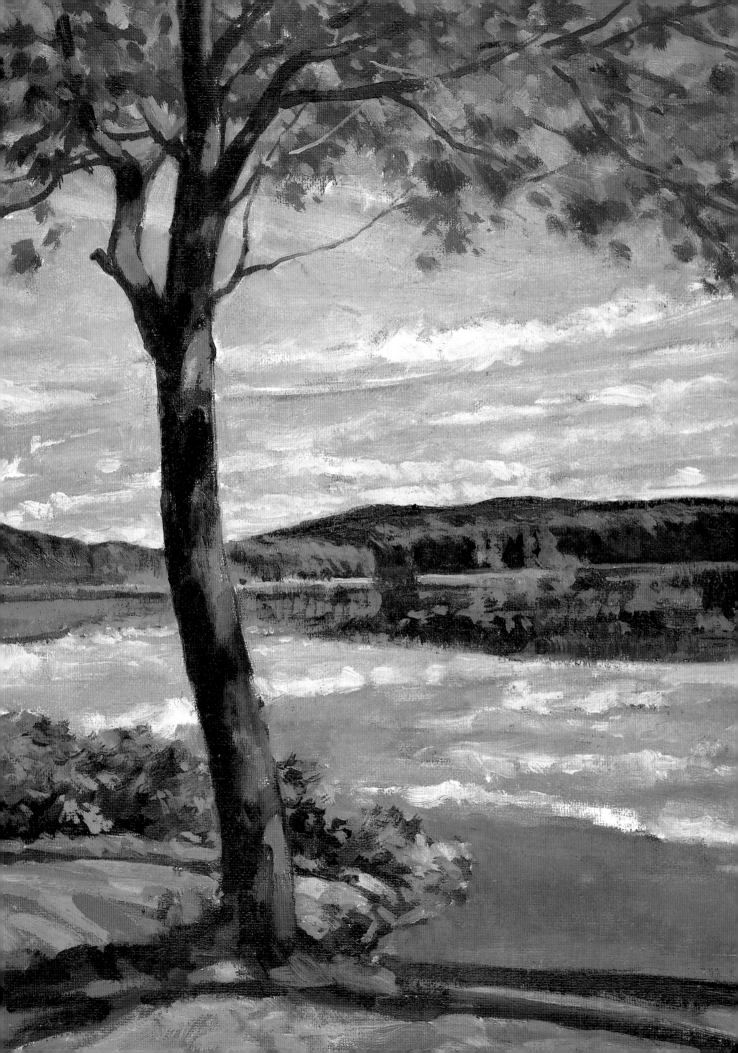

FINISHED PAINTING
Laying the pigment down with
strong, sure strokes, finish the
painting. First build up the leaves
on the tree with cadmium red,
cadmium orange, alizarin crimson,
and Thalo green. The green fo-
liage is rendered with Thalo
green, permanent green light, and
touches of yellow ocher. For the
water, use cerulean blue, Thalo
blue, white, and a tiny bit of
black. The ground is laid in with
bold strokes of burnt sienna,
yellow ocher, and permanent
green light.

DETAIL
Painted with cerulean blue, Thalo
blue, white, and black, the water
is actually darker than the sky it
reflects. By making the water
darker than it actually is, you can
direct attention to it and to the
tree that dominates the fore-
ground.

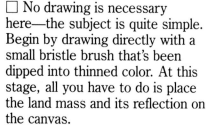

Capturing the Beauty of a Sunset

PROBLEM

Nature's most dramatic moments can be very difficult to capture in paint. Here the fading sun silhouettes the hills and the trees, making them stand in sharp relief against the sky and the water.

SOLUTION

To make your painting more interesting, break up the surface with short strokes of broken color. At the same time, add dashes of purple and pink to the orange sky.

☐ No drawing is necessary here—the subject is quite simple. Begin by drawing directly with a small bristle brush that's been dipped into thinned color. At this stage, all you have to do is place the land mass and its reflection on the canvas.

Now working with Thalo blue and alizarin crimson, lay in the tree-studded land. From the beginning, work with opaque pigment. Lay the color down with short, rapid strokes, and don't let your color become too flat. In some areas, let the Thalo blue shine out; in others, let alizarin crimson dominate.

Next, using the same hues, lay in the reflections that lie in the water.

Now turn to the sky and the water. At the top of the canvas, work with cadmium orange. As you approach the horizon, add cadmium red. Near the land, streak alizarin crimson across the sky. To render the water, work with the same colors.

Let the surface dry, then turn to the leafy branches that fill the upper left corner. Using charcoal, sketch them, then paint them with a mixture of Thalo blue and alizarin crimson, mixed with a dab of painting medium to keep the pigment flexible. As a final step, add the tall scraggly tree that shoots above the land on the left.

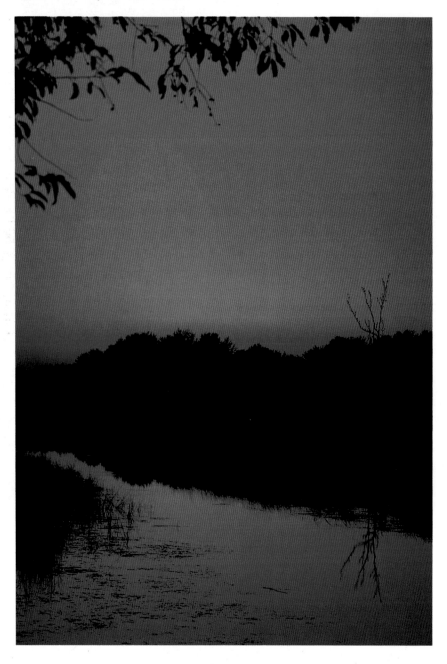

As the sun slowly sets, glorious color floods the sky, the land, and the water.

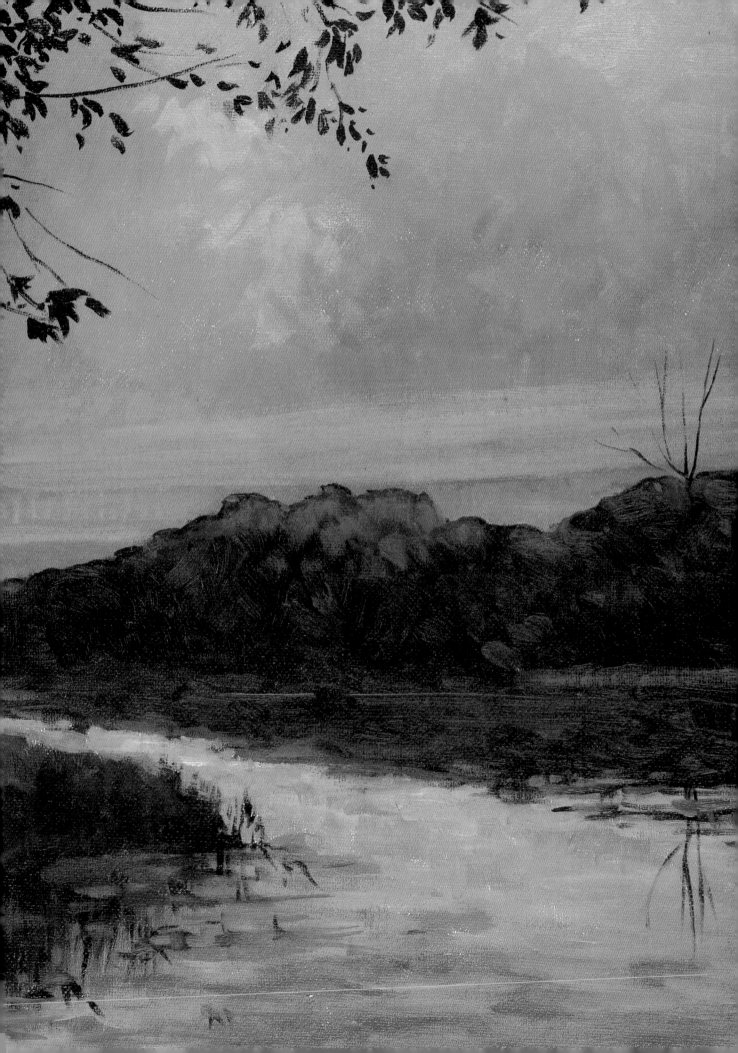

Painting Late-afternoon Light

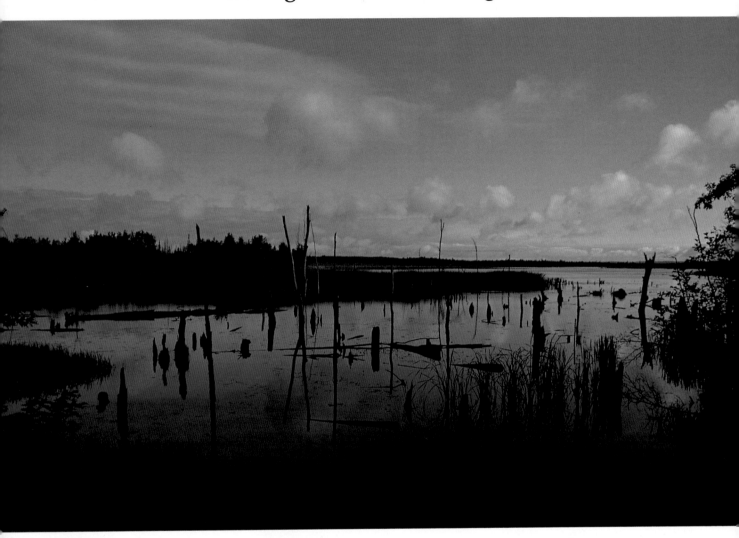

PROBLEM

Two elements give this composition power—the sky and the water. Both have to be rendered with care to make your painting work.

SOLUTION

Tie the sky and water together by using related hues. More important, note what makes the two areas different—the water is darker than the sky and it's filled with shadows.

A marsh sweeps back toward the horizon, its water softly reflecting the cloud-filled sky.

STEP ONE

Think of your preliminary drawing as a form of visual shorthand. In it you can capture what matters to you, be it the movement of the clouds, the physical power of the land, or the reflections that lie in the water. Work rapidly, getting down everything important in soft vine charcoal.

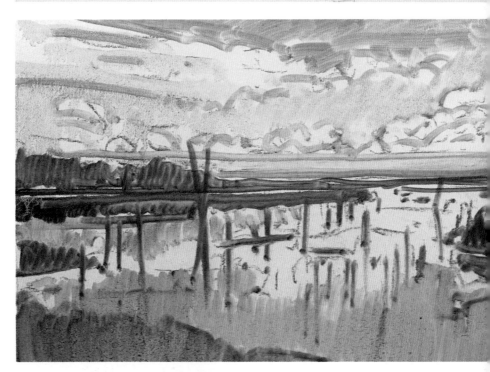

STEP TWO

Working with cobalt and Thalo blues that have been thinned with mineral spirits or turp, establish the value scheme. Think of this step as a color sketch. In it, you can capture not only values, but also the movement that will run through the finished work. For the darkest passages, mix a little black into your blues.

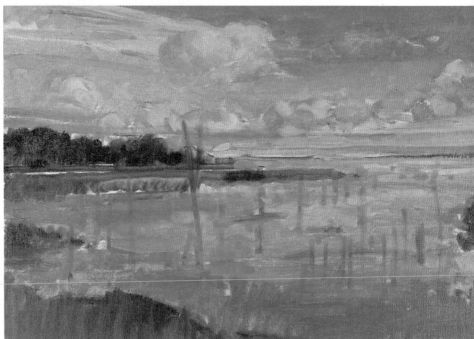

STEP THREE

Working now with thicker pigment, build up your composition. Start with the darks that dominate the water in the foreground and the land, then turn to the sky. As you render the sky, work around the clouds. When you start to paint the clouds, remember that they have both dark and light sides—they're not pure white. Here alizarin crimson warms both the sky and the water.

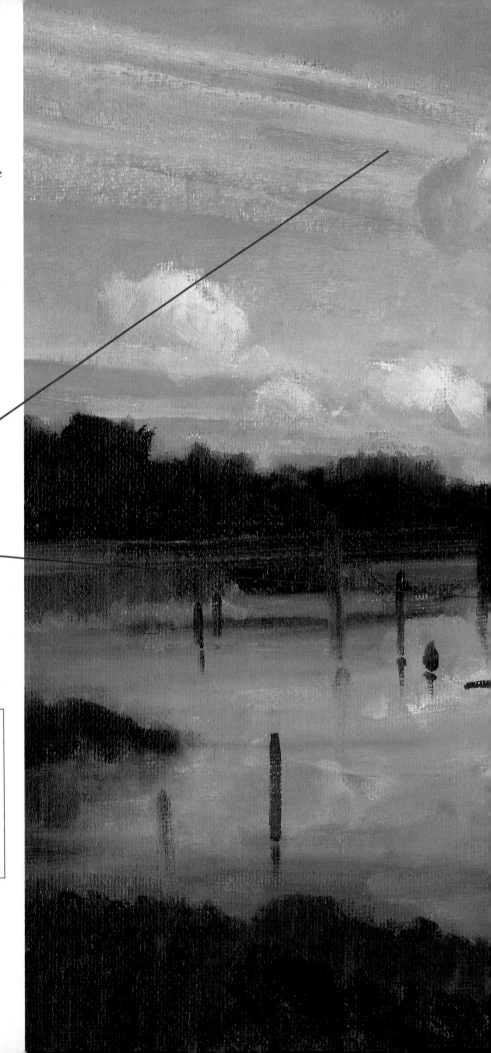

FINISHED PAINTING

Complete the sky. Touches of
yellow ocher enliven the clouds;
strong brushstrokes make them
sweep across the sky. Cerulean
blue warms the water, and
strokes of blue plus alizarin crim-
son and white are laid down in the
foreground.

As a final step, the darkest
values are added. For the land
mass in the distance, scrub a
mixture of Thalo blue, black, and
burnt umber onto the canvas.
Use denser pigment in the imme-
diate foreground, and a drybrush
technique to render the trunks
that break through the water.

*In the final stages of the painting,
while the pigment is still pliable, a
stiff brush is pulled across the sky to
evoke the motion of the clouds.*

*The tree trunks that rise above the
water are rendered with a drybrush
technique. They are still dark, and
add drama to the picture, but not so
emphatic that they steal attention
from the subject of the painting—the
dramatic light that makes the water
and the sky exciting.*

ASSIGNMENT

As this lesson shows, a scene
set in late-afternoon light needn't
center on the falling sun. Try
this: Look away from the sunset,
and study the effect the failing
light has on the rest of the land.
You'll find a world filled with
subdued drama, rich with con-
trast between darks and lights.

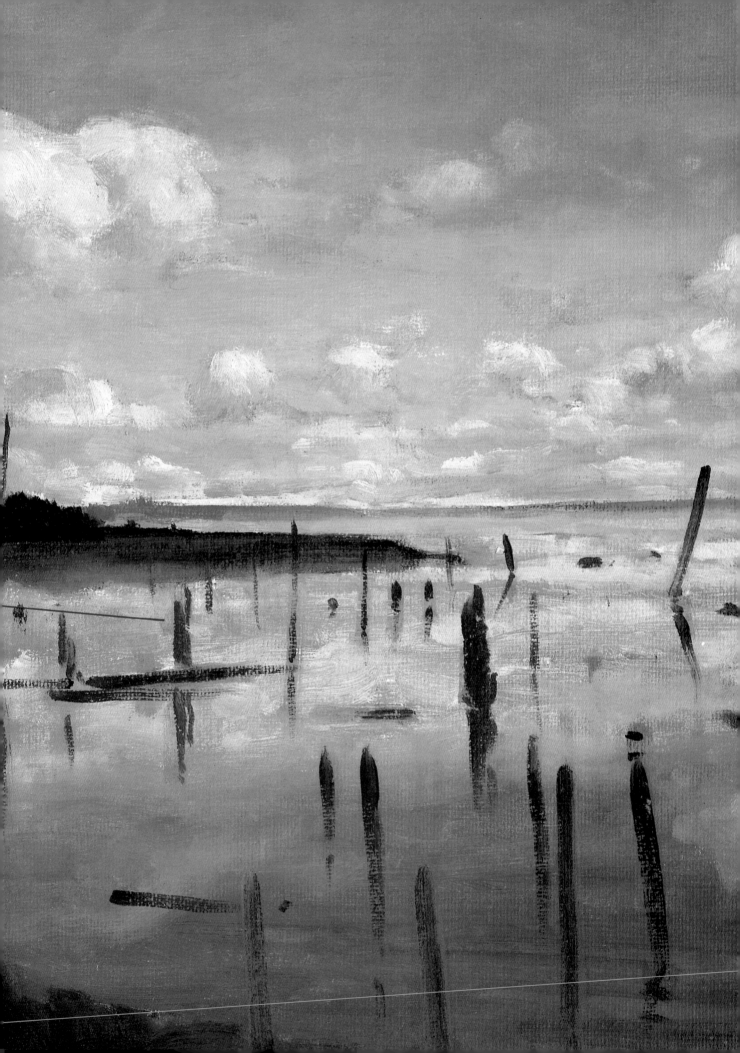

Breaking Up a Pattern of Dark, Dull Green

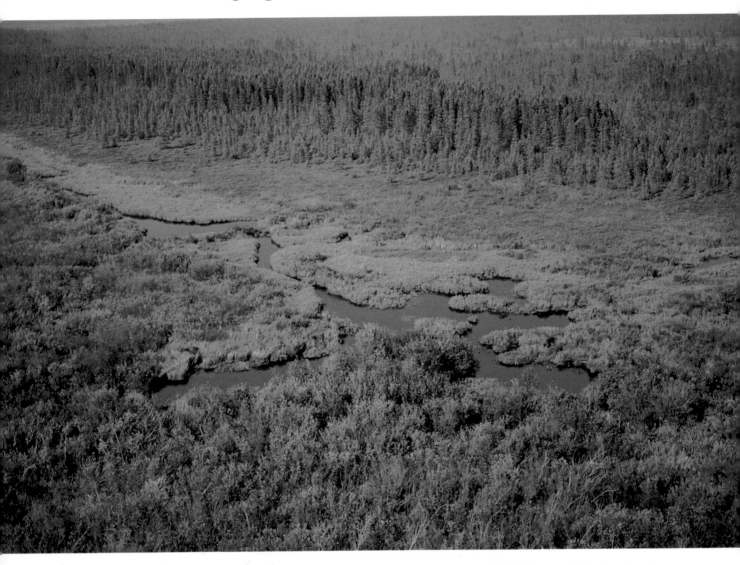

PROBLEM

What makes this scene special is the bright slash of blue that the water cuts against the green foliage. But the greens have to be tamed if the water is going to stand out against them.

SOLUTION

Look for nuance—the greens in the foreground are slightly warmer than those in the background, and their shapes are rounder, too. Make the greens as varied as possible, and exaggerate the differences in every other hue.

☐ Make a simple drawing to place the patterns of the foliage and water. Pay special attention to the foliage; it will be difficult to paint because it has no real form, but blends, instead, into an overall pattern. Now go over your drawing with thinned color, organizing the dark and light shapes—and emphasizing their differences—to add interest to these areas.

Start to work with thicker pig-

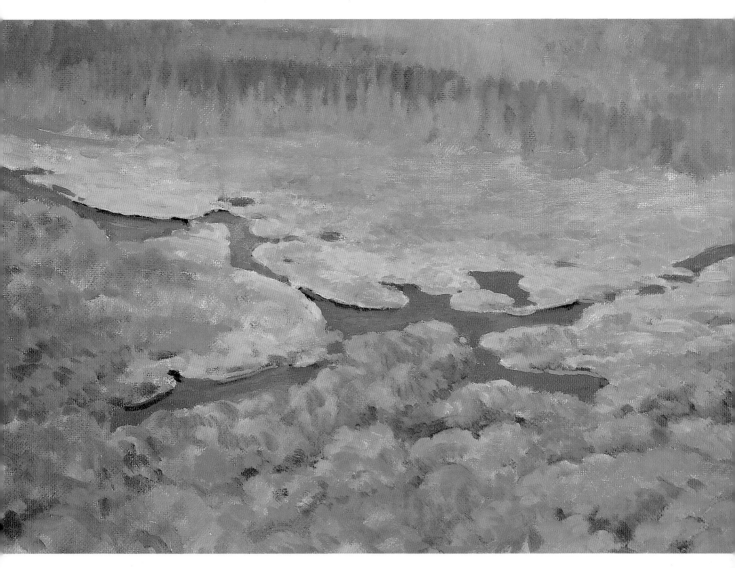

ment. Begin with the foreground, developing the texture of the trees and bushes that lie there. Use short, rounded strokes and warmer hues. Here permanent green light, Thalo green, and Thalo yellow-green, plus white come into play.

Turn to the distant trees. Work with the same greens, but add touches of cobalt blue and still more white. Vertical brushstrokes laid in smoothly will pull the background away from the livelier foreground.

Finally, lay in the water. Make it stand out: It should be carefully drawn before you put brush to canvas. A clear, vibrant tone of cobalt blue is perfect. Once it's down, add a bit of Thalo blue to your palette, then go back and emphasize the shadows that lie right along the banks.

Painting Soft, Blurred Reflections

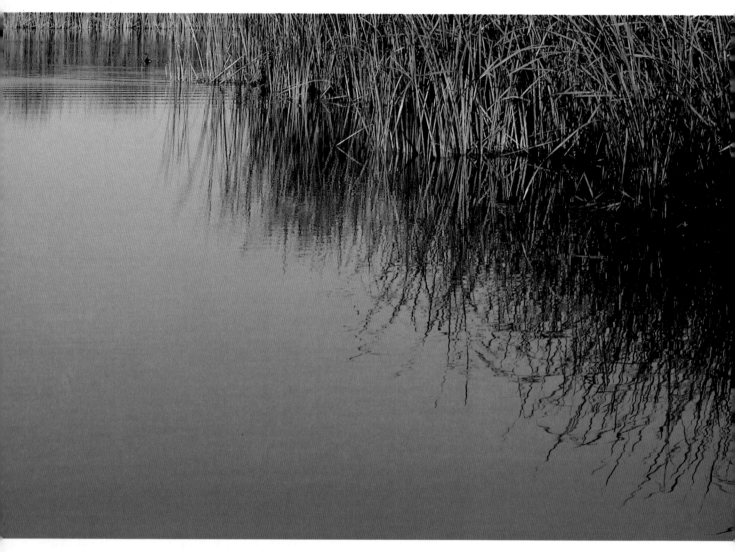

PROBLEM

What makes this scene special at first seems to be the juxtaposition of the greenery and the cool blue water. Look closer. The soft reflections are actually the focus of the composition.

SOLUTION

Paint the grasses with crisp, clean strokes and the reflections wet-in-wet. All the while, work back and forth between the water and the blurred reflections, and you'll make the two areas work well together.

Cattails arch proudly toward the sky, then are reflected in the clear blue water of a pond.

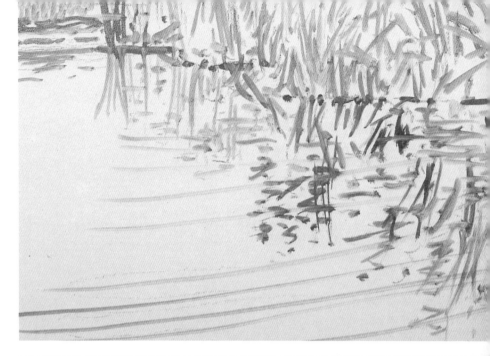

STEP ONE

There's no need to depict every blade of grass; in fact, it would be impossible to do so. So start working immediately with a brush and thinned pigment, instead of executing a preliminary drawing. In your color sketch don't try to capture every detail; just try to get the feeling of the massed grasses and their reflections, and the colors they are made up of. With a few sweeping strokes, suggest the movement of the water.

STEP TWO

With thinned color, go back over the initial oil sketch. At this stage, try to establish the color mood of the painting and its value scheme. Work over the entire canvas with pigment that has been thinned enough to let the oil sketch shine through.

STEP THREE

With thicker opaque pigment mixed with plenty of painting medium, start to paint the water and the reflections. Work wet-in-wet, and don't pay too much attention to detail at this point. Build up the grasses along the bank by laying them in stroke after stroke, working back and forth between the grasses and the darks that lie between them.

FINISHED PAINTING

The stage is now set for the final steps. Working with a small bristle brush, pull out the individual blades of grass. To strengthen their edges, try using a rigger brush. You'll find it especially helpful when it comes time to lay in the long, fluid lines that make up the reflections. As a finishing touch, drag blue pigment over the water to soften it and make it more believable.

The crisp, clean grasses are established with overlapping strokes laid down with a fine brush. Their reflections are worked more loosely, wet-in-wet.

At the very end, the water is subdued with a thin layer of color. Through this final layer of color, you can see the more dramatic brushstrokes that were first put down, but they don't pull attention away from the focus of the painting—the rich green grasses.

ASSIGNMENT

Landscape artists tend to feel that each painting must be made up of land and sky, and sometimes water. This just isn't so. Look at the scene covered in this lesson. The sky is there, of course, reflected in the color of the water. But much more important is the surface of the water, rich with reflections.

Try closing in on subjects, searching for more intimate views of the land. Water is so rich and varied that it provides a logical starting point. Try sketching—then painting—a number of small scenes that feature just the water and land. In the water, try to capture the mood of the absent sky.

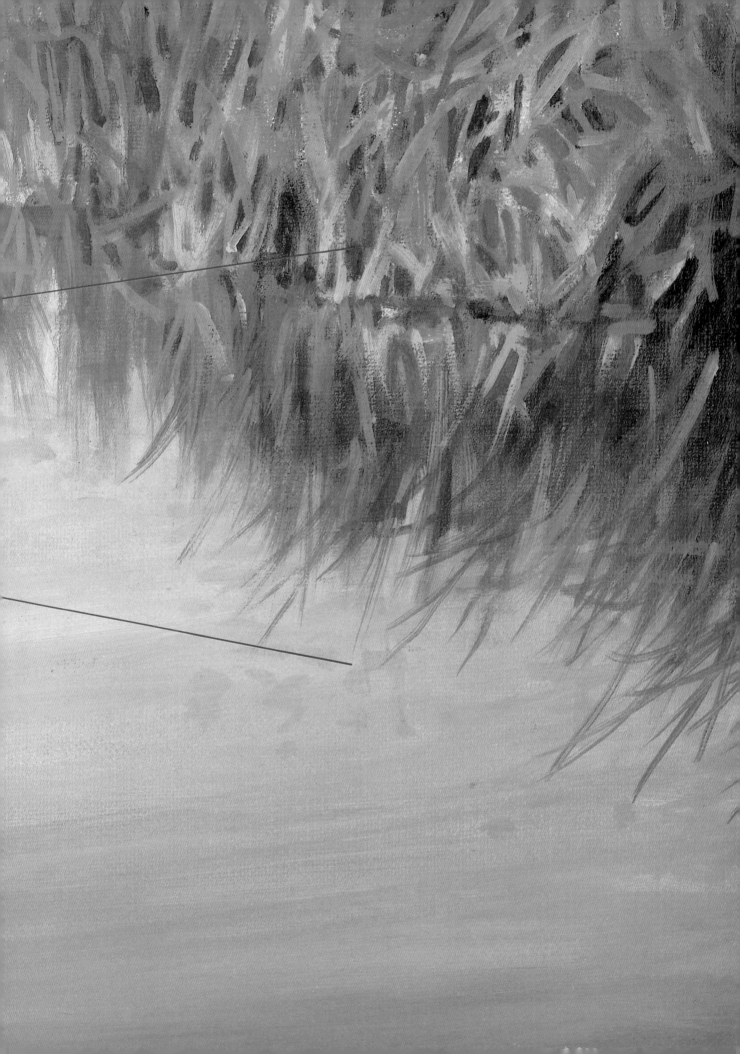

Index